D1120073

THE COMPLETE GUIDE TO
PHOTOGRAPHY

MICHAEL FREEMAN

THE COMPLETE GUIDE TO
PHOTOGRAPHY

NEW
BURLINGTON
BOOKS

A QUINTET BOOK

Published by New Burlington Books
6 Blundell Street
London N7 9BH

Exclusive to Coles in Canada

Copyright © 1989 Quintet Publishing Limited.
All rights reserved. No part of this publication may be
reproduced, stored in a retrieval system or transmitted in
any form or by any means, electronic, mechanical,
photocopying, recording or otherwise, without the
permission of the copyright holder.

ISBN 1-85348-202-1

This book was designed and produced by
Quintet Publishing Limited
6 Blundell Street
London N7 9BH

Creative Director: Peter Bridgewater
Art Director: Ian Hunt
Project Editor: Gavin Hodge
Editor: Belinda Giles

Typeset in Great Britain by
Central Southern Typesetters, Eastbourne
Manufactured in Hong Kong by
Regent Publishing Services Limited
Printed in Hong Kong by South Sea Int'l Press Ltd

The material in this publication previously appeared in *The
35mm Handbook, The Encyclopedia of Practical
Photography, Achieving Photographic Style, How To Take
and Develop Black and White Photographs, How To Take
and Develop Colour Photographs* and *Techniques of The
World's Greatest Photographers.*

CONTENTS

ABOVE *A thorough knowledge of the technical aspects of photography is vital in producing good colour work. However, when all is said and done, it is the human eye and brain that judge whether a particular scene is attractive and worthy of preserving on film.*

INTRODUCTION

PHOTOGRAPHY is undoubtedly in the ascendancy as a creative medium for recording images. It has gained rapidly in popularity in the past few years – thanks largely to increasingly sophisticated cameras and equipment which offers choices from point-and-shoot simplicity to total control over every picture-taking situation.

In admiring the sheer cleverness of the camera and its accessories it is all too easy for the enthusiastic hobbyist to overlook the fundamental point of photography, which is to produce photographs worthy of the name. The image itself is the only product which really matters, and the camera is merely a tool designed to help produce the image in your mind's eye. An experienced photographer may well slightly resent the onward march of camera automation because he feels that he is becoming nothing more than an additional accessory to the camera. But, happily, this is not true because it is the photographer's eye and brain which take the picture through the medium of the camera.

It is easy enough for anyone to pick up an automatic, motorized 35mm compact camera and take pictures of good quality on colour print film: pictures which please the immediate family and will no doubt delight grandchildren in years to come. But exhibited or published photographs which stop a passer-by in his tracks are usually taken by a photographer who really understands the medium and has mastered the techniques.

Although this book may seem dauntingly thick to a novice photographer, he/she can take courage from the knowledge that the basic elements, the grass roots of photographic technique are really very straightforward. Once he has grasped how the shutter speed and lens aperture work together to control the basic appearance of a photograph, and that different lenses add great versatility to the type of image in the resulting picture, he/she will have the key to the door of creative photography.

Holding that key is very exciting. It is like having blinkers removed, and as your confidence grows so does your dissatisfaction with mediocre results, and mediocre equipment. The pursuit of excellence has driven photographers to ever-increasing heights over the years, and thankfully each generation yields a new crop of photographers who thirst for a better way of making a visual statement.

This book is packed with images and techniques created by imaginative and caring professional photographers who are masters of their chosen field. Photography has many fields to choose from although practically everyone begins by taking pictures of family and friends, high days and holidays. But when the bug bites you can take your pick from a host of divers options – wildlife photography; landscape; portrait; travel; reportage and documentary; sport; glamour; fashion; advertising; industrial; astronomy; photomicrography; marine – the list goes on and on, and each field has sub-divisions or areas of specialization: each has its own special requirements regarding the temperament of the photographer and the equipment needed for the job. The choice is yours entirely!

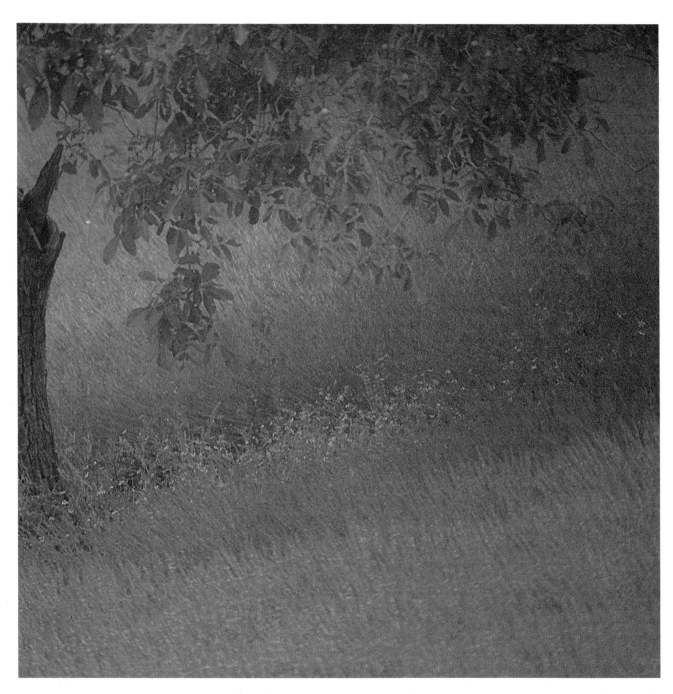

MIRROR LENS *André Martin's highly characteristic pastoral studies of France are made principally, as here, with a long-focus mirror lens. Used from a low viewpoint, so that there is a great visible depth in the subject, the extremely shallow depth-of-field of this lens throws much of the image into a soft, dappled focus. The particular way in which the image appears to be diffused is due to subtle interference from the small, centrally situated front mirror.*

THE ELEMENTS
OF PHOTOGRAPHY

CAMERA TECHNOLOGY is advancing at an accelerating pace – and the irresistable trend is towards battery-dependent, electronic cameras with many automated features, notably autofocus and a multiplicity of methods of automatic exposure control. This has not been welcomed by some established photographers who grew up with mechanical, manually-controlled cameras, and although there are still a number of professional cameras of this type they are becoming thinner on the ground.

The most widely-used camera type, by enthusiasts and professionals alike, is the versatile 35mm single lens reflex (SLR) camera, and this is where electronics have made the greatest impact on camera design.

Minolta cameras bear much of the credit for introducing efficient autofocus to the 35mm SLR, with the original Minolta 7000. The company pushed the frontiers of camera technology still further with the introduction of camera software in the form of Creative Control cards – microchips which can be installed temporarily into a camera to achieve a special technique without technical know-how.

But perhaps the watershed for electronics and autofocus was the launch of the Nikon F4 at Photokina in October 1988. Nikon, manufacturers of the most enduring and popular professional 35mm camera system, had bitten the bullet and made the F4 an autofocus camera, flying in the face of tradition and hard-bitten press photographers. However, the professional's understandable worry is that a battery-dependent camera may fail at a crucial time, and this worry has not yet been effectively answered by camera designers.

Although 35mm SLR cameras reign supreme as the tool most photographers use for creative work, there are several other camera types and film formats which are important parts of the tapestry, and are itemised in this section of the book.

The most widely bought and used camera is the 35mm compact, which usually features automatic film loading, advance and rewind, allied to autofocus, programmed exposure control and built-in electronic flash. This makes the 35mm compact a very complete and convenient camera, well-suited to basic family photography, but the lens is fixed, not interchangeable as on the SLR camera, making the compact much less versatile.

However, the trend is towards 'bridge' cameras which combine the convenience and light weight of a compact with some of the versatility of an SLR, thanks to a fixed zoom lens, sophisticated electronics, and in cases like the Ricoh Mirai and Chinon Genesis an SLR viewing system which lets you compose the picture by looking through the camera lens. These advances have been achieved at a price, and a modest 35mm SLR camera which could become the heart of a system of lenses and accessories, can be had for a similar cost.

The mainstay of commercial and industrial photography is the medium format camera, which uses interchangeable film backs loaded with 120 format roll-film to produce larger negatives or transparencies than 35mm cameras. These yield very high quality images because the original does not have to be enlarged so much to cover, say, a page in a magazine, or an advertising hoarding. Medium format cameras are themselves bigger and heavier than 35mm SLRs, and consequently are not so naturally easy to handle as the eye-level 35mm SLR, but in the quest for quality they are second only to studio technical cameras, and field cameras which use sheet-film.

This section of the book outlines the options available in different camera types, and looks at the systems of lenses and accessories which back them up.

THE CAMERA

ALL CAMERAS, from the simplest to the most sophisticated, function in the same basic way. The housing is a light-tight container that admits only image-forming light through an aperture. This light is focused by means of a lens system, and the unexposed film is positioned so as to receive the image. The increasing complexity and specialization of modern cameras is due to the variety of jobs that they have to perform. Much of the internal complexity is designed to make operation simpler and less demanding.

THE SINGLE LENS REFLEX

Most modern 35mm system cameras are of single lens reflex (SLR) design incorporating a viewing system that enables the photographer to see exactly what the film will record. The heart of the single lens reflex is a mirror/prism arrangement that directs the focused image to the viewfinder during focusing, or the film during exposure. A hinged mirror in the centre of the light path directs the image upwards into a pentaprism, which rectifies it so that it appears corrected left and right and the right way up through the eyepiece. When the shutter mechanism is activated, the mirror lifts up, allowing the light to reach the film plane, and the shutter opens and closes, exposing the film. The cycle ends with the return of the mirror. In order to fit the mirror in, the camera body has to be of a certain minimum width, and the shutter must be located in the body, close to the film (hence the name 'focal plane shutter').

ADVANTAGES

1 The most outstanding attribute of the single lens reflex, which alone probably outweighs its drawbacks, is that the photographer can see precisely what the lens is imaging – not

ABOVE *An SLR camera fitted with a telephoto lens lets you crop tightly-composed pictures of architectural details at a distance.*

REFLEX VIEWING

It is the viewing system in an SLR – directly through the image-taking lens – that gives this camera design its name. Before the shutter release is pressed, the image from the lens is reflected upwards from a 45° mirror onto the viewing screen (below left). From here, a pentaprism rectifies the image left-to-right and projects it out through the eyepiece. When the shutter release is pressed, the mirror flips up, covering the viewing screen, just before the shutter opens (below right). Immediately after the exposure, the mirror returns for viewing.

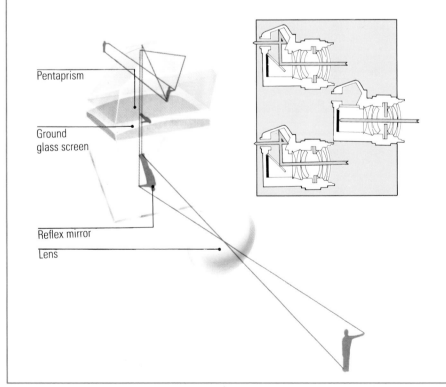

Pentaprism

Ground glass screen

Reflex mirror

Lens

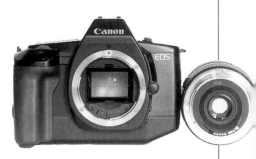

ABOVE *Canon EOS 620 is a versatile autofocus SLR which uses lenses each fitted with its own focusing motor, powered by the battery inside the camera.*

only what it is framing, but also the depth of field. There is none of the parallax error that occurs with a separate viewfinder, and accurate composition and picture selection are possible.

2 By incorporating light sensitive cells inside the camera, highly accurate exposure measurement of the area to be included in the picture is made possible.

DISADVANTAGES

1 The mechanisms are complex, bulky and difficult to repair in the field, in comparison with the simpler, direct viewfinder design.

2 During exposure, viewing is not possible. At fast speeds this is hardly noticeable, but it makes some techniques, such as long, panned exposures, difficult.

3 Under low light conditions or with lenses that have small maximum apertures, viewing and focusing can be difficult. To compensate for this, most lenses are 'pre-set', which means that normal viewing and operation take place with the aperture diaphragm fully open; it stops down to the set aperture only at the moment of exposure. At times, therefore, the view normally seen through the eyepiece can be misleading, and for an accurate preview of the depth of field a special lever must be depressed.

4 The mirror/shutter mechanism is noisy, which can be a problem in candid reportage or wildlife photography, and the amount of mechanical movement can cause camera shake even on a tripod. It is advisable, on a tripod, to lock the mirror up before operating the shutter.

35mm SLR DESIGN

The design of 35mm SLRs changed considerably with the advent of electronics, until which it had remained largely the same since the standard was set by the early Pentax Spotmatic cameras. These featured a top-plate carrying the shutter button and manual film advance lever at the right hand end, a shutter speed dial and film speed dial on either side of the prism housing, and a folding, film rewind crank at the left hand end of the top-plate.

CAMERA BODY

1 Camera strap eyelet
2 Self-timer indicator LED
3 Depth-of-field preview button
4 LCD illumination window
5 Lens mounting index
6 Remote control terminal
7 AFL (Autofocus Lock) button
8 AF coupling
9 CPU contacts
10 Reflex mirror
11 Focus mode selector
12 Camera back lock releases
13 Film speed button
14 Exposure mode button
15 Metering system selection button
16 Film rewind button
17 Exposure compensation button
18 Power switch
19 Shutter release button
20 Film advance mode button
21 Self-timer button
22 Multiple exposure/film rewind
23 Accessory shoe
24 LCD panel
25 Command input control dial

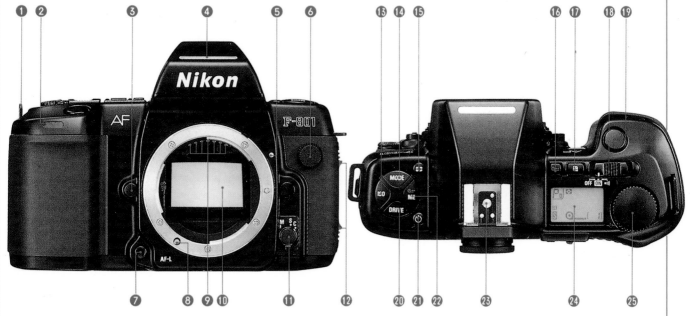

Many modern, electronic SLRs have built-in motor to drive all film handling operations, so the film advance lever and rewind crank handle have disappeared. Buttons have largely replaced knobs and switches, and film speed is set either automatically by DX coding contacts in the film chamber, or manually by pressing buttons. Information is conveyed to the user either by LEDs (Light Emitting Diodes) in the viewfinder, or an LCD (Liquid Crystal Display) panel on the top-plate. Batteries are often housed in a grip on the right hand front of the camera as you hold it, and this grip may be interchangeable.

Cameras are smoothly designed, and comfortable to hold. In many cases, weight has been shed by switching to polycarbonate for the body of the camera, but this loss is counteracted by the weight of the inbuilt motor.

DATA PANEL

The job of an LCD data panel is to keep the photographer informed with exposure details and other information when the camera is not at the eye. Data panel information often duplicates that shown in the viewfinder, but it also shows the film frame number and is used when manually over-riding film speed on DX coded cameras, or keying-in exposure compensation. It may also show the film drive status – such as single frame advance or continuous advance, and additionally the autofocus status, such as single shot or continuous autofocus.

Altering settings such as film speed usually means operating two controls simultaneously while watching the data panel. For example, if you wish to change the film speed you would press the film speed button and perhaps either a slider switch, or rotate a dial, until the film speed you want is shown on the data panel. This same principle is repeated for many different alterations, such as changing the shutter speed, or even the lens aperture size depending on the exposure mode in use.

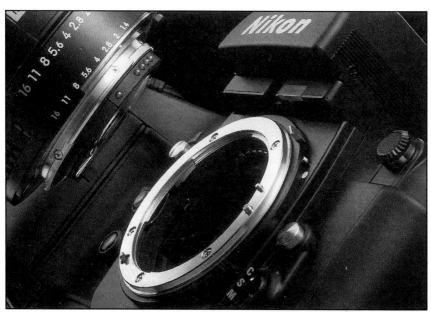

ABOVE *The Nikon F lens mount has been adapted to cope with new autofocus technology.*

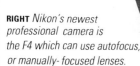

RIGHT *Nikon's newest professional camera is the F4 which can use autofocus, or manually- focused lenses.*

THROUGH-THE-LENS LIGHT METERING

Integrated reading This is the simplest system, where the entire picture area is measured, usually with two cells each reading a different section, and the results averaged. This is excellent for a subject with average brightness levels, but where there is a high contrast between major elements, such as a small white object against a dark background, it is inadequate.

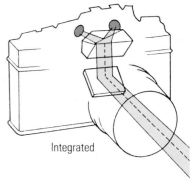

Integrated

Spot reading This type uses the principle of the spot meter. It demands more work, as you may have to point the camera at different areas of the scene in order to calculate an average reading. There is a risk of incorrect exposure if the centre 'spot' is aimed at an atypical part of the picture.

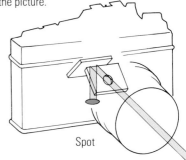

Spot

Weighted reading This combines the previous two in a compromise. The whole picture area is measured, but priority is given to the values in the centre. In most situations this is convenient, following the principle that in the majority of photographs the centre contains the main area of interest. The precise shape of the weighted area varies according to the manufacturers' ideas of what constitutes an average photograph.

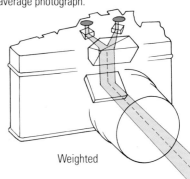

Weighted

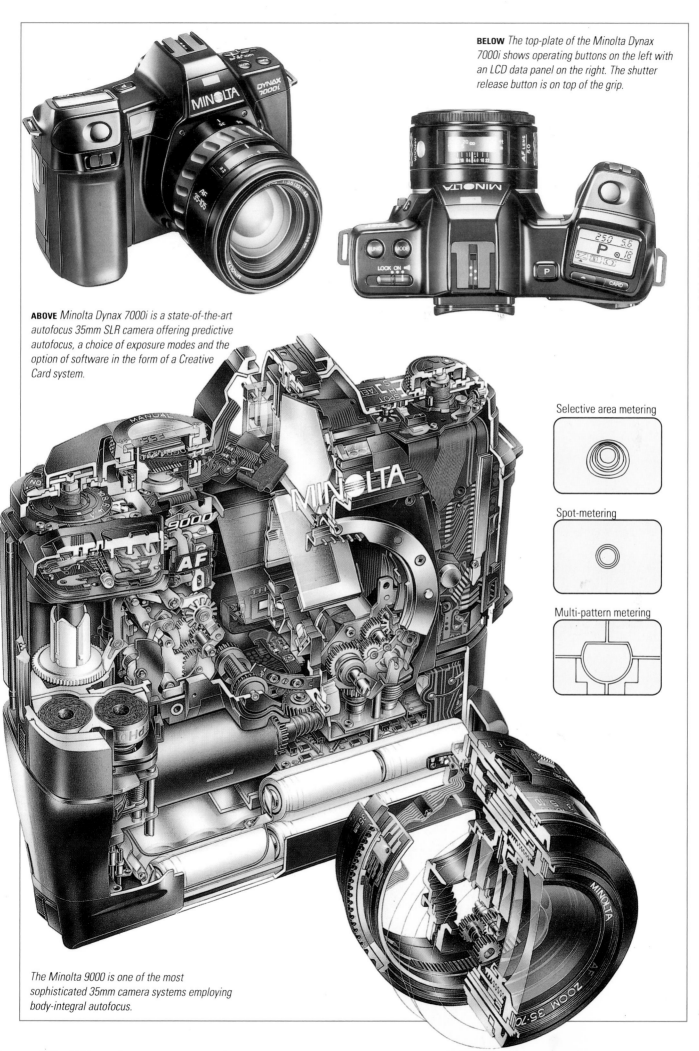

BELOW *The top-plate of the Minolta Dynax 7000i shows operating buttons on the left with an LCD data panel on the right. The shutter release button is on top of the grip.*

ABOVE *Minolta Dynax 7000i is a state-of-the-art autofocus 35mm SLR camera offering predictive autofocus, a choice of exposure modes and the option of software in the form of a Creative Card system.*

Selective area metering

Spot-metering

Multi-pattern metering

The Minolta 9000 is one of the most sophisticated 35mm camera systems employing body-integral autofocus.

ELECTRONICS

Progress in electronic engineering has led to increasingly sophisticated 35mm cameras with many automated functions, and the best 35mm SLRs offer a variety of exposure modes – methods of controlling correct exposure of the film. These modes have the secondary effect of controlling the appearance of the picture since all modes rely on the combination of a shutter speed and a lens aperture size to achieve correct exposure. Both of these factors affect the type of picture produced.

Other functions powered by the camera's battery can include through the lens (TTL) light metering, autofocus operation of the lens, viewfinder information, LCD (Liquid Crystal Display) panel information on the top of the camera, a built in motor to drive all film handling operations from automatic loading to rewind, automatic film speed selection and some means of exposure compensation. Special features might include a built-in, retractable electronic flash, self-timer, multiple exposure facility, or an intervalometer which lets you leave the camera set up on a tripod to take pictures at pre-determined intervals.

The trick of choosing a camera which will suit your particular type of photography is to identify the features which will be most useful to you. It is ironic that the camera designer's constant quest for more automation has bred cameras which bristle with buttons and switches, and complicated-looking LCD arrays. These may well appear intimidating to a novice, but cameras of this type will almost certainly offer at least one programmed exposure mode for totally automatic, point-and-shoot photography. You can use this when you are in a hurry, and then experiment with the other features when you have more time.

ABOVE *Pentax P30N is an excellent beginner's 35mm SLR, offering a choice of manual or programmed exposure control.*

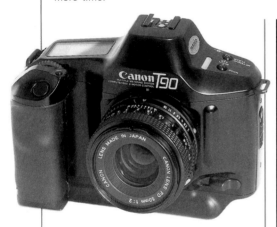

ABOVE *The Canon T90 is one of the most electronically advanced non-autofocus 35mm SLRs.*

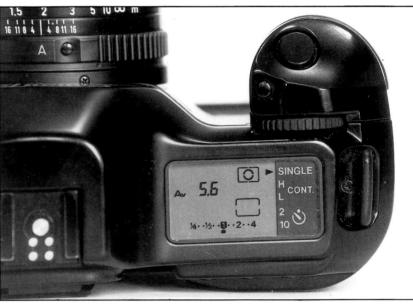

ABOVE *The LCD (Liquid Crystal Display) data panel on the Canon T90 shows exposure mode, lens aperture, metering mode, drive mode and other information as required.*

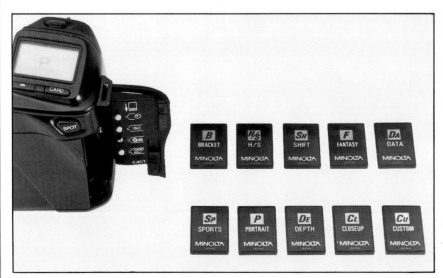

LEFT *Minolta's Creative Card system for the Dynax 7000i gives a novice the chance to shoot specialist pictures without technical know-how.*

LCD PANEL

The data panel on the Canon EOS 620 gives an enormous amount of information, but not all at once as shown here.

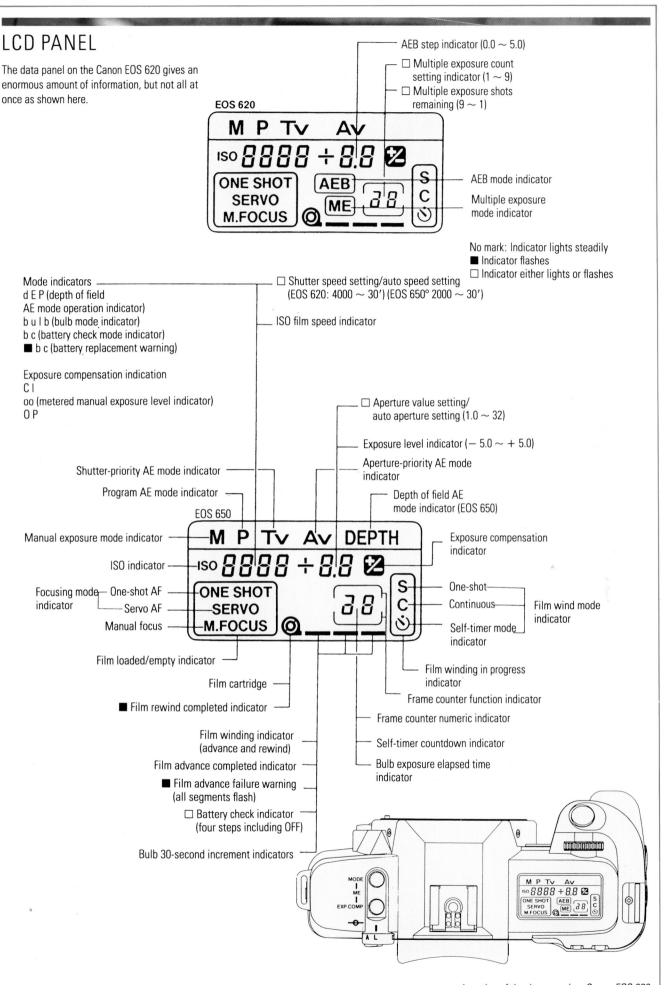

AEB step indicator (0.0 ~ 5.0)

□ Multiple exposure count setting indicator (1 ~ 9)
□ Multiple exposure shots remaining (9 ~ 1)

EOS 620

AEB mode indicator

Multiple exposure mode indicator

No mark: Indicator lights steadily
■ Indicator flashes
□ Indicator either lights or flashes

Mode indicators
d E P (depth of field AE mode operation indicator)
b u l b (bulb mode indicator)
b c (battery check mode indicator)
■ b c (battery replacement warning)

Exposure compensation indication
C I
oo (metered manual exposure level indicator)
O P

□ Shutter speed setting/auto speed setting (EOS 620: 4000 ~ 30') (EOS 650° 2000 ~ 30')

ISO film speed indicator

□ Aperture value setting/ auto aperture setting (1.0 ~ 32)

Exposure level indicator (− 5.0 ~ + 5.0)

Shutter-priority AE mode indicator

Aperture-priority AE mode indicator

Program AE mode indicator

Depth of field AE mode indicator (EOS 650)

EOS 650

Manual exposure mode indicator

Exposure compensation indicator

ISO indicator

Focusing mode indicator — One-shot AF
— Servo AF
Manual focus

One-shot
Continuous
Self-timer mode indicator

Film wind mode indicator

Film loaded/empty indicator

Film winding in progress indicator

Film cartridge

Frame counter function indicator

■ Film rewind completed indicator

Frame counter numeric indicator

Film winding indicator (advance and rewind)

Self-timer countdown indicator

Film advance completed indicator

Bulb exposure elapsed time indicator

■ Film advance failure warning (all segments flash)

□ Battery check indicator (four steps including OFF)

Bulb 30-second increment indicators

Location of the data panel on Canon EOS 620.

THE MINOLTA 9000

Body-integral autofocus system Minolta's Hi-Tech autofocus system incorporates twin separator lenses to project dual images of the subject in the focus frame onto the CCD array in the 9000's AF module. The AF micro-computer compares the signals from the two images to a reference signal, and when they are ' in phase ', the subject is in focus. The signals produced by the CCD array vary according to focus condition: when the subject is in focus, the signals are equal to a reference signal programmed into the AF CPU. If lens is focused in front of subject, the signals are closer together. If lens is focused behind subject, the signals are farther apart.

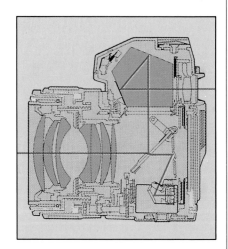

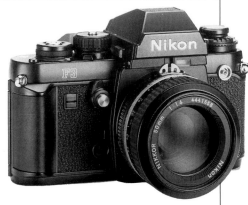

ABOVE *Nikon F3 has been the most widely-used professional 35mm SLR. It uses manually focused lenses on a very rugged body.*

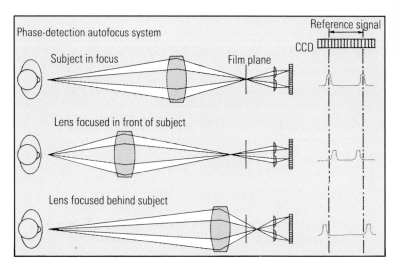

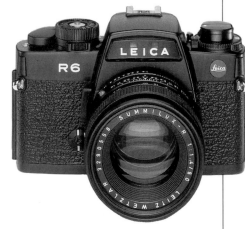

ABOVE *Leica R6 is an exceptionally rugged, conventional manual 35mm SLR.*

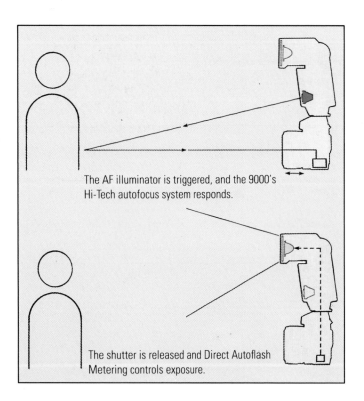

The AF illuminator is triggered, and the 9000's Hi-Tech autofocus system responds.

The shutter is released and Direct Autoflash Metering controls exposure.

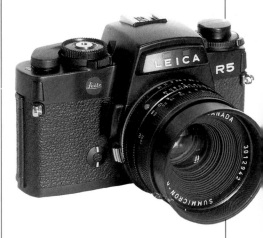

ABOVE *Leica R5 is a top quality multi-mode 35mm SLR, built to last a lifetime.*

AUTOFOCUS

Efficient autofocus for 35mm SLR cameras first appeared on the Minolta 7000, employing a body-integral, phase-detection autofocus system. A CCD array inside the camera analyses light passing through the lens and uses contrast in the subject to assess whether or not it is in focus. If not, the camera's AF CPU detects whether the lens must be focused inwards or outwards, and an electronic motor in the camera body powers the focusing action of the lens.

The area of the subject on which the camera will focus precisely is covered by the focus frame, shown in the centre of the image seen through the viewfinder. The Minolta Dynax 7000i takes autofocus further by greatly increasing the area of detection, linking autofocus to exposure control, and making autofocus predictive so that even subjects moving fast towards the lens will be sharp. For predictive autofocus the camera's CPU is able to estimate where the subject will be when the shutter actually passes across the film.

Canon chose a different autofocus route for the EOS range of cameras: instead of powering the focusing action of the lens by a motor inside the camera body driving a spigot protruding from the lens mount flange, Canon decided to build a tiny actuator into each lens, resulting in even faster autofocus. This tiny electronic motor draws its power from the battery housed in the camera.

Whereas manually-focused lenses have an aperture ring which is rotated to select different sized apertures, many brands of autofocus lens do not have an aperture ring; instead the aperture size is controlled either automatically by the exposure program in use, or manually by pressing buttons on the camera body.

Autofocus SLRs often offer three different focusing modes: firstly, a Focus Priority mode in which the shutter release will lock until autofocus is confirmed, so that you cannot take an out-of-focus picture; secondly, a Continuous Focusing mode which is for use when you are shooting action subjects which are constantly on the move, and lastly, Manual Focus which is for use when you wish to photograph a subject in extremely low light, or a subject

ABOVE *Right hand top-plate of the Leica R5 35mm SLR carries the manual film advance lever, frame counter, and a combined shutter speed/exposure mode selection dial.*

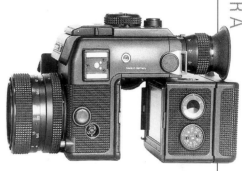

ABOVE *Rolleiflex 3003 is unique in that it is the only 35mm SLR with interchangeable film magazines, similar to those used on medium format cameras.*

LOADING A MANUALLY OPERATED 35mm SLR

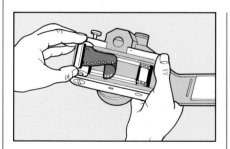

1 Open the camera back and pull out the rewind knob. In subdued light insert the film cassette so that the protruding end of the spool is at the bottom. Push back the rewind knob.

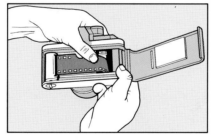

2 Pull out the film leader, and by rotating the take-up spool insert the end of the film into one of the slots, making sure that the perforations engage the lower sprocket.

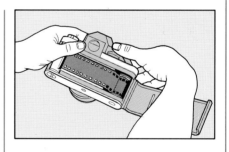

3 Wind on the film until the rop row of perforations engage the upper sprocket and the film is tensioned across the film guide rails.

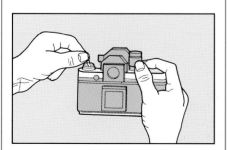

4 Close the camera back and gently turn the film rewind knob in the direction of the arrow until you feel resistance. This is to check that the film is fully tensioned.

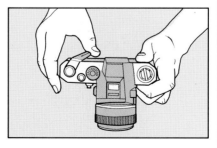

5 Advance the film two frames, making two blank exposures. The frame counter should now read '0'. Advance the film one more time and the first frame is ready for exposure.

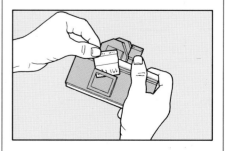

6 Tear off the end of the film carton and place it in the holder on the back of the camera to remind you what type of film you are using.

Manual shutter speed/auto exposure dial (above) shown set to AUTOMATIC for Aperture Priority (AE).

with little or no inherent contrast, such as a patch of cloudless blue sky, just to record the colour.

Operation in very low light was initially a serious drawback for phase-detection auto-focus systems, but cameras like the Nikon F4 can operate by the light of a single candle. Some cameras emit a near infra-red beam of light which acts as an automatic autofocus illuminator, although this function is sometimes built into an accessory electronic flashgun.

MANUALLY OPERATED 35mm SLRs

Only recently has the electronic autofocus SLR succeeded its manually operated counter-part, and many professionals of long standing still prefer to use manual modes.

Manual SLRs differ in that they use manually-focused lenses, each of which has an aperture ring which is rotated to alter the size of the aperture in an iris diaphragm inside the lens. They do not have a built-in motor so they are equipped with a manual film advance lever at the right hand end of the top-plate, and a manual film rewind crank at the other end.

Many such cameras accept an accessory autowinder or motordrive to wind the film through the camera automatically. The difference between the two is that an autowinder advances film one frame at a time while a motordrive advances film continuously and rapidly, as long as the photographer keeps the shutter release button pressed. This makes a motordrive very useful for shooting sequences of pictures, and very popular with sports and action photographers.

Manual cameras may have access to lens and accessory systems every bit as large as autofocus cameras, and in some cases much larger since they were the professional's choice for many years. They may offer optional methods of TTL light metering and a limited choice of exposure modes. Film speed may have to be set manually. The film will usually have to be rewound manually even if an autowinder or motordrive is fitted.

Exposure mode options will usually be Manual, plus either Aperture Priority Auto Exposure (AE) or Shutter Priority (AE). Recent manual cameras are likely to offer at least one programmed exposure mode, but not Program Shift.

Some professionals stick to the Manual exposure mode because they are used to adjusting apertures or shutter speeds manually, and quickly: others because they have been taught to mistrust automatic exposure, or do not understand its benefits, such as stepless shutter speeds. Tomorrow's professional will probably cut his/her teeth on an automated, autofocus SLR with Program Shift which really makes other exposure modes redundant.

THE PANORAMIC CAMERA *The special appeal of panoramic photographs derives from their wide horizontal coverage, eliminating the distraction of foreground and sky. Used for vistas that benefit from a side-to-side scanning, they give the impression of a grand view. Some medium format cameras can use a special panoramic back in conjunction with 35mm film.*

MODES AND METERS

Modern cameras use sophisticated integrated circuits to meter the light reflected from the subject, and to set exposure. Analogue inputs, such as film speed and light passing through the lens, are converted into digital form, and used to control all camera functions, principally shutter speed and aperture.

Initially, camera manufacturers made only limited use of the digital output from the camera's central processing unit, but advances in engineering and electronics have made multi-mode control over the camera a practical reality.

These are the principal operating systems that are currently in use – though many cameras offer the photographer a choice of several modes.

Manual In manual mode, the camera measures the light reflected from the subject, and indicates in the viewfinder whether the shutter speed and aperture selected by the photographer will yield correct exposure. The camera is thus totally under the control of the photographer, who is free to follow its recommendations – or to disregard them.

Aperture priority automatic (or aperture preferred automatic) In this mode, the photographer sets the camera's aperture, and the shutter is automatically set to a speed that will give the correct exposure. This mode is most useful in conditions where control over depth of field is important – landscape or close-up photography, for example.

Shutter priority automatic (or shutter preferred automatic) Conversely, in this mode the photographer sets the shutter speed and the camera chooses the aperture. This mode is most useful when photographing subjects that must appear 'frozen' on film – action and sports photography, for example.

Programmed automatic This is a 'point and shoot' mode in which the photographer completely relinquishes control to the camera. In progressively brighter light, the camera picks smaller and smaller apertures, and faster and faster shutter speeds. 'Sub-modes' include *shutter-preferred programs,* which choose faster shutter speeds before closing down the aperture; and *aperture-preferred programs,* which as the name suggests, pick smaller apertures in preference to faster speeds. A few of the most recently introduced cameras sense

the focal length of the lens in use, and will program faster shutter speeds when a telephoto lens is fitted. This helps prevent camera shake, which is more likely to cause problems with telephotos.

Flash mode The exact function of the camera when set to this mode varies from model to model. In the most simple example, the camera will operate at the flash synchronization speed as long as there is a dedicated flashgun in the accessory shoe, and fully recycled; while the flash is recycling, the camera meters and responds to ambient light as if no flash was fitted.

Other modes Some cameras may switch between one mode and another to provide optimum results even when the photographer makes an erroneous setting – perhaps by failing to set the lens to its minimum aperture (this is a prerequisite in certain programmed modes). To increase the mode count, some camera manufacturers dub this 'crossover mode'.

One camera has a mode that sets the shutter to the ideal speed for photographing TV screens and video monitors, but this and other gimmick modes are of debatable advantage in everyday photography.

METERING

Some 35mm SLRs meter the brightness of the light reaching just a portion of the frame, and ignore the remainder. This is known as *selective area metering,* and prevents the camera from being misled by, for example, a bright sky. The pattern of exposure metering, though, is variable: some cameras meter just a small area of the frame, others sample a much broader area.

Spot-metering is an extreme form of selective area metering. A small circle in the middle of the camera's focusing screen marks the area of the meter's sensitivity. The photographer places the spot over the area to be metered. This system, however, needs to be used with intelligence to produce consistent results – spot metering is not for the hasty photographer. A variation of spot metering permits the photographer to take several spot readings and average these out to determine the exposure.

One option that has been recently introduced is *multi-pattern metering.* This system makes use of several light-sensitive cells that individually meter the four corners of the frame, and the central area. The camera then compares the readings from each cell with a stored computer algorithm to determine the best exposure. This system copes better with unusual lighting than does selective area metering.

35mm COMPACT

The name compact has been adopted for practically every 35mm camera which uses a direct viewfinder, rather than an SLR viewfinder. It is used for very simple, fixed focus, fixed exposure cameras costing a few pounds, and at the other extreme even Leica rangefinder cameras have occasionally found themselves labelled as compacts, although they are really a separate category since they accept a system of interchangeable lenses and accessories.

The majority of compacts are fitted with an autofocus wide-angle lens and have a built-in motor for film handling operations, plus built-in electronic flash and programmed exposure control.

Modestly priced compacts may have lenses focused manually on the zone principle, with a symbol representing the focused distance – this is usually a single figure for close-ups, a couple for middle-distance photography and a mountains symbol for distant views. This type of compact may also have a symbol system for exposure control, whereby a lever or dial must be rotated to a cloudy symbol for cloudy weather or a sun symbol for bright conditions; there are other variations on the theme.

What are known as Tele-Wide compacts are fitted with an autofocus lens which can be adjusted to give a wide-angle focal length, and a short telephoto focal length, greatly increasing the versatility of the camera. It is suitable for photographing views or groups at the wide-angle setting, or attractive portraits at the telephoto setting, usually around 70mm focal length.

Tele-Wide compacts were introduced as a bridge between conventional, wide-angle lens models and zoom-lensed compacts. Fitting a 35–70mm zoom lens to a compact, produced the sort of camera which many family photographers had been crying out for: it is light, convenient and gives excellent results on colour print film if pictures are not to be greatly enlarged. The lens can be zoomed from wide-angle to telephoto and used at any focal length setting between the two extremes, which is a great aid to picture composition. An example of this type of camera is the Pentax Zoom 70–S.

BRIDGE CAMERAS

The principle of the zoom-lens compact has been exploited to the full by a futuristic new type of camera which has been dubbed a 'bridge' camera, since it is seen as a bridge between compact and SLR cameras, combining some virtues of both designs. Examples of this type of camera are the Olympus AZ-300 Superzoom, the Ricoh Mirai and the Chinon Genesis.

The Olympus and the Ricoh are both fitted with wide-ranging zoom lenses which begin to rival the versatility of the SLR camera, although are not interchangeable and so cannot be expected to truly rival the SLR. Both the Chinon and the Ricoh use SLR viewfinders which aid picture composition and banish the problem of parallax which is one of the bugbears of viewfinder cameras.

Bridge cameras have great potential, and are no doubt pioneering the design for stills video cameras of the future. They make full use of electronics for exposure control and easy picture composition, while keeping to a minimum, the bulk which the photographer must carry around.

RANGEFINDERS

Rangefinders are direct viewfinder cameras which use an optical system to show precise focus. A rangefinder window on the front of the camera sends light from the subject via a system of mirrors to the viewfinder where it forms a ghosted image in the centre of the viewed image. If the subject is out of focus the photographer sees a double image in the rangefinder spot; adjusting focus moves a mirror lens in the optical system and the double image merges into one when the focus is correct.

Rangefinder cameras may either have a fixed lens, as in the Olympus XA rangefinder compact which uses a 35mm f2·8 wideangle, or accept a comprehensive range of acces-

ABOVE *The Minox 35mm compact camera is the smallest, fully fledged camera using 35mm film cassettes. This model is the Minox 35 ML.*

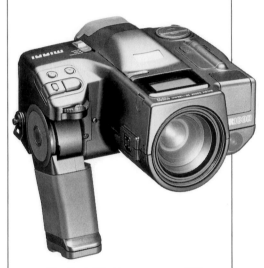

ABOVE *The Ricoh Mirai incorporates an SLR viewfinder, a fix-mounted 35–135mm zoom lens and a host of electronic features in a futuristic body design.*

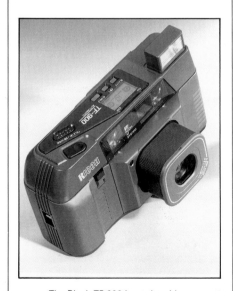

ABOVE *The Ricoh TF-900 is a tele-wide compact with a lens which can be adjusted from 35mm f2·8 wide-angle to 70mm f5·6 telephoto.*

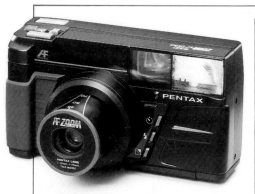

ABOVE *Pentax Zoom-70 was the first zoom-lens 35mm compact and has been superseded by the more advanced Zoom-70S.*

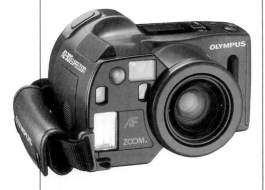

ABOVE *Olympus AZ-300 Superzoom is a 35mm autofocus 'bridge' camera, fitted with a wide-ranging zoom lens and a choice of operating modes.*

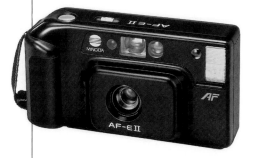

ABOVE *Minolta AF-E II is an example of a basic, single lens autofocus 35mm camera for point-and-shoot photography.*

ABOVE *The Leica M6 rangefinder 35mm camera uses high quality interchangeable lenses and a system of brightframes to aid picture composition.*

sory lenses like the Leica M6. The Leica is the only 35mm camera which truly rivals the versatility of SLR cameras, and it incorporates a set of brightframes as aids to picture composition so that the photographer can see precisely the angle-of-view covered by the lens in use.

Some photographers find the rangefinder easier to focus in poor light, and the direct viewfinder means that the subject can be monitored during exposure, but parallax is a problem for subjects very close to the camera. Rangefinder cameras used to be commonplace until the arrival of the SLR, but are now a comparative rarity. The only other rangefinders in current production are medium format cameras.

SMALL FORMATS

Although 35mm film reigns supreme there are other smaller film formats which are used in snapshot cameras. These include the 110 format which has proved enduringly popular because the film comes in an easy-load cassette. But image quality is poor because the negative needs considerable enlargement to reach even enprint size, and the film is not held perfectly flat by the cassette in which it is housed.

Disc film was launched by Kodak as the ultimate answer for snapshot photography, producing 15 images on an easy-load disc format film which made it possible to build extremely slim cameras which are very easy to carry. But again the negative was too small, and relied too heavily on a good quality lens. Prints from Disc film tend to be too grainy and fine detail is lost.

Although there are no 126 format cameras in production there are still many in use in the hands of amateurs. This format has survived because it produces a relatively large, square format negative, similar in overall area to a 35mm frame. This gives relatively good image quality, but square prints are not popular with everyone.

Sub-miniature film is used in the tiny Minox spy cameras, and although the negative produced is only about half the size of the tiny 110 format, image quality is as good as the best 110. These cameras are really bought as male jewellery and have little practical value except for espionage!

CAMERA SIZES

126-size cameras The Kodak Instamatic 77-X shown below accepts 126 cartridge film, available for colour prints, colour slides and black-and-white prints. A fixed lens gives sharp focus from 1.2 metres (4ft) to infinity. Flash cubes give illumination for indoor photography. There is one shutter speed, of 1/50 second, suitable for photography in bright or hazy sunlight and with flash.

110-size cameras The Kodak Ektra 200 and Ektralite 400 (below) are both examples of simple amateur cameras that accept 110

cartridges. They both have a fixed-focus, one-aperture lens, and a choice of three shutter speeds. The Ektralite 400 has, in addition, a built-in electronic flash. The Ektra 200 uses an accessory flash.

Disc cameras The Kodak Disc 4000 and 8000 cameras (above) are a simple, pocketable system for the amateur market. Both have built-in electronic flash, automatic exposure and automatic film winding; in addition, the 8000 model has a rapid-sequence capability – of three frames per second if needed.

ABOVE *The Canon RC-760 stills video camera uses a 600,000 pixel CCD for outstanding image quality.*

ABOVE *Prototype Pentax stills video camera uses established compact camera features allied to electronic imaging.*

35mm HALF FRAME

The 35mm half frame camera is currently enjoying a revival in popularity, partly because it uses conventional 35mm film cassettes and partly because camera designers are developing ideas which can be converted for stills video use in the future.

A half frame camera carries a mask inside which divides each conventional 35mm frame in two so that each roll of film produces twice as many prints as in a conventional 35mm camera. Image quality is very good – as good as the lens on the camera, but obviously each negative has to be enlarged twice as much as a 35mm frame to yield a print of the same size, so ultimate quality cannot match 35mm.

The format was made very popular several years ago by the Olympus Pen series of half-frame cameras which took a system of interchangeable lenses. Today's camera of the moment is the award-winning Kyocera Samurai, which is a revolutionary design incorporating a power zoom lens. Half frame cameras have good potential for print film users, but it is unlikely that half frame mounts for transparencies will be produced.

STILLS VIDEO

The area of stills photography with the greatest potential for future development is stills video. Instead of using film, the stills video camera records images electronically on a re-usable floppy disc. These images may be played back on a television or monitor by either plugging the camera directly into the TV, or loading the exposed disc into a compatible stills video player. A hard copy print can be produced on a special printer, but the image quality, although much improved from early prototypes, is well short of the standard from conventional chemical photography.

The stills video picture is in a state of flux at the time of writing because all the major manufacturers have prototype cameras on show, some for purely amateur use and others with professional potential, especially in reportage photography.

COMPOSING IN A SQUARE FORMAT

Although a square is neither traditionally nor aesthetically a normal frame within which to compose an image, the early development of roll-film cameras has made it a feature of medium-format photography. Most professional photographers are accustomed to using the square frame loosely, shooting to crop in later to the shape of the magazine or layout that will be using the picture. Otherwise, there are a number of ways designing an image to fit well into this very formal, symmetrical border, as the examples above show.

Compositions that work better than most in a square are:
1 Formal, regular designs.
2 Designs that are organized around the centre.
3 Patterns and other formless areas where texture matters more than shape. The centred, geometrical interior above and the textural pattern of leaves in the forest shot are both examples of natural square composition.

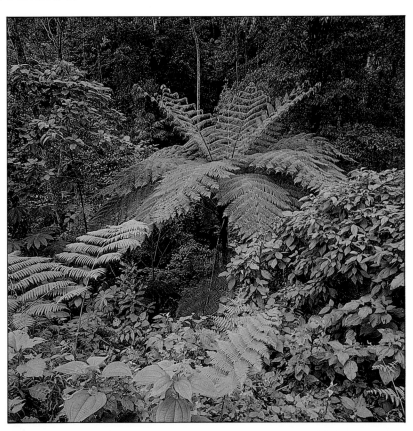

Canon leads the field with the RC-760, fitted with an interchangeable 13–52mm f1·8 zoom lens, but Minolta has shown a system of stills video backs and players which is compatible with the company's existing 35mm camera system.

The Canon records either 25 or 50 images on a 2in floppy video disc and uses a 600,000 pixel CCD giving outstanding image quality within the parameters of current stills video technology. Maximum shooting speed is 10 images per second.

On the other side of the coin is compact stills video, exemplified by the prototype Pentax Stills Video Camera. This is a small, slim camera which looks and operates much like a conventional 35mm autofocus compact, but it has full recording, playback and erase functions and measures only 16.1 × 9 × 4.3cm. The lens is a 3x zoom 8–24mm and has a focusing range from 0.6m to infinity. It is typical of the type of amateur stills video camera which will soon appear on the market.

A revolutionary prototype shown by Fuji is the Fujix DS-1P stills video compact camera which uses a ram-type electronic 16-magabit, digital memory card instead of the floppy disc favoured by the majority of designs. The card can record up to five images in the frame mode and 10 images in field mode, all of which are erasable. Fuji worked in conjunction with Toshiba to produce the card and is planning a version which will record up to 40 images.

The images stored on the digital memory card can be reproduced on a specially-developed digital player, or can be transferred onto optical discs or tapes, during which transfer sound may be added if desired. The prototype Fujix DS-1P is compatible with personal computers, word processors and other office communication equipment.

Stills video is already beginning to make an impact on news gathering from around the globe, and certain British newspapers managed to publish pictures taken the same day at the Seoul Olympics, thanks to electronic imaging.

ROLL-FILM SLRs

Roll-film cameras are in many ways a compromise between size and simplicity. The film they use produces pictures about four times larger than a 35mm frame, yet the cameras are not as cumbersome and unwieldy as those that use sheet-film.

The most convenient and easy to use of all roll-film cameras is the SLR. Like its smaller 35mm cousin, this type of camera has a diagonal mirror that relays the image from the lens up into the viewfinder until an instant before the shutter opens.

However, few roll-film SLRs outwardly resemble 35mm SLRs. The body of the larger species of camera is much more box-shaped, without the broad 'wings' on either side of the lens and mirror box.

There are other differences, too. On the whole, roll-film SLRs are more modular in construction than 35mm SLRs, with lens, focusing screen, viewfinder, and film magazine all interchangeable. The camera body is just a frame, onto which the other working components of the camera clip. The body itself contains the reflex viewing mechanisms, a shutter, and often some other electronic and mechanical components.

SHUTTER TYPES

Whereas all 35mm cameras have focal-plane shutters positioned just in front of the film, few roll-film cameras are arranged like this. Many instead have leaf shutters within the camera's lens. This approach has significant advantages, the most important of which is flash synchronization; leaf shutters will operate with flash at all speeds, whereas focal plane shutters usually synchronize only at speeds slower than 1/60. Additionally, should the leaf shutter in one lens break down, the photographer can continue to take pictures with another lens. If the focal-plane shutter in the camera body fails, a spare body is needed.

Focal-plane shutters are not without their advantages, either. The top speed of a focal-plane shutter is usually 1/1000 sec or 1/2000 sec, but possibly as high as 1/8000 secs compared to the 1/500 of a leaf shutter. And because the photographer does not buy a new shutter with each lens, these are often cheaper. This is a point well worth thinking about if you are building a system on a tight budget.

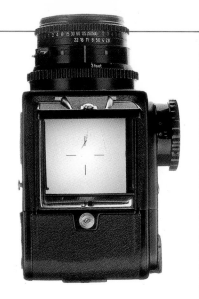

ABOVE *The waist-level finder of a medium format camera folds up to form a shroud around the focusing screen, seen here from vertically above the camera.*

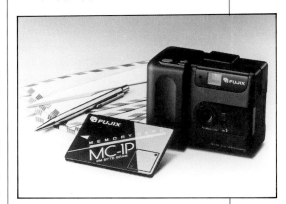

ABOVE *Prototype Fujix DS-1P stills video camera uses digital memory card instead of video floppy disc to record images.*

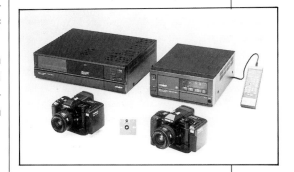

ABOVE *Minolta has developed stills video accessories for the Minolta 9000 autofocus camera system.*

FILM AND FORMATS

Traditional roll-film cameras take 12 square pictures each 6cm wide, on a roll of paper-backed 120 film. With unbacked 220 film, this is doubled to 24 frames. However, many cameras now offer formats larger or smaller than this standard size.

6 × 7cm cameras take 10 frames this size on 120 film, and 6 × 4.5cm cameras, 15 frames. Since pictures made by these cameras are rectangular, more of the film area is used when making rectangular prints than if the starting point was a square negative or transparency. However, rectangular film presents certain difficulties in composition, because turning the camera to change from landscape to portrait format moves the folding focusing hood from the top of the camera to the side. Turning the camera also inverts the image in the viewfinder.

There are two solutions to this. Certain 6 × 7cm format cameras have revolving backs, so that only the back moves, not the whole camera. A more common, and equally practical answer is to fit an eye-level prism.

IMAGE SIZE *The traditional advantage of roll-film is that it gives nearly four times the picture area of 35mm but cameras can still be hand-held. The picture above is actual size from a 6 × 6cm transparency.*

VIEWFINDERS AND SCREENS

The standard viewfinder fitted to a roll-film SLR is usually a waist-level finder with a folding hood. This is just a construction of metal plates which, when erected, cast a shadow across the focusing screen, making the image easier to see. Folded down, the hood takes up little space, and protects the focusing screen from damage. In the top of the folding hood is a flip up magnifier which enables the photographer to see an enlarged view of the centre of the focusing screen – and sometimes the whole image.

Folding hoods do not exclude all ambient light, and when compactness is not a primary consideration, many photographers prefer to use rigid hoods. These are absolutely light-tight, and generally have a magnifier that adjusts to suit each individual's eyesight. However, like folding hoods, these rigid ones suffer from a major disadvantage – they present an image of the focusing screen that is laterally reversed, so that subjects moving from left to right in front of the camera appear to move in the opposite direction on the focusing screen. Prism viewfinders provide a right-way-round image that eliminates this problem.

The prism viewfinder most familiar from 35mm SLRs turns the image of the focusing screen through 90°, so that the camera can be held up at eye-level. However, supporting the camera at eye-level can be tiring, and a slightly different prism, which turns the optical axis through just 45°, can make the camera more comfortable to hold. Both types of prism add considerable weight to the basic camera body.

Cameras that are supplied without an integral meter can be fitted with metering prisms, which meter the light falling on the focusing screen. These may be coupled to the camera's controls to a greater or lesser degree: some simply indicate the required exposure and leave the photographer to set the shutter speed and aperture, while others effectively give the camera fully automated exposure metering. The newer roll-film SLRs, though, generally have metering systems installed in the camera body, and do not need separate metering prisms to provide auto-exposure.

Compared to a 35mm SLR, the standard focusing screen on a roll-film model is simple. Often the screen will be just plain matt, with crosshairs in the middle. Focusing aids are less important with this larger format, because the screen is larger and therefore easier to see. However, interchangeable screens optionally include split-image rangefinders and/or microprisms.

FILM MAGAZINES

On most roll-film SLRs, the back of the camera, which holds the film and its transport mechanism, is interchangeable. To take it off the camera, the photographer inserts a metal darkslide which protects the film inside the magazine, and then pushes a catch to one side to release the magazine. Putting on a new magazine simply means reversing the procedure. Interlocks fix the magazine to the camera when the darkslide is removed so that film cannot be fogged, and prevent the shutter from firing when the darkslide is in place.

Magazines can be loaded with film either when fitted to the camera, or when removed, so the busy photographer can employ an assistant to reload magazines when film runs out.

Interchangeable magazines have a further advantage. The standard roll-film magazine can be replaced by an instant-film magazine, so that the photographer can make instant checks on lighting, colour and exposure. Other magazines may change the film format – perhaps from 6 × 7 to 6 × 4.5cm on 120 roll-film – or the film stock, allowing the use of long rolls of 70mm film, or cassettes of 35mm film, or to switch from black-and-white to colour stock.

LENSES FOR ROLL-FILM SLRs

Each different format of roll-film uses a different focal length as standard: 75mm for 6 × 4.5, 80mm for 6 × 6, and 90 mm for 6 × 7cm pictures. Wide-angle lenses tend to have comparatively modest specification, providing – even in the extreme – angles of view that corresponds to 20 or 30mm lenses on 35mm cameras.

Telephoto lenses give limited magnification, too: the longest focal lengths usually available for roll-film cameras magnify the subject no more than a 250 or 300mm lens on a 35mm SLR.

Most systems additionally have a fisheye lens, a macro lens, and possibly a perspective control lens. Systems fitted with focal plane shutters often also have a portrait lens with its own integral leaf shutter, for faster flash synchronization.

ROLL-FILM SLRs IN USE

These cameras fill a gap between 35mm and sheet-film models. Though not as quick and easy to use as 35mm, they are nevertheless small enough to hand-hold, yet produce usefully large pictures. Consequently, they are often used by professional wedding and social photographers.

In the studio, they are very much more convenient than sheet-film cameras, and therefore find favour for portrait and fashion work where the photographer must catch a fleeting gesture, or a flowing garment.

OTHER ROLL-FILM CAMERAS

Although roll-film cameras are dominated by the SLR type, not all roll-film cameras fall into this category. Twin-lens reflex cameras (TLRs) were once very popular, though less so today. TLRs as the name suggests, have two lenses stacked one above the other. The lower lens serves only for picture-making, while the upper one of the pair relays the image via a fixed mirror to the focusing screen. Both lenses slide back and forth on a single panel for focusing, so when the image on the screen at the top of the camera is sharp, so too will be the image on the film.

TLRs are generally cheaper and quieter than SLRs, but they suffer from parallax error which can cause problems at short subject distances. Usually TLRs have fixed lenses – though Mamiya TLRs can be fitted with pairs of lenses ranging in focal length from 55mm to 250mm.

Rangefinder roll-film cameras have become increasingly popular over a period when use of TLRs has declined. These models resemble overblown 35mm rangefinder cameras, and are very light and compact compared to roll-film reflex cameras. To make them even smaller the lens often extends from the camera body on a bellows, and folds away when not in use. Lenses are not interchangeable, though different models of camera are available, each with lenses of different focal length.

SHEET-FILM CAMERAS

The image of the photographer standing behind a large and unwieldy camera, a black cloth covering his head, may today seem archaic and irrelevant, but it is not. These cumbersome cameras are still in use, and indeed, for colour images used in poster advertising, such sheet-film cameras are essential because they give unbeatable image quality.

HASSELBLAD 500 C/M

One of the pioneer manufacturers of medium-format SLR cameras is Hasselblad. This is very much a system, designed in a modular way, that allows quite different configurations. There is a choice between bodies that incorporate a focal plane shutter and those that do not (relying on leaf shutters in each lens). A distinctive feature is a selection of interchangeable film magazines, permitting not only rapid change between different types of film during one shoot, but also different formats.

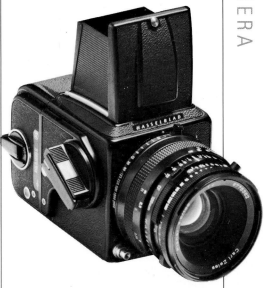

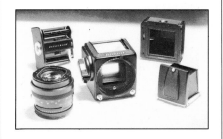

OTHER ROLL-FILM CAMERAS

Other roll-film SLR designs include the following makes, illustrated at left:
1 Mamiya RZ67
2 Mamiya 645
3 Rolleiflex 6002
4 Rolleiflex 2000F
5 Bronica

CAMERA MOVEMENTS

Some of the basic camera movements are here demonstrated on a standard target – a cube.

1 Raising the rear standard shifts the entire image upwards in the frame. Lowering the front standard produces virtually the same effect.

2 Raising the front standard (or lowering the rear) achieves the opposite – the image is shifted downwards.

3 Moving the rear standard to the left (or the front to the right) shifts the image left.

4 A lateral shift in the opposite direction shifts the image to the right. In practice, of course, the image seen on the ground-glass screen is inverted; it is rectified here for clarity.

5 Tilting the rear standard changes both the angle of the plane of sharp focus *and* the shape of the image.

6 Tilting the lens, on the other hand, alters only the plane of sharpness and not the shape.

7 Swinging the rear standard around a vertical axis produces shape distortion, as well as redistributing the sharpness.

8 Swinging the front standard alters only the sharpness.

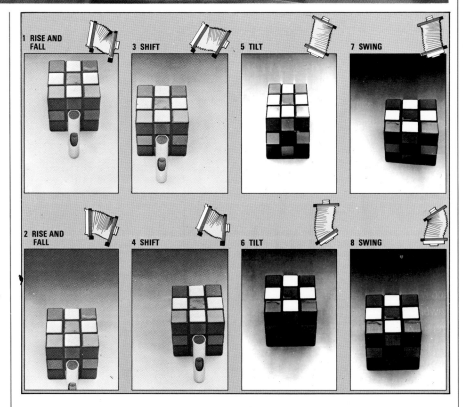

1 RISE AND FALL 3 SHIFT 5 TILT 7 SWING

2 RISE AND FALL 4 SHIFT 6 TILT 8 SWING

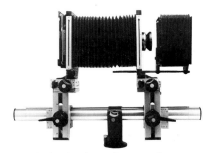

ABOVE *Professional 5 × 4in monorail camera*

FIELD CAMERAS *This traditional design of sheet-film camera (below) (the earliest models were designed to take glass plates) is constructed on the flat-bed principle, with a wooden base carrying the front and rear standards. Focusing is by rack and pinion.*

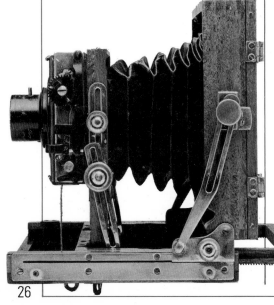

Though modern technology has made these cameras lighter and somewhat easier to use, the changes are partly cosmetic, and a photographer from a century ago would probably feel quite at home with one of today's sheet-film cameras. The converse is also true – some portrait photographers in particular still use cameras the design of which has not changed in 50 years.

BASIC PRINCIPLES

The sheet-film camera is the most basic form of apparatus. It is composed of two flat panels: the front one supports the lens, shutter and aperture; and the back one holds a ground glass screen for focusing. To take a picture, the screen is pushed aside, and a film holder takes its place.

The two panels – called the lens or front 'standard', and film or rear 'standard' – are joined by a leather cloth bellows that excludes light. The whole apparatus is supported on a rail, or a third panel.

To take a picture, the photographer fixes the camera to a tripod, and locks open the shutter and aperture inside the camera's lens so that the lens projects a dim image onto the ground-glass at the back of the camera. By excluding light, using the prominent black cloth, the photographer can see the image and move the two standards closer together or further apart until the image is sharp.

At this point, the shutter is closed, and the aperture stopped down to the chosen setting. The photographer now loads a sheet of film into the film-holder (a flat, shallow box), and pushes this into the back standard of the camera. After pulling out the light-tight darkslide which protects the film, the camera is ready for operation. Pressing the shutter release exposes the film.

Pictures can only be taken one at a time, of course, because the film is in the form of cut sheets, instead of a long roll. However, there are several compensations: first, the large pictures produce superb quality images. Second, by tilting, shifting and swinging the front and rear standards relative to each other, the photographer can change the camera's field of view, the apparent shape of the subject, and the distribution of sharpness within the picture.

The third advantage is less tangible, because it relates more to human nature than to technique. Portrait subjects respond differently to these large-format cameras

CAMERA MOVEMENTS

On a 35mm camera, the lens is locked in position relative to the film, and can move only along its own axis – closer to, and farther from the film for focusing. Sheet-film cameras are not restricted in this way, and both the lens standard and film standard move in several other directions. In addition to the fore-and-aft movement found on smaller formats, the standards can shift left and right, and up and down while remaining parallel. Each standard can tilt forwards and backwards along a horizontal axis, and swing to the left and right around a vertical axis.

These camera movements, as they are called, are used to control the appearance of the image on film. Shifting either the front or back of the camera changes the field of view, because this action moves the film plane to a different part of the large circular image formed by the lens, as shown at right.

This technique finds practical application when photographing a building. Tilting the camera upwards to include the whole of the structure causes the parallel sides to converge on film, so photographers always aim to keep the camera back vertical. However, with the lens in the normal position, the top of the building is cropped out of the picture. The solution is to shift the lens – and with it, the circular image that falls on the film – upwards. This brings the top of the building into view at the bottom of the sheet of film. (Camera lenses always form inverted images.)

Swings and tilts perform different functions. Front swings and tilts – angling of the lens standard – alter the distribution of sharpness within the image. When both standards are parallel, as they are on a 35mm camera, the plane of sharpest focus lies parallel to the film. However, tilting or swinging the lens reorientates the plane of sharp focus. For example, when photographing a carpet on the floor, a photographer wishes to keep the whole floor in focus. This is made possible by tilting the lens forward so that the plane of sharpest focus is horizontal, rather than parallel to the film. The whole carpet will thus be sharp, even at full aperture. Note, though, that the vertical walls of the room will drift rapidly out of focus as they rise upwards from floor level.

Back swings and tilts change the shape of the subject. This is because swinging is equivalent to turning the whole camera. A photographer may want to change the apparent shape of a still-life set, for example, to emphasize an object in the foreground. This could be done by tilting the rear standard of the camera backwards at the top.

than to smaller equipment. So the photographer may capture an image that is quite different in mood and quality – though it may have the same content as a picture taken using a 35mm camera.

SIZES AND TYPES OF A CAMERA

The two commonest sizes of sheet-film are 5 × 4in, and 10 × 8in (12.5 × 10cm and 25 × 20cm respectively). However, there is a profusion of other less commonly used sizes, such as 4¾ × 6½in or 12 × 15in. The larger the film, the larger is the camera in which it is exposed, and only cameras taking the smallest size – 5 × 4in – can really be hand-held.

Broadly speaking, there are two types of sheet-film camera: the monorail, and the field camera. *Monorail cameras,* as their name suggests, have standards mounted on a single metal rail. The two standards are very manoeuvrable, offering the largest possible range of camera movements, so this type of camera is very versatile. However, it is also time-consuming to set up, and ungainly to use, so monorail cameras are most often used in the studio. Outdoors, they are used only when extreme movements are required.

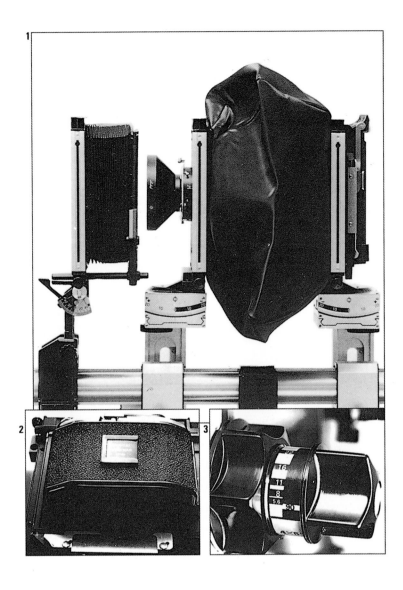

1 **BELLOWS LENS SHADE** *To avoid flare, a shade can be made from one of the standard bellows with one standard.*

2 **ROLL-FILM BACK** *Several makes of roll-film back are available. These fit into the rear standard in place of the ground glass screen and spring-back roll–film is more economical than sheets.*

3 **DEPTH OF FIELD SCALE** *As view cameras do not normally have focusing mounts for their lenses, any depth of field scale must be incorporated into the focusing knob or rack. The version shown here is for a Sinar P.*

4 **VIEWING SCREEN** *the viewing screen in modern view cameras is located in a spring-back – at rest it lies in the film plane, but is opened and moved back to accept the film holders.*

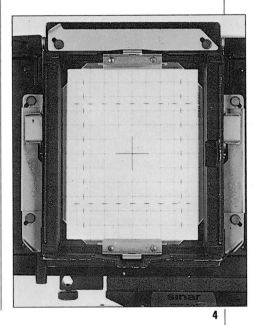

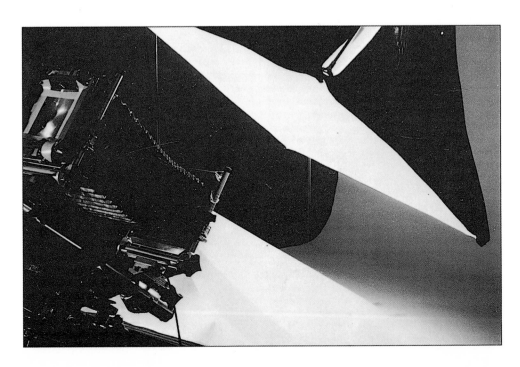

Field cameras, on the other hand, are designed for use out of the studio. They are much more rugged than monorail cameras, and easier to use in difficult conditions – in high wind, for example. They do not have such extreme movements as monorail cameras, though, so they are not as versatile. A few field cameras are fitted with range-finders similar to those on 35mm cameras. This enables the photographer to focus the camera without resorting to the ground-glass screen. The rangefinder usually operates only with a limited range of lenses, though.

LENSES FOR SHEET-FILM CAMERAS

The lens standards of sheet-film cameras have removable centre panels, into which the lens screws. Generally the panels are cheap, so each lens is left fitted into its own panel, which can then be quickly locked onto the camera.

Choice of focal length is more limited than for either 35mm or roll-film cameras, particularly at the long focal length end. However, since a portion of the large film sheets can be enlarged with little loss of quality, this rarely presents problems.

The most suitable lens for any given application depends not only on the angle of view that the photographer wants, but also on the film format in use, and on the degree of lens coverage required. A standard lens for a 5 × 4in camera, for example, would have a focal length of 150mm or 210mm. These lenses give fields of view equivalent to focal lengths of 40mm and 55mm lenses on 35mm cameras. A typical wide-angle lens for 5 × 4in has a focal length of 90mm (equivalent to 24mm on a 35mm SLR) though lenses as short as 65mm (17mm) are available. In the telephoto range, a focal length of 360mm is typical – equivalent to 95mm on a 35mm SLR.

READYLOAD PACKETS

Kodak has recently introduced Readyload packets of sheet film which are the answer to a prayer from harassed photographers' assistants. Readyload packets are used as a substitute for sheet film in a double darkslide film holder, and can be loaded into the camera in daylight. This frees the photographer or assistant from the task of loading sheet film into a film holder in total darkness, and will be a great boon to location photography with field cameras. At present, Readyload packets are only available in the 5 × 4in film format, loaded with Kodak Ektachrome 100 PLUS Professional film, but other films and formats are bound to follow.

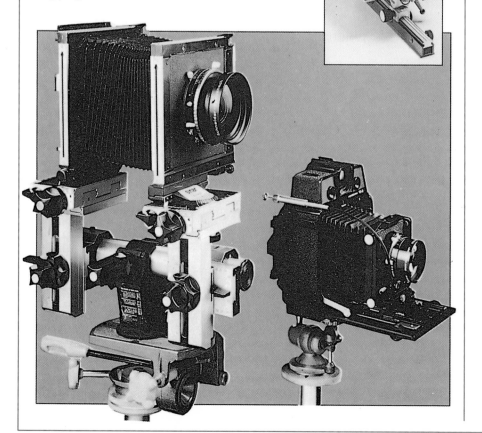

MONORAIL AND TECHNICAL CAMERAS *The two most commonly used current designs of view camera are the monorail (below left and right inset) and the technical camera. The monorail is a highly versatile instrument, but not especially robust, and is used principally in studios. The technical camera is in many respects a more strongly engineered version of the field camera.*

LENSES

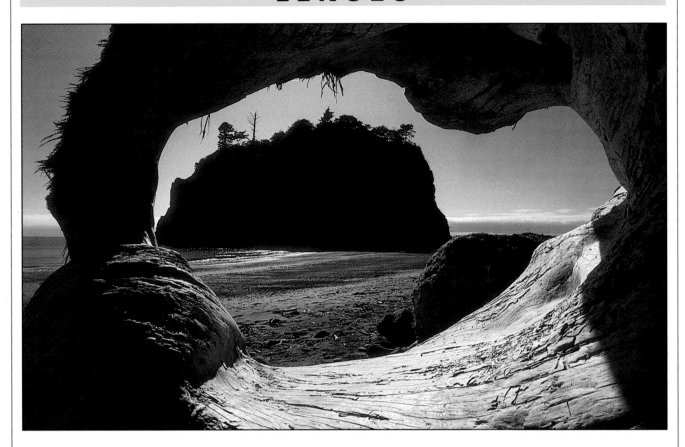

THE LENS is the eye of the camera – the component that turns the three-dimensional world outside the camera into a two-dimensional image on film inside. The quality of the lens determines, to a considerable extent, the quality of the photograph. With a good quality lens, even the simplest, most inexpensive cameras are capable of creating technically good pictures. The converse is not true – fitting a poor lens to a good camera will invariably lead to inferior results.

The lenses used with most cameras today are very complex works of engineering, designed by computer and manufactured with extreme precision. They form images, though, in the same manner as the simple magnifying glass that gathers the light of the sun to burn a hole in a piece of paper.

LENSES AND IMAGE FORMATION

Lenses work because light travels more slowly in glass than in air. A beam of light striking a block of glass at an oblique angle is slewed round as it enters the glass. This is because the edge of the beam that enters the glass first is slowed down significantly sooner than the far edge of the beam.

This bending of light on entering a different transparent medium is called refraction. Different substances refract light by different amounts and the amount of refraction – the bending power of the substance – is called the refractive index. The refractive index of glass is between 1.5 and 2.

To understand how a lens works, think of parallel beams of light passing through a prism. The prism bends the light round at an angle. The degree of bending depends on the roof angle of the prism – the closer to parallel the sides of the prism are, the less bending there is. A lens is like a series of prisms stacked up. The prisms in the centre of the lens have parallel sides, and closer to the edge of the lens, the prisms have steeper and steeper angles. Light passing through near the centre of the lens is only bent a little; further from the centre, light is bent more and more. So parallel light beams passing through the lens all converge on the same point, called the *focus* of the lens.

20MM WIDE-ANGLE *The massive depth of field of a wide-angle lens can be exploited by finding a camera position close to interesting foreground details. In this view of an island, shot on a 20mm lens stopped down to f22, the depth of field extended from the horizon to as close as 0.6m (2ft).*

THE SIMPLE LENS

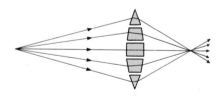

A simple lens works as if it were made up of small individual prisms. Like the prism, each lens section bends light rays. By shaping this lens, each refracted ray from a single point can be made to meet at a common point behind the lens. A subject is made up of an infinite number of points. Focusing each of them behind the lens forms an image.

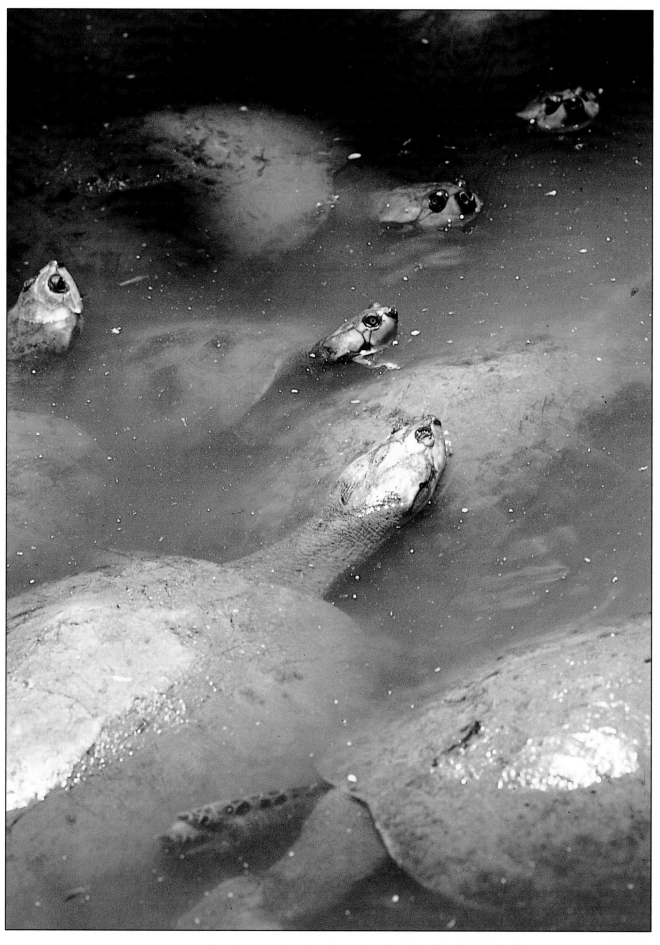

180MM TELEPHOTO *These river turtles basking in shallow muddy water, were packed so closely together that they made an irresistible pattern of broad shells and long necks. A long-focus lens helped to enhance this effect.* Nikon, 180mm, Ektachrome, 1/250 sec, f5·6

HOW FOCAL LENGTH CONTROLS IMAGE SIZE

The convex lens of a short-focus design bends the light rays from the subject (in this case a man) at a sharp angle to bring the image into focus only a short distance behind the lens: hence its name. Because the light is bent so sharply, the image is small. The long-focus lens is less convex than a short-focus design and so brings the light rays together farther behind to form a larger image. This also means that a long-focus lens is more selective, as less of the subject's surroundings are included in the picture.

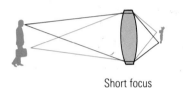

Long focus

Short focus

For a simple lens, such as a magnifying glass, the distance from the middle of the lens to the focus is called the focal length. When using a magnifying lens to burn holes in paper, the lens is held at its focal length from the paper to get the maximum burning effect – the parallel rays of light from the sun then all converge to form the hot spot, which is actually a small picture of the sun on the paper.

Though simple magnifying lenses can form images, they are not very efficient and would be useless on cameras. Simple lenses have many faults, known as *aberrations,* and the aim of the lens designer is to minimize these aberrations and create the best lens possible.

The process of optimizing the lens is very long and difficult, but by way of example, consider just one lens fault, chromatic aberration. Because the glass bends different colours by different amounts, the colours of the sun that the magnifying glass projects will not all be brought to the same focus. Instead, the sharpest image of red light will be formed farther from the lens than the image of blue light. Invisible infra-red radiation will come to a focus even farther away from the lens, which is why the glass burns best when the sun is a little bit out of focus.

These coloured images are unsuitable for photography, for reasons that are clear to anyone who has ever used a cheap pair of binoculars: everything in the field of view is surrounded by coloured fringes. This is because the field-glasses have uncorrected chromatic aberration.

Lens designers minimize the problem by combining two lenses made from two different kinds of glass, each with a different refractive index.

Chromatic aberration, however, is not the only problem that lens designers face. There are many more types of aberration, including aspheric aberration, created by the very slight difference in the focusing of light passing through the centre of the lens and light passing through the edges. Correcting, or at least minimizing, them all, means using many more than two glass elements in the lens. Modern lenses often have seven or eight elements, and zoom lenses even more.

Correction of aberrations is not the end of the story. Lenses must not only form good, sharp images, but they must fulfil other criteria as well. The lens must not be too big or too heavy; it must have a fairly wide maximum aperture, so that picture-taking is possible in dim light; and the lens must not be too costly to manufacture. An optically perfect lens that is big, expensive and slow is of only theoretical, not practical interest.

LENS SPEED

The widest aperture to which the lens can be set is a measure of its maximum light-gathering power – the 'speed' of the lens. This is an important consideration for photographers who take many pictures in restricted light. Most standard lenses for 35mm cameras have maximum apertures of f1·8 or f1·4. A few have apertures of f1·2.

Telephoto lenses usually have smaller maximum apertures because with long focal lengths, the physical diameter of the lens must be greater for the same f-number. This makes fast telephoto lenses heavy to carry and expensive to manufacture.

Maximum aperture is limited ultimately by film flatness, because the wider the aperture to which a lens is set, the more precisely the film must be positioned at the back of the camera. With the lens set to f1·2, even a slight curl in the film will lead to uneven sharpness across the frame.

LENSES FOR 35mm SLRs

The tremendous variety of lenses available for the 35mm SLR make it by far the most versatile type of camera. Each lens fits onto the camera by means of a lens bayonet, or, in increasingly rare cases, 42mm thread. The lens bayonet design varies according to the make and model of camera, and it is important that you get to know the abbreviation for your camera in order to buy only lenses which will fit (e.g. CEF for Canon EF mount).

Some autofocus SLRs use a lens bayonet which has been adapted to suit the design of a new range of autofocus lenses; this mount may also be able to use manually focused lenses which greatly increases the options available. Other bayonets are designed exclusively for autofocus lenses, such as the Canon EF mount used on Canon EOS cameras.

LENS QUALITIES

Focal length and image size By altering the design of the lens to change the focal length, the size of the image at the focal plane can be altered. Reducing the focal length makes the image smaller (below); increasing it makes the image larger. With a smaller image, there is a greater angle of view.

Covering power A lens projects a circular image. The image quality is highest at the centre, deteriorating towards the edges. The point at which the image falls below an acceptable standard marks the circle of good definition, and this represents the covering power of the lens (below). In photography, the film format must fit within the circle. On a camera, the covering power is increased slightly by stopping down the aperture.

Sharpness A lens brings light waves to a point only at the focal plane. In front of, or behind this plane, it projects a circle. This 'circle of confusion' increases with its distance from the focal plane (below), causing parts of the image to appear unsharp (out of focus).

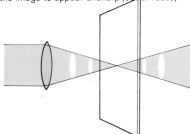

Depth of focus The smallest circles of confusion appear sharp enough to be satisfactory. There is therefore a small range on either side of the film plane that still gives an acceptably sharp image. This is called the depth of focus, and is defined as the distance through which the *film* or *lens* may be moved before the image becomes sharp.

Depth of field This is the distance through which the *subject* may be moved before the image becomes unsharp. A related feature, hyperfocal distance, is the closest at which the subject is sharply recorded when the focus is set at infinity.

LENS FAULTS

Simple lenses have a variety of faults, some due to the inherent nature of light, others to the inefficiency of the lens itself. Most can be partly corrected at least in the design of a compound lens.

Flare This is caused by reflections from surfaces within the lens body, and causes an overall loss of contrast. It is sometimes made worse by reflections within the camera body. A lens hood partly overcomes the problem by cutting down the light that does not play a part in forming the image. More corrections are possible with lens coatings, which are on nearly all modern camera lenses. They work by setting up a second reflection from the lens surface that interferes with the original reflection, nearly cancelling it out. The principle is called destructive interference.

Chromatic aberration The different wavelengths that comprise white light travel at different speeds through the lens, and pass through a lens at slightly different angles; this is called chromatic aberration (below). Blue-violet light is focused slightly closer to the lens than green light, which in turn is focused closer than red light. As the focus is spread in this way, there is some loss of definition. One answer in lens design is to use different lens materials, so that the chromatic aberration of one cancels out the slightly different chromatic aberration of the other. Another effect of chromatic aberration that is less easy to correct is the colour fringe at the film plane caused by the slight divergence of the wavelengths. A recent solution is extra low dispersion glass made by including rare earths in the manufacture of the glass. Fluorite also has low dispersion qualities, but is damaged by the atmosphere and changes shape with temperature changes.

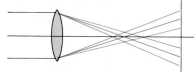

Spherical aberration It is cheaper to produce a lens with a spherical curved surface than one in which the curvature changes. The cost of this is spherical aberration (below), where the edges of the lens focus the light waves at a different point from the centre of the lens, causing unsharpness. In the case of oblique rays passing through the lens, they fall on different parts of the film plane in a blur rather than being superimposed. This slightly different

aspect of spherical aberration is called coma. There are several ways of overcoming this, and for lens manufacturers, it is principally a matter of cost. Mirror lenses, which use reflective surfaces, do not suffer from such aberrations.

Distortion The aperture stop of the lens prevents oblique light waves from passing through the centre of the lens, and, as the lens surfaces at the edges are not parallel, the image-forming light is bent. This does not affect sharpness, but does distort the image shape (below). If the shape is compressed, it is called barrel distortion; if stretched, pincushion distortion. Symmetrical lenses (that is, with complementary elements at the front and back) cancel out this distortion, but telephoto or retrofocus designs, which are asymmetrical, suffer to some degree. A fish-eye image is an extreme example of barrel distortion, because the lens uses an extreme asymmetrical design.

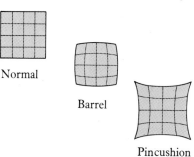

Normal

Barrel

Pincushion

Field curvature The focal plane of a simple lens is not precisely flat, but curved so that if the film is flat, not every part of the image will be sharp (below). Curving the film is one answer, but some modern compound lenses are designed to have a flat field.

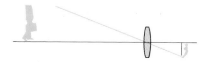

Diffraction The edge of an opaque surface, such as the aperture blades, scatters light waves slightly. If the aperture stop is closed down to its smallest size, this scattering, called diffraction, is increased (stopping down, which tends to correct most lens faults, actually worsens this one). In practice, most lenses perform at their best when stopped down about three aperture stops from their maximum – this is called their optimum aperture.

STANDARD LENS

This standard 50mm lens has a 46° angle of view that gives a natural perspective and a moderately wide minimum aperture of f2. Its six elements arranged in four groups allow the manufacturer design flexibility to correct most common aberrations.

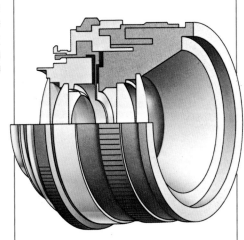

When the lens focal length (a) is approximately the same as the diagonal measurement of the film format (b), the image will appear normal.

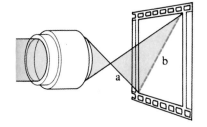

Although the lenses described in the next few pages are manually focused examples, the basic characteristics are exactly the same for autofocus lenses only the method of focusing is different, and hence the lens mount. This may employ a spigot protruding from the mount flange on the camera body which mates with the lens and drives the focusing attention. Other autofocus lenses have the motor actually inside the lens and an electronic contact between lens and body draws power from the battery inside the camera to power the focusing action.

FITTING AND REMOVING A LENS

A lens is attached to a camera body by aligning a mark on the lens with a mark on the body, inserting the lens carefully into the body then twisting it anticlockwise (clockwise for Nikon) until it locks into place. To remove a lens you press and hold down a release lock button, either on the camera body or on the lens, twist the lens in the opposite direction until it can be carefully withdrawn. Never use excessive force when either fitting or removing a lens.

THE NORMAL LENS

The angles of view for 35mm SLR lenses range from more than 200° to less than 1°; and those few lenses that are in the middle of the spectrum – neither wide-angle nor long-focus – are generally considered normal or standard. 'Normal' means that the lens covers approximately the same angle of view as the human eye, without perspective distortion.

Lens descriptions – 'normal', 'wide-angle', and so on – depend on the film size, for a lens that gives a certain coverage on one film format will project a wider angle on a larger format. When the focal length of the lens equals the diagonal measurement of the film frame, the image will appear normal. A 35mm film frame measures 43mm diagonally, so theoretically 43mm is normal. In practice, the most common lens (supplied by manufacturers as normal) is 50mm, and any length between 40mm and 55mm will appear free of perspective distortion. These figures are necessarily imprecise because of the way the eye sees. The eye scans the view in front of it, and the whole scene is recorded on the retina in different degrees of sharpness, from the fuzzy borders of view at about 240° down to perfect sharpness over an angle of just 2° in the centre. Nevertheless, the apparent coverage is around 45°–50°, and a lens that comes close to this appears to have none of the distortions associated with wide-angle and long-focus lenses.

ZOOM LENSES

Zoom lenses are optically complex, incorporating at least several separate glass elements that must be moved in coordinated groups. 14 elements in 11 groups, for example, is not unusual for a high ratio zoom lens. The zoom ratio (or range) is the key consideration in choosing lenses, particularly if more than one is to be carried. To make up a full range of focal lengths the following lenses go well together:
28–45mm
43–86mm
80–200mm
200–600mm (for specialised use)
Some manufacturers make lenses with a very wide zoom range approaching the ideal of a 'unilens'.

A RANGE OF FOCAL LENGTHS
FOR 35mm SLR CAMERAS

An effective demonstration of the characteristics of lenses of different focal lengths is to choose one viewpoint and, with a selection of lenses from very short to very long focus, shoot the same scene with the camera pointing in the same direction. The opportunities for making as good a composition with every lens are very rare, and inevitably one or two stand out as more effective. In this series, shot in a Hong Kong harbour, the camera position was unchanged, but the lenses used ranged from a 16mm fish-eye to an 800mm telephoto. The extent of the magnification (which can be calculated by dividing 800mm by 16mm – 50 times) is so great that the final telephoto image cannot be seen on the fish-eye photograph even with a magnifying glass. In fact, the pictures at either end of the scale are so completely different that only the intervening shots, which are less satisfactory, show the gradual progression.

16mm fish-eye

20mm wide-angle

35mm moderate wide-angle

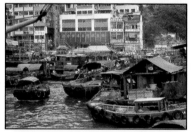

50mm standard

180mm moderate long-focus

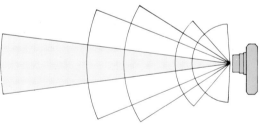

400mm extreme long-focus

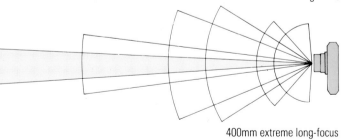

800mm extreme long-focus

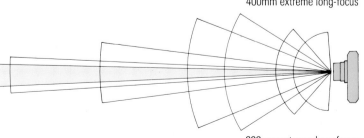

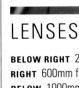
LENSES

BELOW RIGHT 24mm f2 retrofocus
RIGHT 600mm f5.6 telephoto
BELOW 1000mm f11 reflex mirror

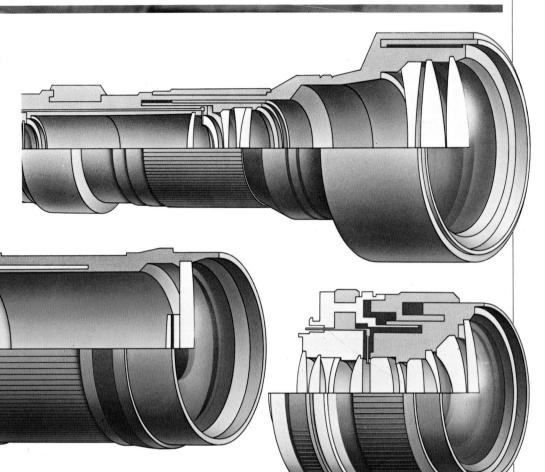

Of all focal lengths, the normal lens is the least obtrusive picture-making tool. Its distortion-free optics allow a faithful, straightforward treatment of the subject imposing little graphic control. Photographers looking for a literal rendering find it indispensable.

Yet, precisely because of these qualities, many photographers find this normal view too ordinary and restricting, and look for more dramatic and unusual images at the ends of the focal length scale. The wide range of lenses now commercially available has accustomed us to stronger graphic images.

One very practical advantage, however, that is associated with a normal focus length, is the ability of the lens manufacturer to increase its light-gathering power, and therefore its speed. The additional optical problems of the wide-angle and long-focus lenses restrict their maximum aperture: the very fastest lenses are around the normal focal lengths and can have a maximum aperture of up to f1·2, and in the case of some specialised night-time lenses, this can be even faster.

WIDE-ANGLE LENSES

Lenses with a shorter focal length than a 'normal' lens can be divided into two categories – moderate wide-angles which give little noticeable distortion, and extreme wide-angles that unmistakably impose their distortion on the picture. Short-focus lenses enable the photographer to obtain a wide-angle coverage even in small spaces and give great depth of

field. Together these properties open up exciting possibilities of controlling the relationships between different elements of a scene.

The most noticeable property of the wide-angle lens is its coverage, 62° in the case of a moderate focal length such as 35mm, or a wide 94° in the case of a 20mm lens, for example. In cramped spaces where the photographer cannot move back far enough to

cover the scene with a normal lens, a wide-angle lens is essential. Its generous coverage gives a feeling of space to interior views and will often best convey the full sweep of an open landscape. Perhaps most important is its ability to include both the immediate foreground and distant objects, which allows the relationship between near objects and their backgrounds to be explored.

Because the lens compresses the image on to the film plane, it is very efficient at gathering light, so the wide-angle lens needs only a small aperture even when it is wide open. As a result, the depth of a wide-angle lens is much greater. In reportage photography, for example, this can be perfect for unplanned shots that need quick reactions – with, say, a 28mm lens on a fairly bright day, anything from a few feet to infinity will be sharp, so the photographer can aim and shoot without adjusting the focus.

EXTREME WIDE-ANGLE LENSES

The extreme wide-angle lenses have angles of view well over 100°, the majority of them around 180°, but the price of this coverage is extreme distortion, demanding careful and restricted use. Most, including the 'fish-eyes', are uncorrected, and give a very characteristic curved distortion, bending straight lines around the circumference of the picture. Only lines that pass through the centre (radial lines) remain straight.

The most extreme of these uncorrected lenses compresses the image into a circular frame – a 'fish-eye'. When fish-eyes first became commercially available, they enjoyed a brief vogue, but the strong graphic control that they impose swamps the subject matter and restricts their use.

More adaptable is the kind of uncorrected wide-angle lens that covers the full frame. It can be used either as a problem-solving lens, utilising its wide angle of coverage and depth of field, or for the dramatic effect of its distortion. In small spaces it comes into its own, but in this case the distortion is usually a nuisance and you should try to avoid the more glaring effects. If possible, compose in such a way that any clean, straight lines or familiar shapes are near the centre, where the distortion is less.

WIDE-ANGLE LENS

The 24mm lens (below), with an angle view of 84°, uses a retrofocus design to lengthen its extremely short focus so that it can be used with the reflex mirror in the camera housing. To overcome the problem of poor image quality at close focusing, the elements 'float' inside the housing. Their relative positions can therefore be changed as the lens focuses closer.

28MM WIDE-ANGLE *This lens can lend drama to a landscape scene (below). Depth of field is great, and even focusing becomes a secondary consideration.*

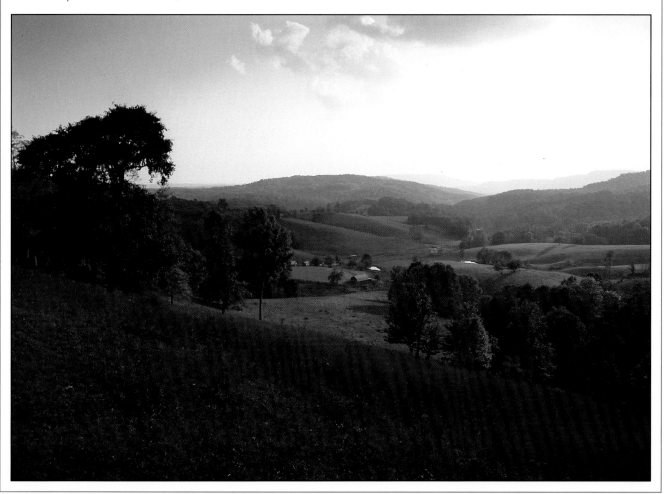

EXTREME WIDE-ANGLE LENS

A true fish-eye design, covering exactly 180° and producing a circular image, this 8mm lens produces images with extreme barrel distortion, straight lines at the edge of the picture being bent to the circumference. Because of the wide coverage, the lens contains its own built-in filters in a revolving turret. This fish-eye lens allows reflex viewing, although less expensive models can only be used with the camera's mirror locked up.

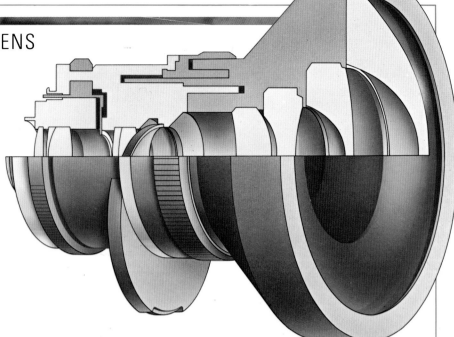

TYPOGRAPHIC SPHERE

From qualified optimism about British farming we come to qualified pessimism about the world's food prospects. Dame Barbara Ward, President of the International Institute for Environment and Development, examines the balance sheet. On the debit side, increasing direct and oil-related costs, diminishing returns, and the weather. On the credit side, is the growing recognition of an enlightened community approach to the world's nutritional needs. The American 'grain sheikhs' will be balancing the books.

This was one of the rare occasions when a true fish-eye lens was indispensable to give a circular setting of typography the appearance of being a sphere. The original typography measured only 4in (10cm) in diameter, so to achieve this degree of distortion, the front element of the lens had to be less than 1in (2.5cm) from the paper. To preserve the focus, the lens had to be stopped right down, and as reflex viewing was not possible with this design of lens, positioning was done by opening the camera back and placing a ground glass screen on the film plane before loading the film.
Nikon F2A, 6mm (220° coverage), Kodalith line film, 10 sec, f22.

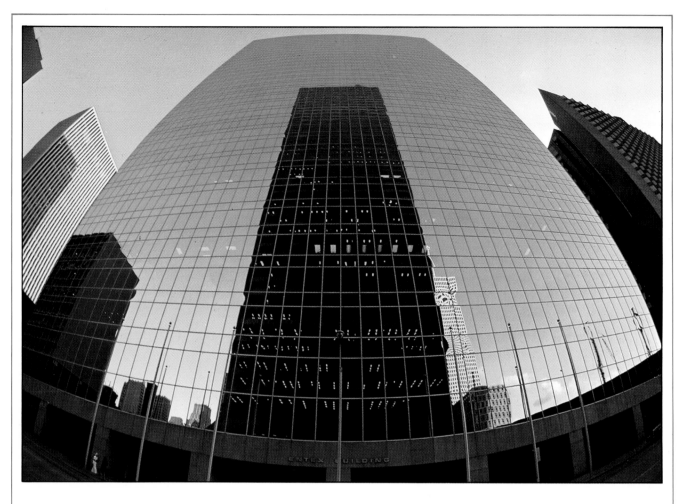

PENNZOIL BUILDING *Using a fish-eye 16mm lens for effect rather than for coverage, I chose the uncomplicated skyscraper skyline of downtown Houston (above). The lens imposed a symmetry on what was already a very ordered and precise arrangement of buildings.*
Nikon F2AS, 16mm (170° coverage), Kodachrome 25, 1/125 sec, f5·6

Using the extreme wide-angle lens for effect is technically much simpler, but excessive use is tempting. Try to use the curvature to some graphic effect rather than playing with it for its own sake. Complicated outlines and irregular shapes are normally poor subjects with this type of lens since they are further complicated by the lens.

Because of the wide coverage, it is often difficult to avoid having the sun in frame in an outdoor shot. As a result, it is important to take great care when setting the exposure; the sun or a large area of pale-toned sky in the frame can easily result in the main subject being underexposed. When taking a TTL reading, either aim the camera in a slightly different direction, or cover the image of the sun with your hand.

Correcting the curvilinear distortion of the lens is possible, at a price. Such lenses are usually bulky and very expensive, and none can reach the coverage of an uncorrected lens. Although all straight lines do appear straight in the picture, there is considerable angular 'stretching' towards the edges, and circular objects distort badly near the corners.

Attaching filters can be a problem, as the angle of view is so wide that the rim of the filter would appear in the picture frame. Consequently, all the lenses feature built-in filters, situated between the elements, but for some reason, most manufacturers have failed to appreciate that most photographers work in colour, and the filters are usually geared to black-and-white photography. As a last resort, it is just possible to bend an oversize gelatin filter around the front of the lens, holding it in place with tape.

FISH-EYE LENS *Just as a telephoto lens alters the proportions of an image in one direction, so does a wide-angle lens in the other. Photographed with a fish-eye lens – so-called because of its curved, barrel distortion – these sand dunes (left) would never look like this in reality. The angle of view from top to bottom is nearly 140°, and the effect is further exaggerated by being reproduced on this page in a relatively small format.*

LONG-FOCUS LENSES

If the wide-angle lens draws together all the components of the scene and involves the viewer, the long-focus lens is a device that isolates and detaches. Through its magnification, it can be used to pick out individual elements of a scene. This ability is enhanced by the shallow depth of field of all long-focus lenses. Because they need to gather more light for their magnified images, these lenses have relatively large apertures; as a result, the depth of field is limited even when the lens is stopped down; and the subject in focus often appears against a blurred foreground and background.

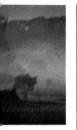

LONG-FOCUS LENS

A favourite of many photo-journalists, the fast 180mm lens has a maximum aperture of f2·8 which makes it fairly easy to hand-hold at quite slow speeds. For colour work in poor lighting conditions it is an ideal telephoto lens. It is quite heavy for its size but this can be an advantage, as it lies steadily in the hand.

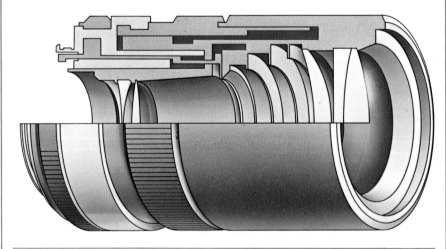

Practically, long-focus lenses have the great advantage that the photographer can work at a distance – especially useful when making candid shots of people. With a 135mm lens, a figure will fill the frame at 24 feet (7 metres), and a tightly-cropped portrait can be taken at 6 feet (1·8 meters). Most moderate long-focus lenses cannot, in fact, focus closer than about 5 feet (1·5 meters).

An extra bonus for portraiture is the flattening effect that a long-focus has on perspective. Whereas a wide-angle lens exaggerates perspective, increasing the apparent difference in size between near and far objects, the long-focus lens compresses it.

An alternative to a long lens is a tele-converter, essentially a supplementary set of elements that fits behind an ordinary lens to increase its focal length. A converter will multiply the focal length of the lens it is used with. A two-times teleconverter, for example, will double the effective focal length of the lens. Until recently, the inferior image quality of teleconverters was such that they had little serious application, but more recent designs give quite acceptable definition. Their greatest advantage is their small size, and when used with a long-focus lens they can save quite a lot in weight. The disadvantage, apart from a slight loss of image quality, is a drastic reduction in lens speed.

TEST MATCH CROWD *Another useful quality of long-focus lenses is their ability to isolate small subject areas from their surroundings. This photograph (left) was composed so that only the massed faces of these cricket spectators would appear edge to edge, like an intricate pattern.*
Nikon, 400mm + 2× teleconverter, 1/250 sec, effective aperture f11.

BASIN STREET, NEW ORLEANS *The severe compression of perspective that is such a noticeable feature of very long-focus lenses reveals strong patterns in a city thoroughfare. With this kind of picture (above), which relies strongly on its graphic elements, it is usually important to stop the lens aperture down sufficiently to render everything in sharp focus. Nikon, 400mm, Kodachrome, 1/60 sec, f16.*

EXTREME LONG-FOCUS LENS

One of several relatively recent long-focus lenses that are both compact and quite fast, this 400mm f5·6 telephoto design allows handheld shooting under many conditions. Extra-low dispersion glass is used, and although this is expensive, it reduces chromatic aberration, the chief cause of unsharpness in long-focus lenses. It also allows the lens to operate at its optimum performance while at full exposure.

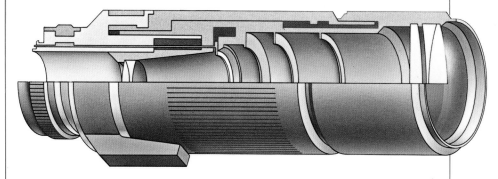

EXTREME LONG-FOCUS LENSES

Lenses of 300mm and longer share the same characteristics as moderate long-focus lenses, but they also present new opportunities and problems. Foreshortening is an essential quality with these lenses, making distant objects, such as mountains or the sun, loom large over the foreground and middle ground. Their extreme magnification allows them to be used at considerable distances from the subject, and as a result they are indispensable for wildlife photography. Also, try using a very long-focus lens for candid shots of people; although more difficult to handle, it makes it possible to work completely unobserved.

The very shallow depth of field of these lenses has a special advantage – by keeping the aperture wide open, distracting foregrounds such as foliage are thrown so far out of focus that they virtually disappear. Practically speaking, the lens shoots right through the obstruction.

Inevitably, such lenses are heavy and bulky, even space-saving improvements in design. They combine all the worst camera-handling problems: they are heavy and difficult to hold steady, and any camera shake is more apparent at these greater magnifications.

Relative movement of the subject is also greater, and needs a faster shutter speed (from the same viewpoint, a moving object will cross the narrow picture frame of a long-focus lens faster than that of a wide-angle lens). To make matters worse, long-focus lenses tend to be slow. They must gather more light for their magnified images, and therefore essentially have maximum apertures that are sometimes as little as f8 or f11.

Because of these problems, very long-focus lenses usually need a secure support, such as a tripod, and even then the vibration of a single lens reflex camera mirror can blur the image at speeds slower than 1/60 sec. To get the maximum use out of these lenses, practise holding them steady, using a wall or whatever support is available. It is possible to improve the slowest speeds at which you can hand-hold them with practice.

The very best long-focus lenses are extremely expensive, mainly because optical excellence is difficult to achieve. Chromatic aberration, where the blue and red light rays do not quite come together in focus at the film plane, is more apparent at great magnifications, and even when the characteristic coloured 'fringe' has been corrected, the image often remains subtly unsharp. New optical glasses now overcome this, but they are costly.

ZOOM LENSES

A zoom lens has a variable focal length, which means that, in a single housing, a range of different magnifications and angles of view can be combined. The image quality possible with this kind of lens used to be noticeably poorer than that which could be achieved with

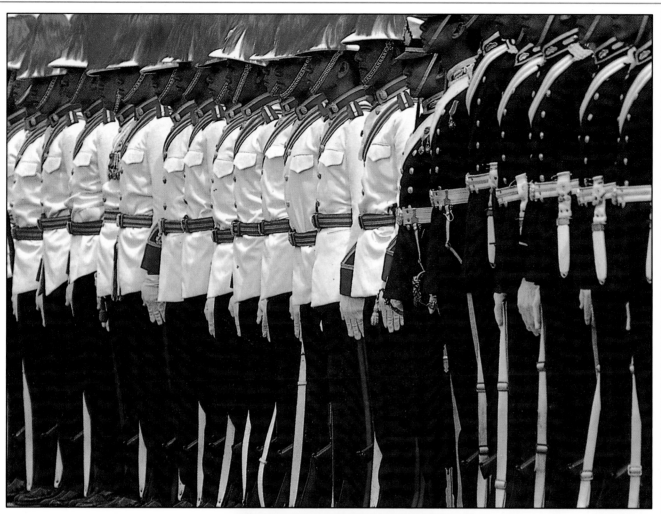

600MM TELEPHOTO *True perspective is only influenced by the viewpoint; it changes when the camera is moved closer or further away. The apparent perspective, however, changes dramatically with focal length. A 600mm lens magnifies a small portion of a scene (above) and appears to compress its proportions. The explanation lies in range – here we see a very much larger view than we would have seen with our own eyes.*

250MM TELEPHOTO *In this photograph of giant Victoria Regia lily leaves (right), the compressing effect of a moderate, 250mm telephoto on a 6 × 6cm camera, combined with the selective framing of a small part of the scene, give a rhythmic effect to the lines. This kind of abstraction is one of the functions of long-focus lenses.*

400MM TELEPHOTO *In the later afternoon sun, a Ndjuka girl bathes in the shallows below the Granholo Rapids (left). Compressing the perspective, a 400mm lens made a simple, uncluttered composition.*

ZOOM LENS

Using very recent design techniques, wide-angle zoom lenses, such as this 28–45mm f4·5 model, can now be manufactured to high optical standards. Zoom lens technology has always been hampered by problems of distortion and aberration, particularly with the retrofocus designs needed with wide-angles, but these are now being overcome significantly.

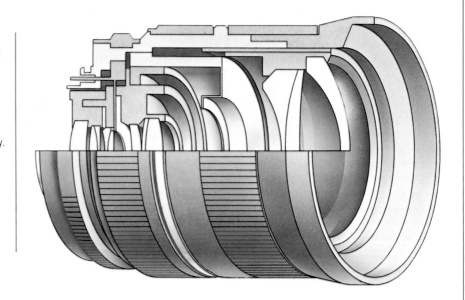

LENS HOODS

Non-image-forming light striking the front of the camera lens always has a degrading effect on the image. At best, the effect is a pale haze that reduces contrast and weakens colour. At worst, flare spots – coloured images of the camera's iris diaphragm – will spread across the frame.

A lens hood or shade can prevent this problem, or at least reduce it. A few lenses have hoods built-in, notably ultra-wide-angles and some telephotos. For most lenses, though, the hood screws into the front of the lens.

A hood should only be used with the lens for which it is designed; too shallow a hood gives inadequate protection and too deep a hood may cut the corners off the picture. The best hoods are actually concertina-like bellows, that can be racked out to match exactly the coverage of the lens in use.

Lens hoods are available in several designs, of varying efficiency: integral sliding hoods on telephoto lenses (**1**), detachable round hoods (**2,3**), detachable rectangular hoods with bayonet fittings (**4**), collapsible rubber hoods (**5**), adjustable professional bellows shades (**6**).

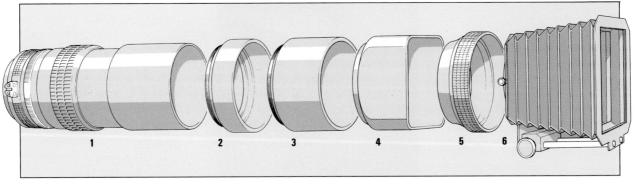

1 2 3 4 5 6

SHIFT LENSES

Perspective correction lenses for rigid body cameras feature a movement to slide the optics off-axis – typically by 10mm for a 35mm camera. This enables, for instance, buildings to be photographed without converging verticals; the camera back remains vertical, and the optics shift upwards, as for the example at right.

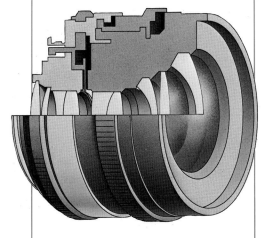

Lens flare and shading Shooting towards the sun is likely to produce flare effects from the internal surfaces and apertures of the lens, as shown below. The difference that a hood makes (left) is usually striking.

Shift lens for architecture A shift lens is often used to avoid the convergence of parallel vertical lines in buildings. In a situation such as right, for a fairly close view from ground level the camera would have to be tilted upwards to include the top of the building, and the result would be convergence. A shift lens, however, has sufficient coverage to be moved upwards and include the entire buildings with the camera aimed horizontally.

a conventional, fixed focal length lens. Recently, however, lens design has improved, and modern zoom lenses can have excellent optics.

Zoom lenses are available in different ranges, from a wide-angle range to a very long-focus range. These often overlap slightly so that almost the complete spread of possible focal lengths can be encompassed in three or four zoom lenses. Generally, the range of a zoom lens is between two and three times its shortest focal length; 35–70mm is a popular lens, as are 80–200mm and 100–300mm. At the extremes of focal length, either very short or very long, the optical design is most complex and the lenses most expensive.

There are two clear advantages to a zoom lens. Firstly, although the lens may be heavier and bulkier than any single fixed focal length lens within its range, it is naturally much lighter than a range of several conventional lenses. For photographers who need a broad selection of focal lengths, a zoom may be more convenient and portable. Secondly, precise framing is possible without changing the camera position; this is particularly important when you do not have completely free access to your subject, as in many sports events, or when the subject changes position quickly, as in many wildlife situations.

Another, more specialised, use for zoom lenses is to operate the zooming control during an exposure. This produces a very characteristic streaking of the image, which can be used as a special effect.

This extremely useful facility to alter the focal length has certain drawbacks, however. Today, image quality among the best makes of zoom lens is very good, but in situations where high resolution is critical, a lens with a fixed focal length, of the same standard of manufacture, is still better. Lens flare tends to be more pronounced because there are more lens elements. Also, the widest aperture of a zoom lens is never as large as that of a conventional lens, so that where fast shutter speeds are needed, it is less useful. Finally, zoom lenses focus less closely than conventional lenses.

Whether you build up your range of lenses from those of fixed focal lengths, or from a lesser number of zoom lenses, depends on the kind of work you expect to do, and your personal taste. Except for some very specialized occasions, zoom and conventional lenses are not complementary; most photographers inevitably use one or the other.

FILMS

THE INSTANT ease with which today's films produce full-colour images seems far removed from the cumbersome processes used in the infancy of photography more than a century ago. Yet despite the revolutions in materials and processing that have changed photography almost out of recognition, the very basis of image-making has remained largely untouched. Today, just as in 1839 when the first photographs amazed the world, photography is possible only because light causes subtle changes in certain salts of silver.

Even the most sophisticated of today's films relies on this one fact. The change is so subtle that it is invisible to the eye; only when the silver salts are transformed by other chemical compounds does the change in structure become apparent, and the crystals that were struck by light turn to black metallic silver; those which were kept in the dark remain undarkened.

Of course, things have changed since Fox-Talbot and Daguerre made, quite independently, the discoveries on which photography is founded. Nowadays, all films make use of the power of developing chemicals to enhance the action of light; Fox-Talbot's paper-based 'film' darkened of its own accord – but only after exposure to light millions of times longer than today's fast films require.

Furthermore, the darkening of silver is now only half the story. As sections later in the chapter explain, the silver formed in colour films simply acts as a stimulant to the production of the clouds of dye that make the picture. Once the dye has appeared, the silver is redundant – and is washed away.

Black-and-white film has remained almost unchanged over the years, and the principles of its exposure and development prove the key to an understanding of how all other types of photographic processes work.

LIGHT SENSITIVITY

In their natural state, the silver halide crystals in the emulsion of the film are sensitive only to blue light and ultraviolet radiation. Consequently, films made using these crystals – as the earliest emulsions were – reproduced blue subject areas as white, and other colours in tones much darker than they appeared to the eye. This led to unrealistic pictures –

FILM GRAIN AND EFFECTS

Fine grain – slow speed On 35mm Panatomic X, the image remains crisp even when magnified. The silver halide grains are small and spread thinly.

Medium grain – medium speed The price of more sensitivity to light is noticeable graininess in smooth mid-tones. The film is Kodak Tri-X, now superseded by T-Max 400.

Grainy – high speed Ultra-fast film, such as Kodak recording film 2475, has large, clumped grains that give a noticeably gritty appearance

19TH-CENTURY EMULSIONS *Three of the most significant processes at the beginning of photography were the Daguerrotype, the Calotype and the Wet Collodion plate. The Daguerrotype, of which the portrait (above) dating from 1840 is a fine example, was the first practical process to be used widely. It could not, however, be reproduced, unlike the paper negative printed Calotype such as the group portrait by Henry Fox Talbot in 1848 (below right) and the later Wet Collodion plates like the picture (above right) by Gustave Le Gray (1855).*

particularly in portraiture, where skin-tones would appear too dark and swarthy.

The situation changed with the discovery that, by mixing very small quantities of dye into the emulsion, it was possible to change the film's sensitivity to coloured light. This process was called *dye sensitization*.

Initially, the sensitivity of film was increased from UV (ultraviolet) and blue light to UV, blue and green light; and eventually, to the full spectrum of colours. Modern camera films give almost equal weight to all colours of the spectrum, though blue subjects still appear a little too pale. The light sensitivity of such films is described as *panchromatic* ('pan', all; 'chromatos', colours).

Not all of the black-and-white emulsions in use today are panchromatic. Graphic arts films, for example, which are used for copying from one black-and-white image to another, are *orthochromatic* – insensitive to red light. Black-and-white printing paper is sensitive only to blue light and UV radiation.

FILM SPEED

The sensitivity of film to light is of crucial importance to photographers. This is because to give a good picture, the exposure must be adjusted to precisely match the film's sensitivity and the brightness of the subject. A camera's meter measures the subject brightness, but to convert this light reading into exposure settings effectively, the metering circuits must be programmed with the sensitivity of the film loaded.

Light sensitivity is measured on a standard scale – the ISO scale.

The ISO rating of a film is usually written in the form 'ISO/400/27°'. The higher the number, the faster the film forms an image, so the more sensitive it is to light.

Nowadays, the ISO system is almost universal on new films and equipment, but the older ASA (American Standards Association) and DIN (the German industrial system) ratings are still sometimes found. Indeed, the ISO number of a film is simply a combination of its ASA and DIN numbers; an ISO 400/27° film is rated 400 ASA and 27° DIN. When using ISO numbers, many photographers ignore the DIN component and use the first number (before the oblique line) alone. This makes it much easier to calculate the effect of changes in film speed.

Doubling the speed of a film halves the amount of light that is needed to form a picture. So ISO 100 film needs half as much light to make a satisfactory picture as ISO 50 film and the photographer can set the shutter one speed faster or close the aperture down one stop.

FILM SPEED AND QUALITY

Since faster film gives the photographer a wider choice of apertures and shutter speeds, it is reasonable to conclude that the faster the film, the better. After all, with a faster film, and therefore a faster shutter speed, the camera can be hand-held in dimmer lighting conditions.

However, there are some drawbacks. Fast film makes up the image from larger grains of silver, and clumps of these grains become quite prominent in prints from fast film negatives. Definition is poorer, too. Slow film, on the other hand, produces smooth-toned, sharp images.

DIM AND BRIGHT LIGHT

The ISO system works well in most conditions, but falls down in very bright light and very dim light. In these conditions, film's response to light does not obey the same rules as in normal lighting, and the film loses some of its sensitivity. This loss is called *reciprocity failure*, and photographers must compensate for it by allowing more exposure than a meter indicates.

Compensation is most often needed in very dim light, where the film receives a particularly low-intensity exposure. Nevertheless, reciprocity failure occasionally causes problems in extremely intense light, when exposures are very short. However, since problems start only with exposures of 1/10,000 second or so, difficulties are rare.

BLACK-AND-WHITE FILM

Black-and-white is both the simplest and the subtlest of photographic processes. For the beginner, monochrome offers an economical and easy-to-learn introduction to basic darkroom work. Yet paradoxically, perhaps, black-and-white is such a broad and challenging medium that many enthusiasts find in monochrome a lifetime's challenge.

IMAGE FORMATION

The physical structure of black-and-white film is broadly similar to that of other films. The light-sensitive part of the film is contained in a minutely thin layer of gelatin, which is coated onto a flexible plastic base.

Within the gelatin layer are crystals of silver halides – silver combined with chlorine, bromine and iodine. The gelatin holds each crystal in a fixed position, yet swells when wet, allowing processing chemicals to penetrate the spongy structure and reach each crystal. Together, the gelatin and its burden of crystals are called the 'emulsion' of the film.

ABOVE *Kodak T-Max black-and-white films give very fine grain relative to film speed.*

STILL LIFE *Slow films (ISO 100 and under) are perfectly suited to still life work, where a photograph's ability to show detail is all important.*

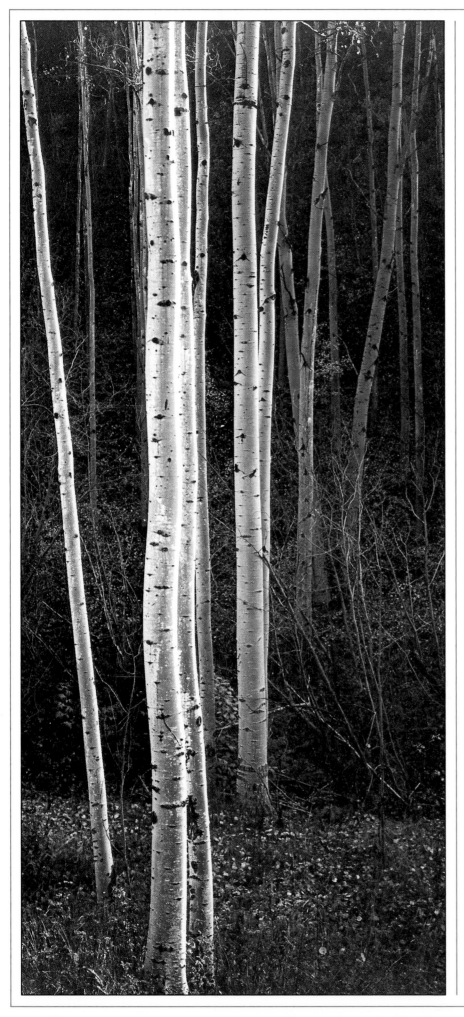

BLACK AND WHITE *This famous photograph by Ansel Adams is a fine example of elemental appeal of black-and-white.*

HOW BLACK-AND-WHITE FILM WORKS

In black-and-white film, the active element is the emulsion – a thin layer of light-sensitive crystals of silver halide suspended in gelatin. This is spread on a tough, flexible but not stretchable base of cellulose-acetate. Protecting the delicate emulsion layer is a scratch-resistant coating, while under the base is another coating to reduce reflection of light back into the emulsion.

1 When black-and-white film is exposed to the light in the camera individual grains that are struck by light react, but invisibly. The mechanism of this reaction is rather more complicated than might at first be imagined, and is triggered by free independent silver ions and small specks of impurities such as silver sulphide. Some of the silver ions collect together at sites that have been exposed to light, forming a latent image. It is called 'latent' because, although real, it still needs the action of a developer to increase it in the order of about ten million times and make it visible.

2 Adding developer solution to the exposed film converts those silver halide crystals that contain silver ion traces into black silver metal. At this stage, which must be performed in darkness, the crystals that did not receive any light are still sensitive.

3 The final stage in the process is the removal of the developer and the addition of fixer, which turns the remaining silver halid crystals into salts that can be washed away. When this is complete, the image is stable and the film can be exposed to light without any further changes taking place.

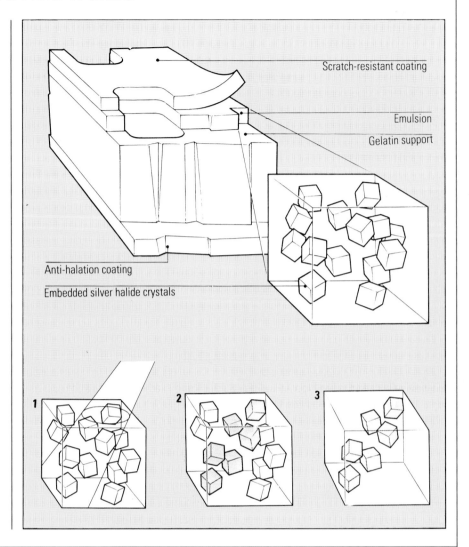

Scratch-resistant coating

Emulsion

Gelatin support

Anti-halation coating

Embedded silver halide crystals

SILVER HALIDE v DYE-IMAGE

Conventional black-and-white film develops to black silver grains (below left). Chromogenic dye-image film, however, is processed in much the same way as colour film, and the silver halide grains are replaced with a dye 'cloud', with less distinct edges (right).

When the lens projects an image on the film, some of the crystals are struck by light – they are exposed. Exposure causes changes in the crystals at an atomic level, changes that turn the silver halides into metallic silver. The amount of silver formed, though, is far too small to be visible; the silver just forms tiny specks at the most light-sensitive points on the crystal.

After exposure, the film is in a state of limbo. There is an image recorded in the emulsion, but as yet the image is invisible. This image – which will become the photographic negative after processing – is called the 'latent image'.

Development is essentially a process known to scientists as reduction. During development, the crystals of silver halide that were struck by light are reduced to metallic silver. The specks of silver formed on each exposed crystal grow and expand until the whole crystal has turned black. Additionally, filaments of metallic silver spread to link crystals of silver together in heavily exposed areas of the film.

Development can therefore be viewed as a multiplication or amplification process. Exposure causes very small amounts of silver to be formed, but development increases the amount of silver at each point on the film a millionfold or more, so that even very short exposures yield a visible image. Without development, film can admittedly still form an image, but it is a feeble one and the exposure required to form it is very long indeed – a matter of hours, rather than milli-seconds.

After development, another process is necessary before the film can be used for printing pictures. Within the gelatin emulsion there still remain residual silver halide crystals; these are present in areas not exposed to light. If these crystals are not removed, the film

BLACK-AND-WHITE FILM

Slow, Fine-Grained	Speed (ISO)	Format
Kodak Technical Pan	25	35mm, sheet
Agfapan 25	25	35mm, 120, sheet
Ilford Pan F	50	35mm, 120
Polaroid Positive/Negative	50 (prints)/ 25 (negatives)	Polaroid cameras, holders to fit 120, sheet
Agfa dia-direct	32	35mm
Orwo NP15	25	35mm
Efke KB14	20	35mm, 120

Medium Speed, Fine Grain		
Kodak T-Max 100	100	35mm, 120

Medium Speed, Medium Grain		
Agfapan 100	100	35mm, 120
Kodak Plus-X	125	35mm, 120, sheet
Kodak Verichrome Pan	125	120
Ilford FP4	125	35mm, 120, sheet
Agfapan 200	125	sheet
Polapan CT	125	35mm
Efke KB21	100	35mm, 120

Fast, Medium Grained		
Ilford XP1	400	35mm, 120
Kodak T-Max 400	400	35mm, 120
Figi Neopan 400	400	35mm

Fast, Grainy		
Kodak Tri-X	400	35mm, 120, 70mm
Kodak Tri-X Professional	320	220, sheet
Ilford HP5	400	35mm, 120, sheet
Agfapan 400	400	35mm, 120, sheet
Kodak Royal Pan 400	400	sheet
Orwo NP27	400	35mm, 120

Ultra Fast, Very Grainy		
Kodak Royal-X Pan	1250 (usable in flat lighting up to ISO 2000)	120, sheet
Kodak Recording Film 2475	4000	35mm
Kodak T-Max 3200	3200	35mm

Special Purpose		
Kodak High-speed Infra-red	80 (no filter)/ 25 (87 filter)	35mm, sheet

will gradually darken when exposed to light. So the film is fixed – soaked in a solution that turns the insoluble silver halides to soluble compounds which can be washed away in running water. This washing, followed by a drying stage, completes the development process.

The developed film is darkest in areas that received the greatest exposure to light. These areas therefore represent the brightest areas of the subject. The shadows cast by the subject create less exposure on the surface of the film, so these areas darken the least, or not at all. The result is an image which represents each tone of the subject as its opposite – dark areas of the subject appear white on film and light areas, black. This reversed image is called a 'negative'.

To get from the negative a picture that represents the tones of the subject naturalistic- ally, the negative must be copied onto photographic paper. This has a structure broadly similar to film and is processed in similar chemicals. Exposure of the printing paper to the projected image of the negative takes place not in a camera, though, but in a darkroom using an enlarger.

DYE-IMAGE FILMS

Chromogenic, or dye-image films, are a relatively recent innovation in black-and-white. They borrow the technology of colour negative films and are processed in the same chemicals. Instead of forming a colour image, though, they form a black-and-white one.

The advantages of this approach are considerable. These films have tremendous expo- sure latitude, and can be exposed at speeds ranging from ISO 100/21° to 1600/33° with no loss of quality. The grain size of the films is very small and can be further reduced by overexposure.

COLOUR NEGATIVE FILM

Of all the photographs taken every year, by far the greatest number are taken on colour negative film, also called colour print film. Like black-and-white film, colour negative film does not produce positive images directly. Instead, there is an intermediate negative stage which reverses not only the tones of the subject but the hues as well.

This film type is so widely used that it probably needs no introduction. The orangey- brown negatives that accompany prints returned from laboratories are familiar to every

FINE DETAIL *Where fine detail is of great importance a slow, fine-grained colour negative film will give excellent, sharp prints. This is Kodak Ektar 25.*

COLOUR NEGATIVE FILM

The basis of the colour process is that of conventional black-and-white film, involving the exposure and development of silver halide emulsions. The major differences are that there are three emulsion layers, each sensitive to a different part of the colour spectrum, and the final image is formed not from silver but from clouds of dye.

1 When the film is exposed, the emulsion mix of silver halides (represented here by cubes) and colour couplers (represented by spheres), does not change visibly – the image, which awaits development, is latent.

2 During the development stages, in the blue sensitive emulsion layer, for example, any of the silver halides struck by blue light develop into black silver. Adjacent colour couplers turn into yellow dye.

3 In the final stage, the black silver and the unchanged colour couplers are bleached away, leaving only the magenta dye in the green-sensitive layer (as this is negative film, magenta is the opposite of green).

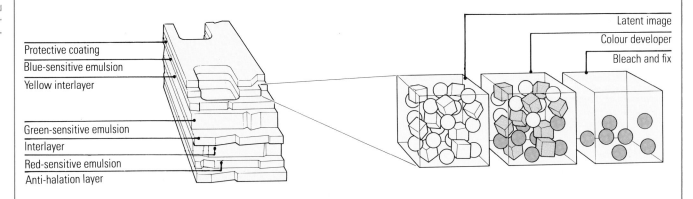

Protective coating
Blue-sensitive emulsion
Yellow interlayer
Green-sensitive emulsion
Interlayer
Red-sensitive emulsion
Anti-halation layer

Latent image
Colour developer
Bleach and fix

COLOUR NEGATIVE FILM

SLOW	Speed (ISO)	Format	Process
Kodak Ektar 25	25	35mm	C-41

DAYLIGHT BALANCED (5500K)			
MEDIUM			
Agfacolor XRS100	100	35mm, 120	AP-70/C-41
Agfacolor XRG100	100	C-41	
Kodacolor VR100	100	35mm	C-41
Kodacolor Gold 100	100	35mm	C-41
Kodak Ektapress Gold 100	100	35mm	C-41
Fujicolor CN100	100	35mm, 120	CN-16/C-14
Ilfocolor 100	100	35mm	C-41
Scotch HR100	100	35mm, 120	CN-4/C-41
Vericolor IIIS	160	35mm, 120, 70mm, sheet	C-41
Konica SR-V100	100	35mm	CNK-4/C-41

FAST			
Kodacolor VR200	200	35mm	C-41
Kodacolor Gold 200	200	35mm	C-41
Kodak Ektapress Gold 200	200	35mm	C-41
Agfacolor XRS200	200	35mm	AP-70/C-41
Konica SR200	200	35mm	CNK-4/C-41
Kodacolor VR400	400	35mm	C-41

Agfacolor XRS400	400	35mm	AP-70/C-41
Fujicolor CA400	400	35mm, 120	CN-16/C-41
Ilfocolor 400	400	35mm	C-41
Scotch HR 400	400	35mm	C-41
Konica SR400	400	35mm, 120	CNK-4/C-41
Kodak Ektrapress Gold 400	400	35mm	C-41
Kodak Vericolor 400	400	35mm, 120	C-41

ULTRA FAST			
Kodacolor VR1000	1000	35mm	C-41
Kodak Ektar 1000	1000	35mm	C-41
Kodak Ektapress Gold 1000	1000	35mm	C-41
Fujicolor HR 1600	1600	35mm	CN-16/C-41
Konica SR 1600	1600	35mm	C-41

TUNGSTEN BALANCED (3200K)			
Agfacolor N80L	80	120, sheet	AP-70/C-41
Vericolor IIL	100	120, sheet	C-41

DAYLIGHT AND TUNGSTEN			
Eastman 5247	100–400	35mm	ECN-2
Eastman 5293	400–1600	35mm	ECN-2

photographer, from the greenest snapshooter upwards. Nevertheless, it is worth looking for a moment at how colour negative film forms images.

COLOUR PICTURES IN THE MAKING

Instead of the single layer of emulsion that is coated onto black-and-white film, colour negative film has several, each one sensitive to a different colour of light. The top layer of the film – the one nearest the camera's lens – is sensitive only to blue light and ultraviolet radiation. Beneath this layer is a second layer, which has sensitizing dyes added so that the emulsion responds additionally to green light. The bottom layer of the film, nearest the base, is manufactured so that it responds to blue light, red light and ultraviolet.

Between the top two layers is a non-light-sensitive yellow filter layer. This layer prevents blue light and ultraviolet radiation from penetrating to the two lower layers. So the

film's three layers each respond to just one third of the spectrum – blue (and UV) for the top layer, green in the middle and red at the bottom.

According to the colour of the light falling on the film, a latent image will be formed in one or more of the three layers. White parts of the subject form a latent image in all three layers. Red parts form images in the bottom layer alone. Blue areas are recorded just in the top layer. In reality, of course, few subjects are pure blue or red. Orange subjects, for example, form images in the two bottom layers, because orange light is made up of a mixture of green and red light.

These latent images have no colour themselves; they are similar to the latent image on black-and-white film. The colour is added during processing.

PROCESSING

Latent images, of course, are of no value to the photographer because they are invisible. Only after processing does a picture appear.

The developer used for colour negative film is rather similar to that used for black-and-white film. The magic ingredient that creates colours is incorporated in the film itself, rather than in the processing solutions.

Incorporated in the three layers of colour negative film are complex organic compounds called couplers. In combination with suitable chemicals, these couplers form brilliantly-coloured dyes. The coupler in the top layer (the blue-sensitive layer) forms yellow dye. The coupler in the middle (green-sensitive, layer) forms magenta dye – a purple colour. In the bottom layer, which is sensitive only to red light, there is cyan coupler. This forms a blue green dye.

The chemical that triggers the release of these dyes is formed when a silver image develops. So coloured dye is formed in each of the three film layers in amounts proportional to the exposure that each layer received. Where blue light struck the film, yellow dye appears; where the film was exposed to green light, magenta dye appears; and in areas that red light reached, a cyan image is formed.

These coloured dye-images are perfect replicas of the silver images that formed them, and after development, the film looks like a muddy, negative picture. The muddiness comes

NIGHT PHOTOGRAPHY *Kodak Ektar 1000 colour negative film is ideal for colourful night photography.*

from the silver images, which are then bleached away – leaving just the dye pictures and the unexposed silver halide crystals. This bleaching stage also removes the yellow colour from the second layer of the film. To end the processing cycle, there is a fixing stage (though this may be combined with bleaching) and a wash and dry. The finished negatives are then ready to print.

Printing reverses the negatives back to positive – just as it did with black-and-white film. And again, the paper and chemicals that carry out the reversal of colours and tones have a lot in common with the film emulsion and the chemicals used to develop the initial negative image.

COLOUR TRANSPARENCY FILM

In applications where picture quality is of paramount importance, photographers usually choose colour transparency film. This film, which is also called colour reversal film or slide film, produces a positive image directly, without the need for an intermediate printing stage. Each time an image passes through a lens, some quality is lost, so a direct-positive system has a lead over a negative-positive system right at the very beginning.

There are other advantages in using transparencies, too. The grains of silver from which the picture is formed are the smallest grains in the emulsion, so the actual image structure

of reversal film is finer than that of a negative film of the same speed. Colours are brighter and cleaner, as well.

Although transparencies are intended mainly for projection, and for reproduction in magazines, they can also be printed by a lab, or in the home darkroom. For the beginner, in fact, it is easier to make prints from transparencies than from negatives, because colour casts are simpler to track down and eliminate.

THE REVERSAL PROCESS

Colour reversal films closely resemble negative films in their composition. The only difference is that the couplers in slide films are colourless, while those in negative films are coloured. At the exposure stage, the two films act in exactly the same way, with each film layer recording one third of the spectrum. Only in processing do the two paths diverge.

The processing of transparency film is more complex than that of negative film, because extra stages are needed to turn the negative back to a positive. The first development stage does not create dyes from the colour couplers. Instead, primary development just forms a negative silver image in the exposed areas of each film layer.

HOLIDAY PHOTOGRAPHY *Medium speed colour film is the choice for holiday photography. Use a tripod, or other camera support in failing light.*

FASHION PHOTOGRAPHY *Most studio fashion photography (left) calls for fine-grained colour transparency film used in medium format cameras.*

The second stage of processing is to chemically fog the whole of the film, forming a positive latent image in each layer of the film. So in the top layer of the film, for example, there will be two images after the second processing step: one of these is a negative silver image of the blue parts of the subject; and the other, a latent image, is the exact opposite of the first – a positive image of the blue parts of the subject.

The step that follows is colour development. At this stage, the developing chemicals act on the newly-formed latent image, producing both a silver image, and an identical dye image. The colours formed are the same as with negative film – yellow, magenta and cyan in the layers of film sensitive to blue, green and red light respectively.

The final stages of the process remove the silver that has been formed over the whole of the film, leaving only dye. Since the dyes were formed from positive images, the dye-images are also positive, as the following example illustrates.

In sections of the film exposed to blue light, a latent image forms only in the film's top layer – and the first stage of development changes this latent image to a silver one. Chemical fogging and colour development then create matching silver and dye-images in the areas that were not exposed to blue light – the bottom two layers – and subsequent bleaching removes the silver. The colour couplers in these two layers form cyan and magenta dyes, and mixed together, these two colours form blue. A corresponding process forms all the other colours of the spectrum.

THE AKHA TRIBE *Transparency film is the tool of the travel photographer whose work (right) will be used in magazines and brochures.*

COLOUR FILM PROCESSING

1 The first step is the exposure to light of the silver halides, in exactly the same manner as the simpler, negative films. Those grains that received the light are minutely altered, and the emulsion now carries a latent, negative image.

2 The first processing stage is development of the exposed silver halides in a black-and-white developer. No colour couplers are activated at this point.

3 The remaining, undeveloped, silver halides are then fogged chemically during the application of the second solution – a colour developer. This converts the halides into black metallic silver and turns adjacent colour couplers into dye.

4 Finally, as with the processing of colour negative film, the metallic silver is bleached and removed in solution, and the image fixed.

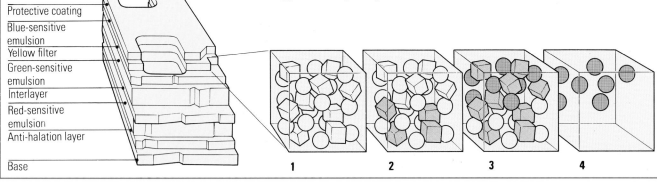

Protective coating
Blue-sensitive emulsion
Yellow filter
Green-sensitive emulsion
Interlayer
Red-sensitive emulsion
Anti-halation layer
Base

1　　2　　3　　4

FILMS

COLOUR TRANSPARENCY FILMS *undergo a continuous process of evolution, often benefiting from the technology developed for colour print films. Ektachrome 100 Plus is the latest version of Ektachrome to emerge from the Kodak stable and offers minor improvements over its predecessors. It pays to keep your eye on the news pages of photographic magazines so that you can take advantage of new and improved films as they become available. Films with the tag 'Professional' are designed for excellent batch consistency and are sold in peak condition for immediate use: colour print films aimed at the amateur market often remain for long periods inside the camera and are designed accordingly.*

An interesting point to note is that it is the grains of silver that were intially *unexposed* which act as templates for the dye-images that makes up the picture. Since the largest grains of silver in an emulsion are the most sensitive to light, and therefore the first to be exposed, it follows that reversal images are made up of the film's finest grains. Negative films, on the other hand, form their images from the grains that were exposed first – the largest grains. So compared to negative film, the grain structure of transparency film is far less apparent.

COLOUR TRANSPARENCY FILM

DAYLIGHT BALANCED (5500K)

MEDIUM	Speed (ISO)	Format	Process
Kodachrome 25	25	35mm	Kodak (+ certain independent labs in US)
Polachrome CS	40	35mm	User (rapid)
Agfachrome 50RS	50	35mm, 120, 70mm, sheet	Agfachrome 41
Fujichrome RD50	50	35mm	F-6
Agfachrome 64	64	35mm	Agfachrome 41
Kodachrome 64	64	35mm, 120	Kodak (+ certain independent labs in US)
Ektachrome 64	64	35mm, 120, 70mm	E-6
Ektachrome 6117	Nominally 64	sheet	E-6
Fujichrome 64	64	35mm, 120, sheet	E-6
Agfachrome 100RS	100	120, sheet	AP-44/E-6
Ektachrome EN100	100	35mm, 120	E-6
Ilfochrome 100	100	35mm	RP-6/E-6
Scotch 100	100	35mm	E-6
Konicachrome 100	100	35mm	E-6
Orwochrome UT21	100	35mm	Orwo

FAST

MEDIUM	Speed (ISO)	Format	Process
Kodachrome 200	200	35mm	Kodak (+ certain independent labs in US)
Agfachrome 200RS	200	35mm	E-6
Agfachrome CT200	200	35mm	E-6
Ektachrome 200		35mm, 120	E-6
Ektachrome 6176	200	sheet	E-6
Ektachrome EL400	400	35mm, 120	E-6
Scotch 400	400	35mm	E-6
Fujichrome 400	400	35mm	E-6

ULTRA FAST

MEDIUM	Speed (ISO)	Format	Process
Scotch 1000	1000	35mm	E-6
Ektachrome P800/1600	400–1600	35mm	E-6
Fujichrome 1600	1600	35mm	E-6
Agfachrome 1000RS	1000	35mm	E-6

TUNGSTEN BALANCED (3200K)

MEDIUM	Speed (ISO)	Format	Process
Kodak Ektachrome 64T	64	sheet	E-6
Kodachrome 40	40	35mm	Kodak (+ certain independent labs in US)
Agfachrome 50L	50	35mm, 120, sheet	Agfachrome 41
Ektachrome 50	50	35mm, 120	E-6
Ektachrome 160	160	35mm, 120	E-6
Scotch 640T	640	35mm	E-6

DAYLIGHT AND TUNGSTEN

MEDIUM	Speed (ISO)	Format	Process
Eastman 5247	100–400	35mm	ECN-2
Eastman 5293	400–1600	35mm	ECN-2

SPECIAL PURPOSE

MEDIUM	Speed (ISO)	Format	Process
Ektachrome Infra-red 2236	100 with Wratten 12	35mm	E-4

56

INSTANT FILM

Photography has been called 'instant art', and it is certainly true that even conventional photographic processes put effortless creativity within the reach of anyone with a camera. Instant films take this process one step further, so that photographers of all abilities can turn ideas into pictures within seconds.

Instant photography is not just an entertaining way to make pretty pictures, though. Instant film has had a profound effect upon the way that photographers now work. A successful lighting and exposure test on instant film is an insurance that there are no serious problems on a shoot, and the photographer can therefore expose conventional film with complete confidence. Clients in the professional's studio can see immediately how their products will look on film, and guide the photographer to an ideal result.

BLACK-AND-WHITE INSTANT FILM

Almost all of the instant film used by professionals is the so-called 'peel-apart' type. After exposure, the photographer pulls a tab at the end of the instant camera or instant-film back, and withdraws two sheets of paper, stuck together with a gooey, alkaline liquid. After a short wait, the two sheets are peeled apart. One sheet – the one on which the image from the camera's lens fell – carries a muddy negative image, and is usually discarded. The other sheet carries the finished picture.

The simplest of the peel-apart films makes a black-and-white picture, and like all instant films, relies on the diffusion of the image from one part of the film to the other. The negative sheet which is exposed to light carries a fairly conventional light-sensitive emulsion. The other sheet, which is not light-sensitive, is a piece of specially coated paper. This receives the image after the two sheets are laminated together by pulling through metal squeegee rollers.

These rollers burst a pod of viscous chemicals, which develop the image on the negative sheet. At the same time, a chemical in the 'goo' dissolves away the unexposed silver halides in the areas which must appear darkest on the print. These silver halides are now mobile, and diffuse across to the image-receiving sheet, leaving behind the silver image in the areas that *were* exposed to light.

The receiving sheet contains chemicals that turn the migrating silver halides to silver – forming a positive image which is visible when the sheets are separated.

Black-and-white instant films are available in a wide variety of speeds and types. Some

POLAROID PEEL-APART FILMS *(below), types 55 and 665, offer a permanent negative as well as a fine-grained black-and-white print, and this is of such high quality that it has certain advantages over conventional negative film (very high resolution, immediate proof of success, and an absence of dust specks and similar blemishes). Before drying, it needs a clearing bath of sodium sulphate – this can be given on location in a special bucket.*

produce line images, but most form conventional continuous-tone pictures. The fastest has a speed of ISO 3000/136°, and of the other types in regular use, one, rated at ISO 75/20°, produces not only a print but a black-and-white negative, too.

INSTANT COLOUR

This works on a similar image diffusion principle, and again, the most popular professional emulsions are of the peel-apart type.

Like conventional films, the negative sheets of these instant films have three layers, sensitive to blue, green and red light. Laminated between three layers, though, are layers of ready-formed dyes in colours complementary to the sensitivity of the three emulsions. So, linked to the blue-sensitive layer is a layer of yellow dye, and the green and red sensitive layers have associated magenta and cyan dyes respectively.

After exposure, the film is pulled through rollers as before, and the layer of processing 'goo' spreads between negative and receiving sheets. In areas of the negative that were exposed to light, the processing chemicals anchor the dye. In other, unexposed areas, the dye diffuses across to the receiving sheet. Taking as an example an area exposed to blue light only, here the developer will anchor the yellow dye in the layer associated with the blue-sensitive part of the film. Cyan and magenta dyes, though, are not anchored, so they diffuse across, where they combine to form blue.

This peel-apart colour film is widely used for exposure testing, and is rated at ISO 80/20° – conveniently within a third of a stop of the speed of the most popular professional colour films.

SINGLE-SHEET FILMS

The more modern types of instant film do away with the messy alkaline goo and the discarded negative sheets that are characteristics of the peel-apart process. These single-sheet films are the type most often used in amateur cameras.

The principles of their operation are broadly similar to those of peel-apart colour films – non-achored colour dyes migrate during processing from an image-forming layer to a receiving layer. In these films, though, the two layers are integrated inside a plastic envelope, so the processing reagent can never escape.

Extra layers and chemicals are required in these more complex films. For example, in Polaroid instant film there is an opaque black chemical which keeps light out during development. As the process continues, the goo inside the print becomes less alkaline, and in the more neutral environment, the black light-protective chemical becomes transparent, so the image is visible.

Polaroid single-sheet films are viewed from the side that faced the film during exposure.

INSTANT TRANSPARENCIES

The 35mm instant transparency film introduced by Polaroid has, paradoxically, most in common with the black-and-white peel-apart film. In fact, the image-forming emulsion on the film is of the same type, and the principle of exposure and processing broadly the same. What makes this film different, though, is that it is overlaid with a regular pattern of red, green and blue filter bands. Each of these narrow bands filters the incoming light from the camera's lens, and the light-sensitive emulsion beneath the stripe forms an image only of light the same colour as the band above it. When viewers examine the film's black-and-white picture, they look through the coloured stripes, and these put the natural hues back into the picture.

Development takes place in a special processor. Within this, the film is wound into contact with a stripping ribbon, and covered with viscous chemicals. After the correct time has elapsed, film and stripping ribbon are pulled apart – and with the ribbon goes the unwanted negative silver image.

This method of forming colour pictures – known as the 'additive' principle – sounds fine, but in practice it produces extremely dark transparencies which cannot be projected alongside conventional materials. Big enlargements are possible, because the pattern of lines show up on the print. Nevertheless, the film can be used in an ordinary 35mm camera, and is therefore a useful method of making instant proof pictures.

POPULAR POLAROID *Polaroid single sheet film cameras are popular with party-goers, and cameras have built-in flash which balances automatically with daylight. Image quality and colour balance do not match up to the standard of conventional 35mm photography.*

FILTERS

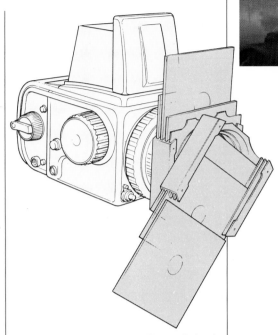

The action of the human eye and the action of the camera are often compared and it is certainly true that the two have a lot of features in common. Each has an adjustable lens; each forms an inverted image; each houses a light-sensitive medium at the rear of a darkened chamber. Unfortunately, the comparison breaks down when the process of human vision is compared with the process of photography.

These two ways of seeing – with the eye and the camera – have separate and quite distinct characteristics, as anyone who has tried taking pictures by the light of a table lamp knows. Photographs often bear only slight resemblance to the scene we pointed the camera at. In the table lamp example, we remember seeing our friends' faces in their normal hues; but on the photographs, the portraits come out as sickly orange/yellow masks.

Fortunately, filters can help to correct the distortions that the camera introduces and bring photography more into line with vision. They can do other things, too, helping the photographer to introduce deliberate distortions, or to enhance reality – perhaps to show portrait sitters as they would like to be seen, rather than as they are. Of all the filters used in photography, though, the most valuable are those that match the colour of the light source in use to the spectral sensitivity of the film. One of these filters would restore the true colours to our portrait taken indoors by the light of a table lamp.

SPECIALITY FILTER SYSTEMS *The popularity of effects filters – such as graduated and soft-focus filters – has encouraged some comprehensive and sophisticated filter systems.*

COLOUR BALANCE

Unlike the eye, which can adapt to light of all colours, photographic film only works perfectly in light of just one colour. Most films are formulated to give correct colour rendering at noon on a sunny summer's day; a few films, though, are balanced to give ideal results in tungsten light. Using films in lighting conditions other than those for which they are manufactured will create colour casts – the pictures will seem washed over with a single hue. *Light-balancing* filters eliminate these colour casts.

There are numerous light-balancing filters and it is not always easy to decide which one to use. To simplify things, the colour of each different light source can be measured and a filter picked to match the light source to the film. Photographers specify the colour of each light source using a scale called *colour temperature*. There are two different measurements of colour temperature.

VAPOUR LIGHTS

Not all light sources fall on the colour temperature scale. Some – such as fluorescent light – have an admixture of green or magenta light, which necessitates the use of two sets of filters: one yellow-blue set for light balancing; and a second magenta-green set for colour correction. Many of these light sources have what is called a 'discontinuous' spectrum. Although the light looks white to the eye, it actually lacks certain colours of the spectrum. Since filters can only remove colours, not put them back, no amount of filtration will produce perfect colour with these light sources. At best, filtration provides a close approximation.

Certain light sources are virtually monochromatic, and no filter will provide even a remotely correct colour picture. Some sodium vapour lamps, for example, produce a brilliant yellow beam that contains no other colours of the spectrum. The only way to get life-like colours is to supply supplementary illumination for foreground subjects.

COLOUR TEMPERATURE METERS

For absolutely accurate colour correction, a colour temperature meter is essential. There are two types of meters – those that measure just red and blue light; and three-cell meters that measure red, green and blue. The latter type are of far more practical value, as they can indicate the correction necessary for the vapour lights which are otherwise difficult to cope with.

FILTERING COLOURS INTO TONES

Each of the four distinct colours in this still-life are susceptible to alteration by filters. With no filter used, the over-sensitivity of normal black-and-white film to blue and its under-sensitivity to red give pale tones to the cigarette packet and a too-dark version of the red Dutch cheese on the left of the picture. A yellow filter lightens the yellow cheese and darkens the blue design on the cigarette packet. An orange filter performs a similar function to the yellow, but more strongly. A red filter dramatically lightens the red cheese and darkens the blue packet. A blue filter turns the yellow cheese almost black. A green filter lightens the tone of the apple, but makes the red cheese appear black.

No filter

Wratten 8 Yellow

Wratten 16 Orange

Wratten 25 Red

Wratten 47 Blue

Wratten 58 Green

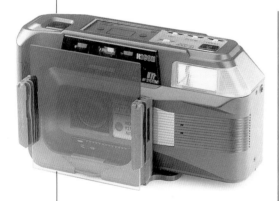

FILTER KITS *Cokin market an interchangeable filter kit for compact cameras. The filter holder attaches to the base of the camera, either by means of the tripod bush or with a velcro pad.*

The commoner of the two scales is called the Kelvin scale. On this scale, light sources are assigned a Kelvin value, which runs from about 2,000 Kelvin for deep reddish-coloured light sources such as candles, up to 20,000 Kelvin for the light from a clear blue sky. Summer sunlight has a value of 5,500 on the Kelvin scale and requires no filtration with normal film. Other light sources with higher or lower colour temperatures need filtration if they are to give accurate colours on film. This filtration can go either on the camera lens, or between the subject and the light source.

The filters most widely used to balance the colours of light sources to the sensitivity of films are the Kodak Wratten series. These filters – about 20 in number – range from deep blue through to deep yellow. The yellow filters, which are designated series 81 and 85, are used when the colour temperature is too high. For example, if the subject is sitting in summer shade, lit only by blue sky, a Wratten 85 filter fitted over the camera lens would give correct colour rendition. Without this filter, pictures taken on transparency film will come out tinged with blue. (With negative film, this and other colour casts can be at least partly corrected during printing.)

Blue filters – series 82 and 80 – are used when the colour temperature is too low, as it is when tungsten light illuminates the subject. Photographic floodlights, for example, will give correct colour rendering with daylight-balanced film only if a Wratten 80A filter covers the camera lens or studio lights.

In the same light, tungsten-balanced film requires no filtration, but when this film is used in daylight, an orange 85B filter must be used.

FILTERS FOR BLACK-AND-WHITE FILM

Although today's panchromatic black-and-white films produce a strictly lifelike interpretation of the scene in front of the camera, this is not always what the photographer is seeking. For example, the flowers of many types of plant are more or less the same tones as the leaves of the same plant. To the viewer looking directly at the plant, there is no problem in distinguishing bloom from foliage, because they are different colours. But to panchromatic film, colour is irrelevant, and so the camera records all parts of the plant in the same shade of grey.

Such an even-handed response to colour therefore causes problems for the photographer who is seeking to make the blooms of the plant appear distinct from the leaves. Fortunately, though, the problem can be solved using filters.

A filter absorbs coloured light from part of the spectrum. A red filter, for example, absorbs green and blue light. By fitting a red filter over the camera lens, a photographer can increase the film's sensitivity to red light, and decrease sensitivity to other colours. This means that red parts of the subject will appear lighter on the print and other colours, darker.

Returning once more to the garden, it is clear that filtration can aid the photographer of flowers. When photographing red roses, a red filter will darken the leaves and lighten the petals, thereby separating the two parts of the plant. A green filter would have the opposite effect, making leaves lighter and bloom darker.

Other colours of filter affect the tones of black-and-white film in different, but equally valuable ways. The most useful ones are orange and yellow. Yellow filters reduce the film's slight over-sensitivity to blue light, so that the film renders tones closer to how the eye sees them. Orange filters have a more pronounced effect and are particularly useful for darkening blue skies, so that clouds stand out more clearly. Used for such pictures, red filters turn blue sky almost black, creating dramatic, if tonally distorted pictures. All three filters increase contrast in sunlit scenes.

For portraiture, orange and yellow filters will hide blemishes on faces, and the cooler colours – green and blue – make complexions more swarthy.

All of the filters used for black-and-white films are very much brighter in colour than the light-balancing and colour correction filters used with colour films and the two types are more or less incompatible. However, the bright colours of monochrome filters can occasionally be used to produce extreme colour distortions with transparency or colour-print films.

FILTERS FOR PRINTING *Colour printers can add special effects in the darkroom by using filters under the enlarger lens. Cromatek market a darkroom filter system.*

SCREW-IN FILTERS *Many camera manufacturers produce their own system of screw-in filters. These are usually for tone or colour correction, but may include special effect filters such as soft focus.*

FILTER MATERIALS

Filters are made from many different types of material, but not all of these are suitable for use over the camera lens. The most common optical-quality filters are made of glass, gelatin or resin.

Glass filters are the most resistant to scratches and marks, but are also quite expensive. They are round and mounted in threaded brass rings. These filters screw into the front of the lens so a different size of filter is needed for each different lens size. Fortunately, though, lenses from each manufacture now have standard-sized filter threads, so photographers using, say, Nikon lenses with focal lengths between 20 and 200mm need buy only 52mm filters.

Resin filters are unmounted rectangles of plastic. They slide into plastic filter holders, which can be fitted with several different adapter rings; so one holder fits several different lenses. Resin filters are of poorer quality than glass or gelatin and though many special effects filters are available, there are few light-balancing filters in the manufacturers lists and the colours of those that are available are not accurately controlled.

Gelatin filters are optically the best of all, because they are thinner than glass or resin and therefore introduce less distortion to the photographic image. However, they are quite expensive, easily damaged and virtually impossible to clean. They must either be taped over the lens, or mounted in a special holder.

A few filters are not intended for use over the camera lens. Dichroic filters are made from heat-resistant glass, tinted blue with a thin film of evaporated metal. Used over tungsten lights, these filters convert the beam to daylight-colour.

Colour acetates and gells are designed for the same purpose. These filters, though, are not as heat resistant as glass, though most are now non-flammable.

ACCESSORIES

AN IMPRESSIVE and growing array of ancillary equipment is available from photographic dealers. Photography is markedly gadget-prone, and choosing which accessories are essential is often difficulty. As a general rule, buy the highest quality basic equipment to start with rather than try to improve mediocre cameras and lenses with an extensive collection of accessories.

CAMERA SUPPORTS

At slow speeds, particularly with long-focus lenses, some kind of camera support is necessary. It is possible to improve your ability to hand-hold the camera without shaking, but after a certain point, a tripod or other means of rigid support must be used. When precise composition is important, as it often is in the studio, it is an advantage to control the camera position exactly.

TRIPODS

A tripod is the standard means of camera support. Ideally it should be solid enough to hold the camera and lens rigid under the prevailing conditions, but light enough to be portable. In the studio, portability is not particularly important, so that heavy tripods and camera stands are usual. On location, the tripod you choose will inevitably be a compromise between weight and rigidity. Even though the heaviest tripods are normally the firmest, this is not necessarily so, and different brands vary. When buying a tripod, test not only its ability to hold a steady weight, but also its resistance to torque (try to twist the head; if it moves significantly, the design is poor). The acid test is to mount a camera and reasonably long lens on the tripod and tap the end of the lens; use this method to compare tripods. With a heavy extreme long-focus lens, such as 1000mm, not only will a heavy duty tripod be necessary, but also perhaps a second smaller tripod to support the front of the lens.

Most tripods have telescopic sectioned legs; if you are using the tripod less than fully extended, make sure that the narrowest sections are retracted. A useful design is one that enables the legs to be spread to a wider angle for a lower camera position; an alternative is to reverse the centre column so that the camera hangs from the tripod. Some centre columns have a ratcheted column with crank handle for raising and lowering, but on cheap tripods this device can simply make them less steady.

Although tripod heads are a separate piece of equipment, they become, for the purpose of rigidity, a part of the tripod. Ball-and-socket heads come in all sizes and are very rapid to alter in position.

TRIPOD HEADS

Tripod heads should offer the greatest freedom of movement. The basic choice is between the highly flexible ball-and-socket head, and those with separately controlled movements.

Monoball This Arca-Swiss head (above) is the most secure ball-and-socket design available, capable of holding the heaviest 35mm configuration in any position.

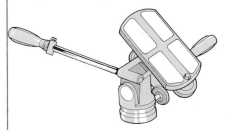

Pan-and-tilt-head Separate movements on this Gitzo Rationelle head (above) allow individual adjustments with greater accuracy.

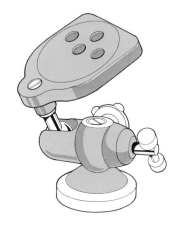

Ball-and-socket-head Lighter and more common than the Monoball, this head (above) is secure enough for most combinations of camera and lens.

Professional sports photographers (left) use either a tripod or monopod to support the camera and telephoto lens. Finding elbow room and height are an added problem. You can stand on a block or aluminium camera case to gain height.

TRIPODS

Basic tripod This French Gitzo (right) is sturdy yet relatively light. The telescopic sectioned legs lock with friction collars, as does the adjustable centre column, which permits camera elevation without disturbing the whole tripod. Some models allow the legs to be spread to a wider angle (below right) for a low camera position and greater rigidity.

Miniature tripods Provided a solid and fairly flat surface is available at the right height, these pocket-sized supports (above and below) can function almost as well as a regular tripod, and are less troublesome to carry.

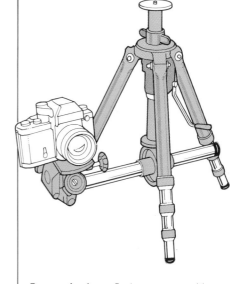

Reversed column For low camera positions, some centre columns can be reversed (above). For ease of access to the camera controls, this can be combined with a horizontal arm fitting.

Monopod Highly portable, this one-legged support (below) steadies hand-held shooting.

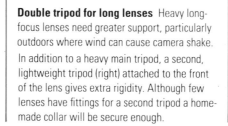

Horizontal arm A separate horizontal section (left) attached to the centre column is useful when pointing the camera vertically downwards, as in copying. With the camera supported out to one side, the tripod legs do not appear in the shot, a frequent problem when the camera is used from a basic tripod.

Double tripod for long lenses Heavy long-focus lenses need greater support, particularly outdoors where wind can cause camera shake.

In addition to a heavy main tripod, a second, lightweight tripod (right) attached to the front of the lens gives extra rigidity. Although few lenses have fittings for a second tripod a home-made collar will be secure enough.

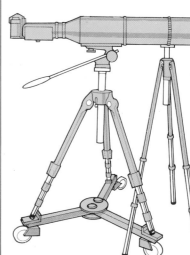

63

THE GYRO STABILIZER

Photographs taken from a moving vehicle inevitably lack sharpness due to the vibration of the vehicle. A gyro stabilizer, like this Kenyon model, attaches to the camera base and can compensate for most vibrations. Weighing just over two pounds, this unit contains two small gyroscopes. When set in motion they start to spin, reaching a top speed of 20,000 rpm. At this point the vibration is overcome and the camera is steadied.

Some tripods have the facility of fitting a lateral arm – useful for vertical copy shots – while pan-and-tilt heads allow more controlled movements. To reduce further the risk of camera shake, use a cable release or the camera's own self-timer; locking up the mirror of a single lens reflex also reduces vibration.

OTHER CAMERA SUPPORTS

In the absence of a tripod, any support is useful. A G-clamp specially adapted with a ball-and-socket head is one alternative; a monopod, while hardly rigid, adds some steadiness. Even a pistol grip can help, while rifle stocks are available for hand-held shooting with long-focus lenses. At worst, either wrap the camera strap tightly around your wrist, or rest the camera on something soft, like a folded jacket.

USEFUL ACCESSORIES

There is a wide, seemingly endless, choice of accessories available to supplement the basic 35mm camera system. Some are essential, others are gimmicks of limited practical value, and yet others have highly specialized applications.

LENS SHADES

Flare degrades the image, even with the latest multi-coated lenses, and a lens shade that cuts off extraneous light from outside the picture frame will improve image quality. Some

ACCESSORIES

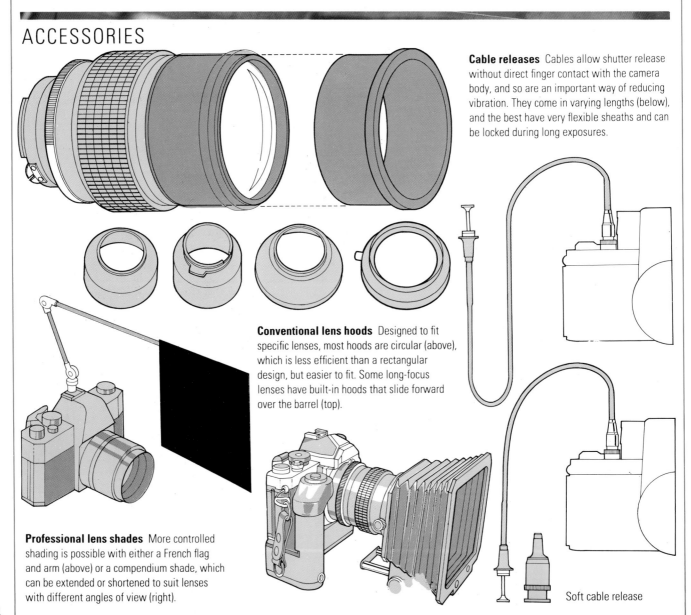

Cable releases Cables allow shutter release without direct finger contact with the camera body, and so are an important way of reducing vibration. They come in varying lengths (below), and the best have very flexible sheaths and can be locked during long exposures.

Conventional lens hoods Designed to fit specific lenses, most hoods are circular (above), which is less efficient than a rectangular design, but easier to fit. Some long-focus lenses have built-in hoods that slide forward over the barrel (top).

Professional lens shades More controlled shading is possible with either a French flag and arm (above) or a compendium shade, which can be extended or shortened to suit lenses with different angles of view (right).

Soft cable release

lenses have built-in lens hoods that retract when not needed; most take separate hoods that screw or clip onto the lens front. A lens shade also has a second use in protecting the front of the lens from scratches or abrasions. The most efficient lens shade is an adjustable bellows that can be altered to suit a variety of lenses. Alternatively, a piece of black card held close to the lens will shield it from a single light source, such as the sun.

MOTOR DRIVES AND WINDERS

The value of a motor drive is not simply that it permits fast action shooting. By substituting an electric motor to trigger the shutter and wind on the film, the camera becomes a more flexible instrument and two mechanical operations are made less distracting – a valuable asset in situations where you need all your concentration for the subject. The firing rate is usually adjustable, normally up to five frames per second on most models, and the unit can also be set to fire single frames. Power is normally from a battery pack which can be separate or integral. Automatic winders are basically simplified motor drives without the capacity for continuous firing.

FILTER HOLDERS

When using gelatin filters, which are less expensive but more fragile than screw-on glass filters, a filter holder reduces wear and tear.

MANUAL SHUTTER RELEASES

Cable releases are flexible sheathed cables that screw into or around the shutter release button. The longer and more flexible the cable, the less the risk of vibration. Most cable releases have a locking device to keep the button depressed for time exposures. Where the camera body and lens are mechanically separated, as with some bellows, a double cable release is necessary.

MOTOR DRIVES

Professional system cameras are designed so that motor-drive operation can be added. A true motor drive as opposed to an automatic winder not only drives the film transport and re-tensions the shutter, but allows continuous firing (between four and six frames per second is typical). Motor drive accessories, shown below, include a bulk film back (about 250 exposures) and an intervalometer for automatic operation.

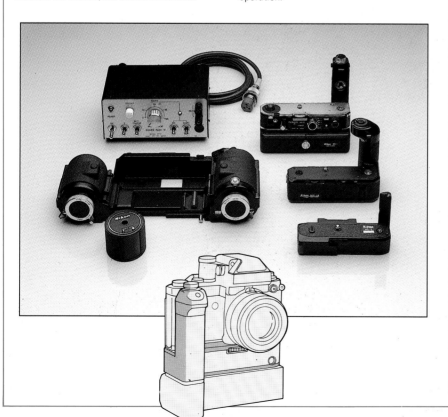

PISTOL GRIPS

Pistol grips (below) and rifle stocks are both aids to hand-held shooting, useful mainly with long lenses.

VIEWING SCREENS

(a) Matte/Fresnel with split-image rangefinder (general purpose). (b) Matte/Fresnel with ground glass centre (combines clear image and fine centre focusing). (c) Plain matte (gives unobstructed view, good for long-focus lenses). (d) Matte/Fresnel with grid (architecture and copy work). (e) Matte/Fresnel with microprism (easier focusing for slow lenses). (f) Fresnel with millimeter-scaled reticle (close-up work).

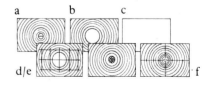

ACCESSORIES

Equipment cases The main function of a camera case is to provide maximum protection. Moulded aluminium cases such as this American Haliburton (below), or the West German Rox, are the most secure, and are gasket-sealed against grit and water.

Camera cases These can be rigid and an exact fit for the camera (top) or made of soft leather (above) which will fit several models.

Lens and body caps Caps for the front and rear of lenses (below), and for the camera body, are a necessary protection against dust particles.

Shoulder bag (below) Many styles are available. Separate pockets help prevent equipment scraping together. Some models have rigid compartments.

Tripod case An alternative to carrying the tripod attached to a shoulder bag is a separate case (above), like a miniature golf club bag.

Camera straps For safety, a strap (below) should always be fitted, except when the camera is being used on a tripod.

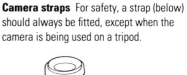

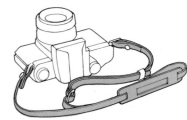

Lens cases Cases for individual lenses are available in hard leather, soft padded leather (above), or clear plastic with a screw base (right).

Allen keys

File

Standard pliers

Pencil claw

Tweezers

Set of jeweller's screwdrivers

Sharp-nosed pliers

Repair equipment Simple-on-the-spot repairs are usually possible with a few basic tools such as these.

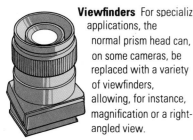

Viewfinders For specialized applications, the normal prism head can, on some cameras, be replaced with a variety of viewfinders, allowing, for instance, magnification or a right-angled view.

Changing bag The best are of heavy black cloth with a double flap for access (below). With a new bag, check that the inside is free from fluff particles.

X-ray proof bags These are available in different sizes (above, left), and as wrapping sheets.

Cleaning equipment Cans of compressed air or an inert gas (above) are useful for removing dust from inaccessible corners.

Blower brush

Toothbrush

Cotton swabs

Lens-cleaning tissue

VIEWFINDERS

Many single lens reflex cameras have interchangeable viewing heads. A magnifying pentaprism head allows rapid viewing of an enlarged screen without having to press the eye up close to the camera. A waist-level finder is essentially a hood that shades the light from the ground glass screen and is used for low-level viewing or when a two-dimensional view is desirable. A high-magnification focusing viewer also facilitates a right-angle view of the image, but is particularly useful for close-up or copy work.

CLEANING EQUIPMENT

Constant use, particularly outdoors and in wet or dusty conditions, causes eventual wear and tear on all parts of the camera system. Lens surfaces and the camera's moving parts are particularly vulnerable. Always keep a small brush (preferably a blower brush), lens cloth or cleaning tissue, a toothbrush and small cotton swabs with your equipment. A small bottle of de-natured alcohol and a can of compressed air or an inert gas are also useful for cleaning lens surfaces and removing dust and grit.

MAINTENANCE AND REPAIR EQUIPMENT

Advanced camera repair is a specialized skill, demanding great precision, but there are often occasions when you have no alternative but to try it yourself.

CHANGING BAG

A changing bag is a light-tight black cloth bag with an inner liner, double zips and two sleeves. It is used as a portable darkroom that can be used if the film jams in the camera, or if you have to load a very sensitive emulsion like infra-red.

X-RAY PROOF BAGS

Lead-lined bags in various sizes are one way of ensuring that airport X-ray machines do not fog your films (despite inevitable assurances, some do). If you have to mail unprocessed film, they also provide an extra measure of safety.

CASES

Cases prolong the life of equipment. Ever-ready cases for cameras and invidual lenses provide excellent protection, but if you have a lot of equipment, it may be more convenient to pack everything into one compartmentalized case. The cases that provide the best protection are aluminium, and gasket-sealed against grit and water. Some have adjustable compartments, others have foam blocks which can be cut to take your own choice of equipment. They should have either a reflective metallic finish or be painted white, to reflect as much heat as possible.

REMOTE CONTROL

Pressing the shutter-release button of a motor-driven camera closes an electrical switch. This in turn opens the shutter. It is therefore quite simple to place the switch somewhere outside the camera body, perhaps at the end of a 9m (50ft) cable.

CLIPS, CLAMPS AND TAPE

An assortment of devices for holding things together is always useful. Use G-clamps, spring clamps, alligator grips from electrical stores, and the ubiquitous Gaffer tape, capable of supporting more than you imagine.

Alligator grip

Joint sleeve

Gaffer tape

Sellotape
Masking tape
Double-sided tape

INSTANT DUST-PROOFING

A simple answer to conditions in which dust, sand *or* water are flying about is to wrap the camera in a transparent plastic bag.

Use a tight rubber band to seal the bag's opening around the lens, trimming the surround with scissors.

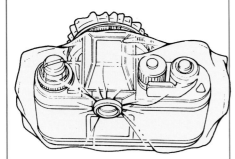

This, then, is the simplest of remote control mechanisms, and enables the photographer to take pictures while actually some distance from the camera. Remote control is often the only way to get a picture of dangerous subjects such as lions and other big cats; in hostile environments – nuclear reactors, for example; and with timid subjects like birds.

The disadvantage of an ordinary electric cable is that there must be a physical link between camera and photographer. Other remote-control devices do not require such a link. *Infra-red releases* operate the shutter by means of a pulse of infra-red radiation. The photographer holds a small handset – essentially a sophisticated flashgun with the reflector covered by a filter that is visually opaque, but transparent in the infra-red part of the spectrum. Pressing a button on the handset sends a pulse of infra-red to a receiver attached to the camera. This device closes the contacts to operate the shutter.

Infra-red releases are limited to quite short distances – usually less than 100m (330ft) – and to line-of-sight operation. In other words, to operate the shutter, you must be able to see the camera. An additional drawback is that other photographers using similar handsets may inadvertently operate your camera – a major problem at news events heavily covered by the press.

Radio-releases do not suffer from any of these drawbacks. They can be operated on a narrow frequency band chosen by the photographer, and the camera can be a considerable distance away – even out of sight. However, radio releases are illegal in some countries, and in urban areas radio-frequency interference can trigger the camera at the wrong moment.

AUTOMATIC TRIGGERS

All the systems described above rely on the photographer observing the subject, and operating the shutter at the appropriate moment. However, in certain applications, it is more convenient if the subject itself triggers the camera. A typical example is in wildlife photography at night: catching an image of a flying owl is near-impossible in the usual way – how can you tell when the bird is in focus? With an automatic trigger, it is possible to prefocus the camera during the day, and then rely on a sensing device to detect when the bird is flying through the point of sharpest focus. At this instant, the shutter opens, and an electronic flash lights the scene.

The method of sensing is limited only by the photographer's imagination, ingenuity and budget. A few 'off the peg' devices are available, but more often, remote triggers are custom-built for specific applications. Here is a rundown of the principal detection methods:

Simple switches can be operated by pressure pads or trip wires to catch images of, say, medium-sized and large creatures.

Passive infra-red systems detect body heat, and trigger the camera when a living creature approaches. In much the same way, visible light – say from a rocket exhaust – can be made to operate the camera.

Active infra-red systems trigger the shutter when the subject breaks one or more beams of infrared – some systems use visible light.

Sound triggers take pictures when activated by noise – perhaps to catch an explosion.

INTERCHANGEABLE BACKS

The standard back of a 35mm system camera generally carries nothing more complex than a pressure plate on the inside, and a film memo-holder on the outside. On most medium-format system cameras, though, the camera back is a modular film holder that can be removed and exchanged.

This means that the photographer is free to change from one film type to another in mid-roll. The basic back contains a load of 120 roll-film, but this may be replaced with a different back carrying long lengths of sprocketed 70mm film; instant film for test exposures; double-length 220 roll-film (for twice as many frames as 120 film); and in some instances, 35mm film, taking either regular 24mm × 36mm images, or perhaps panoramic pictures. Even for 120 film, there may be options of different formats – 6 × 4.5cm, 6 × 6cm or 6 × 7cm.

CAMERA MAINTENANCE

General cleaning procedure Cleaning saves repair. Dirt can clog mechanisms, scratch film and glass and even wear down and loosen some moving parts, such as the lens focusing ring. Apart from full-scale cleaning after a trip, when the camera is obviously dirty, also clean regularly and as often as possible.

Never begin by using a cloth on delicate surfaces or you may simply wipe particles into the glass or plastic. Blow away loose particles with compressed air or your breath, then to brush away the remainder. Finally wipe with a clean cloth.

Use these cleaning diagrams (below) to avoid missing essential parts. Always work on a clean surface.

Compressed air

Typewriter cleaning brush

Toothbrush

Lint-free cloth

Cotton bud

Blower brush

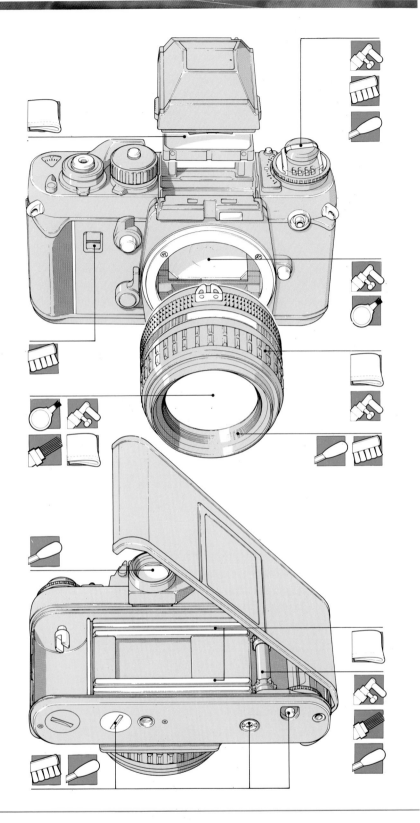

The design of almost all 35mm SLRs precludes the use of such a wide range of interchangeable film magazines. However, a few manufacturers now produce an instant-film back that can be adapted to fit most 35mm cameras. These backs produce pictures only the size of a contact print, but are often adequate for lighting and exposure tests.

Data backs can be fitted to many 35mm system cameras. They imprint alphanumeric characters on the film, usually by means of tiny LEDs mounted on the camera's pressure plate. Most data backs will imprint the time or date, or number each frame sequentially. More sophisticated models double as intervalometers, or imprint whole sentences on the frame-edge.

LIGHTING

WHAT IS LOOSELY TERMED 'artificial lighting' covers a surprising range of forms, some for photographic use and so suited to conventional films, others that are out of the photographer's control but often interesting in their effects. There are three principal sources of man-made light: incandescent, created by the slow burning of a filament such as tungsten; electronic flash, which is almost exclusively used for still photography; and vapour discharge, which includes fluorescent strip lighting, mercury and sodium lamps. Although the lighting quality, emission spectra and colour temperature of all these sources differ widely, all can, with some precautions and adjustments, be used for photography, in black-and-white and in colour.

After dark in houses, offices, streets and public buildings, there are several types of artificial lighting used – all tend to be difficult to take photographs by. These artificial lights are not only relatively weak and often given uneven illumination (a mixture of deep shadows and pools of light is typical); they also bathe subjects in light of a different colour. While the human eye adapts to these variations so quickly that they are barely noticed, film does not adapt so readily.

The chief restriction on photography by available artificial light is often the shutter speed. The light level in a typical modern office or department store is more than 100 times less than outdoors in ordinary sunlight – a difference of, say, seven stops. And, as a filter may be needed to balance the colour cast from some lamps, notably fluorescent ones, even less light will reach the film. Film makers provide charts giving typical shutter speeds and apertures for various available-light settings. They show that for useful shutter speeds – those that permit hand-held shots of people moving – a high-speed film and a fast lens help enormously.

TUNGSTEN LIGHTING

Domestic tungsten lamps are little different in type from the photographic tungsten variety, but the filament does not burn so hotly. As a result, they give a more reddish light; the colour temperature varies from about 2500K–2900K, and to balance this a bluish filter such as 82C should be used with Type B colour film (itself balanced for 3200K). Accurate colour balance is more important for slide film than for colour negative emulsions, as the latter can be filtered during enlargements afterwards. Some high-speed films, such as Ektachrome 400, give less red results than others. An alternative is to replace existing bulbs with photographic ones (rated at 3200K).

VAPOUR LIGHTING

While fluorescent lamps have a coating of fluorescent materials to help give a visual white, sodium and mercury vapour lamps do not. As a result, sodium vapour lighting looks and photographs yellowish, mercury vapour lighting looks and photographs bluish. Each emits light in just a narrow part of the spectrum, and while mercury vapour lighting is often close to 'normal', sodium vapour is distinctly coloured and cannot be filtered – using a blue filter to reduce the yellow simply reduces the light, as there is only yellow present. The only practical alternatives are to live with the colour cast, or to use flash. For mercury vapour, a CC30 Red filter may help.

FLASH

Electronic flash has become the most common form of artificial lighting for photography. Indeed, it is a light source that is uniquely photographic: too brief to be of any use to the eye unaided by the camera.

At the heart of all flash units is a toughened glass tube. This is filled with a rare gas called Xenon that is normally an electrical insulator, like most gases. However, when atoms of Xenon are charged with electricity, the gas becomes a conductor, and a spark jumps between charged electrodes fused into each end of the flash tube. This spark creates a flash of light similar in colour to daylight, and ideally suited to photography.

CANDLE-LIGHT *One of the weakest and reddest sources of available light is a small naked flame. The colour temperature is below 2000K and variable. Full correction to a visual white would require filtration in the order of three 82C gels used with Type B tungsten-balanced film, but as candle-light is expected to have a reddish glow, it is usually acceptable to shoot with no filters at all.*

SODIUM VAPOUR *Lamps like those used (above) in the floodlighting of a cathedral, have a 'discontinuous spectrum' that gives a yellow-green cast on colour film. This cannot be corrected by filtration.*

FLUORESCENT AND DAYLIGHT MIXED

When two different light sources are mixed, it is impossible to filter for both. Here, diffused daylight from the windows combines with overhead strip-lighting that appears distinctly green by comparison.

Fluorescent lighting Fluorescent strip lamps are the most common kind of artificial lighting, and often give the most even illumination. However, though white to the eye, the light they throw appears green on colour film. Different coatings on the glass envelopes of these lamps give a variety of greenish casts, and it is difficult to predict the exact appearance on film. For most, a CC 30 Magenta filter, or any of the proprietary fluorescent correction filters, will give a reasonably neutral result on daylight-balanced film. For absolute accuracy, it is necessary to expose a test roll of film through different strengths of magenta filter and develop that before returning for a full photographic session. Alternatively, existing fluorescent lamps can be replaced with types made specially for photography, or can be covered with magenta stage-lighting gels.

With colour negative film, the colour can be balanced during printing, but slide film must be filtered at the time of shooting. Polachrome slide film uses an additive colour process and usually gives accurate results *without* filters.

MIXED TUNGSTEN AND DAYLIGHT *The orangeness of tungsten lights on daylight-balanced film is usually acceptable when mixed with daylight, as in this interior shot (right).*

HAMMERHEAD FLASH

Massive portable flashguns for hand-holding or attaching to a camera bracket may be considerably less manageable than the light flashgun that fits into the hot shoe, but the kind of power this kind of gun can give is needed to exploit the full range of flash techniques to the full. The smaller guns are, in particular, all but useless for bounced flash and may even be of limited value for fill-in flash. But powering large guns calls for considerable power and the grips are designed as much to hold large batteries as to provide a hand-hold. Some high-powered guns have a separate lead-acid accumulator carried in a shoulder pack.

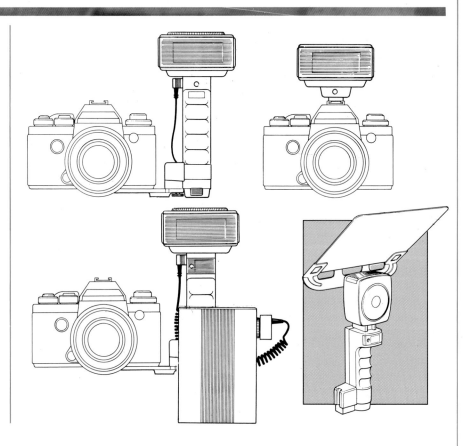

CORRECTING COLOUR BALANCE

The most reliable way to overcome the uncertainty of exactly how green a particular set of fluorescent lights will appear on film is to conduct a test shoot using magenta correction filters of differing density. Make notes during the session so that you can assess which filter gave the best result when you examine the test transparencies. If there is no time or opportunity for a test shoot, you will need to use a colour temperature meter to determine the best filtration.

CC30M

CC20M

In practice, operation of a flash unit is a little more complex than this simple description might suggest. One of the two electrodes fused into the tube must be raised to a very high voltage relative to the other. This is done by charging a capacitor with high-voltage electricity produced using a step-up transformer, and a rectifier to turn the alternating current (AC) into direct current (DC). The transformer is powered from the mains or, in portable units, from an oscillator that creates AC from the DC of a battery pack.

To make the Xenon conduct electricity, a thin wire spirals round the flash tube. Passing a pulse of high-voltage current through, this ionizes the gas, triggering the flash. The trigger pulse comes from yet another circuit, which, via a second transformer, links the flash unit to the camera's shutter. When the shutter opens, synchronization contacts close, and a small current flows through one side of the transformer. This induces a flow of current at a much higher voltage on the other side – the trigger pulse.

When there is enough power to take another picture, the ready light comes on. This lamp monitors the charge on the main capacitor, and lights up when charging is nearly complete – usually about 75–80 per cent of a full charge.

With portable flashguns, there is a high-pitched whine, too, which cuts out soon after the ready light comes on. This noise is made by the oscillator turning DC to AC. Studio flash units needs no oscillator, and are therefore silent in operation.

The power output of a flash unit depends on the characteristics of the capacitor, and the voltage that it stores. The higher the voltage, and the more power the capacitor can store, the bigger the flash. Power of studio flash units is usually measured in joules (also called watt-seconds). A large studio flash unit may have a power of some 4000j, compared with the 25 or so joules of a typical mid-range camera-mounted portable flash.

PORTABLE FLASH UNITS

Clamped to a hand-held camera, a portable flash unit makes the photographer completely independent, and free to photograph anything, at any time, anywhere. The smallest portable flash unit fits neatly into the camera's hot-shoe, and is hardly bigger than a matchbox. At the other end of the scale, a large press flashgun requires a separate power pack, and itself may dwarf the camera.

Compared to their bigger studio-based brothers, portable flash units are electronically very sophisticated. Most are now *automatic*, that is to say, they incorporate a photocell to measure the flash light reflected from the subject. When the unit has emitted just enough light to ensure a correct exposure, the flash is quenched. All the photographer has to do to produce correctly exposed pictures is set a calculator dial to the film speed in use, read off an aperture from a scale, and set this aperture on the camera lens. Within a broad range of subject distances, the flash unit will correctly meter the exposure.

Most units offer the photographer a choice of apertures – sometimes two or three, and in a few instances, six or eight. Some manufacturers add as confirmation of correct exposure a *confidence light* which comes on after the exposure, if the subject was within range of the camera's auto-sensing circuitry. This reassures the feckless photographer that the pictures will be neither too dark nor too light.

A relatively recent innovation is the *dedicated* flashgun that operates exclusively with one particular make or model of camera. A dedicated unit automates certain flash functions – though precisely which functions are affected varies from camera to camera. Most dedicated flash units set the camera's shutter to the flash synchronization speed (usually between 1/60 and 1/250 on 35mm) but switch the camera back to available-light exposure measurement in the periods while the flash unit is recycling. Some also illuminate a flash-ready light in the camera's viewfinder and this may blink to confirm correct exposure.

The most sophisticated dedicated flash units actually meter the light reflected from the film surface during exposure, using a photocell mounted in the camera's mirror box. The method of metering makes flash exposure virtually foolproof, and is of considerable value in macrophotography. Many recent SLR cameras have off-the-film flash metering which further increases reliability.

The smallest portable flash units fit quite comfortably in the camera's accessory shoe, because they need the power of just one or two AA cells. However, high-power units require more batteries, and larger capacitors and transformers, so their weight may overbalance a small camera. The largest units are invariably in the 'hammer' style – a thick vertical shaft containing capacitors and sometimes batteries, with a flashtube and reflector on top. Two-piece units also require a separate battery-pack attached to a belt or slung over the shoulder.

Power and power sources For simple snapshots indoors, virtually any portable flash unit is satisfactory, but for more advanced photography, small flashguns often prove underpowered. Out of doors, particularly, the reach of a flash unit is cut by anything up to 50 per cent, because there are no walls and ceiling to reflect light onto the subject. Bouncing or diffusing the beam of the flash to soften the lighting also absorbs a lot of power, and with a small unit, this can lead to underexposure, or more likely, severe restrictions on aperture choice and maximum subject distance.

The flash guide number (GN) is an indication of a unit's power. Dividing the guide number by the camera-to-subject distance gives the approximate aperture that will yield correct exposure. For example, a unit with a guide number of 40 would supply enough light for the photographer to use an aperture of f8 when the subject is five metres away. The guide number can in fact be used to estimate the correct aperture when the flash is used manually, but this involves a short calculation, so it is usually simpler to use in the automatic mode.

Guide numbers are generally quoted for ISO 100/21° film, and either for feet or metres. When comparing flashguns, always check that the guide numbers are quoted for the same film speeds, and that both use the same units – either metric or Imperial.

Guide numbers express only the maximum power of the unit. When there is a choice of several apertures, the various options will progressively cut down the power from this maximum figure.

The smallest portable flash units have GNs of around 15 (metres/ISO 100/21°). This rises to around 25 or 30 for the larger and more versatile hot-shoe mounted units, and to about 50 for a powerful hammer-head flash.

With the exception of the large press units, almost all flashguns now operate from standard-size AA cells. However, these are commonly available in three different formula-

INVERSE SQUARE LAW

Light falls off with distance geometrically, as the diagram (below) demonstrates. At twice the distance, the same flash output must cover four times the area. This is particularly important in basic flash photography with a camera-mounted unit.

Guide numbers Dividing the guide number of a flashgun by the distance of the subject (below) gives the aperture needed, and vice versa. The higher the guide number, the more powerful the flash.

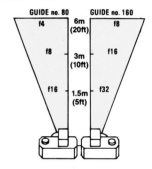

LIGHTING SMALL SUBJECTS

Both of the flash arrangements illustrated here – the ringlight (below) and the bellows and flash bracket (below) – are suitable for close-up photography and considerably simplify the problems of lighting small, nearby subjects.

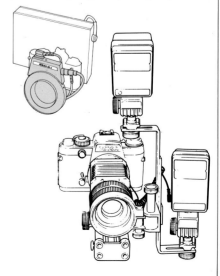

FLASH FILTRATION AND HOT SHOES

Flash filtration An alternative to fitting a filter to the camera lens is to attach one to the flash head. A more complex use is to fit, for example, a magenta filter on the lens to correct ambient fluorescent lighting, or a green flash filter to neutralize the flash-lit colours.

Hot-shoes For camera-mounting flash units, these can be fitted as extras to some bodies.

tions. Zinc-carbon cells are the least powerful, giving fewest flashes per set of batteries, and the longest recycling times. Manganese-alkaline cells ('alkaline energizers') greatly reduce recycling times, and last very much longer than zinc-carbon cells. Both types must be discarded when exhausted. Nickel-cadmium cells ('Nicads') on the other hand, can be recharged. They give the shortest recycling times, but need recharging sooner than alkaline cells need replacing. Since the price of these rechargeable cells is high, their purchase is justified only for frequent use of flash.

High-power units may additionally offer users the option of a shoulder-slung lead-acid accumulator. Though heavy, these power packs give the shortest recycling times and longest life of all. Changing the batteries on a flash unit does not, unfortunately, increase the power of the beam.

Using portable flash Locked into the accessory shoe of a camera, and pointed directly at the subject, the versatility of even the most sophisticated flash unit is limited. Direct light from the camera position produces harsh, unflattering illumination that is particularly ill-suited to portraits, which are perhaps the most common flash-lit subject.

However, there are several ways to improve flash pictures. The simplest is to direct the flash at a white reflective surface, such as a wall or ceiling, and illuminate the subject by the reflected light. This technique is called 'bounce flash' and to make it easier, many of the more powerful automatic flash units have a tilting head, so that the reflector and tube of the flash can be directed upwards or sideways, while the metering photocell continues to point at the subject. The flashgun can thus continue to function automatically. Units without tilt-heads must be mounted on separate brackets, or hand-held, and exposure must be calculated, which makes the procedure a rather hit-or-miss affair.

Lighting a section of ceiling or wall in this way turns the small source lighting of the flash into a broad source, and this produces softer, more pleasant illumination. An additional benefit is that the lighting direction is no longer frontal, so that features in a portrait are more clearly modelled.

Bounce flash can create quite heavy shadows under the chin and nose of portrait subjects, and a few flashguns incorporate a second flashtube and reflector, below the primary tube, to fill in these shadows. An equally effective way of solving the problem when using single-tube flash units is to tape a small piece of silvered card diagonally over

FILL-IN FLASH TECHNIQUE

With an automatic flashgun, fill-in flash is straightforward – simply a matter of balancing the exposure from the sun and that from the flash unit. The ideal proportion of sun to flash is largely a matter of taste, but is also affected by the exposure latitude of the film, and of the use to which the resulting pictures will be put. For example, colour slide film has little exposure latitude, and the normal ratio is between 4:1 and 2:1 – that is to say that the sunlight is between four and two times brighter than the flash. However, with black-and-white film, the contrast range of the negative can often be adjusted later in the choice of paper grades.

To set up camera and flash unit, follow this simple procedure:

1 Choose the ratio of flash-to-sunlight that you think will produce the best result.
2 Multiply the nominal speed of the film you are using by the ratio, and set this new speed on the flash unit's calculator dial. So, using ISO 100/21° film and a 3:1 ratio, set ISO 300/26°.
3 Select an aperture from the flash calculator dial, and set this on the camera.
4 Take an exposure meter reading in the normal way to calculate the correct shutter speed.
5 Check that this is no faster than the camera's top synchronization speed. If it is, choose the next smallest aperture option that is available, and repeat (**4**) above.

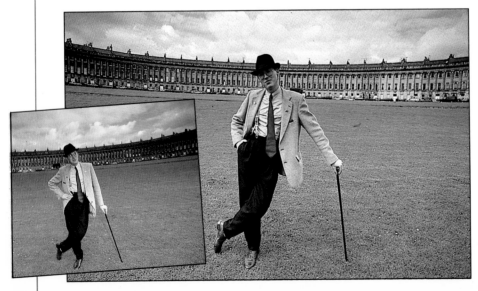

a portion of the upward-pointing flash reflector. This spills a portion of the main flash directly onto the subject.

Another way to modify and improve the light from a flashgun is to remove it from the camera's accessory shoe, and hold it to one side of the camera, using a cable to maintain synchronization with the camera's shutter. This makes the lighting less frontal, and yields significant improvement in modelling. However, bear in mind that with the flash moved away from the camera, the unit's sensor will be 'seeing' a view of the subject different from that which the camera records. This can lead to exposure errors, so many flash manufacturers supply a removable sensor that remains in the camera's hot-shoe when the flash itself is removed. Dedicated units additionally need special synchronization cables which relay the extra data between camera and flash.

Multiple flash takes the flash-off-camera technique a step further, permitting quite elaborate lighting set-ups. However, exposure determination when using several portable units can be quite complex unless the photographer uses either a flashmeter or instant-film test.

Portable flash units have a vulnerable role to play in daylight, as well as in the dark. In bright sunlight, heavy shadows across the faces of portrait subjects create a very harsh impression of the sitter's features. Set to reduced power, an on-camera flash can soften these shadows. This is called *fill-in flash,* or sometimes synchro-sunlight.

Accessories Unlike studio flash systems, nearly all portable flashguns are limited to a single reflector so that the spread of the beam is fixed. Most flash units produce a beam broad enough to illuminate the field of view of a 35mm lens on a 35mm camera. To light the areas covered by lenses with shorter focal lengths, beam spreaders or diffusers are necessary. These usually take the form of Fresnel lenses that fit in front of the flashgun's reflector, expanding the beam to cover the wider area.

In principle, focal lengths longer than 50mm present no special difficulties with flash, but in practice, much of the light of the flash is wasted, since the unit forms a beam far broader than the field of view of the lens in use. To make more efficient use of the light, it is possible to direct the flash into a reflector to concentrate the light.

Coloured filters which fit over the front of a portable flashgun find occasional use. The most valuable of these is orange-coloured, and converts the light of the flash to the colour of tungsten light. The unit can then be used with tungsten-balanced film.

Perhaps the most valuable flash accessory, though, is the slave unit. This tiny device – half the size of a matchbox – houses a photocell and a cluster of other electronic components encapsulated in resin. At one end there is a female flash synchronization socket, into which the synch cable of the flash unit is plugged. This slave cell then provides cordless synchronization: a flashgun in the camera's accessory shoe will trigger the slave and fire any auxiliary flash unit in the vicinity. This simplifies multi-flash set-ups, and eliminates trailing wires.

Studio flash In the studio, portability is not important, but versatility and power certainly are. The smallest studio flash units have a power output of around 100j, as much as the largest portable flashguns. A large studio may have flash units with 200 times this power.

Why is all this power necessary? Because studio photography often involves the use of sheet-film cameras which must be stopped down to minutely small apertures to obtain sufficient depth of field. For example, with 10 × 8in (25 × 20cm) film, an aperture of f90 is by no means unusual. Also, modern studio photography utilizes heavy diffusion of light sources, and this invariably absorbs a great deal of power.

Studio flash units work in broadly the same way as portable flashguns. To cope with the extra power, though, the flashtube must be very much larger than the tube in a portable flash. In studio units, the tube is usually formed into a ring.

In the centre of this circular tube is a tungsten bulb – either a photoflood or, more usually, a tungsten-halogen lamp. The bulb is continuously illuminated, thereby simulating the light of the flash. Called a *modelling lamp,* this tungsten bulb allows the photographer to judge approximately the effect of moving lights around the subject, or reducing their intensity.

STUDIO FLASH

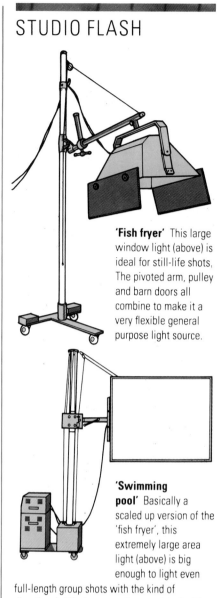

'Fish fryer' This large window light (above) is ideal for still-life shots. The pivoted arm, pulley and barn doors all combine to make it a very flexible general purpose light source.

'Swimming pool' Basically a scaled up version of the 'fish fryer', this extremely large area light (above) is big enough to light even full-length group shots with the kind of directional diffusion normally associated with still-life shots. The stand is extremely flexible, enabling the light to be swung into different positions (below).

The smaller studio flash units resemble overblown portable flashguns, mounted on stands. These *monobloc* units integrate all the components in a single casing, with the flashtube, modelling light and reflector, at the front, capacitors, transformers and control electronics in the middle, and a panel of controls on the back.

Monobloc construction is convenient and inexpensive, and the units are easily portable, making them ideal for location as well as studio work. Into a single fibre case that can be carried by one person, it is possible to pack two monobloc units, stands, all cables, umbrella reflectors and flashmeter. The principal disadvantage of such units is instability. Perched near the ceiling on top of a stand, a monobloc flash unit can sometimes sway alarmingly, and tripping over a cable often has disastrous results.

Monobloc construction is impractical for really powerful studio flash units. Instead of integrating all components in a single housing, these big units are split into two. A box on the studio floor houses the power supply – the capacitors, transformers and other electronic components – and only the flashtube, reflector and modelling light sit at the top of the stand.

The power supply usually has at least two outlets, so that one power supply can run two flash heads. Optional splitter boxes divide the power still further.

Switches on top of the power supply reduce the output progressively from full power down to one-quarter or one-eighth, distribute it among each of the heads in use, and control the functioning of the modelling lights. These can be switched off altogether, switched on at full power, or attenuated in proportion to the power of the flash head in which each is mounted. (This last option gives the truest simulation of the effect of the flash illumination.)

Studio flash heads The standard flash head for a studio unit accepts a wide variety of different reflectors, diffusers and other lighting accessories. The studio photographer is not, however, limited to just the one basic head.

High power electronic flash heads have specially lengthened flashtubes, which are

DIRECT FLASH *on the camera, while not subtle, can be effective in circumstances where the colours and tones of the subject are distinct and rich, as above. Light from the camera position can give very saturated colours.*

POWER IN THE STUDIO

The scale of studio flash equipment makes its handling characteristics quite different from those of the more familiar hand flash guns. At the heart of the studio flash system are high-voltage capacitors with sufficient output to meet the needs of small-aperture studio work. Output is measured in joules (watt/seconds) – as a very approximate guide, 1000 joules diffused through a 2-foot square (·6m square) window light placed 2 feet (·6m) from the subject would let you use an aperture of f22 or f32 with ISO 64 film. Fractions of the total power output can be selected, the actual amount of light being controlled by the duration of the flash.

Studio flash systems can be either in the form of a separate power-pack connected to several heads (varying amounts of power can be switched through each head) or in the form of a single integrated unit that combines power and head. The latter design is increasingly popular for its convenience and portability, and although its power output is limited, it is sufficient for most 35mm lenses, which do not stop down as much as large format lenses.

Flash tubes are normally filled with xenon gas, and are commonly ring-shaped, spiral or linear. They are generally balanced to a colour temperature of about 5500°K, but different

reflectors and diffusers will alter this. For setting up the shot and focusing, a tungsten lamp or fluorescent tube is fitted close to the flash tube, to give representative lighting.

Power units One of the most powerful units available is this 5000-joule console (above) on its own trolley. The output can be discharged variably to several outlets. A smaller unit (above right) produces from 250 joules up to 1000 with other units. A booster can be used to reduce recycling time.

Flash meter Integrated circuitry has mode modern light meters smaller and more efficient (below). Readings are normally made using the incident light method, as this is generally more convenient for the controlled conditions of a studio.

wound into a short helix and can cope with the output from several linked power supplies. These heads incorporate a more powerful modelling light, and a cooling fan.

Striplights also have longer flashtubes, but in these heads the tubes are straight, and usually about a metre (3ft) long. Striplights produce a very even light along their entire length, so they are ideal for illuminating studio backdrops. A fluorescent tube next to the flashtube acts as a modelling light.

In ringlights the flashtube forms a wide circle – wide enough to poke a camera lens through. Since the tube totally surrounds the lens, these heads provide the shadowless illumination which is periodically in favour in fashion photography circles.

For applications where the light-source must be concealed, perhaps in a table lamp that forms part of a room set, very small heads are available. These are hardly bigger than a 150W domestic light bulb, and contain no modelling light.

BULB FLASH

Expendable flash bulbs were the ancestors of today's electronic flash systems, and for a few specialized areas, electronic flash still cannot rival bulb flash. Flash bulbs range from bean-sized up to the shape and proportion of an ordinary light bulb. Inside its blue-tinted glass envelope, each bulb carries a charge of magnesium wire or foil, and a small heating coil which is connected to contacts on the base of the bulb. Passing a current through the coil causes the magnesium to burn, giving out a brilliant flash of daylight-coloured light.

Flash bulbs give out relatively massive amounts of power, yet require only a low electric current from a simple circuit for triggering. To produce the same power output as a single flash bulb would require a very large and cumbersome studio flash unit.

FLASH BY NIGHT *Portable flash can be used simply as a supplement to daylight or other available light, but it comes into its own at night. The darkness of the night covered all unwanted details in this shot (above), leaving just the flash to illuminate the subject and give a very finished, 'studio' look to the shot.*

FLASH HEAD DESIGN

In studio units, which are mains-powered, the flash head is only ever regarded as a raw source of illumination, and must be modified for nearly all uses. There are two basic types of design (below), a separate head (top) connected by lead to the capacitor and controls, and a monobloc or integral design (bottom), which is a self-contained unit. Separate heads are needed for high-output flash (the tube illustrated here can handle 5000 joules), but monobloc units are tidier and more compact.

TUNGSTEN LIGHTING

Although now largely superseded in professional studios by flash, tungsten lighting has the advantage of being relatively inexpensive and better able to light very large areas (through increasing the exposure time). Its major disadvantage is the inconsistency of the light output, particularly the colour temperature.

Tungsten lamps used in photography are essentially up-rated versions of domestic light bulbs; consequently they have shorter lives, some as little as 2–3 hours. They have colour temperatures of either 3200°K or 3400°K, compared with about 2800°K for domestic lamps. With use, the tungsten in the filament gradually forms a deposit on the glass envelope, reducing the light output and colour temperature. One answer to this problem is the quartz-halogen lamp, in which vaporized tungsten disperses in the halogen gas and re-deposits on the filament. The output and colour thus remain constant, but as high temperatures are necessary, quartz is used instead of glass as the envelope.

In fact, any tungsten lamp, even the low-wattage domestic type, can be used in photography, provided the colour temperature is known and compensated for with colour-correction filters. A colour temperature meter should be used for complete accuracy in studio work.

Designs of tungsten lights vary considerably, from small, compact units, such as the Lowell Totalite (right) to the larger spotlights normally used in film studios (far right).

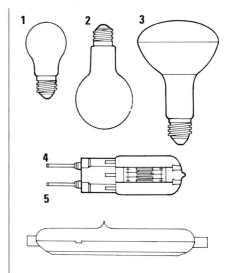

1 275W photoflood
2 500W photolamp
3 Half-silvered reflector lamp
4 Two-pin high-intensity spot lamp
5 Linear quartz-halogen lamp (800W–1000W)

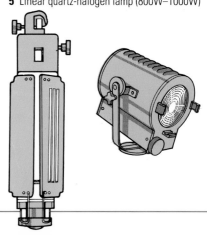

TUNGSTEN LIGHTING

Among the various designs of studio lighting are lensed units, simple dish reflectors that accept basic photoflood lamps, and folding portable holders for location work.

1 Photoflood
2 Mini-spot with Fresnel lens
3 Portable heavy-duty
4 Totalight
5 Luminaire with Fresnel lens
6 Red, with barn doors
7 Softlight with bar to conceal lamp

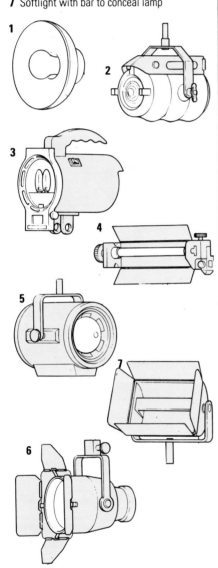

Consequently, bulb flash is generally used to light very large spaces such as factories, foundries or aircraft hangars. Multiple bulb arrangements are very common, with each bulb fitted into a lampholder and reflector, and positioned so as to be invisible from the camera position. An electric cable links all the bulb-holders.

Since flash bulbs can be used only once, the photographer must visit all the bulb-holders to change over the lamps between exposures. So bulb flash is best suited to jobs that require just one or two pictures.

LAMPHOLDERS

One of the reasons why tungsten light retains a following among professional photographers is because it can easily be shaped into a tight beam – a parallel or converging beam if need be. With flash, this is possible, but the beam of the modelling light rarely matches the shape of the beam from the flashtube itself.

To make a really well-defined beam, the tungsten lamp must be fitted into an optical system comprising a reflector and lens – rather like a slide projector. The lens at the front is a Fresnel lens similar to that used on lighthouses or below the focusing screens of SLR cameras. Lampholders of this type are called *luminaires* or *focusing spots*. A knob on the housing of the unit adjusts the angle of the beam from broad flood to tight spot, but the beam always casts hard-edged shadows.

Focused spots range tremendously in size from the giants that are often used to light film sets, down to small mini-spots that provide just enough light for head-and-shoulders portraiture.

Focused spots cannot produce soft lighting, and for this purpose, photographers use a much simpler lampholder. At its most basic, this consists of a tin box with a curving reflector inside. The lamp itself is supported at the focus of the reflector and faces into it, so that only reflected light reaches the subject. This softens the beam, producing very soft-edged shadows.

The broader and less shiny the reflector, the softer is the light. Matt white reflectors form very soft, but relatively weak beams. Shiny silver reflectors are far more efficient, but produce much harder light. Matt silver is a good compromise. These lights are known by a variety of names, such as 'broadlight', 'softlight' and others.

For location lighting, compactness and light weight are priorities, and for this purpose, photographers have adopted lights from the movie industry, such as the ever-popular

FLASH AND TUNGSTEN COMPARED

	Flash	Tungsten
1	Freezes fast action but cannot give blur of motion.	Can give blur of motion but can rarely freeze fast action.
2	Same colour as daylight so can be mixed with daylight to fill in shadows, and can be used with the wide range of daylight-balanced colour films.	Colour balance can be a problem even with tungsten-balanced film. With daylight colour film, heavy, light-cutting filtration is needed.
3	Needs modelling lights to preview the lighting.	Photographs as it looks.
4	Cool, so comfortable to work with and allows enclosed fittings.	Hot, so cannot be used with delicate subjects such as plants and cold food, and cannot be enclosed without good ventilation.
5	Exposure can only be increased beyond a certain point by multiple flashes.	With static subjects, exposure can be increased by extending exposure time.
6	Relatively costly.	Relatively cheap.
7	Relatively heavy.	Relatively light.
8	Complex technically.	Uncomplicated and easy to repair.

LIGHTING

Reflector attachments This basic Magnaflash head with flash tube and modelling lamp accepts a variety of attachments (right) general purpose or wide-angle reflectors, barn doors, and different shapes of snoot.

Diffuser attachments Different degrees of diffusion can be achieved with attachments that vary from plastic opalescent discs to a large shallow bowl fitted with a cap that blocks off direct illumination from the flash tube (below right).

Striplights Two long trough-shaped lights (below) fitted with inside flash tubes are ideal for lighting a background evenly.

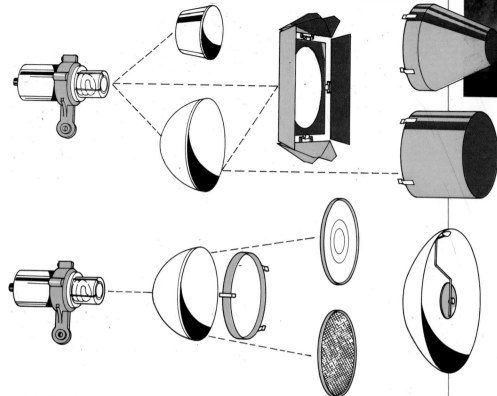

Umbrellas These are excellent for portraiture. A silvered finish gives more light intensity but harder shadows than white, and a square umbrella is useful where its reflection may appear in the photograph. Aim the flash through a translucent umbrella (below) for direct diffusion.

Trace frame A simple, non-adjustable large area diffuser can be made from wood. The frame is covered with tracing paper (below), muslin, or other translucent cloth.

'Redhead' design, as it is universally described.

Other similar units have their own unique advantages. Tota-lights are the smallest of all portable units; video lights produce a powerful beam, yet they can be hand-held and even run for half an hour from a rechargeable battery pack.

TUNGSTEN ACCESSORIES

The range of lighting accessories is more limited for tungsten lights than it is for flash, because the lamps themselves get very hot and cannot be fitted into enclosed spaces as flash heads can. Some types of diffusing material, though, are heatproof and a few accessories are made specially to withstand the heat of tungsten bulbs.

The most valuable of these is the dichroic filter. This heatproof glass plate fits over the front of the lampholder and adjusts the colour of the beam of tungsten light from 3,200K to 5,500K – the colour of daylight. So tungsten lamps can then be combined with daylight, using daylight-balanced film. Heat resistant plastic sheets that do the same job are also available, and though these are less robust than the glass filters, some of them combine the function of diffuser and filter. Held a metre or two in front of a powerful tungsten lamp, such a filter/diffuser forms the light into a soft, daylight-coloured window light.

COMBINING TECHNIQUES *The only illumination in this tribal house in Thailand was the fire on which the pig was being roasted. Since flash would not have captured the right mood, other techniques were employed to record an image under the low light conditions. These were to use fast film, a fast lens at full aperture, and a slow shutter speed (one-eighth of a second). The combination of very shallow focus, flare from the wide-open lens, and moving flames and sparks, give an impressionistic effect that, while not exactly deliberate, makes a strong image. Photographs taken under these and similar conditions are not completely predictable, and so often contain an element of surprise for the photographer when processed.*

PART TWO

APPLYING THE PRINCIPLES

ONCE YOU HAVE ACQUIRED THE TOOLS, you need the skills to use them, especially if you hope to take pictures which will stand out from the crowd.

Although the basic skills are simple enough to understand only you can dictate the philosophy of your approach to photography. Camera design technology is now so advanced that it gives you almost too many options on how to tackle a particular photographic problem. The constant quest for more and more automation has led to what may seem a bewildering choice of exposure modes and programs – as many as six options on some cameras, and that doesn't include flash photography.

You may embrace with open arms the concept of autofocus which does, on the face of it, automatically cope with one of the most important stages leading up to pressing the shutter button. But on the other hand you might ask yourself why professionals have been so reluctant to use autofocus and programmed cameras, and you may well enjoy the challenge of doing more yourself – taking control rather than abdicating responsibility for an exposure.

Many photographers are weaned on autofocus, auto-exposure 35mm compact cameras, so it is understandable that they grow to believe that the camera can take care of the mechanics of photography, leaving the photographer free to compose the picture and shoot. But as your photographic awareness grows so does the realisation that there is more to exceptional photography than seeing, pointing and pressing a button.

This is all the more likely if you decide to try and make money out of photography and find that what the advertising and publishing industries need are perfect transparencies for reproduction on the page, or, greatly enlarged on advertising hoardings. Newspapers and many periodicals need sharp, crisp black-and-white prints because they have acres of white pages to fill every day, every week and every month. Only by mastering the basic skills explained on the next few pages can you hope to produce pictures good enough to sell in a highly competitive market-place.

This section of the book looks at focusing, both manual and autofocus, and then gets down to the real nitty gritty – the combination of shutter speed and lens aperture size which dictates the appearance of the picture. Armed with this knowledge you will be able to stop action in its tracks, or let it show as a blur of colour in the picture; to shoot a landscape with everything pin-sharp from two feet away to the distant horizon; to make your subject stand out sharp and clear against an out-of-focus background; to begin to understand how to tackle the vagaries of fickle lighting, or set about creating your own lighting, either in a studio or on location.

One of the most absorbing aspects of photography is darkroom work – making your own prints which you can then manipulate to say exactly what you want them to say. Photography is a garden of Eden, and these basic skills are the key you need to enter.

FOCUSING

ALL BUT THE SIMPLEST cameras incorporate a focusing mechanism – a means of controlling which parts of the picture appear sharp, and which parts blurred and indistinct. Together with the shutter and aperture, focusing is one of the camera's three fundamental controls.

At first sight, focusing appears to be straightforward, simply a matter of making sure that the subject is sharp. However, focusing is not always just a mechanical procedure, as anyone who has an autofocus camera that has got it wrong will know. Often, focusing involves complex decisions about the relative importance of different parts of the image; or about which areas to render sharply, and which to conceal in an indistinct haze. Even the most sophisticated autofocus mechanism cannot make such deductions, so cameras that delegate the task of focusing to a microchip sometimes focus on totally irrelevant trivia. Manual focusing puts the decisions in the hands of the photographer.

As the pages that follow show, the basics of focusing are easy to understand. The decisions about where to focus, though, are more subtle, and demand an aesthetic input and appreciation on the part of the photographer. These things are learned by experience.

FOCUSING FUNDAMENTALS

All lenses form three-dimensional images in space: sharp images of distant objects are formed close to the lens; and sharp images of nearby objects are formed farther back behind the lens. However, film is a flat plane, not a volume in space, so the lens projects onto the film an absolutely sharp image of objects just one distance from the camera. On film, these objects are described as being 'in focus' – they are sharp and clearly delineated, with textures well defined. Objects closer to the camera and farther away appear less well defined – they are 'out of focus', as if seen through a misted window.

Since film is a flat plane behind the lens, the parts of the subject that are in focus form a flat plane in front of the lens. This plane is called 'the plane of sharp focus', and is usually at right angles to the axis of the lens.

The act of focusing is the process of changing the position of the plane of sharp focus, moving it nearer to the camera to take close-up pictures; and farther away, for distant views. This movement is accomplished by moving the lens in and out – away from the film for close-ups, and closer to the film for scenic views. The separation between lens and film is mathematically related to the distance between lens and subject. With an understanding of the relationship, it is possible to move lens and film a measured distance apart to bring a specific part of the subject into focus.

No photographer wants to carry a tape measure and a pocket calculator everywhere, and anyway, the lens position must be set with great accuracy – to within a fraction of a millimetre. So, on inexpensive cameras which have adjustable lenses, the lens moves in and out in a threaded barrel. This allows for very precise setting of the lens-film separation, and has the additional advantage that a large angular rotation of the barrel produces a small forward or backward motion of the lens. Thus the barrel can be marked with widely spaced indexes to indicate the correct position of the lens for a range of subject distances. This focusing scale runs from infinite distances (marked with the infinity symbol ∞) through to distances a metre or two from the camera. The markings are most widely spaced at close distances, but progressively more tightly packed for objects increasingly far away.

Using such a camera means guessing the subject distance. This is fine for far-off subjects, where focusing does not need to be so precise. But guesswork is less than adequate for close-ups, so most cameras have some sort of focusing aid.

Large sheet-film cameras have a very direct and straightforward means of checking sharp focus. At the rear of the camera is a sheet of matt glass, on which the lens throws an image of the subject. The photographer can then move the lens in and out while watching the image change in sharpness on the screen. When the picture is sharp, the screen is moved out of the way, and its place is taken by a sheet of film. The camera is constructed in such a way that film is positioned in precisely the same place as the surface of the matt glass. So what was sharp on the glass will also be sharp on the film.

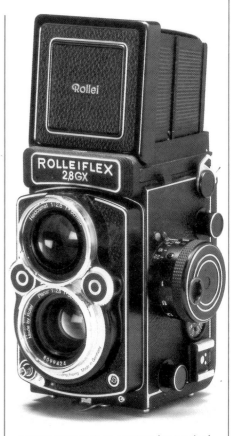

A TWIN-LENS REFLEX CAMERA *has a pair of lenses. The top lens is used for focusing while the lower lens forms the image on the film.*

FOCUS AND DEPTH

Essentially, focusing determines the sharpness of different areas of the image. As such, it cannot be treated independently of the depth of field, which, in turn, depends largely on the aperture. In the three photographs (below), the row of mail boxes were focused at just over 7ft (2m) with a standard lens; the aperture, however, was varied from full (f3·5) (left), to a middle setting (f8) (right), to minimum (f22) (bottom left). In effect, the view is selective at full aperture, concentrating attention on the middle of the row, but comprehensive at minimum aperture (all the mail boxes appear sharp), even though only one focus setting was used.

In the smaller set of three images (bottom right), the effects of selective focusing at full aperture are shown.

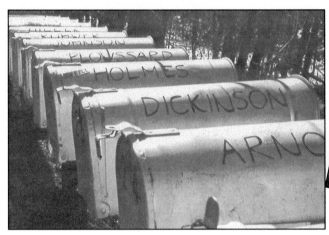

REFLEX FOCUSING

The direct focusing procedure used with a sheet-film camera is very slow and cumbersome, and totally unsuited to even slow-moving subjects such as people walking; and the image on the screen is inverted and reversed left-to-right.

Reflex cameras get around these problems by using a mirror, which projects the image from the lens upwards onto a viewing screen positioned the same distance from the lens as the film is. The reflection by the mirror turns the image upside down, so that subjects appear the right way up on the screen. The addition of a prism above the screen eliminates the left-to-right reversal, making viewing even easier.

Twin-lens reflex cameras (TLRs) have two identical lenses, one above the other. The lower lens forms the image on film, the upper one on the glass viewing screen. The lenses are linked rigidly together, and move in and out on the same panel for focusing. This ensures that the images on film and focusing screen are focused on the same point.

TLR focusing is not a perfect answer to focusing problems, though, largely because the two lenses are separated by several centimetres. This means that the viewing lens does not see precisely what will appear on film, so framing is not always accurate. This 'parallax error' is rarely a problem with distant subjects, but is very serious at short distances. The problem is partly solved by marking the viewing screen to show the different fields of view at short and long subject distances, or by fitting a sliding mask under the screen. The mask moves progressively downwards as the photographer focuses closer, indicating how much

ELEMENTS OF A FOCUSING SCREEN

There is a variety of screen designs for SLRs, but there are three standard elements, each particularly suitable for focusing on certain kinds of subject. The screens supplied with most cameras feature all three: split prism finder which shows displacement of an out-of-focus subject, microprism grid, which 'scrambles' unfocused images, and plain screen for detailed, but slower focusing.

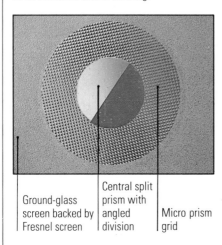

| Ground-glass screen backed by Fresnel screen | Central split prism with angled division | Micro prism grid |

Many SLR cameras offer a choice of viewing screen types (below), which are usually fitted or removed via the lens mount with lens removed. Some professional cameras have a removable prism which makes the job easier.

will appear in the picture. These measures alleviate parallax error but they do not eliminate it. The two lenses still see slightly different views of the subject.

Single-lens reflex cameras (SLRs) eliminate even this problem by using one lens for both viewing and taking the picture. The mirror that reflects the image upwards to the viewing screen is hinged, and springs upwards out of the light path an instant before the shutter opens. After exposure, the mirror drops down again, so that the viewfinder image disappears for a split second.

SLR focusing is particularly valuable when taking close-up pictures, because there is no problem of parallax error, even when the subject is just a centimetre from the lens. Because the optics of the focusing mechanism are the same regardless of the lens in use, the system works equally well with telephoto and wide-angle lenses.

FOCUSING THE SLR

The introduction of effective and efficient autofocus for the 35mm SLR has revolutionized camera design to such an extent that manufacturers have all but stopped introducing new, manually-focused models. However, several autofocus SLRs have a lens mount which will accept manually-focused lenses, and most autofocus lenses can be focused manually.

All manually-focused lenses have a focusing ring or barrel which is rotated to correct focus as seen through the viewfinder. The same principle is used for autofocus lenses which are to be focused manually. The position of the manual focusing ring on autofocus lenses varies; it may be at the front, as on many Minolta AF lenses, or centrally located as on Canon EF fixed focal length lenses. It may also be concealed beneath a sliding cover to prevent accidental rotation when the camera is being used in autofocus mode.

In a focus priority mode autofocus cameras allow you to lock focus on whatever is central in the viewfinder by putting gentle pressure on the shutter button; you can then recompose the picture if you wish before pressing the shutter button more firmly to shoot. The area shown centrally in the viewfinder of an autofocus camera is known as the focus frame and the camera will focus automatically on whatever is shown inside it when the shutter button is pressed.

PHASE DETECTION AUTOFOCUS

By far the most successful method of autofocus for 35mm SLRs is called phase detection, and uses contrast in the subject as a basis for determining correct exposure. A beam splitter inside the camera passes some of the light which strikes the reflex mirror to a CCD array and the camera's CPU determines whether focus is correct or needs adjusting.

If the point of focus is beyond the subject this is called rear focus, and if in front of the subject this is front focus; the camera lens needs to be moved outwards to correct rear focus and inwards to correct front focus. The job of powering the autofocus mechanism is done either by a motor inside the camera, or a tiny motor inside the lens. Power is drawn from a battery or batteries inside the camera, and these also power the cameras light metering and information systems.

ABOVE *By exploiting added depth of field, inherent in a wide-angle lens, this family scene has remained sharp without focus being spot on.*

BOTTOM LEFT *When shooting in low light levels use points of light in a scene, such as the lamps here, to focus upon.*

FOCUSING WITH LONG LENSES

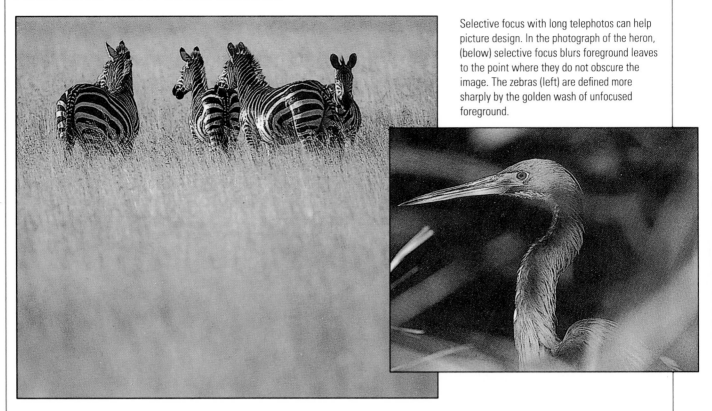

Selective focus with long telephotos can help picture design. In the photograph of the heron, (below) selective focus blurs foreground leaves to the point where they do not obscure the image. The zebras (left) are defined more sharply by the golden wash of unfocused foreground.

AUTOFOCUS SLR CAMERAS *like the Canon EOS 620 use a phase detection autofocus system which is fast and efficient. Lenses can also be focused manually.*

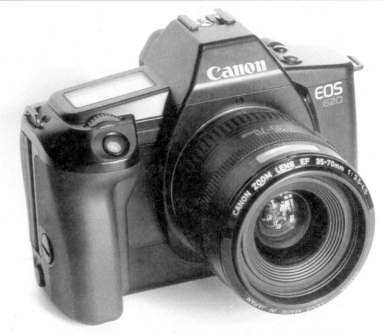

OTHER METHODS OF AUTOFOCUS

Passive systems bear a close resemblance to rangefinder focusing systems, except that two photoelectric cells (actually grids of light-sensitive elements) replace the photographer's eye as the detectors of sharp focus. An image from each of the two rangefinder windows is projected onto the photocells, which produce two slightly different signals when the subject is out of focus. When the image on each cell is the same – corresponding to the merging of the two coloured rangefinder patches – the signals are identical, and the camera knows that the point of sharp focus has been reached.

Passive systems work well in bright light and with heavily patterned or contrasty subjects, but are fooled by dim light and featureless subjects. On the positive side, these

FAR RIGHT *The head of this cayman was chosen as the point of focus with a telephoto lens.*

BASIC PRINCIPLE OF AUTOFOCUS DETECTION

The autofocus system of the Nikon F-801 is a TTL phase detection system using Nikon's 'Advanced AM200' autofocus sensor module. By comparing the electronic output of two line sensors, the system detects the amount of focus correction needed, and the direction in which focus must be adjusted – either in front or behind the current point of focus.

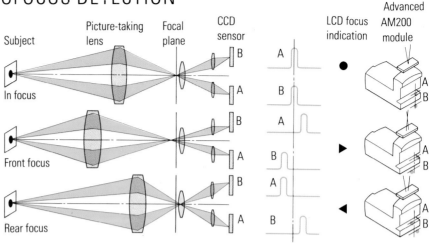

BELOW Autofocus 35–105mm Lens for 35mm SLR camera

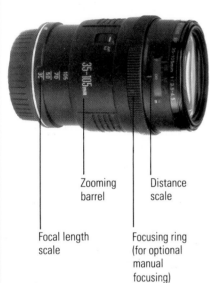

Zooming barrel

Distance scale

Focal length scale

Focusing ring (for optional manual focusing)

cameras can take pictures of reflective subjects, and through windows – situations that often fool other autofocus cameras.

Infra-red triangulation systems function by projecting a spot of infra-red radiation. As the lens focuses from near to far, the spot crosses the field of view. A narrow-angle infra-red receptor pointing forwards detects when the projected spot of infra-red strikes the subject, then immediately locks the lens, and releases the shutter. This system is again similar to a rangefinder camera, but instead of light coming into the camera by reflection off the rotating mirror, infra-red radiation travels out of the camera on a similar optical system linked to the focusing action.

Infra-red triangulation is the most effective autofocus system for everyday snapshots: it works with most subjects, and can operate even in the dark. However, this system will not work with reflective surfaces such as still pools of water. These reflect the IR beam, and the camera focuses on infinity.

Flash reflection systems are fitted to a few autofocus cameras. These rely on the fact that nearby subjects reflect more electronic flash-light to the camera than distant subjects. The camera releases a flash of light or infra-red radiation just before the exposure, and measures the light reflected back. Electronic circuits then estimate the approximate subject distance, and set the lens accordingly. The advantages are: it is a simple and reliable mechanism, and cheap to manufacture. The drawbacks are: it does not work well with very dark or light subjects; its accuracy is limited.

Some instant cameras measure distance using sound, rather as bats' high-pitched squeaks enable them to navigate in the dark. The camera emits an ultrasonic 'chirp', and measures the time taken for the echo to return. Since the speed of sound is relatively constant in air, the delay is proportional to the subject distance. Again, a motor moves the lens to the best focus.

These 'sonar' systems are effective in the dark and with non-patterned subjects, but are misled by windows – the camera focuses on the glass.

RANGEFINDER FOCUSING

Reflex cameras are difficult to use in dim lighting conditions, and the swinging reflex mirror adds to the bulk of the camera, and the noise it makes. When silence is essential, in dim light and in certain other conditions, many photographers prefer to use rangefinder cameras.

These work on quite a different principle to reflex cameras. They have a viewfinder that is quite separate from the camera's lens, and that shows a slightly reduced image of the subject – rather like looking through the wrong end of a low-power telescope. The viewfinder image is sharp and clear over its entire area, because it does not contain the matt-glass screen of the reflex camera.

To focus, the photographer looks at the centre of the viewfinder, where there are two coloured spots. One of these spots is just a tint that overlays the middle of the viewfinder

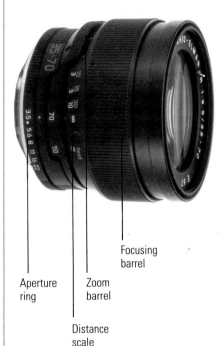

BELOW *Manually-focused 35–70mm zoom lens for Leica M6 rangefinder.*

Aperture ring

Zoom barrel

Focusing barrel

Distance scale

proper. The other spot of colour is actually a second image of the subject, formed by a small mirror of prism a few centimetres from the main viewfinder window. Mechanical linkages turn the mirror or prism as the lens is focused, thereby changing the area of the subject that appears in the second of the two coloured patches. When the image in each of the coloured patches is identical, the two images appear to fuse into one, and the picture is sharply focused.

Rangefinder focusing is equally precise with all focal lengths of lens, but since telephoto lenses require more precision in focusing than wide-angle and standard lenses, 35mm rangefinder cameras function properly only with 135mm lenses or shorter focal lengths. The other side of the coin is that focusing of wide-angle lenses is more accurate on a rangefinder camera than on an SLR.

Since the viewfinder of a rangefinder camera does not see through the taking lens, the same amount of the subject is visible regardless of the lens in use. To indicate the camera's field of view with different lenses, there are bright frame lines visible in the viewfinder. Changing lenses brings a different frame into the viewfinder.

To compensate for parallax error, the bright frame lines also move down within the window, though simpler rangefinder cameras often lack this feature, and indicate parallax error by a couple of marks at the top.

PARALLAX ERROR

Because the viewing window of a rangefinder camera is displaced slightly from the picture-taking lens, the image viewed differs from the image recorded. This difference is insignificant at distances of more than several metres, but close up it must be allowed for. Sophisticated rangefinder cameras like the Leica have parallax correction built in the viewing system.

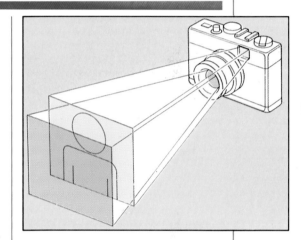

Rangefinder focusing Because the image cannot be focused visually with a non-reflex camera some cameras of this type intended for the serious photographer have a rangefinding system. This is essentially a form of triangulation, in which the slightly different angles of view from two windows on the top panel of the camera are measured accurately and linked to the lens focusing system. The lens focus can be adjusted until the two halves of the image match.

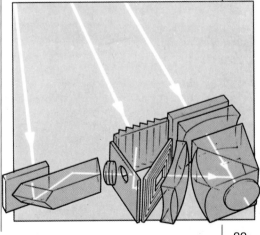
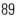

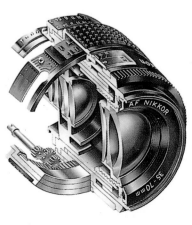

ABOVE *Each AF Nikkor autofocus lens has a microprocessor built in to speed up autofocus response.*

SHUTTER

THE EARLIEST CAMERAS had no shutters; they did not need them, because the light-sensitive materials of the day were very slow, and exposures lasted several minutes, even in bright sunshine. Photographers often covered the lens with their caps – even today, people still talk of 'uncapping' the shutter.

As photographic materials improved, so exposures got shorter – eventually to less than a second. Taking these 'instantaneous' pictures without a shutter proved difficult, because it was impossible to uncover, then re-cover the lens quickly enough.

Modern films are many times faster than those of even 20 or so years ago, and the speed of shutters has kept pace with the speed of films. The fastest of shutters in common use exposes film for just 1/8000 second, and can arrest the movement even of falling water, or the wings of a tiny bird. Nevertheless, the basic concept of the shutter remains very much the same as it did a century ago.

SHUTTER PRINCIPLES

The purpose of a shutter is to protect the film from light until the chosen moment, then to open for a precisely measured time before closing once more. In a sense, then, a shutter is like a fast-acting and completely opaque roller blind, opening and closing to briefly admit light to a room. (This metaphor is actually rather close to reality, because many shutters physically resemble roller blinds).

All shutters – apart from those on the most rudimentary of cameras – have a range of speeds, usually in a doubling sequence that runs from one full second to 1/2 second, then 1/4, and so on, usually as far as 1/1000. The sequence is not an exact doubling sequence – 1/1000 should be 1/1056 – but the errors are negligible. Many modern cameras have speeds beyond this range – as fast at 1/8000, and as slow as 8 seconds.

This doubling sequence of shutter speeds is important, because it matches the doubling and halving sequence of apertures, and simplifies exposure calculations. Changing from one speed to the next fastest exactly halves the time during which light can reach the film.

LEAF SHUTTER

Usually situated between the elements of a lens, a leaf shutter works on the principle of an iris – a number of interconnected curved blades operate to give an expanding then contracting aperture. The sequence (below) illustrates half of the action, and so half an exposure

sequence. This type of shutter is virtually standard on 35mm compact cameras, but is also used in lenses for medium format and sheet-film cameras. The practical top speed for a leaf shutter is 1/500 sec.

SPEED AND EFFECT

In the rapids of a fast-flowing river (right), even the individual drops of spray are frozen with a shutter speed of 1/1000th sec; there is no image movement visible. At the other end of the scale, at one second, the water has lost all recognizable characteristics and appears almost as a dense fog. In between these two extremes, varying amounts of blur are visible. At 1/250th sec the brightest reflections and the fastest moving flecks of foam begin to show a little streaking; at 1/15th sec no part of the scene is crisp.

To produce this series of photographs both shutter and aperture controls were altered in tandem, so as to preserve the same exposure. At the slowest shutter speeds not even the minimum aperture of f32 was sufficient to keep the light level down to the right amount, and a neutral density filter was placed in front of the lens. Note that, although all the exposures are identical, the slow-speed shot appears lighter. This is because the movement of the white foam across the picture 'wipes out' the images of the darker rocks (with blurred movement, lighter subject areas always tend to eliminate the darker ones).

1 sec

1/60 sec

1/4 sec

1/250 sec

1/15 sec

1/1000 sec

The time for which the shutter is open is controlled either mechanically, using clockwork mechanisms, or electro-mechanically. Electro-mechanical shutters, usually called electronic shutters, operate on battery power, and time the exposure using a quartz clock mechanism. Such shutters are capable of very precise speeds, and can provide stepless shutter speeds in programmed or automatic exposure modes.

Speeds are marked as reciprocals on the control that is used for changing the shutter speed; 1/2 is marked just as 2. Full seconds often appear in a different colour.

Besides this series of numbers, shutter speed dials may carry other symbols. The letter B appears on many dials and stands for 'bulb'. This setting holds the shutter fully open for as long as the shutter release is depressed, and is a hangover from the days when expendable flashbulbs were common. The photographers would set the camera to B, press the shutter release, detonate the bulb by closing a switch and then release the shutter button again.

Today, the shutter mechanism itself closes the circuit that fires an electronic flashgun, but the shutter may not synchronize with flash at all speeds. Often the fastest speed usable with flash is marked with a lightning bolt or the letter X, or the fastest flash synchronization speed is engraved in a different colour. This speed is usually mechanically controlled, even on electronic shutters. So if the camera's batteries fail, the X speed is often the only one usable.

A few cameras have a letter T alongside the B. At this setting the shutter is locked open as soon as the shutter release is pressed. Pressing it again, or moving the shutter speed dial to a different speed, closes the shutter.

LEAF SHUTTERS

The ideal shutter is totally opaque when closed, and opens instantly to become totally transparent over its entire area. All the shutters used for everyday photography, though, rely for their effect on some sort of moving blades or blinds. Since solid matter cannot be accelerated from rest instantaneously, all shutters are a compromise of one sort of another.

Leaf shutters come close to satisfying the requirements of the ideal shutter but cannot match the top speed of focal-plane shutters. They are also called lens shutters, or Compur shutters. A leaf shutter is usually built into the lens with which it is to be used and consists of a number of thin metal plates. When the shutter is closed, the metal leaves overlap, stopping light from passing through the lens. Pressing the shutter release causes the leaves to spring apart, allowing light to pass. Having opened, the blades remain at rest briefly before snapping closed to terminate the exposure. Light therefore reaches the whole of the film area simultaneously while the shutter is open, so electronic flash can operate with these shutters at all speeds.

Leaf shutters are limited by the mass of the blades, which cannot accelerate instantly, nor come to rest instantly. Consequently, few shutters of this type offer the photographer speeds faster than 1/500. Because the centre of the lens is uncovered marginally sooner than the edges, the shutter may give a degree of overexposure at small apertures. In practice, the error rarely causes problems.

Leaf shutters are used in many roll-film cameras, and in virtually all sheet-film cameras. Simple leaf shutters expose the film in 35mm compact cameras, and in smaller formats, such as 110 Instamatic cameras, the leaf shutter may play the extra role of aperture, opening to varying sizes as well as for varying times.

FOCAL-PLANE SHUTTERS

The other major category of shutter is housed not in the lens but in the camera, just in front of the film. One of these focal-plane shutters therefore operates with all the interchangeable lenses fitted to a camera – whereas individual leaf shutters must be fitted into each and every lens if the camera lacks a focal-plane shutter. This makes interchangeable leaf shutter lenses more expensive.

Focal-plane shutters resemble roller-blinds that cross the area in front of the film either vertically or horizontally. These shutters, though, are composed of twin blinds, so that the shutter is like a window with a roller-blind both at the top and the bottom. Prior to

FOCAL-PLANE SHUTTER

Essential in SLR cameras because the reflex viewing system requires an open lens right up to the moment of taking the picture, focal-plane shutters operate on the principle of roller blinds. There are a pair of these flexible, tensioned blinds, and both travel across the frame through which the film is exposed. The illustration shows a horizontal-run shutter, but many SLRs use a vertical-run shutter which has a shorter distance to travel. At slow speeds the entire frame is exposed, but at high shutter speeds the two blinds are timed to unroll so that a thinner gap is revealed. Adjusting the gap alters the shutter 'speed'. The top speed for a focal-plane shutter is currently 1/8000 sec.

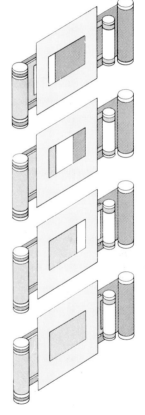

exposure, the lower blind is unwound, covering the window. The upper blind is fully rolled up at the top of the window.

At slow shutter speeds, the exposure is made by releasing the top edge of the lower blind, which rapidly rolls up onto its roller at the bottom of the window. This uncovers the whole of the window for the prescribed time, and when it has elapsed, the upper blind is unrolled, covering the window from top to bottom.

After exposure, the overlapping edges of the two blinds are wound from the bottom of the window to the top, thereby unfurling the lower blind, and rolling up the top one, ready for another picture.

At faster shutter speeds, the action of the shutter is different. On pressing the shutter release, the lower blind starts to roll up, but as soon as a small part of the window is clear, the upper blind begins to unroll. The result is that the edges of the two blinds make a slit that travels across the film. The faster the shutter speed set, the narrower the slit. The time taken for the slit to cross the frame remains the same at all shutter speeds.

Although all parts of the film may therefore receive an effective exposure of, say, 1/500, the top of the film is exposed well before the bottom, and the whole of the film area is never exposed simultaneously. Electronic flash can therefore not be used when a focal-plane shutter is operating at the faster speeds – the brief flash of light illuminates just a narrow band of the film.

The blinds of a focal-plane shutter are not necessarily made from fabric, though many are. Some shutters are made from a complex arrangement of sliding metal plates, or from thin sheets of titanium foil. The lower the mass of the shutter, the better, because light shutters can travel faster. The faster the shutter travels, the faster its top speed will be, and the faster will be the speed at which the whole film area is exposed simultaneously. This speed is the fastest speed at which the camera can be used with flash – the flash-synchronization speed.

SHUTTER SPEED AND MOVEMENT

Two alternative techniques for dealing with linear movement are shown here in the context of horse racing. In the larger picture (below), the camera has been panned with the horses to make the most of the shutter speed – the result is a blurred background of spectators at the finishing line. In the smaller photograph (below), at Ascot, a more oblique viewpoint onto the rails makes panning unnecessary. Both photographs are by George Selwyn.

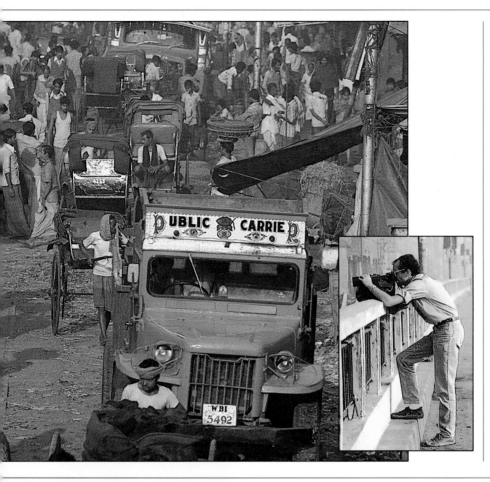

CAMERA-SHAKE

Besides arresting the images of moving subjects, fast shutter speeds also prevent movement of the camera from blurring the picture. Camera-shake causes especially bad problems when the camera is hand-held, but even mounted on a tripod, a camera can move significantly during exposure.

The slowest speed at which it is safe to hand-hold the camera is affected by the focal length of the lens in use. Telephoto lenses magnify the effects of camera-shake, while wide-angle lenses minimize them. A practical rule of thumb is that the slowest safe speed at which a lens can be hand-held is the reciprocal of the focal length. So standard lenses need speeds of 1/50 sec – effectively 1/60 sec, and a 135mm lens, 1/135 sec – for practical purposes 1/125 sec. Heavy lenses need a faster speed.

Long telephotos have inevitable camera-shake problems, because of the size and weight of the lens and because of the magnified image (the effects of camera movement are similarly magnified). Ideally you should mount the camera on a tripod or monopod, but if one is not available use every support possible, such as the soft shoulder bag and wall in the long street photograph (left).

Most focal-plane shutters have top speeds of 1/1000 second, and flash synchronization speeds of between 1/60 and 1/90. A few have top speeds as high as 1/2000 or 1/4000, and flash-synch speeds of 1/125 or 1/250.

STOPPING MOVEMENT

The importance of fast shutter speed lies in the camera's ability to freeze the motion of speeding objects. However, the shutter is not the only factor that affects this ability.

The apparent sharpness of a moving subject on film depends on how far the *image* of the subject moved in the course of the exposure. Consider two examples – an aircraft a mile or so from the camera, and a sprinter a few yards away. The aircraft may be travelling at hundreds of miles per hour, yet it takes, say, five seconds to cross the frame. During an exposure of 1/250, the image of the plane travels just 1/70mm or so – an undetectable distance. The runner, moving at say 10 mph, crosses the frame in a second, and his image moves 1/7mm during a similar exposure. When the photograph is enlarged ten times, the runner's image will have moved 7mm across the print, and the picture will be visibly blurred.

So, besides speed, the other factors involved are: subject distance, focal length of lens, direction of movement, and even the degree of print enlargement. If subjects are far off, moving towards or away from the camera, photographed with wide-angle lenses, and with the resulting images enlarged only a small amount, then even slow shutter speeds will arrest motion. Conversely, nearby subjects crossing the field of view, photographed with telephoto lenses and then greatly enlarged may be badly blurred, even at the camera's fastest shutter speed.

Of course, absolutely sharp images do not always evoke subject motion. They can look static and dull, like a bronze sculpture depicting a figure in motion. At slow shutter speeds the camera blurs the image of moving subjects, and this can create a more convincing image of movement. Again, though, the same factors govern how blurred the subject appears on film, and trial and error is the best way to learn the best speed to use.

MOVING SUBJECTS *Panning the camera to follow a moving subject, and using an intentionally slow shutter speed, can turn even the prosaic into a graceful design. By choosing a dark background – a group of trees – the seagull (above) was kept clearly visible even through a one-second exposure.*
Nikon, 400mm, Kodachrome, 1 sec, f32.

APERTURE

THE CAMERA'S APERTURE is just that – a hole through which light passes on its journey from the subject to the film. What makes the camera's aperture unusual, though, is that it is adjustable, from a tiny hole – almost a pinprick – to the internal diameter of the lens itself.

Together with the shutter, the aperture controls how much light reaches the film. The aperture does more than this, though; it also affects how much of the picture is in focus. Small apertures let through little light, yet they enable the camera to render most of the subject sharply. Large apertures let through more light, but record only a shallow plane clearly. Choosing the right aperture is not, therefore, just a matter of getting the exposure right – it is necessary also to take into account the nature and depth of the subject and how the scene before the camera is to appear on film.

THE IRIS DIAPHRAGM

The size of the aperture within the lens is controlled by the iris diaphragm. This is a series of crescent-shaped blades that makes a circular opening in the middle of the lens. Moving the blades enlarges or reduces the size of the central hole.

The aperture ring on the exterior of a manually operated lens, controls the size of the hole made by the blades – turning the ring back and forth enlarges and reduces the size of the hole. On rangefinder cameras and certain other types, the aperture setting ring and the iris diaphragm are directly linked, and looking in the front of the lens, it is possible to see the aperture closing down as the ring is turned. However, on single lens reflex cameras which use full aperture light metering, the linkage is more complicated, and until an instant before the exposure, the iris diaphragm remains fully open. Then, shortly before the shutter opens, the aperture closes down to the value preset by the photographer.

This rather complex arrangement is called a 'fully automatic diaphragm'. It is necessary because SLR cameras use a single lens for both viewing and focusing. Reducing the aperture of this lens prior to exposure makes the focusing screen darker, and the process of focusing less accurate. So it makes sense to keep the iris diaphragm wide open for focusing and composing the picture, closing it down just before the shutter opens.

Whereas the action of stopping down the lens diaphragm used to be the job of mechanical pins and linkages, the electronics revolution has changed the design of lens mounts on camera bodies. Electronic contacts have replaced mechanicals, and some manufacturers have done away with an aperture ring on the lens. Instead, the size of the aperture is either controlled automatically by the exposure mode in use, or by pressing or rotating controls on the camera body.

APERTURE CALIBRATIONS

The aperture ring on the lens is calibrated with a series of numbers that at first glance seems curious and almost random, though progressively increasing. The series usually starts at 2, 1.8 or 1.4, and increases to 4, 5·6, 8, 11, 16, and perhaps further to 22, or even 32. The numbers, in fact, are far from random, as closer scrutiny reveals; the series double at every other value.

These numbers are called f-stops, or f-numbers and are a measure of the size of the lens aperture. Each number though, is not the diameter of the aperture, it is the number by which the focal length of the lens must be divided to yield the aperture diameter. So the numbers can be written as f/2, f/16 and so on – f being the abbreviation for focal length.

For example, when a 50mm lens is set to f/2, the diameter of the aperture is 50/2, or 25mm. When referred to in speech, the numbers become 'eff-two' and 'eff-sixteen' – the oblique line is ignored.

This may seem like a very complicated way of measuring the power of a lens to transmit light. However, it has certain advantages. Telephoto lenses form a magnified view of the subject, compared with wide-angle or standard lenses. So the light from a given area of the subject is spread over a larger area of film with a telephoto lens. This means there is less light for any given aperture diameter. The f-stop system gets around this problem

SHUTTER AND APERTURE TOGETHER

The same level of exposure can be achieved with different combinations of shutter speed and aperture. In the first photograph (below, top) the aperture is small (giving good depth of field) and the shutter speed slow. In the next picture (below, centre), the settings are reversed. The photograph (bottom) is a compromise.

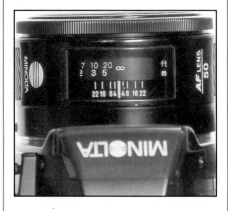

ABOVE *Minolta AF 50mm standard autofocus lens has no aperture ring because the aperture size is controlled electronically from the camera body.*

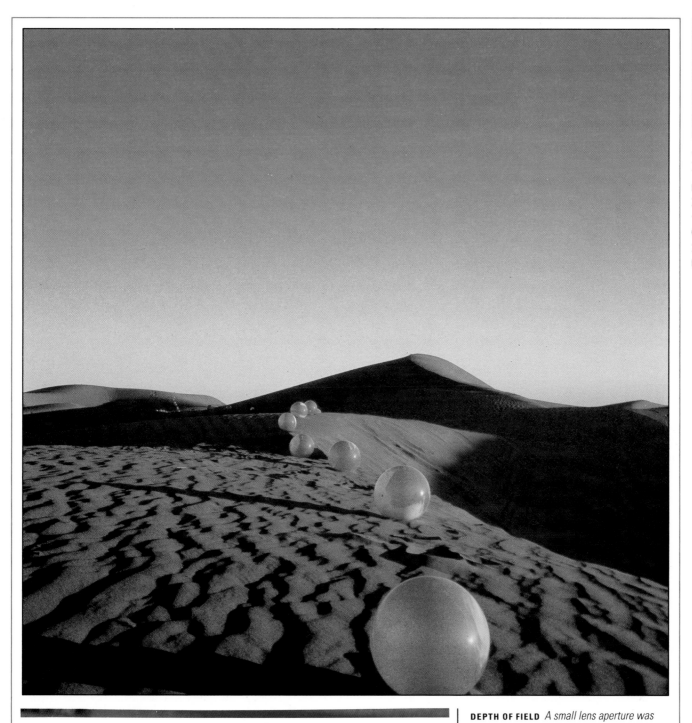

APERTURE AND FOCAL LENGTH

Lens focal length affects depth of field. With a long-focus lens, to give the same exposure, for any given f-stop, the actual diameter of the aperture must be larger than that needed by a lens of short focal length. As the diagram shows, to achieve as bright an image the aperture opening of the 180mm lens has to be much greater than that of the 35mm lens. Because the aperture is larger, the depth of field must be less.

DEPTH OF FIELD *A small lens aperture was vital for this imaginative picture (above), since it ensured depth of field from the ball in the foreground to the distant horizon.*

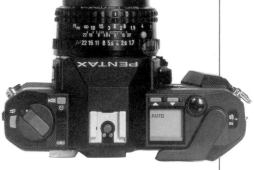

ABOVE *Pentax-A series 50mm standard lens shows the aperture ring close to the camera body.*

OPTIONS ON DEPTH

These two photographs (below) of a row of Buddhas in Bangkok's Wat Phra Jetupon were taken from exactly the same camera position at the same distance – 12ft (3.6m). The depth of field for the 180mm lens (top picture) encompasses only one Buddha, whereas the depth of field for the 35mm lens (bottom picture) is greater and extends to the two Buddhas on either side.

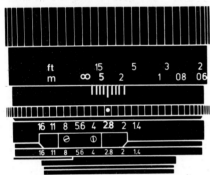

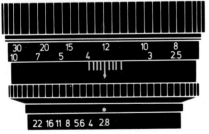

because it is independent of focal length. An f-number is a ratio, not an actual measurement, so that an aperture of f8 on a 50mm lens admits exactly the same amount of light as an aperture of f8 on a 400mm lens.

This is important when changing lenses. A photographer who is switching from one lens to another can maintain the same f-number on both lenses. If the aperture was measured in millimetres, instead of as a numeric ratio, lenses of different focal lengths would need to be set differently.

Why then the curious progression of numbers? Again the choice is quite logical. Each setting of the aperture ring lets through twice as much light as the one before, so with the lens set at f4, the image on film is twice as bright as at f5·6, and half as bright as f2·8. This doubling/halving sequence may be familiar – shutter speeds increase and decrease in a similar manner.

Note, though, that large f-numbers let through little light, and small f-numbers, such as f2, admit very much more light.

SHUTTER AND APERTURE

The matching progression of shutter speed and aperture makes setting of the two controls very easy and convenient. If the camera's meter indicates that a particular combination of shutter speed and aperture will give correct exposure, then moving each control by an equal number of increments – but in opposite directions – will not affect the exposure. For example, when the meter indicates that settings of 1/60 at f8 will give correct exposure, then equal exposure will be given by settings of 1/30 at f11 or 1/125 at f5·6.

Because altering the shutter speed by one setting is exactly equivalent in exposure terms to changing to the next aperture, the term 'stop' is commonly used to refer to both controls. 'Give one stop less exposure' means 'change to the next fastest shutter speed, or the next smallest aperture'.

Different combinations of settings suit different picture-taking situations – stopping fast action, for example, would mean choosing a fast shutter speed such as 1/1000 at f2. Generally, though, choosing the best combination means making a compromise between shutter speed and aperture.

DEPTH OF FIELD

Only one plane of the subject – the plane of sharp focus – is rendered absolutely pin-sharp on film. Subjects close to this plane but not actually in it are recorded less sharply, but they do not just snap suddenly out of focus. The transition from sharp to unsharp on either side of the plane of sharp focus is thus gradual and progressive.

In effect, subjects are in tolerably sharp focus not just in one plane, but over a range of distances – a zone of sharp focus. The depth of this zone is known as the depth of field.

Depth of field is directly proportional to aperture, and is least at wide apertures. Closing the lens down to smaller apertures increases depth of field, bringing more of the subject into focus.

When all of the subject must appear sharp, the lens must be stopped down to small apertures such as f11 or f16. However, great depth of field is not always desirable, and a photographer may deliberately choose a wide aperture to reduce the depth of field – perhaps to blur an unsightly background behind a portrait subject.

Aperture is not the only factor that influences depth of field. Focal length, subject distance and degree of print enlargement do too. Long focal length lenses have shallower depth of field, and wide-angle lenses more depth of field when compared with standard lenses. Similarly, depth of field increases in proportion to subject distance.

Enlargement is something that is frequently overlooked when considering depth of field, yet it is as important as focal length or aperture. Slight unsharpness that goes unnoticed on a contact sheet or on a transparency seen without a magnifier may render an image useless for great enlargements.

ESTIMATING DEPTH OF FIELD

On SLR cameras, the lens is set to full aperture until immediately before exposure, so the image on the focusing screen always shows depth of field as it is at the maximum aperture

MAKING THE BEST USE OF DEPTH OF FIELD

In this Indian cemetery in Taos Pueblo, New Mexico, the nearest cross was 23ft (7m) from the camera. With a 180mm lens focused on it (below), the other crosses were completely out-of-focus at the maximum aperture of f2·8. With the lens focused on the far cross (below, centre) – 33ft (10m) away – the nearest cross

became unsharp. The lens focusing ring was adjusted so that the 23ft (7m) and 33ft (10m) marks of the distance scale were equally spaced on either side of the central focusing mark. The depth of field scale showed that it was just possible to extend the depth of field to these near and far limits by stopping the lens

down fully to f32 (below, right). As the limits of the depth of field are not equally on either side of the plane of sharpest focus, this could not have been done simply by focusing on a point half-way between the nearest and farthest crosses.

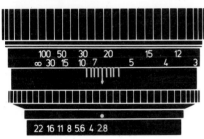

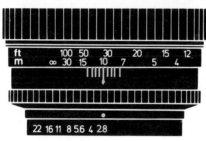

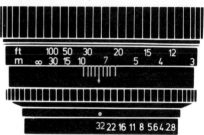

SELECTING VIEWS BY VARYING APERTURE

In the two photographs at left, a standard lens was focused on the distant trees. At f16, the minimum aperture, both foreground and background are equally sharp (top). At f1·2, however, the foreground is very much out of

focus, and acts as a frame (bottom). With a long telephoto lens, the loss of foreground sharpness can isolate a subject. With a 600mm

lens used at f16 (small picture in the pair below), the intervening grass almost obscures the image, in contrast to the main picture taken at f4.

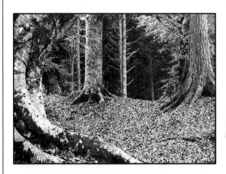

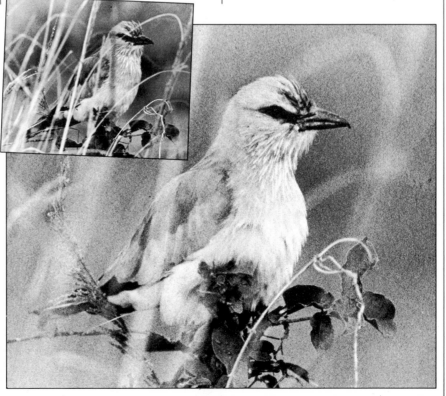

APPARENT DEPTH OF FIELD

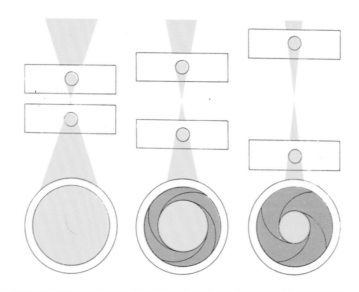

Depth of field depends on circles of confusion, the smallest circles in an image that the eye interprets as points (0.033mm is a standard measurement). In the diagrams above, the circles of confusion are represented in the pairs of rectangular panels (the near and far limits of the depth of field). The steepness of the cones of light on either side of the point of focus depends on the lens aperture, and this determines the depth of field.

of the lens. This can give a false impression of what the picture will look like – particularly if the aperture set on the control ring is a small one, such as f22. A typical result of this is that a background that looks blurred in the viewfinder appears sharp on film, revealing all sorts of unwanted detail.

To enable the photographer to preview the depth of field, many SLR cameras have a manual stopdown control, usually called the depth of field preview, that closes the lens down to the preset working aperture. Pressing this control makes the focusing screen much darker, but gives a truer picture of how the final picture will look.

Additionally, cameras of most types have a depth of field scale. This is a series of markings on the lens barrel that indicates how much of the subject will be in focus. The markings are either numbered or coloured to correspond to similarly coloured engravings on the aperture ring.

Depth of field can be calculated, too, provided the photographer knows the focal length of the lens, the aperture, the subject distance and the degree of enlargement. In practice, scales on the lens and observation of the screen image are of greater value than calculations.

SHARPNESS AND LENS APERTURE

No lens gives its best performance at full aperture. This is because at the edges of the lens, the glass elements have to bend light more than at the centre, and the greater the bending, the more the faults in a lens – the aberrations – are revealed. Stopping down the lens to a small aperture ensures that only the centre of the lens is used, so light needs to be bent very little to form the image and the performance of the lens improves.

There is a limit to the improvement gained by stopping down the lens. Usually the optimum aperture is two or three stops smaller than the maximum aperture. Stopping down to very small apertures may actually reduce sharpness.

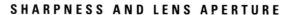

DEPTH CHECKS

1 Visually Depress the DOF preview button on an SLR.
2 Lens scale
3 Depth of field table
4 Equation

H = hyperfocal distance; F = focal length of lens; f = f stop; u = focused distance

a) Calculate the hyperfocal distance, H:

$$H = \frac{F^2}{f \times 0.033}$$

b) Near limit of field $= \dfrac{H \times u}{H + (u - F)}$

c) Far limit of field $= \dfrac{H \times u}{(H - F)}$

MAXIMIZE DEPTH

There is often more than one way of using depth of field, as in the examples (below), all shot with a 20mm lens.

1 At full aperture of f3·5 the depth of field appears only moderate when the lens is focused on infinity.

2 Also at f3·5, but focused at 0.3 metres, the depth of field appears much shallower.

3 At f3·5, focusing at the hyperfocal distance (3.5m) maximizes depth of field.

4 Full sharpness across the entire picture needs both focus on the hyperfocal distance (0.6m) and a small aperture (f22). The wider the angle of view of a lens, the greater depth it can give.

HYPERFOCAL DISTANCE

When a lens is focused on infinity, depth of field ensures that subjects in the middle distance are still sharp. The depth of field on the far side of the plane of sharp focus, though, is wasted – for there is nothing beyond infinity.

This 'wasted' part of the zone of sharp focus can be put to good use by positioning the infinity symbol opposite the depth of field marking for the chosen aperture, instead of opposite, the focusing index (as here). All the zone of sharp focus will then be on the near side of infinity – and more of the picture will be sharp.

When the infinity symbol (like an 8 on its side) is positioned opposite the depth of field mark, say, f16, the main focusing index will point to a setting known as the hyperfocal distance. This distance varies with the aperture – at small apertures, hyperfocal distance is closer to the camera than at large apertures.

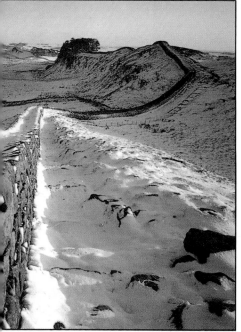

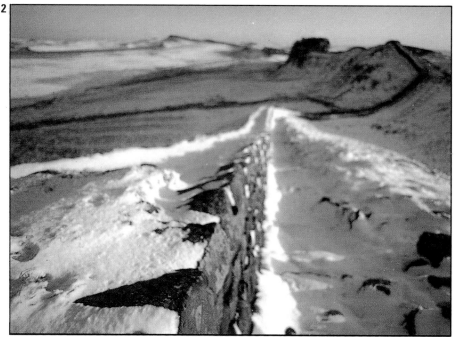

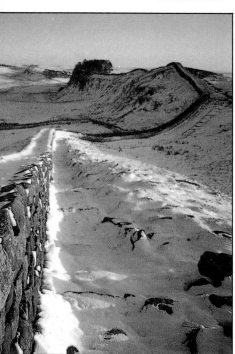

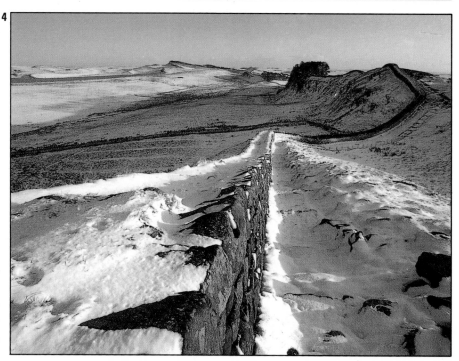

EXPOSURE

EXPOSURE IS THE PRODUCT of the *intensity* of light that reaches the film, and the *time* this light falls upon the film. On this simple formula, fundamental to all photography, a very complicated structure of camera technology and individual creative decisions has been built, necessary in the eyes of some photographers, a distracting burden to others.

The intensity of light striking the film depends on the brightness of the scene in front of the camera, and on the size of the lens aperture. The brightness of the subject is controlled by its own arrangement of tones and colours, and by the intensity of the light source. It is, therefore, possible to break down the process of exposing film into this sequence:

1 Light of a certain intensity falls on a subject that may be light or dark, shiny or matt.

2 The product of this is reflected light, which passes through the camera's lens.

3 The aperture of the lens can be adjusted to allow more or less of this light through.

4 Inside the camera, the light has to travel a certain distance. The longer this is, as in close-up photography, the less intense the illumination at the film plane.

5 The sensitivity of the film, slow or fast, determines how much exposure it needs to record a particular image.

6 Finally, the shutter can be set to different periods of time, from a few thousandths of a second to several hours.

Essentially, exposure entails adjusting the amount of light that reaches the film so that the result, when processed, appears as the photographer wants it to. But this simple statement disguises a whole world of problems. While in a technical sense there are only two camera functions involved in actually making the exposure – the shutter speed and the size of the lens aperture – achieving a satisfactory image involves a complex mixture of sensitometry and personal taste.

Sensitometry is the study of the effect of light on light-sensitive materials. A certain amount of exposure of light will, when the film is developed, produce a given density in the silver or dye, and this can be calculated precisely. The characteristic curve graph is the standard sensitometric way of displaying this, and from this curve the results of particular camera settings can be worked out.

For any given film and picture situation, there is one particular exposure that will record the maximum amount of information. For a fairly typical outdoor scene photographed on a medium-speed black-and-white film (ISO 125, for example) this exposure might be (1/125 second at f8). Less exposure than this would result in less information being recorded in the darker, shadowy areas of the picture – a negative would be thinner and a transparency denser. More exposure would cause the highlights to 'block up', losing the detail in these brightest parts of the photograph – a negative would be dense with silver or dye, a transparency weaker.

This is an objective way of looking at exposure, making the most of any film's ability to carry tones and detail. However, maximum information is not the same as 'best' and the idea of correctness in exposure has grown to be something of a millstone for many people. A major concern for a large number of amateur photographers is achieving an acceptable exposure, a concern that may well distract attention that could be better spent on more interesting picture decisions. The response from camera manufacturers has been to apply more sophisticated technology to automatic and programmed exposure modes than to any other area.

CONTRAST RANGE AND LATITUDE

If the only kind of subjects that film had to record were of a single tone – a grey stone wall, for example – exposure decisions would be fairly simple. In fact, most scenes have a variety of tones, from light to dark, and this is called the *brightness range*. This range can be quoted as a ratio, such as 1:50, or more usefully for photographers as the number of stops of exposure difference.

Even those subjects that may look at first glance to have little difference between the darkest and brightest areas, such as a figure in diffuse lighting, may contain surprises when measured.

EXPOSURE MODES

Exposure modes and programs may differ in detail, but they are all designed to do the same job, namely to ensure correct exposure on the film, on the basis that the subject is evenly lit, and even in tone. They rely on TTL (through-the-lens) light metering and do not take into account the latitude of the film in the camera, or that the subject may be backlit or contrasty, or either much darker or much lighter than its surroundings.

Metered Manual The grass roots exposure mode which relies on the photographer to set the shutter speed and lens aperture, using a light meter reading shown in the viewfinder as a guide for an average exposure.

Aperture Priority AE The photographer sets the lens aperture he/she wants to use and the camera automatically sets a shutter speed which will give a correct average exposure.

Shutter Priority AE The photographer sets the shutter speed and the camera automatically provides a suitable aperture for correct exposure.

EXPOSURE PROGRAMS

Normal Program Also called standard program, this program is designed to automatically provide the correct shutter speed and aperture for an average exposure according to the light coming through the lens.

Tele Program Also known as Hi or High Program, this program also provides shutter speed and aperture automatically but it is biased towards fast shutter speeds. This serves a triple purpose in that it will help freeze action, especially if fast film is used; it will help prevent camera shake especially when telephoto lenses are used and it will give large lens apertures which will help to throw the background out of focus.

Wide Program Also known as Low or Lo Program, this mode again sets shutter speed and aperture automatically but it is biased towards small apertures giving good depth of field and slower shutter speeds. Even so, a wide program is likely to have a low shutter speed which will avoid camera-shake in hand-held photography.

Program Shift A mode within a mode, this makes all other exposure modes and programs redundant since it provides shutter speed and aperture automatically, but the photographer

THE EXPOSURE LATITUDE OF COLOUR FILM

This sequence of exposures, each varying by one stop, shows how one popular make of colour film, Kodachrome 64, reacts to different quantities of light. The through-the-lens meter reading, averaging all the tones in this scene of an Indian pueblo in New Mexico, indicated an exposure of 1/30 sec at f11. This is the exposure shown centrally. With one stop more exposure, the sky is noticeably affected; it is less intense and has a slight greenish tinge. With yet another increase in exposure, large areas of highlight become a featureless white, while the most extreme over exposure (below, top) records virtually no hues and very little detail. Decreasing exposure, shown in right-hand column, is subjectively more acceptable to many people. One stop under exposure seems quite satisfactory, with little loss of shadow detail and an actual improvement in colour saturation. With progressive under exposure, shadow areas become featureless.

1/30 sec f8 = +1 stop

1/30 sec f22 = −2 stops

1/30 sec f4 = +3 stops

1/30 sec f11 = TTL reading

1/60 sec f22 = −3 stops

1/30 sec f5·6 = +2 stops

1/30 sec f16 = −1 stop

1/125 sec f22 = −4 stops

can adjust each individually at will.

TV Program A special program which automatically sets a shutter speed suited to taking pictures from the TV screen or a monitor, and matches it with a suitable aperture.

Depth Program A special Program designed to give maximum depth of field for the lens and aperture in use.

Intelligent Programs The term given to self-setting programs which automatically adjust to suit the focal length of the lens in use. For example, lenses of between 35mm and 70mm focal length will set a Normal Program, while lenses of shorter focal length set a Wide Program, and longer lenses a Tele Program. Electronic contacts in the camera's lens mount automatically detect the lens type fitted and the appropriate program is set.

Two commonly used words in this respect are *shadow* and *highlight*. Precisely, they refer to the extremes of tone in a scene that contain useful or desirable detail and they set the limits of the brightness range.

Film emulsions vary in their ability to record all of a wide brightness range. The ability to record extremes of brightness is the film's *contrast range*. The contrast range of a slow black-and-white film, for example, is shorter than that of a fast emulsion; it is, in popular terms, 'more contrasty'. The contrast range of a transparency is shorter than that of a negative, and that of a negative longer than that of a print made from it. For practical purposes, the range of most negative films is about seven stops and that of most trans-parency films is about seven stops and that of most transparency films about five stops. Most instant films have shorter ranges – less than four stops for the most popular integral prints – and line films the least of all.

Now, if the contrast range of the emulsion is the same as the brightness range of the subject, one exposure setting will make the ranges match. Everything from the shadow detail to the highlight detail will be recorded.

Understandably, this does not happen all the time. If the brightness range of the subject is less than the range of the film, then there is a choice of exposures that will deliver an acceptable, recognizable image. This spread is the *latitude* of the film. So, with a 'flat'

READINGS IN NON-AVERAGE CONDITIONS

This selection of pictures illustrates how the combination of varied lighting and differently toned subjects easily produces views that would be mishandled by an averaging meter.

1 The extreme contrast between the shiny mosaic pattern on the pyramid roof and the shadowed building behind is beyond the five stop range of a typical colour slide film. The double choice offered here (a two stop difference exposure), depends very much on what is considered important in the picture. Note that the placement of the key detail differs.

2 In this photograph, the most important consideration was that the large area of white should appear white in the photograph. Yet an averaging meter could easily be fooled into indicating too little exposure for a reading from the white and too much from darker areas. The correct exposure was given by adding two stops to a direct reading from the white.

3 Back-lighting offers a fairly wide choice of exposure. In this example, shot for a silhouette, details of the boatman were considered unimportant, but the colour was felt to be important. Consequently, the sky was the key element in the reading, and the exposure was set to only ½ stop more than the average direct reading.

4 The mixture of subject tone and lighting in this picture stretches the capacity of colour transparency film a little too much, so the exposure was set for the reading off the adobe wall. This setting preserved detail on the cross but rendered the deep blue sky even darker than it appeared to the eye.

5 For this picture, the only consideration was that the rich colour of the sky should be retained, while the rest of the picture could be in silhouette. So the photograph was exposed for the sky.

1

3

2

● **KEY DETAIL**
○ **DARKEST SHADOW**
▽ **BRIGHTEST HIGHLIGHT**
□ **AVERAGE TONE**

5

4

EXPOSURE

TTL METERING

Now by far the most common system of light measurement used in photography, through-the-lens metering has developed a variety of measuring patterns. A spot measurement is the most selective; an average reading is indiscriminate; centre-weighting pays little attention to the frame edges; multi-pattern metering calculates exposure under different conditions.

Spot

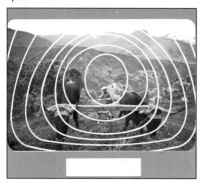

Centreweighted

Average

Multi-pattern

PRINT LATITUDE

With no fill lighting to alleviate the shadows, this photograph of a cellar door opening out onto a sunlit courtyard has an extremely high contrast range – beyond the capacity of either the negative or print. However, what is obvious is that the negative carries much more information at the high and low ends of the tonal scale than does the print – even though this has been enlarged carefully. As this demonstrates, the latitude of a negative is usually greater than that of a positive, whether a print or film.

104

subject, such as a block of weathered stone under a cloudy sky, a normal negative emulsion will have a reasonable amount of latitude. This can, at the least, allow for errors in making the exposure.

The other side of the coin, however, is when the subject has a long brightness range and the film has a short contrast range – that is, when both are 'contrasty'. Not only is there no latitude, but all of the tones in the scene *cannot* be recorded. In this common case, something has to give, and the decision can only realistically be made by the photographer, using judgement.

COMPROMISE

In a situation where the film cannot cope with the range of tones in the scene, there are a number of things that can be done. Sometimes the lighting can be adjusted – in the studio a typical solution would be to add shadow fill with a reflector or another lamp, while outdoors fill-in flash might be used. An alternative might be a neutral gradated filter to make part of the image, such as the sky, seem less bright. It may also be feasible to alter the contrast range of the film, by reducing its development.

However, these manipulations apart, the most common of all exposure problems is to decide on the setting when either highlight or shadow detail is bound to be lost. Then, the priorities of the image have to be followed. It is not enough to make an average exposure when the result can leave an area of sky washed out or when an essential part of the picture is deep in shadow. The subject itself, and the reasons for the photographer wanting to take the picture, come into play. Most experienced photographers in this type of situation quickly run through the visual consequences of different exposures in their minds, even if they make no conscious effort.

The exposure compromise is also affected by the film. With transparencies and with instant prints, the image is produced in one step, while negatives need a second stage – printing. Normally, washed-out highlights are more objectionable than over-dark shadows, so underexposure tends to be more favoured with transparencies and instant prints. With negatives, underexposure does not lead to washed-out highlights and there is always the chance of putting some tone back during enlargement.

WORKING METHODS

Most modern cameras have built-in exposure meters that measure the light reaching the film. However, measuring the light reflected from the subject is only one of three basic metering methods, each with its advantages and limitations.

Direct, or Reflected Light Reading In this, the brightness of a scene is measured directly. This naturally takes into account both the tones and textures of the subject, and the level of illumination. A basic direct-reading meter simply averages the different levels of brightness in the view that it takes in, and with most subjects the results are acceptable most of the time. If the meter is inside the camera, close to the film, it will also take care of such additional factors as light lost through filters or through lens extensions for closer focusing.

The main problem with direct-readings is that the meter cannot discriminate between, say, a whitewashed wall and a black dress. It will, instead, give the reading that would record both as mid-grey. Direct-readings work well for average subjects, but may be misleading for subjects with extreme tones.

Incident Reading By measuring the light falling (incident) on the subject, any problems of tone in the subject can be ignored. This is done by fitting a translucent diffusing attachment over the meter's cell or the camera lens with TTL meters. The meter is then placed next to the subject, usually pointing towards the camera position. In situations where the lighting is consistent (and particularly where it can be controlled), incident readings are simple and have a high level of accuracy. They too, however, are less capable with very bright or very dark subjects, but in a different way – an incident meter will suggest slight overexposure of a bright object and underexposure of a dark one, the exact opposite of a direct-reading meter.

HAND-HELD METERS

The earliest light meters were entirely separate from the camera, and although for convenience and speed many photographers now prefer metering systems that are built into the camera body, these hand-held meters still remain popular, and useful. In particular, they are used by professional photographers in situations where there is both sufficient time to make detailed measurements and complex lighting that might fool a TTL meter. One special advantage of a hand-held meter is that it can be easily carried around to different corners of a set.

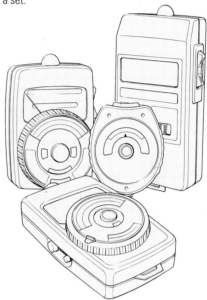

DIFFICULT EXPOSURE CONDITIONS

Most unusual, non-average exposure situations fall into one of the following categories (the numbers correspond to the photographs):

1 Light subject, dark setting The bird is the important detail, but appears so small in the frame that only a spotmeter reading would be useful, and this would normally be impractically slow to make. One solution is to take an incident reading in the same strength of sunlight, another is a substitute reading of an area of average tone also sunlit, outside the picture.

3

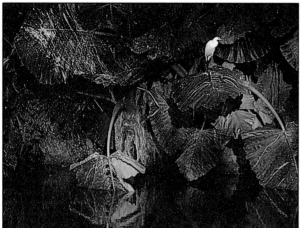

1

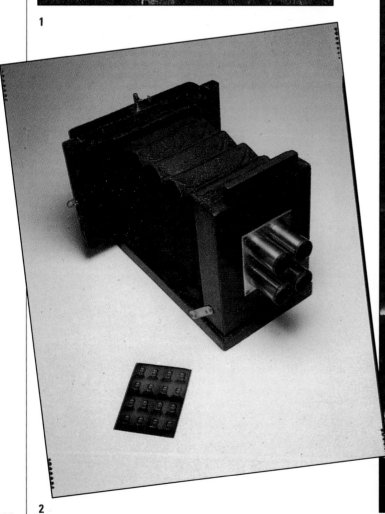

4

2

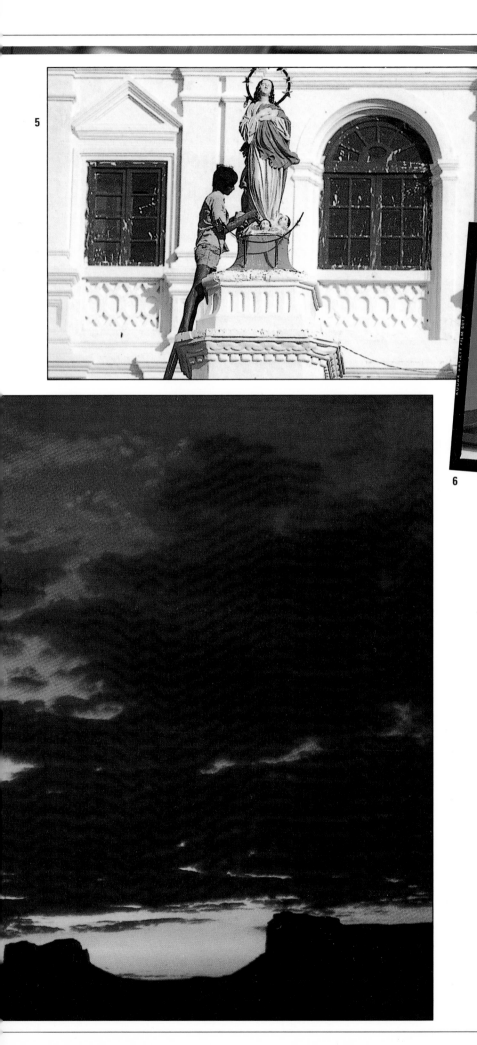

2 Dark subject, light setting A direct reading of neither the dark subject nor the white setting would be useful, and an average reading would be uncertain. The normal solution for a studio shot such as this is to take an incident reading, or a substitute reading directly off an 18% grey card.

3 High lighting contrast Here, the scene has a higher brightness range than a normal film could handle due to the lighting – sunlight verses shadow. As overexposed bright areas are usually unacceptable, the normal solution is to silhouette the foreground figures by exposing for the background – with an SLR a 'spot' reading can be taken with the TTL meter.

4 Overall dark As envisaged, this landscape was to remain dark – an average exposure treatment would lose the drama. Consequently, the exposure was worked out on a rule of thumb basis – two stops less exposure than a TTL reading indicated. For later choice, a bracketed range of exposures was also made.

5 Overall light This telephoto shot of a white painted cathedral facade was intended to appear realistically white. Once again, the basis of the setting was a direct TTL reading, but the exposure given was one stop more than indicated.

6 High subject contrast White paint against a rich blue sky here gives a contrast range of about six stops – rather too much for colour transparency film. For an exposure that held detail in the paintwork and allowed the sky to appear darker, a spotmeter reading of the white was increased for the exposure by two stops.

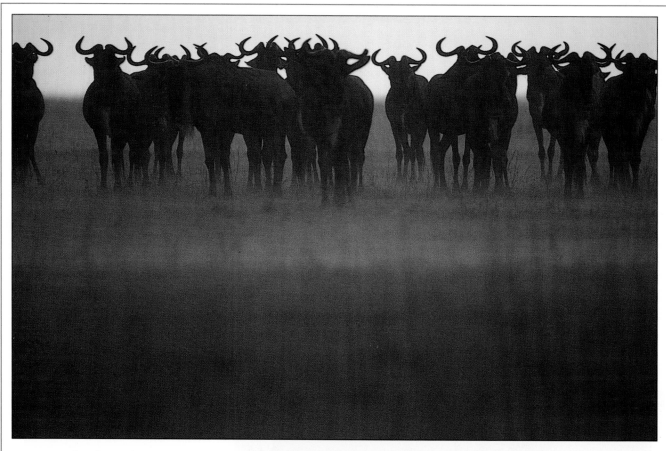

WILDEBEEST *In a picture where colour and details are suppressed, in this case largely by heavy rain, the outlined horns and heads set up a horizontal rhythm across the frame that becomes the dominant element. The photographer could have shown more detail in the wildebeest by increasing exposure, but chose not to.*

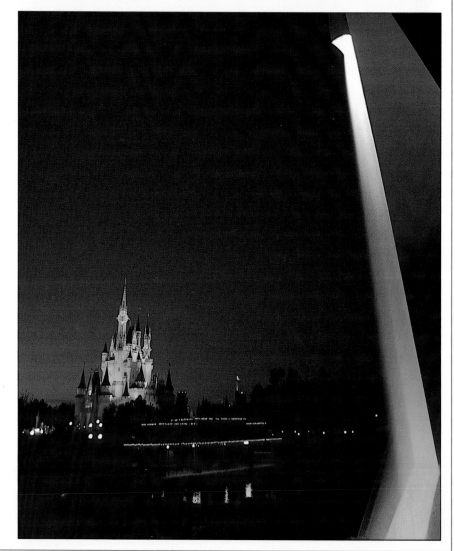

NIGHT SHOTS *Photographs taken at night are notorious for providing exposure difficulties. Here, it is advisable to bracket exposures, starting with a reading from the most important subjects and then bracketing, for example, two stops in either direction.*

SPOTMETERS

Also a hand-held meter, but operating on a different principle, a spotmeter makes direct (reflected light) readings over an extremely small area. Using a lens system similar to that of a simple camera, the spotmeter's display (below) indicates the small central circle which alone is used for measurements – its acceptance angle is normally only 1°.

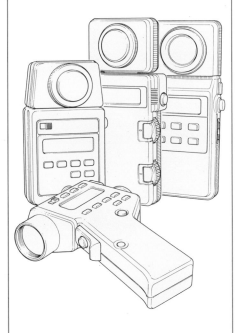

Substitute Readings One reason for metering problems with the direct method is that the main subject may be surrounded by areas that are much lighter or darker, and so affect the reading – a bird flying against a light sky, for example. An alternative method is to take a direct reading of a substitute surface nearby. The most logical substitute would be a matt, mid-toned surface, and such 'grey cards' are available from suppliers such as Kodak. In fact, any surface, coloured or neutral, that reflects 18 per cent of the light will do – this level is the average. Some photographers use the palm of their hand, adjusting the setting slightly (Caucasian skin is in the order of one stop lighter than a mid-tone). Another method, particularly useful in dim light, is to read a pure white surface and then reduce the exposure shown by about 2½ stops.

Of these three metering methods, each has some special advantage in certain situations, but personal preference also plays a large part. Experience, and constant practice at making readings, is the most valuable commodity in measuring exposure.

Just as there are three main methods of metering, so there are three types of reading:

Average This is the most basic, in which the entire scene is measured over an angle of view similar to that of the camera's lens.

High-Low Measuring the brightest and darkest parts of the scene shows the brightness range – an important reading if the scene appears to be contrasty or, indeed, if it seems flat and calls for some method of increasing the contrast. A spot meter, which usually has an acceptance angle of about 1°, is ideal for this more precise reading.

Key In extreme or unusual exposure conditions, it is often better to decide which is the important part of the scene to be recorded, and to measure just that. Again, spot meters are ideal for such detailed, key readings.

INDIVIDUAL CHOICE

Exposure decisions clearly involve the photographer's own ideas, and while there are certain objective guidelines to 'correctness', personal taste is the final arbiter. Even scenes that have no excessive contrast and will record satisfactorily on any film with an average meter reading are open to interpretation. A landscape at dusk, for example, can be photographed so that the tones are average and most of the details can be seen; all it needs is sufficient exposure. However, it might be preferable to underexpose so as to convey the darkness of the scene rather than the maximum information. In a transparency, less exposure will give more saturated colours and many photographers prefer to 'under-expose' slide film by half a stop or so. Overexposure in certain conditions will increase flare, give a pastel-like finish to colours, and create a less realistic, light-soaked appearance. These, and many others, are decisions about how the image should look, and can be made only by the photographer.

SHUTTER SPEEDS (Sec.)

f-numbers	1	1/2	1/4	1/8	1/15	1/30	1/60	1/125	1/250	1/500	1/1000
1	0	1	2	3	4	5	6	7	8	9	10
1.4	1	2	3	4	5	6	7	8	9	10	11
2	2	3	4	5	6	7	8	9	10	11	12
2.8	3	4	5	6	7	8	9	10	11	12	13
4	4	5	6	7	8	9	10	11	12	13	14
5·6	5	6	7	8	9	10	11	12	13	14	15
8	6	7	8	9	10	11	12	13	14	15	16
11	7	8	9	10	11	12	13	14	15	16	17
16	8	9	10	11	12	13	14	15	16	17	18
22	9	10	11	12	13	14	15	16	17	18	19
32	10	11	12	13	14	15	16	17	18	19	20

Exposure values The exposure value, or EV system, consists of combination numbers that are proportionate to the amount of light reaching the film. They combine, therefore, aperture and shutter speed, which are now always stepped by doubling and halving.

EXPRESSWAY *Diagonals tend to convey movement, and never more simply than in this downward view. Several lines and the flow of vehicles repeat the direction, while the strong backlighting from the afternoon sun removed colour and form, making an abstract design composed of shapes and lines.*

LIGHTING

THE BASIC SOURCE of illumination for most photography is either sunlight or artificial light. The sun furnishes a virtually endless variety of lighting conditions – from the hard direct light of the overhead sun to the shadowless enveloping light of thick fog. Even moonlight is a reflected version of sunlight.

By contrast, artificial light has many different sources. For practical purposes, the photographer differentiates between that over which he normally has no control, such as streetlights, and that which he intentionally provides, such as studio lighting.

The quality of light from all these sources varies enormously. The tonal differences are immediately obvious to the eye – compare the smoothly graduated tones under an overcast sky with the extreme contrast in objects lit by a car's headlights. Less obvious are the differences in colour. This is partly because our vision accommodates small colour changes in the overall light source so that we think we are seeing by white light when we are not.

COLOUR AND WAVELENGTH

The colour of any light source is determined by its wavelength. However, most light sources emit not just one single wavelength but many. They have what is called a continuous spectrum; if they radiate more energy at some wavelengths than at others, then they have a definite colour. Some artificial light sources, on the other hand, radiate energy in just a few narrow lines of the spectrum. Sodium and mercury-vapour lamps are

COLOUR TEMPERATURE

From candlelight at this end to the reflected light from a blue sky at the other end, this scale covers the range of colour temperatures most likely to be met in photography. The lower colour temperatures are associated with longer, redder wavelengths; the higher ones with shorter wavelengths that contain more blue. Noon sunlight, in the middle, is balanced. Individually, any colour temperature within this scale may appear white to the eye, which can adjust to these differences, but in photography the film and filters must be chosen to match.

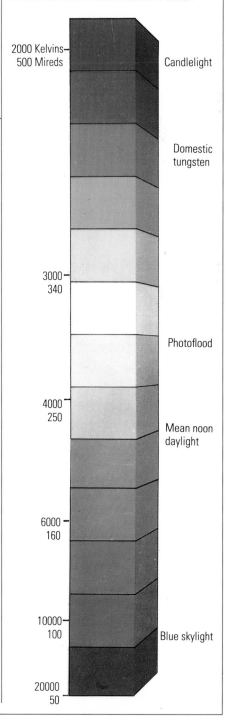

COLOUR CONVERSION FILTERS

A wide range of filters are available to raise or lower the colour temperature of light reaching the film. The table below shows which filters you can use with which films to produce a normal lighting effect. Adding filters reduces the effective film speed. The mired scale gives the exposure increase you will need.

To work out your own filter requirements it is easiest to work in *mired shift values* which are a constant rating at any part of the scale of colour temperature. The mired scale (below the table) is calculated by multiplying the reciprocal of the colour temperature by one million

(eg daylight at 5500°K has a value of $\frac{1,000,000}{5500} = 182$). To convert any light source to any colour temperature find the difference on the mired scale and then select the filter, or combinations of filters, which have that value. For instance, the difference in the mired values between 5000°K daylight (182) and 2900°K tungsten lighting (345) is 163. To raise the colour temperature means lowering the mired value, for which you would need, in this case, an 80A filter (−131 mired shift value) and an 82B filter (−32 mired shift value) combined.

Light source	5500°K	3400°K	3200°K	2900°K	2800°K
Film type					
Daylight	No filter	80B	80A	80A + 82B	80A + 82C
Tungsten type A	85	No filter	82A	82C + 82	82C + 82A
Tungsten type B	85B	81A	No filter	82B	82C

Mired shift values for Kodak filters

Filter (yellowish)	Shift Value	Approx. increase	Filter (bluish)	Shift value	Approx. increase
85B	+131	⅔	82	−10	⅓
85	+112	⅔	82A	−18	⅓
86A	+111	⅔	78C	−24	⅓
85C	+81	⅔	82B	−32	⅓
86B	+67	⅔	82C	−45	⅔
81EF	+53	⅔	80D	−56	⅔
81D	+42	⅓	78B	−67	1
81C	+35	⅓	80C	−81	1
81B	+37	⅓	78A	−111	1⅔
86C	+24	⅓	80B	−112	1⅔
81A	+18	⅓	80A	−131	2
81	+10	⅓			

Colour temperature scale labels:
- 2000 Kelvins / 500 Mireds — Candlelight
- Domestic tungsten
- 3000 / 340 — Photoflood
- 4000 / 250 — Mean noon daylight
- 6000 / 160
- 10000 / 100 — Blue skylight
- 20000 / 50

like this, and therefore have discontinuous spectra. Fluorescent tubes combine both kinds of spectra – as well as radiating in just a few spectral lines, they contain phosphors inside the tube that fluoresce at longer wavelengths.

COLOUR TEMPERATURE

Once method of describing the quality of light sources is on a scale of colour temperature. A solid substance, such as a piece of metal, begins to glow red when it is heated to a particular temperature. The hotter it becomes, the whiter it glows, and at very high temperatures, provided it undergoes no chemical changes, it glows blue. It is not the actual composition of the substance which is important, but the temperature which defines the colour precisely, on a scale from red, through white, to blue. Strictly speaking, this is intended only for measuring incandescent lights, but in practice it can include daylight and even fluorescent light. What makes it a particularly useful scale is that the differences between light sources can be measured, and it is quite a straightforward matter to select the right film for the light source and to choose filters that correct the light for the film you are using.

Colour temperature is measured in kelvins – similar to degrees celsius, but starting at absolute zero – and occasionally by mired value which is a reciprocal of the kelvin measurement 1 million/kelvins. The practical value of the mired scale is that the differences between points on it are constant, which facilitates the use of conversion filters.

The scale illustrated here gives the colour temperatures of many of the light sources encountered in photography, but a colour temperature meter is the most accurate method of measurement. The key value for photography is *mean noon sunlight* – 5400°K, the average colour temperature of direct sunlight at midday in Washington DC.

Remember, however, that the light from fluorescent tubes and other sources with discontinuous spectra does not fit particularly well into the colour temperature scale and cannot be measured with a colour temperature meter. Treat them as special cases.

NATURAL LIGHT

One single light source illuminates the Earth, yet with the help of an atmospheric screen and a constantly changing pattern of clouds, water-vapour and dust particles, it creates an infinite variety of lighting conditions. Several factors determine the direction, quality and colour of natural light. For most occasions a photographer need only consider four: season, time of day, weather and atmospheric conditions. Altitude and latitude also affect the quality of natural light, but this only becomes noticeable when you are working at very high altitudes or close to the Equator.

No studio can reproduce the variations of natural light, which can bring surprise and unpredictability to outdoor photography, but we can think of the outdoors as an enormous natural studio set. The atmosphere is an envelope, partly a diffusing screen for the sun,

AN OUTDOOR STUDIO

Thought of as a large studio set, any outdoor scene contains light source, diffusers and reflectors. The sun is a constant spotlight, changing angle throughout the day. The sky acts as both diffuser (more effective when the sun is low and its rays have to pass through a greater thickness of atmosphere) and reflector, making shadows blue during the middle of a cloudless day. Clouds, mist and fog are more variable but stronger diffusers and reflectors. Some light is even reflected back from the ground.

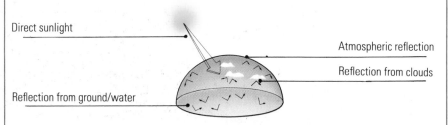

Direct sunlight

Atmospheric reflection

Reflection from clouds

Reflection from ground/water

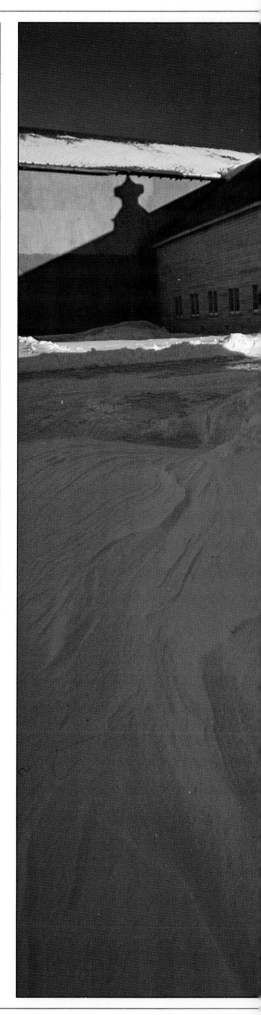

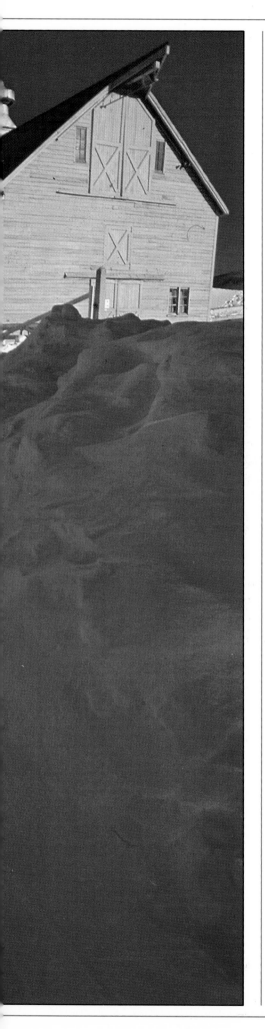

SHAKER FARM, NEW ENGLAND

With the sun high on a cloudless day, shadowed areas receive most of their illumination from the blue sky (left). Ordinarily this is not very noticeable, but with a highly reflective white surface, such as this snow bank, the effect can be striking.
Nikon, 20mm, Kodachrome, ⅟₁₂₅ sec, f11.

PARTHENON AT DAWN

Less than half an hour before sunrise, the eastern sky over Athens is a definite pink (below). At this low angle, the sun's rays have to pass through a large body of atmosphere and this scatters the blue and ultra-violet wavelengths. Sadly, it is the city's infamously high level of pollution that makes this scattering so strong.
Nikon, 180mm, Kodachrome, ¼ sec, f2·8.

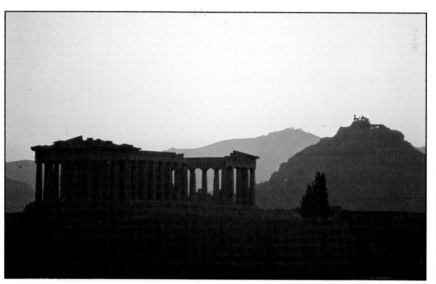

and partly a larger reflector (a little light is also reflected back from the ground, more from snow, sand and other bright objects). Finally, a constantly changing and drifting screen of clouds and suspended particles function as a complex array of filters.

To understand the properties of this large natural studio, consider first the basic lighting set-up – the passage of the sun through a clear sky. Because our eyesight has evolved under the light of the sun, we think of normal midday sun as standard, and judge other colours against it.

When the sun rises and sets, natural light appears much warmer – anything from yellow to red. This is because the atmosphere acts as a screen, scattering some wavelengths and passing others. Short wavelengths, at the ultra-violet and blue end of the spectrum, are those most affected; as the sun clears the horizon, its light is passing through the greatest thickness of atmosphere, and the short blue wavelengths are scattered so much that only the longer green and red hues can penetrate. Whatever particles are in the air, even if just a light haze of water-vapour, reflect this warm light.

As the sun rises higher, it shines through a less heavily filtered sky, and appears a purer white. The same scattering that gave the pink hues of sunrise now makes the sky blue, because the short blue wavelengths are scattered less (they now penetrate) and also bounce around the air molecules to give an overall blue cast. This skylight is a vast bluish reflector, and shadows, particularly on neutral tones such as snow, are recorded blue on film (the human eye tends to ignore this cast when looking at the original scene).

DOUBLE ARCH, UTAH

At midday, the overhead sunlight is difficult to work with, and usually gives unattractive modelling. One exception is a subject such as these sandstone formations in Arches National Park (below), where the shapes are definite enough to benefit from the stark lighting. *Nikon, 20mm, Kodachrome, 1/125 sec, f11.*

SWANS, WESTERN SCOTLAND

When the sun is just a short distance above the horizon, it reflects strongly off any flat, reflective surface (below). By shooting directly into these reflections colours are submerged and contrast increased to the point where the images can be virtually silhouettes. *Nikon, 400mm, Kodachrome, 1/500 sec, f22.*

CASTILLO SAN FELIPE, CARTAGENA

Well after sunset, or before sunrise, little light is left but a violet afterglow (below). The effects can be subtle, but can generally only be used for silhouettes. *Nikon, 35mm, Kodachrome, 1/8 sec, f1·4.*

EARLY MORNING AND LATE AFTERNOON *These are the best times for general photography. The texture of a landscape can be shown to its best advantage in low, reddish sunlight (below right), while reflections of low sunlight on water can lend atmosphere to an evening shot (above right).*

At its zenith, the sun casts the sharpest and deepest shadows (its disc actually covers only ½° of arc), and the contrast range is at its greatest. In summer, or close to the Equator, the midday sun is most nearly overhead, and this flat, formless lighting is the most difficult to work with. Most scenes benefit from a lower angle of sunlight, but the very starkness of an overhead sun can be effective with a scene that has inherently strong shapes or tones. Of course, at high latitudes, the sun always remains close to the horizon.

The afternoon and evening are essentially a repetition of the morning, in reverse. Most photographers prefer the lighting at the beginning and end of the day when the quality of light changes most rapidly. A few hours before sunset (or after sunrise), the sun is low enough to use as backlighting without appearing in the shot and creating flare in the image. This is the best time to use the strong reflections of sunlight from water and polished surfaces, which can give graphic silhouettes.

Sunset is a re-play of sunrise. In a clear sky, light from the reddish sun has little to reflect off, and such sunsets are not spectacular. Dusk is often more interesting, when the filtered light from below the horizon illuminates a graduated scale of subtle hues.

As the light fades, it passes below the threshold of our colour vision and we experience night-time as shades of grey and black, even in moonlight. In fact, the moon is simply a

FARM BY MOONLIGHT

In theory, a scene photographed by moonlight should appear almost identical to the same view by sunlight (below). However, the long exposures necessary at night cause shadow softening, and reciprocity failure gives the greenish cast.
Nikon, 20mm, Kodachrome, 30 mins, f3·5.

RICE FIELDS, NORTHERN THAILAND

The muggy heat haze over these flooded fields is almost as dense as a fog, acting as a very efficient diffuser of sunlight so that shadows are virtually eliminated (below). The haze also separates the planes of huts and trees, increasing the sense of perspective.
Nikon, 400mm, Kodachrome, 1/125 sec, f6·3.

THE BOXER *Because the boxing ring was so dimly lit, a daylight-balanced film was used for its extra sensitivity (ISO 400) with tungsten lighting (above). The result is red but still acceptable.*
Nikon, 180mm, Ektachrome (daylight), 1/125 sec, f2·8.

GOLDEN GATE BRIDGE, SAN FRANCISCO

Characteristically shrouded in a summer fog, details of the bridge's suspension make an abstract pattern (below). Fog and mist, although unpredictable, are useful for isolating subjects. The light is so diffused that it is almost directionless.

Nikon, 400mm, Kodachrome, 1/125 sec, f6·3.

neutral reflector of sunlight, and its light is exactly the same as that of the sun, but 400,000 times less. Theoretically, a photograph by moonlight will appear exactly as if by day. In practice, the long exposure necessary causes a softening of the light as the moon crosses the sky, and the film's own reciprocity failure can cause colour shifts. Moreover, we expect a night-time photograph to look quite dark and sombre, another example of how our preconceptions determine what is acceptable.

ATMOSPHERIC CONDITIONS

What gives the most variety to natural light is the changing nature of the sky itself. There are innumerable patterns of cloud cover, and not only do they alter the appearance of the sky, but also filter, diffuse and reflect the light from the sun. Clouds, in all their forms, are no more than water droplets, which are so much larger than air molecules that they do not discriminate between the wavelengths that they refract and disperse. They scatter the whole of the spectrum, and as a result appear white. As reflectors, they are responsible for the visual appeal of the most dramatic sunsets and sunrises.

A thin haze over the sky reflects white rather than blue into shadows, and softens their edges. As cloud cover increases, the sun's light is diffused over a greater area and becomes less directional until, on a completely overcast day, there are practically no discernible shadows and the quality of the light is almost flat. Although many subjects will look dull and unappealing in such weather, it can be very effective for subtle shapes and details, and gives the most faithful rendering to colours. Contrary to what many people imagine, green grass has a more intense hue under heavy clouds than in bright sunlight!

At the extremes of weather, in falling snow or rain, both contrast and colours are subdued, and subtle, often impressionistic results are possible.

AVAILABLE LIGHT

If you are using artificial light that is specially designed for photography, such as flash or photoflood lamps, then you can control it quite precisely. But if you are working only with available artificial lighting such as household light bulbs or street lamps, your control is reduced. You may only be able to guess at the colour rendering and frequently you will have a problem of excessive contrast; where the light source appears in the scene, for example, the contrast may be much too high for the film to handle.

In view of the problems of available lighting, it may seem surprising that many photographers deliberately choose to use it. One reason is that it can convey a naturalism and an atmosphere that are extremely difficult to create intentionally. There is no ideal style of lighting, and an important quality that well balanced, evenly distributed lighting usually lacks is excitement. In candid photography, of course, you have no choice but to use ambient lighting.

ULTRA-VIOLET

This view of the Cascade Mountains has an overall blue cast due to the easier penetration of ultra-violet waves through the thinner atmosphere. Film is more sensitive to these longer wavelengths than the human eye, and so benefits from the use of an ultra-violet filter over the lens.

THE MITTENS, MONUMENT VALLEY, USA

At dawn, low layers of cloud act as reflectors for the warm direct sunlight and even redder sky (right). Provided that they are not so dense as to block all sunlight, a few sparse clouds nearly always add drama to sunrise or sunset.

Nikon, 400mm, Kodachrome, 1/250 sec, f5·6.

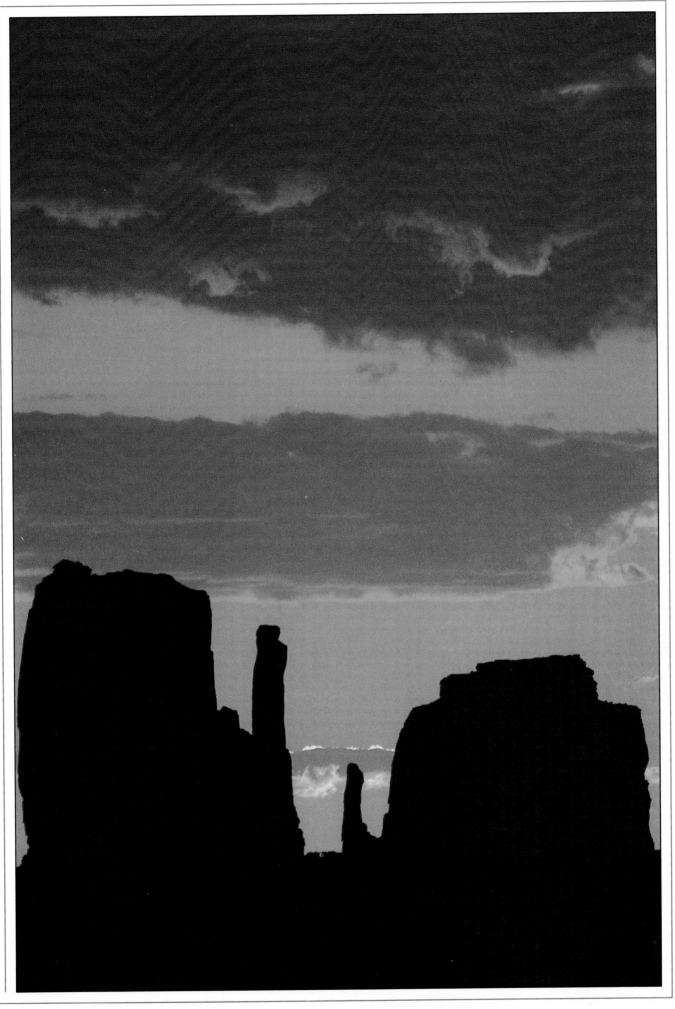

FERMENTING WINE, NAPA VALLEY

This barrel-aging room in a California winery is typical of many industrial interiors, lit by overhead fluorescent lamps. The uncorrected exposure (below) has a characteristically green cast. Being unable to check the make of lamps, several filter combinations were tried; the most successful was CC30 magenta (inset).
Nikon, 180mm, Kodachrome, ¼ sec, f3·5 and f2·8.

SHIPLEY WINDMILL, SUSSEX

Scattered clouds on a bright summer day reflect some of the sunlight back down to the ground, reducing the contrast range slightly (right). A polarizing filter was used to darken the appearance of the sky.
Nikon, 20mm, Kodachrome, ¹⁄₆₀ sec, f5·3, plus polarizing filter.

GENERAL TECHNIQUES

There are certain techniques common to all available light situations. To begin with, there is nearly always less light than you would really like and this reduces your flexibility between film, lenses, use of depth of field and shutter speed. In many cases you will have to make some compromises, sacrificing some picture quallity such as resolution or viewpoint in order to be able to take an acceptable picture. For this reason many available lighting techniques are concerned with getting enough light to the film.

To begin with, the film you choose is important – good fast films are available in black-and-white with speeds up to ISO 3200 and in colour to ISO 1600 and available film speeds are increasing all the time.

As tungsten balanced films are slower than their equivalent daylight-balanced emulsions, you may find it easier to use a daylight film with appropriate conversion filters (the resulting speeds are similar). Once again decide to what degree you want to correct the lighting: an 80B filter will balance a daylight film for 3400° Kelvin lighting; an 80A filter gives stronger correction for 3200° Kelvin lighting; and 80A and 82C filters combined will render most domestic tungsten lighting to the equivalent of daylight.

FLUORESCENT LIGHTING

Although potentially better for photography than mercury-vapour because the phosphors in the tube add a continuous background spectrum, fluorescent lighting is still the bane of available lighting assignments. Its ubiquity and unpredictability make it very important to test before shooting. The apparent colour temperature of fluorescent tubes varies with make and age, with no standardization among manufacturers or type classification. High efficiency tubes have a high output but are very deficient in red, while de-luxe tubes more closely approach 'normal'. It is usually impossible to predict the correct filtration merely by

GOLDSMITHS' HALL, LONDON *This ornate hall (above) was lit solely by chandeliers fitted with tungsten lamps and the contrast range was inevitably high. Tungsten-balanced film was used for a 'normal' effect.*
Nikon, 20mm, Ektachrome (tungsten), 1/60 sec, f3·5.

EXPOSURE SETTINGS FOR DIFFICULT AVAILABLE LIGHT CONDITIONS

These are approximate guides to use as starting points for a bracketed series of exposures where exposure readings are difficult to make. If the shutter speed still seems too slow for the subject, use a faster film or increase the development.

Film speed (ISO)	25	64	125	200	400
Brightly lit night time street scene	1/8 sec f2·8	1/15 sec f2·8	1/30 sec f2·8	1/60 sec f2·8	1/60 sec f4
Very brightly lit night scene, eg nightclub district	1/15 sec f2·8	1/30 sec f2·8	1/60 sec f2·8	1/60 sec f4	1/60 sec f5·6
Floodlit football stadium	1/15 sec f2·8	1/30 sec f2·8	1/60 sec f2·8	1/125 sec f2·8	1/250 sec f2·8
Moonlit scene (full moon)*	2 min f2	2 min f2·8	1 min f2·8	30 sec f2·8	15 sec f2·8
Town at night in the distance	1 min f2·8	30 sec f2·8	15 sec f2·8	8 sec f2·8	4 sec f2·8
Lighting	T f2	T f2·8	T f4	T f5·6	T f8
Firework display	T f2	T f2·8	T f4	T f5·6	T f8
Floodlit industrial factory at night (eg refinery)	2 sec f2·8	1 sec f2·8	1/2 sec f2·8	1/4 sec f2·8	1/8 sec f2·8
Moon in clear sky (full or nearly full)	1/60 sec f5·6	1/125 sec f5·6	1/125 sec f8	1/125 sec f11	1/125 sec f16
Candlelit close-up	1/4 sec f2·8	1/8 sec f2·8	1/15 sec f2·8	1/60 sec f2·8	1/125 sec f2·8
Neon sign**	1/15 sec f2·8	1/30 sec f2·8	1/60 sec f2·8	1/60 sec f4	1/60 sec f5·6
Fairground	1/4 sec f2·8	1/8 sec f2·8	1/15 sec f2·8	1/30 sec f2·8	1/60 sec f2·8
Boxing ring	1/15 sec f2·8	1/30 sec f2·8	1/60 sec f2·8	1/125 sec f2·8	1/250 sec f2·8
Theatre stage, fully lit	1/8 sec f2·8	1/15 sec f2·8	1/30 sec f2·8	1/60 sec f2·8	1/125 sec f2·8

*Reciprocity failure is the chief problem here, and that varies with the emulsion. For some colour film more exposure may be needed. Try to use a fast lens rather than long exposure times.
**If the neon sign is a changing display, use an exposure time long enough for a full cycle.

THE STRIP, LAS VEGAS *In an overall night scene, particularly with display lighting, mixed illumination is rarely a problem. No one light source covers the whole scene, and although there is a large colour difference between the reddish tungsten and greenish fluorescent lamps, it is not objectionable.*
Nikon, 400mm, Kodachrome, 1/8 sec, f5·6.

NEON LIGHTS *Multi-coloured neon displays do not present the same problems as fluorescents, and can give rewarding results.*

VAPOUR LIGHTING

Champagne tanks Sodium vapour lamps are used to light this room (right) full of stainless steel tanks. This comparatively rare type of lighting has a strong yellow emission.
Nikon, 20mm, Kodachrome, 1/15 sec, f3·5.

Space shuttle external tank In a NASA hangar, the main fuel tank for the Space Shuttle (below) was lit with mercury vapour lamps. Even with a CC20 magenta filter, the blue-green cast is pronounced.
Nikon, 20mm, Kodachrome, 1/4 sec, f3·5.

examining the tubes, but a fairly strong magenta filter (from 20M to 40M) will usually figure prominently in the filter pack (this is with daylight film). If you have to work without testing, use daylight film (its added speed over tungsten balanced film is a big advantage) and experiment with 20M, 30M and 40M, perhaps adding a 20C or even a 20Y on some exposures.

A more elaborate alternative is to replace the existing tubes with tubes that are colour corrected for photography.

VAPOUR DISCHARGE LIGHTING

The most common type of discharge lamp is mercury-vapour, used increasingly in large industrial facilities and in some stadiums. Its advantages are low cost and low heat output, but, having a discontinuous spectrum, with great gaps in the red part of the spectrum, it can be disastrous for photography. Mercury-vapour lamps have a typically strong output of green-blue and ultra-violet but they are not consistently predictable. Test them if you can with different filters; if you cannot, bracket your filtration around 20M, 30M, 20R and 30R. Sodium vapour lamps are fortunately becoming less widely used; over 90 per cent of their output is in the yellow region of the spectrum, making full correction impossible.

MIXED LIGHTING

When one form of available lighting is dominant, whether tungsten, mercury-vapour, or fluorescent, then you need only concern yourself with balancing the film to that one type. However, when different sources are mixed in the same scene, you may have to compromise. Fluorescent and tungsten combined are particularly unpleasant. However, by using camera angle and position intelligently, you can overcome the problem to some extent. In your composition, and in the placement of your model or subject if one exists, try to favour

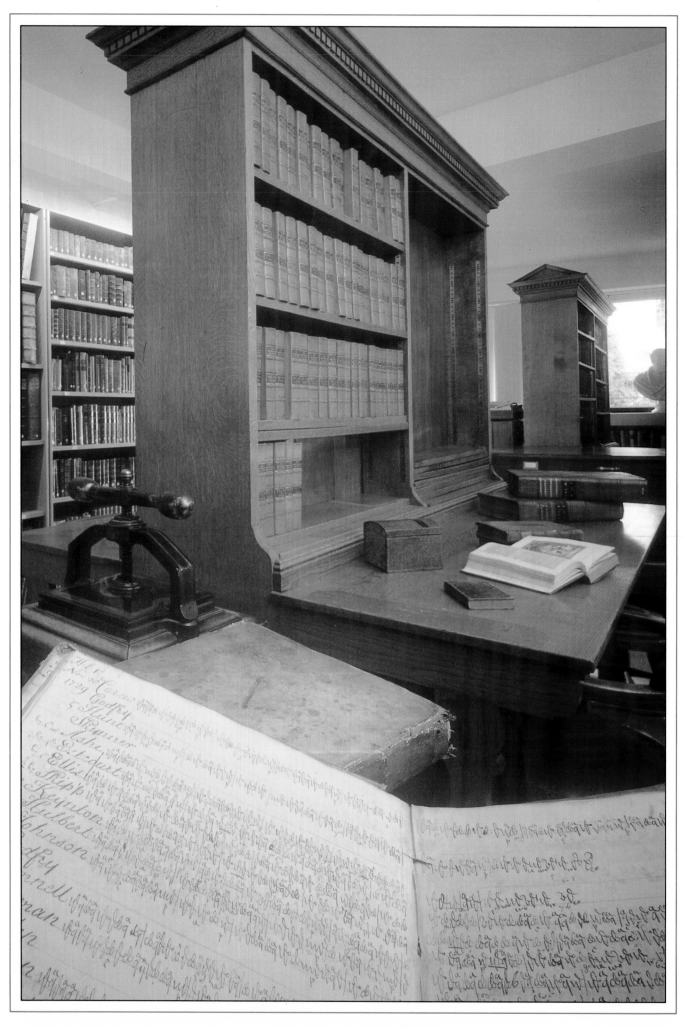

BALANCING PHOTOGRAPHIC AND AVAILABLE LIGHTS *To light the foreground adequately in this library (left), additional photographic lights were essential. Yet the photographer wished to include the window. The set-up chosen was daylight-balanced tungsten lighting (with blue gels) close to the camera and behind the nearer stand of shelves, and magenta gels taped over the concealed fluorescent lights. Even with an 800W lamp bounced off the wall next to the camera (see inset) and tilt movement on the 5 × 5in view camera, a six minute exposure at f45 on ISO 64 film was needed to give enough depth of field to show the details of the old ledger and the room beyond. Polaroid tests in black-and-white and colour were made to check the balance of lighting for both intensity and colour.*

SHWE DRAGON PAGODA *Timing, viewpoint, and of course the selection of a dramatic subject, characterize travel photography of the exotic. Taken just after sunset, on the evening of the Burmese Buddhist festival of light, this picture of the Shwe Dagon pagoda in Rangoon (below) makes the maximum use of colour to convey a sense of spectacle.*

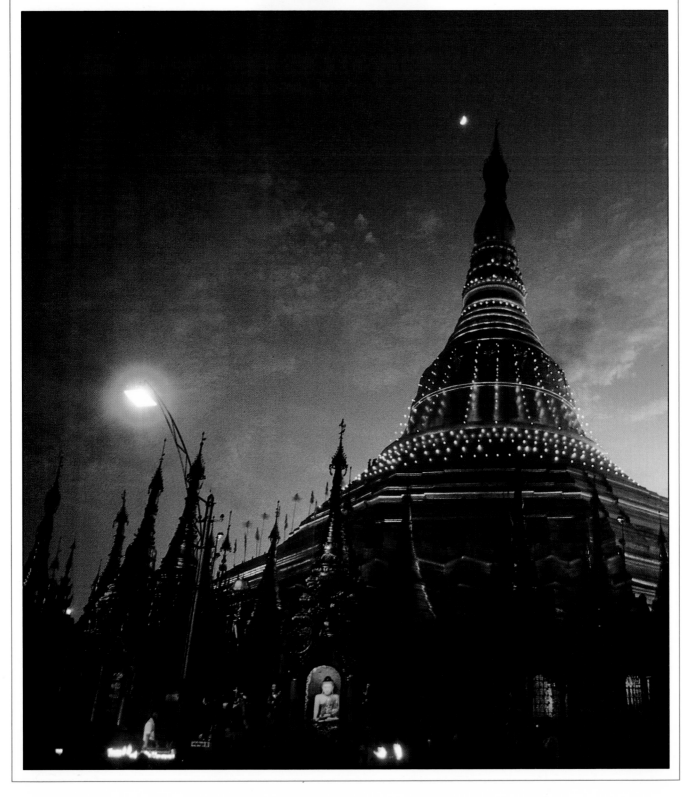

SOFTENING THE LIGHT FROM A PORTABLE FLASH

The harsh light from the small tube and polished reflector of a portable flash can be very unflattering to many subjects. One basic method of diffusing the light is to bounce it off a large white or neutral surface, such as a ceiling or wall. This drastically reduces the light reaching the subject, but the hard shadows are eliminated. Some flash units are deliberately designed for this, with heads that swivel upwards. If the flash unit is automatic, then the sensor must still point towards the subject to give correct exposure automatically.

A few flash units have special attachments either to diffuse or reflect the light, and so soften it.

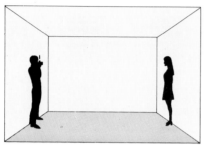

Direct flash without diffusion.

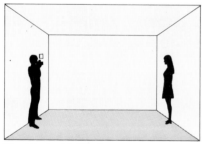

Direct flash with diffusion.

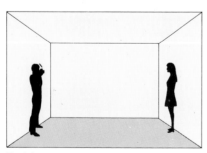

Flash bounced off ceiling.

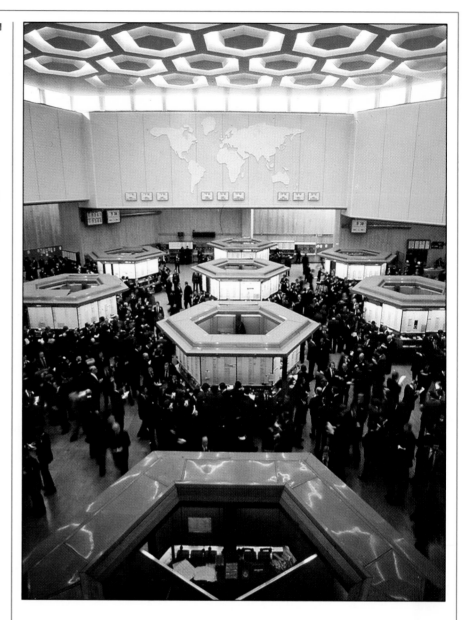

one of the light sources. For instance, if a room has fluorescent lighting at one end and tungsten at the other, and you are photographing a person, move the subject close to one end of the room and apply the filtration for that type of lighting. Also decide which of the lighting types, if uncorrected, would look least unpleasant. If an interior is illuminated by daylight and tungsten equally, and you add a blue filter to balance the film to the lamps, then the deep blue light from the window or doorway may look odd. In this case, balancing for daylight and accepting a very warm light from the tungsten lamps would probably be more acceptable.

There are no hard and fast guidelines for dealing with mixed lighting, and you will have to treat each situation as a new case. Depending on the subject, the contrast of colour from the mixture of different light sources may even be attractive.

PORTABLE FLASH

Although the available lighting discussed in the preceding pages is artificial, it is essentially uncontrolled by the photographer – it is 'found' lighting. Lighting specifically intended for photography gives you more control over the choice of subject and its treatment.

In the studio, highly specialized light sources are used, and these are dealt with under the studio photography sections. The simplest method of providing your own light source is a portable flash unit. These are compact and powerful enough for many picture-taking situations, and can enable you to work in conditions of very low light. They can also give some control over balancing existing lighting.

LONDON STOCK EXCHANGE *Interiors with mixed lighting are a problem. Here, the artificial illumination was fluorescent, but there was also daylight. In this instance (left), it was decided to accept pink light through the windows rather than have any hint of green from the interior lighting, and a CC30 magenta filter was used.*
Nikon, 20mm, Kodachrome, ⅛ sec, f5·6.

AUTOMATIC THYRISTOR FLASH

In common with all electronic flash units this portable model operates by converting low voltage from the batteries into a higher voltage, and storing the charge in a capacitor. When the unit is triggered, the capacitor, with the help of a smaller trigger capacitor, discharges the stored energy in a burst, ionizing the gas in the flash tube to produce a brilliant white flash. Automatic operation is made possible by using a light-sensitive photo-cell that measures the amount of light reflected back from the subject. This is connected to a thyristor – a very fast-acting electronic switch – which can cut off the supply of energy to the flash tube at any point.

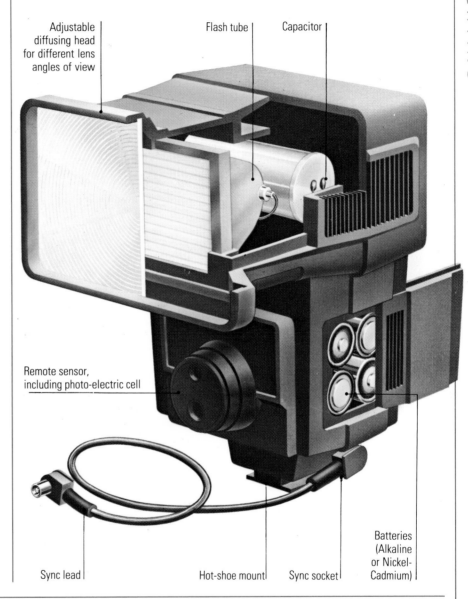

Adjustable diffusing head for different lens angles of view

Flash tube

Capacitor

Remote sensor, including photo-electric cell

Sync lead

Hot-shoe mount

Sync socket

Batteries (Alkaline or Nickel-Cadmium)

Modern portable electronic flash units are powered by either rechargeable batteries (usually nickel-cadmium) or replaceable ones. Many have automatic exposure control and in more recent models the camera's electronic shutter can be set automatically, overriding the through-the-lens metering information.

FILL-IN FLASH

Where the contrast in a scene is extremely high, such as a backlit view, you can use a portable flash to fill in detail in the shadow areas. However, if you want to preserve a natural feeling in the picture, you should use the flash with restraint; if the flash output dominates the lighting it will produce an odd effect. As a guide, the maximum output of the flash should be only one-half of the recommended setting, and it may look even more natural if less. The exposure setting for the camera should be based on the highlight

Hot-shoe For cameras without a built-in hot-shoe (for instance, some Nikon models), a detachable hot-shoe can be fitted.

LIGHTING

BRIDE, CALCUTTA *At a wedding in India the photographer had no fast colour film, and the room lighting was too weak for hand-held shooting (right). Although this picture portrays the hard and unnatural effect that a portable flash unit gives, there was no alternative. Here the ornamentation of the bride made the hard shadows less obvious.*

ROD STEWART *Stage lighting at rock concerts is usually dramatic and interesting, and generally preferable to flash. The light levels, however, are often low, and up-rating the film by extended development is usually the only solution. In this shot (above) the small aperture on a long-focus lens made a tripod essential.* Nikon, 500mm, Ektachrome Type B, pushed 3 stops, ⅟₃₀ sec, f8.

reading; the extra light from the flash will then just raise the shadow levels slightly. To reduce the flash output you can reduce the aperture setting. If, for example, the recommended setting is f5·6, you can provide ample fill-in flash at f8. To do this you will have to adjust the shutter speed, which must be no faster than its synchronization speed (1/60, 1/100 or 1/125 sec for a focal-plane shutter, depending on the camera).

Alternatively, you can position the flash unit further away, using an extension cord. If you move it twice as far from the subject, then the subject will receive a quarter of the light output. If the flash unit is automatic, switch to manual, or the thyristor circuit will compensate for the extra distance. Or, you can tape a neutral density filter over the flash head, remembering to switch to manual if the unit is automatic.

CONTROLLING LIGHT QUALITY

Photographic lamps free the photographer from dependence on available, but unalterable, sources of light – and provide almost complete control over the way a picture is lit. But the lamps themselves are no more than the raw source of the lighting. It is the way their

NATURALISTIC LIGHTING

The quality of lighting in the location portrait (left) was intended to be unobtrusive and to fit in with existing room lighting. A large, diffused lamp was placed to the left of the seated subject, and its output regulated to match the ambient lighting using Polaroid test shots.

output can be modified by an assortment of fittings that is really important. Yet since certain key fittings depend very much on the type and brand of lamp, the choice between flash and tungsten studio lighting is fundamental.

Flash has largely replaced tungsten lighting in still photography studios, principally because of its consistent light output, its action-stopping power and its relative coolness. Certainly, for moving subjects, such as fashion models, flash has a clear advantage, while the low heat output allows the use of attachments that enclose the lamp – now widely used in still-life photography. However, the tungsten lighting does provide a *continuous* output of light. This means that you can increase the amount of light reaching the film simply by lengthening the exposure – provided that the subject is static and the camera can be locked down – which is easier than tripping a flash discharge several times. In most photography, flash is limited by its maximum discharge; if more light is needed, multiple flash is the only answer. With small apertures and large-scale subjects, an exposure with tungsten lighting that runs into seconds or minutes is likely to be more practical than firing off flash heads several times (the numbers double for each extra f-stop).

MULTIPLE LIGHTING

While most subjects can be lit efficiently with only one lamp and a few reflectors, using more than one opens up a great variety of effects. Multiple lighting often appears artificial and although this is not necessarily objectionable, it contrasts obviously with the naturalism of single-area lights.

The usual, but not the only, principle in using several lights is for there to be a single main light, secondary fill lights, and secondary effects lights. The idea is to make it look as if there is really only one light source. Fill lights simply alleviate shadows to reduce overall contrast; effects lights are used to pick out edges and add highlights.

STYLIZED LIGHTING

By contrast with the basically naturalistic style of lighting (left), the high-key effect (below) was achieved by using a main frontal light with heavy diffusion, a spot from behind, and a soft-focus filter to increase flaring. In addition, the exposure was generous, to further eliminate shadows.

LIGHTING FOR EFFECT AND SUBJECT QUALITIES *Lighting can draw out the physical qualities of a subject. At right, a translucent onyx egg is made to glow by aiming a single lamp from beneath, diffused through a milky plastic base and confined by a circular black card mask on the underside.*

EMERALD BOA CONSTRICTOR *In wildlife photography, portable flash is often the only way of being able to take a picture. In deep shade, natural light photography is usually not possible with animals that have fast reactions (above).*
Nikon, 180mm, Kodachrome, flash sync, f11.

VINEYARD

These leaves looked best when backlit by the sun. The grapes, however, appeared too dark (below) at the correct exposure of 1/125 sec at f8. Using a small flash unit on an automatic setting, the indicated aperture for flash was also f8, but as this would have swamped the picture with artificial light, the aperture was reduced to f16, and the shutter speed increased to 1/30 sec (right). *Nikon, 20mm, Kodachrome.*

BACK-LIGHTING *For soft, even back-lighting –
the standard treatment for transparent objects
such as glass – an area light is aimed from the
back, through a diffusing sheet, masked to the
edges of the picture to avoid flare. Flare is
always a problem with back-lit subjects, cutting
down contrast and degrading the image. It is
particularly acute with glass, which can catch
undamped bright spots and throw unwanted
light towards the camera. A careful
arrangement of black cards is needed to cut out
flare. With such problems, it may seem back-
lighting glass is hardly worth the trouble – but
back-lighting heightens contrast in the structure
of the glass, giving it solidity and weight.*

CONTROLLING FLARE

It is a tradition of photography – although not always a justified one – that technical image perfection is an ideal. This means sharpness, freedom from distortion, colour accuracy, and a full tonal range with good contrast. In arranging the lighting, lens flare is the principal danger to these standards, but it can be avoided by shading the lens efficiently from the lamp. This can be done close to the lens in the form of a lens shade, or close to the lamp in the form of barn doors or a *flag* (which need be no more than a black card clipped to a stand). Flare, strictly defined, is non-image-forming light, and avoiding flare means ensuring that no direct light falls on the lens.

BASE LIGHTING

With base lighting, light is projected upwards through a translucent sheet, commonly opal perspex, just as in a lightbox for viewing transparencies. The applications of this type of lighting are necessarily limited, but it can work well with transparent objects – this is the standard way of making glasses of liquid glow. In combination with normal overhead lighting it provides an extremely clean white background.

RIM LIGHTING

For rim lighting a single spot is positioned out of sight of the camera behind the subject, pointing towards the camera. The edges of the subject, if textured, catch the light, and against a dark background the effect can be that of a halo. With shiny-surfaced objects, spot lights behind but just out of frame produce a similar effect.

MODIFYING ATTACHMENTS

Basic attachments can be fitted to a single lamp to diffuse its light. They work on the principle of increasing the area of the light source.

Filters include, top-to-bottom, a honeycomb design in black metal, scrim, half-scrim, gauze and opal.

Dish and bowl reflectors are available in different sizes, depths and interior finishes (silvered or white, for example).

Bowl and spiller A special design of bowl reflector that gives more diffusion is a shallow white-painted dish with a spiller cap. The spiller hides the bare lamp from view.

Umbrella Apart from the largest area lights the heaviest diffusion is that from a white umbrella, available in different sizes and shapes.

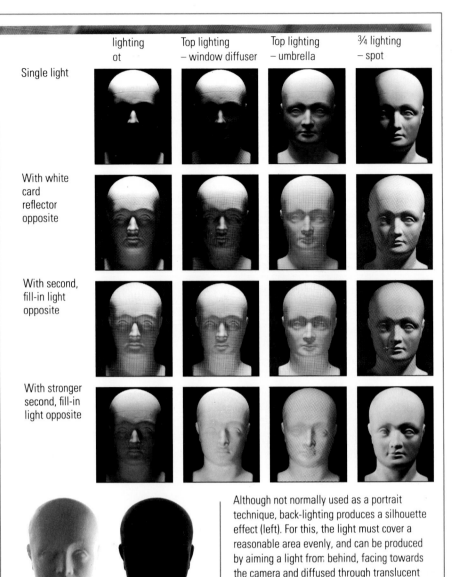

	lighting ot	Top lighting – window diffuser	Top lighting – umbrella	¾ lighting – spot
Single light				
With white card reflector opposite				
With second, fill-in light opposite				
With stronger second, fill-in light opposite				

Although not normally used as a portrait technique, back-lighting produces a silhouette effect (left). For this, the light must cover a reasonable area evenly, and can be produced by aiming a light from behind, facing towards the camera and diffused through translucent material on a trace frame. Adding a reflector card in front of the subject (far left) reveals some detail.

BACK-LIGHTING

One method of back-lighting is to place a floodlight behind the subject, usually diffused so as to appear even. With no shadow-fill, the result is a silhouette. Two alternative methods are to hang a large sheet of diffusing material (or tracing paper on a frame) behind the subject with lights behind that, or to use a white wall or paper background as a large reflector for lights aimed at it from the front. In back-lighting, the base of the set, if visible, can be a problem by appearing as a discontinuity. One method of hiding the edge of the base is to use a highly reflective surface, such as glass or perspex. This appears to merge with the bright background.

MIRRORS

All kinds of mirrors can be useful in studio photography for re-directing light. With care, they can give the effect of multiple lighting with only one source. In small still-life sets, dental mirrors are particularly useful, as they can be positioned close to the subject for precise effects.

AXIAL LIGHTING

Axial lighting takes its name from the lens axis, and the principle is to direct the light along the line of sight from the camera. The usual technique is to place a half-silvered mirror at a 45° angle in front of the lens, and to shine a light towards it from the side, at 90° to the

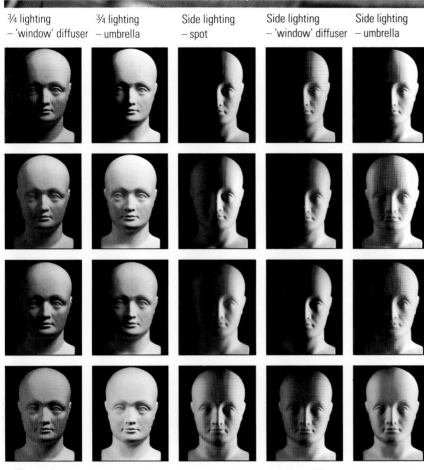

¾ lighting – 'window' diffuser	¾ lighting – umbrella	Side lighting – spot	Side lighting – 'window' diffuser	Side lighting – umbrella

LIGHTING THE HUMAN HEAD

Some of the permutations of the most common pieces of lighting equipment are shown in the chart opposite featuring a plain phrenological head.

The more conventional range of methods is shown above. Different types of light and different positions run left-to-right, while increasingly efficient shadow-fill runs from top-to-bottom. The most contrasty light is a single spot, and because of its sharp shadows and pin-point highlights (more obvious on real eyes and shiny skin than on this model head), it tends to be used only for dramatic effect. The subtle but distinct differences between the two most common lighting attachments – umbrellas and window-like area lights – can be seen in the coverage and in the shadow edges; umbrellas give a more enveloping light, less obviously directional, and rather softer shadows. The basic methods of shadow-fill are passive (reflector cards with white or silvered surfaces) and active (second lights).

lens axis. The camera can see right through the mirror to the subject but is unaffected by the light. Half of the light shines straight through the glass, and half of it is reflected directly towards the subject, giving completely shadowless lighting.

LASERS

The point of light from a laser is so small that it has no real value as a light source in studio photography. Neither will the kind of low-powered laser likely to be used by the photographer give the striking, intense shafts of light familiar in discos – unless the atmosphere is so dusty or smoky that reflections from particles in the air pick out the beam. However, a moving laser, aided by mirrors and prisms, can be used to create some exotic effects.

SINGLE VERSUS MULTIPLE LIGHTS

One of the most important stylistic choices is between one and several light sources. The argument for using a single light is partly one of simplicity and partly one of naturalness. Interiors are usually illuminated by daylight streaming through a window; any studio light that imitates this effect (an area light does this to best effect) appears generally pleasing, and normal.

The case for multiple lighting, on the other hand, is that a wide range of effects can be created, including a more distinctive style, and that great precision is possible, revealing

LIGHTING TO SUIT THE SUBJECT *Lighting in photography is often highly stylized. The bottom right photograph has the softness characteristic of de Meyer, while the precise, textural lighting in George Hurrell's portrait of Marlene Dietrich is typical of Hollywood in the 1930s. The still-life by Robert Golden uses filtration and a single, distant spot.*

MARLENE DIETRICH
in Paramount Pictures

PIIG. 7-538

Copr. 1937 Paramount Productions, Inc., Permission granted for Newspaper and Magazine reproduction. (Made in U. S. A.)

BASE LIGHTING

For this mixture of opaque and solid objects, two lighting techniques are used: light diffused through a perspex screen from underneath for the transparent objects provides the main illumination; a large area light suspended above the table fills in the shadows on the opaque objects such as the tape.

detail here or enhancing textures there. Multiple lighting can often generate an air of theatricality and lends itself to mannered design.

HIGH-KEY VERSUS LOW-KEY

The overall tone of a picture is another feature in the style of lighting. In most pictures, there is an even range of tones, from dark to light. By deliberately tipping the balance towards the dark tones, a rich, moody, *low-key* effect is created. Tipping the balance the other way, towards the light tones, gives a bright, often delicate, *high-key* result. In both cases, important details of the image can be picked out in the opposing tone – for instance, they eyes and mouth in a portrait that is principally white, or just the outline of a dark object caught against a black background by a light well to the side and behind. The 'key' in this sense of lighting design is not simply a matter of under- or overexposure, but involves constructing both a lighting arrangement and a set or subject that contribute to the effect. A heavily diffused flood of light, for instance, helps to create a high-key effect because it eliminates shadows, while precise spotlights, used carefully, often help to create a relatively low-key image.

LIGHTING STYLES

The range of lighting equipment available – indeed, the design of the many different lamps and their attachments often depends on something more fundamental than just efficiency. It depends also on the styles of lighting that have become popular in different fields of photography. What tends to happen is that occasional major changes in lighting design made by one or a group of professional photographers catch the imagination of others, including the large amateur market and manufacturers of lighting equipment adapt their range accordingly. This happens particularly when the work is widely published, such as in the advertising and editorial pages of national consumer magazines. In the early days of American fashion photography, for example, the romantic haze and flare created by De Meyer by means of soft, filtered back-lighting was very popular. Later, in the 1930s, the sharper, more visually active style of photographers such as Steichen, using large numbers of klieg lights from all directions became the norm.

Sometimes, lighting equipment precedes, or even inspires, a new lighting style. During the mid-1970s a number of photographers adapted powerful ringlights originally designed for medical photography, or fashion work. The brash, frontal effect of ringlighting soon

became the vogue for all of the major fashion magazines. The results contrast strongly with the traditional diffuse lighting reflected from large umbrellas. In common with most other distinct styles of lighting, the use of ringflash in fashion was, in fact, a deliberate reaction to existing styles that certain photographers were beginning to find boring. Its popularity, however, proved to be short-lived.

On other occasions, equipment manufacturers have belatedly followed the innovators of a lighting style, and produced commercial versions of lights that had previously been custom built, so both fulfilling a demand and encouraging more use among a much wider group of photographers. An example of this is the window/area/box/soft light, as it is variously known. Exactly when it was 'invented' is unclear, but during the 1960s most professional still-life photographers in Europe and America began using these large, precisely shaped box-like diffusers. Many built their own, while a very few manufacturers of expensive, professional-quality flash lighting produced versions. These lights were developed as tastes in advertising illustration moved towards the clear and simple (at least for product shots), and also because they are a very efficient and uncomplicated way of lighting a basic still-life, particularly when used overhead. Among mass-produced equipment, however, there was nothing comparable until the mid-1970s, when sufficient numbers of other photographers, including amateurs, had seen and liked the results that appeared in magazines and posters to create a demand for the style.

Not surprisingly, as a fashion in lighting design percolates through the market, some photographers begin to experiment with different techniques. Often, their inspiration may

LOW-KEY LIGHTING *The low-key style of the portrait above has a predominance of dark tones. The effect is achieved with a single and relatively small light source that strikes the man's face from behind and slightly to one side. There is no shadow-fill, so it is only the outline that defines the shape.*

HIGH-KEY LIGHTING

High-key lighting gives a lightness and airiness to the still-life (below). Generous exposure and light tones enhance the effect.

Area light The window-like effect of an area light gives diffuse but directional modelling, as in the photograph of the necklace (right).

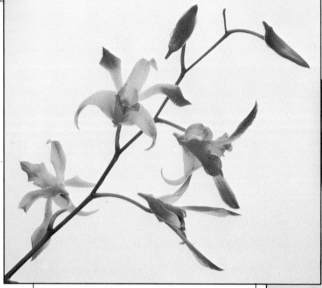

3/4-frontal umbrella This, the most standard lighting style in modern portraiture gives a soft light and good coverage (right).

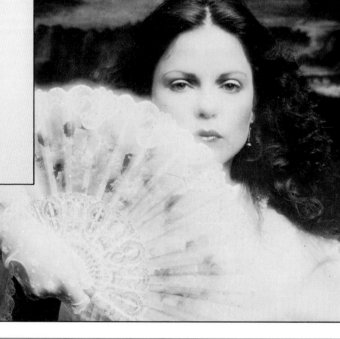

be the renewed interest in a style long fallen out of fashion. For instance, the renewed interest in Constructivism and the Bauhaus that occurred in several areas of design in the early 1980s encouraged experiment with the sharp shadow shapes from naked lamps and spotlights, mimicking the bright, hard utilitarian sense of style of the Bauhaus movement.

FLAT VERSUS CONTRASTY LIGHTING

Another parameter in lighting design is the degree of contrast that the lighting creates. Contrast exists, of course, in the subject and setting themselves, but the position of the lights and the attachments used with them has a crucial influence on contrast. The most extreme contrast is silhouette back-lighting; the lowest contrast is diffused frontal lighting. Strong diffusion or bounced lighting reduces contrast by reducing both the density of shadows and their edges. A small, intense lamp tends to throw sharp, deep shadows and so raise local contrast in a photograph, while any device that limits the beam, such as a lens or a snoot, increases contrast by darkening the area beyond the edges of its focus.

PRECISION

When using studio lighting, it is often assumed that the photographer must take meticulous care over the arrangement of the lights. Indeed, the skill of professional photographers is often judged by how well they can control studio lighting. This is usually a fair judgement. Nevertheless, while precision in lighting design is an important aspect of craftsmanship, absolute and pre-determined control in every instance may not necessarily be the most exciting way of making photographs. Sometimes, the unexpected results of experimenting with lights produces more interesting images, gaining in spontaneity what they lose in precision. Portraits in particular may respond to a less painstaking approach.

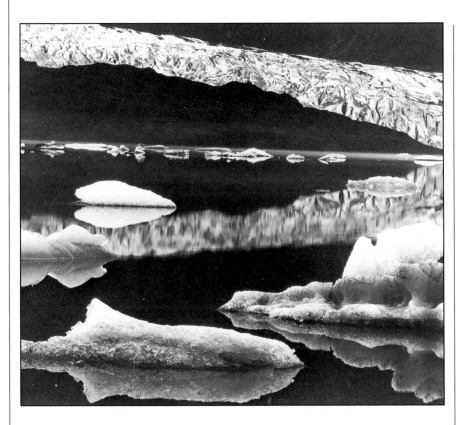

BLACK-AND-WHITE, FINE-GRAINED SHEET-FILM *Used in a field camera this gives outstanding sharpness and clarity. This example by Brett Weston demonstrates the formalist tradition of relying on elegance of design and presentation, for effect and visual impact, rather than on the real properties of the subject matter.*

CHOOSING BLACK-AND-WHITE FILM

Many photographers use black-and-white film just as a matter of personal taste, because they feel it gives them a freer rein to be creative with the camera. But there are other reasons for using monochrome film.

One of these is the rapidity and ease with which black-and-white pictures can be processed and printed – only minutes from exposure to print. Another is the fact that most of the world's daily papers are printed in black-and-white and the wire services, which photojournalists use to transmit urgent pictures down telephone lines, cannot cope with colour pictures. Additionally, black-and-white film is oblivious to small changes in colour of subject illumination.

Choice of a specific black-and-white film will depend on the application for which the film will be used. Fast film (ISO 400/27° and faster) is ideal for dim light and in conditions in which the photographer must take pictures first, and think later; fast film permits the use of a fast shutter speed to stop action and a small aperture for good depth of field.

Medium speed films (ISO 100/21°–320/26°) are fine for all general-purpose monochrome photography where lighting is good and where very high quality is not a prerequisite. For applications involving considerable enlargement of the negative, though, or for copying, a slow film (ISO 80/20° or slower) is better.

CHOOSING COLOUR NEGATIVE FILM

The differences between different makes of colour negative film tend to be masked by processing and printing; and the primary distinction between one film and another is speed. The slowest general-purpose colour negative film has a speed of ISO 100/21°, and the quality of most films of this speed is exceptionally good; negatives will enlarge ten times without grain becoming objectionable.

As the speed of colour negative films increases, though, so the quality falls. ISO 200/24° films are marginally worse than their slower stablemates, though overexposure of the faster emulsion can make the gap between the two barely perceptible. The leap to ISO 400/27° brings a more noticeable drop in quality, though. Colours appear paler, the picture looks grainy and definition is poorer.

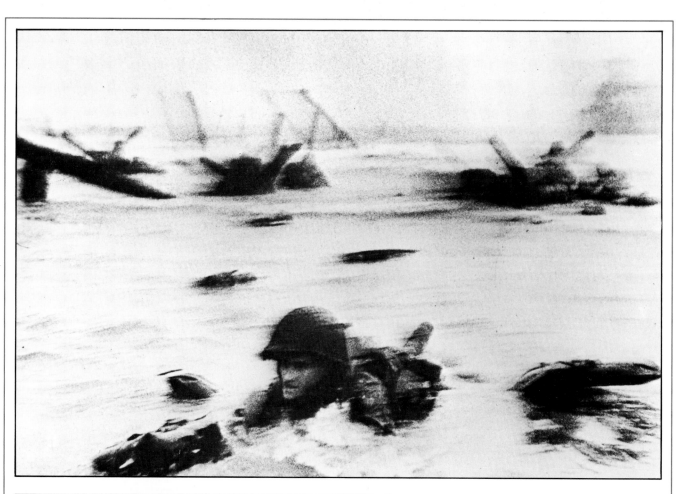

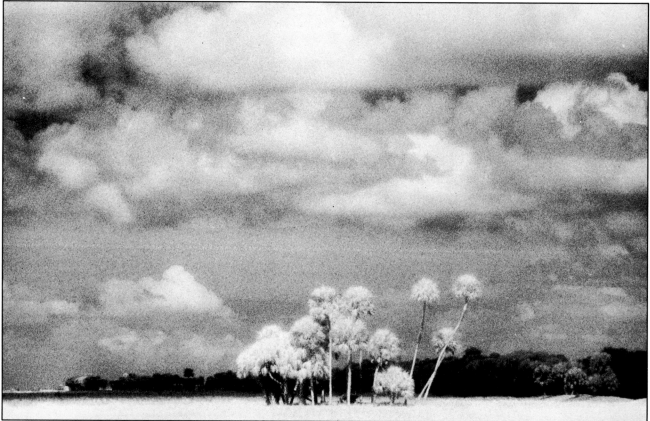

TOP *Fast, grainy black-and-white film adds to the drama of this Robert Capa grab shot during the D-Day landings.*

ABOVE *The Florida landscape was shot on high-speed infra-red film. The grain has almost the texture of coarse sand, while the use of a visually opaque Wratten 87 filter gives an unearthly glow to the vegetation and clouds.*

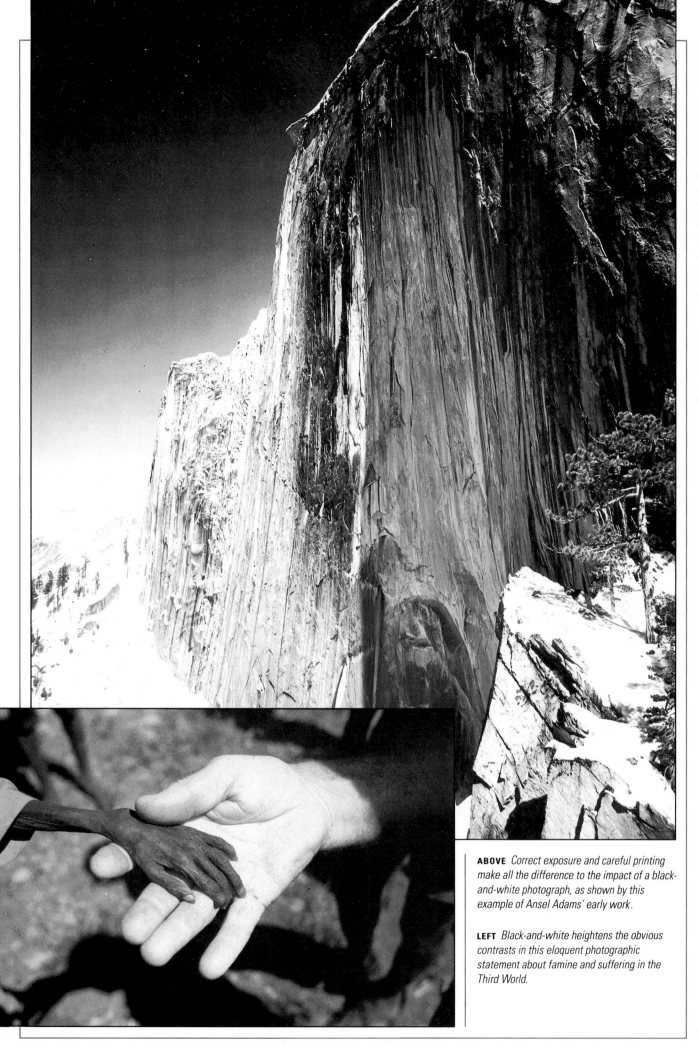

ABOVE Correct exposure and careful printing make all the difference to the impact of a black-and-white photograph, as shown by this example of Ansel Adams' early work.

LEFT Black-and-white heightens the obvious contrasts in this eloquent photographic statement about famine and suffering in the Third World.

141

Very fast films of ISO 1000/30° up to ISO 1600 are for use in very poor light and give grainy results and poorer colour saturation. Unless the graininess is an integral part of the picture these films are not suitable for big enlargements.

Choice of negative film will always depend not just on the particular challenges of the individual photo-assignment, but also on taste. Many photographers simply prefer the colours of one brand over those of another, and this is as good a reason as any other for choosing a particular film type.

CHARACTERISTICS AND APPLICATIONS

Colour negatives have tremendous exposure latitude, particularly to overexposure. For this reason, they are ideally suited to the casual photographer who does not take very much care about setting exposure – or who owns a camera that has no exposure controls. Most of the exposure latitude is to overexposure; the leeway for underexposure is more limited. So many experienced photographers tend to err on the generous side when exposing colour negative film, giving half a stop more exposure than their meters indicate. This technique also reduces grain size and yields better shadow detail, particularly in sunlight.

Just as they are very forgiving of exposure errors, so colour negative films side step problems created by the colour of the light falling on the subject. Within limits, colour casts can be removed at the printing stage. This, again, makes the film ideal for the snapshooter, who is as likely to take pictures in a room lit by fluorescent strip-lights or warm table-lamps as in bright sunlight.

This is not to say that colour negative film is exclusively for the amateur. Professional photographers use negative films for pictures which will eventually be reproduced in the form of colour prints, rather than as reproductions in magazines. Colour negative films are

FILMS FOR FINE DETAIL *The relationship between film speed and graininess is the same as in the more basic black-and-white emulsions, although in colour films the actual metallic silver grains have been replaced during processing by less distinct dye clouds. Consequently, for highly resolved images, such as details in nature (left), a slow emulsion is the usual choice. The film used here, Kodachrome, has the additional advantage of a special process – the colour dyes are not present in the film when it is used (they are introduced later, during processing) and the emulsion layer can be thinner and resolve more detail.*

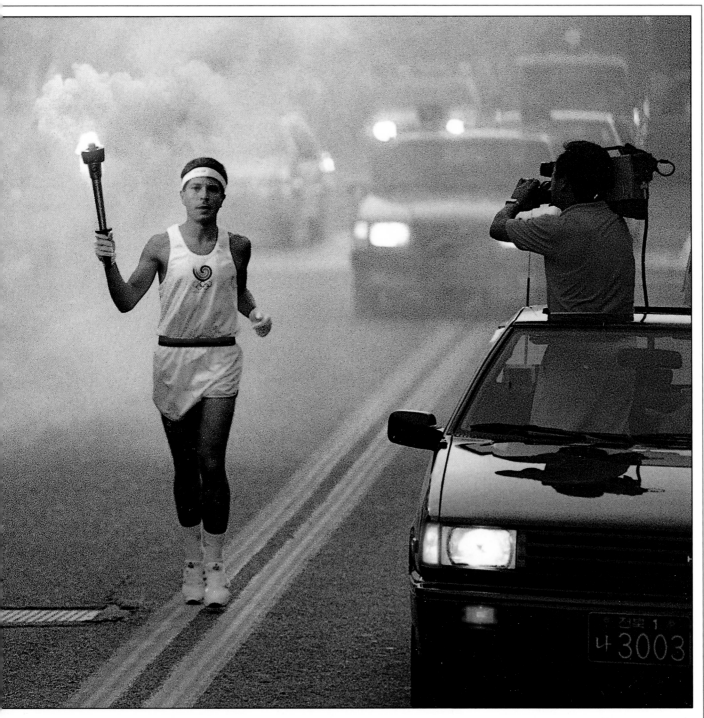

HIGH-SPEED COLOUR PRINT FILM *This is useful for shooting in failing light, especially where the use of flash is either not possible or would spoil the atmosphere of the picture.* Kodak Ektapress Gold 1600.

also invaluable in conditions where the exact colours of the light sources are unknown, making the use of transparency film difficult and unpredictable. They may also be useful for situations where an accurate exposure reading cannot be taken – colour negative has far more exposure latitude than slide film.

CONTROLLING TONES AND COLOUR

Slide film must be exposed with much more care than negative film, because there is no intermediate stage en route to the finished picture where errors can be corrected.

For realistic tones and colours, exposure measurement must be very precise. With some transparency films in bright sunlight, overexposure of just half a stop can ruin the picture. Latitude for underexposure is usually greater, but overall, the exposure latitude of slide film is a fraction of that of negative film.

The colour of the light that falls on the subject is as crucial as the intensity. Most slide films are balanced to give good colour at noon on a sunny summer's day, with a blue sky. Even in overcast weather, filtration is needed to provide correct colour rendition.

In artificial light, the problems are even more severe, with heavy blue filtration neces-

sary when the subject is lit by tungsten light. As an alternative, special tungsten-light balanced films are available, though even when using these in domestic lighting, some fine-tuning of colour with filters may be required.

LOW LIGHT

Dim light causes additional difficulties when using transparency film. Each of the film's three layers has slightly different characteristics, so that the required compensation for reciprocity failure may vary from layer to layer. In practice this means that not only must transparency film receive extra exposure in dim light, but colour correction filters are necessary as well.

Film manufacturers supply data tables that outline how much filtration, and how much extra exposure is required, but these are only a guide. The only way to find out precisely how much compensation to use is to run tests, using several films from the same batch.

First, the photographer makes a series of exposures with the shutter held open for one, ten and a hundred seconds. The pictures are bracketed using the aperture, at half-stop intervals over a range +½ to +3 stops. Processing this first roll reveals the necessary exposure compensation, and gives a clue to the colour shift. A second, and perhaps a third test with gelatin colour correction filters on the lens reveals how much filtration is needed for this particular batch of film, at each exposure time, and of what colour.

At very long exposures, correction for reciprocity failure may be impractical, and only with supplementary lighting will colours appear lifelike.

MATCHING FILM TO TASK

The differences between different reversal films are more marked, and the range of available speeds greater than with colour negative film. The slowest of slide films – Kodachrome 25 – is legendary for its high resolution, fine grain, and bright colours. However, as the box at right explains, this and other Kodachrome films must be returned to the manufacturers for processing.

At the other end of the scale, the fastest slide films have speeds of ISO 1600/33°, and this can be boosted still further with push processing. As might be expected, though, these films produce weak colours and generally poor quality, and they should be used only as a last resort. What these superfast films do offer, however, is the chance to shoot by available light, even in very low-light conditions. The loss of quality may be more acceptable than the loss of atmosphere by introducing artificial light.

SPECIAL FILMS

The enormous majority of the available colour films are formulated to give the most realistic tones and colours possible, but for a few specialized photographic tasks, realism is not of primary importance. Although aimed at specific applications, these films can sometimes usefully be borrowed for ordinary photography.

INFRA-RED FILM

Infra-red radiation lies just outside the visible spectrum, and includes wavelengths that most people would describe simply as heat. However, near-infra-red radiation can be used to form images in the camera, with appropriate film and filtration.

There are two sorts of infra-red film – black-and-white and false-colour film. Both types are sensitive not only infra-red, but also to visible light, so they must be used with filters if the full effects of the infra-red, but also to to visible light, so they must be used with filters if the full effects of the infra-red are to be seen.

The sensitivity of the black-and-white emulsion stretches furthest into the infra-red portion of the spectrum. This film is rarely kept in stock, and must be ordered specially by photo-dealers. It must be loaded in total darkness, and kept refrigerated before use.

Exposure is rather haphazard, because meters do not respond to infra-red. Pictures must therefore be bracketed heavily around the indicated meter reading. To take full advantage of the film's sensitivity, the camera can be fitted with a visually opaque filter

KODACHROME *This film has a very high blue sensitivity. In these pictures, the yellow cast from the setting sun (above) has been counteracted by the blue sensitivity of Kodachrome (right).*

TRANSPARENCY FILMS COMPARED

In normal, non scientific use, colour transparency films can be compared for:

- sensitivity (film speed)
- resolution
- graininess
- colour fidelity
- colour accuracy
- contrast

The slight differences between films are surprisingly hard to spot in isolation, and even side by side comparison of films of similar speed may reveal only small dissimilarities. The most distinctive qualities tend to be graininess, colour saturation, and the rendering of subtle tones such as grey and skin colours.

The most significant difference is between slow and fast transparency films. Kodachrome 25 sets the standard for resolution and several other image qualities. Sharpness and colour saturation in particular are significantly better than Ektachrome 400.

Kodachrome 25 resolution is 100 line pairs per millimetre; Ektachrome 400 is only 63 line pairs per millimetre.

145

TYPES OF TRANSPARENCY FILM

By shooting the same scene on a variety of films (below) and studying the results side by side, subtle differences can be spotted which would otherwise go unnoticed. For everyday use, almost all of the brands would be acceptable, but there are variations in sharpness, overall colour balance and graininess which can be used to advantage in particular situations. Most films are designed to reproduce *certain* colours well, and photographers will select film based on its intrinsic characteristics and their particular needs for the shot. For example, one manufacturer may aim for a rich blue – good for seaside shots or holiday brochures – and another instead for accurate reproduction of flesh tones.

Kodachrome 25

Kodachrome 64

Ektachrome 64

Ektachrome 200

Ektachrome 400

Fujichrome 400

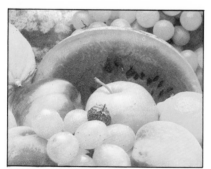
Fujichrome 100

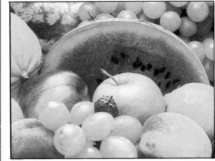
Agfa CT 18

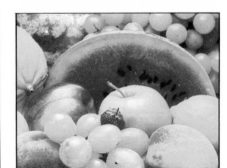
Agfa CT 21

that lets through only infra-red wavelengths. Pictures taken using such a filter show sunlit foliage glowing snowy white, and record skin as waxy and mask-like. But the tones are still acceptably natural for many non-living subjects, and black-and-white infra-red film can be an effective way of cutting through mist.

Some change of technique is required when focusing, because all ordinary lenses bring infra-red radiation to a different focus from visible light. Most lenses are marked with an infra-red focusing index, alongside which the subject distance is aligned.

False-colour infra-red film forms surreal images which have curious colouration. The film is sensitive to green and red light, and infra-red, but all three of the film's layers are also sensitive to blue light. Therefore, to take full advantage of the film's unusual sensitivity, filters must again be used. The recommended filtration is yellow, but for pictorial purposes, other filters give equally interesting effects.

Focusing can be carried out normally with this film, but the lens should be stopped well down if the image formed in the film's infra-red-sensitive layer is to be recorded sharply.

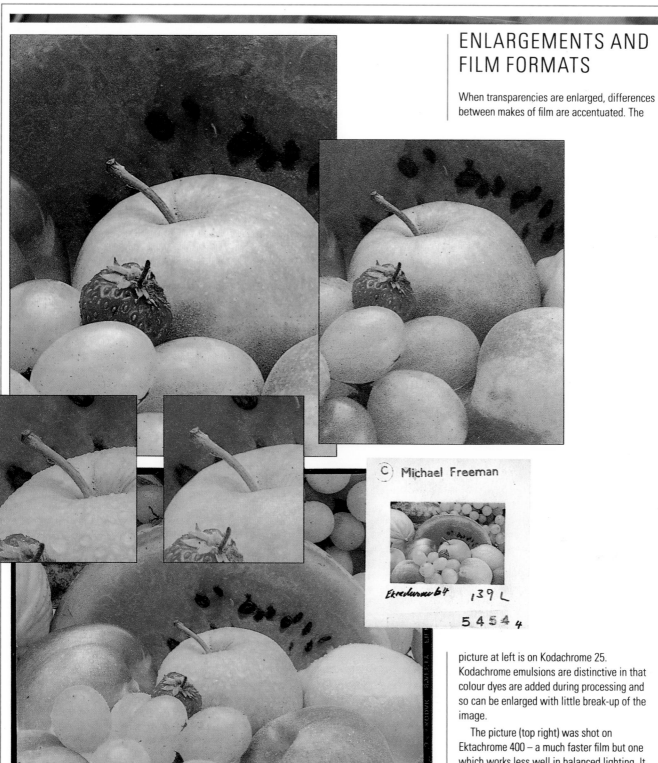

© Michael Freeman

Ektachrome 64 139 L

5 4 5 4 4

ENLARGEMENTS AND FILM FORMATS

When transparencies are enlarged, differences between makes of film are accentuated. The picture at left is on Kodachrome 25. Kodachrome emulsions are distinctive in that colour dyes are added during processing and so can be enlarged with little break-up of the image.

The picture (top right) was shot on Ektachrome 400 – a much faster film but one which works less well in balanced lighting. It has a slightly bluish tint and generally flat colour reproduction.

Film size and sharpness Even more important than the choice of brands and film speed is the film format. A large film size needs to be enlarged less, and so the image will appear sharper in its final form. Both the 5 × 4in sheet film at left and the 35mm transparency above are on ISO 64 Ektachrome. The enlargements of the apple stalk show the advantages of shooting on a large format – the 5 × 4in version is on the left.

FILMS AND FILTERS

147

INTENSIFICATION OF GRANULARITY *The special grain texture of this photograph, The Birds, by George Krause, was achieved by high intensification of a Tri-X negative. Krause has experimented with the graphic possibilities of different chemical intensifiers, because of their effect on the graininess. In this example, he used a proprietary brand, Victor's Mercury Intensifier. Mercury intensifiers work principally on the thin areas of a negative, helping to separate tones and increase contrast.*

149

PROFESSIONAL FILMS

Some transparency films are available both in professional and regular versions. Professional film is different in several ways, although the differences are not in manufacture, but in packaging and storage.

Film as it emerges from the coating machine is not ready for use. Like good wine, it must be aged. Amateur films, though, are despatched immediately, on the assumption that they will age on the dealer's shelf, and in the photographer's camera.

Professional films, on the other hand, are retained at the factory in controlled conditions, and periodically tested. When they are in peak condition, they are tested again, so that the manufacturer can overprint the true, measured film speed on the instruction sheet enclosed in the film pack. The tested speed may be up to ⅓ stop different from the nominal speed on the film box. The film is despatched in refrigerated containers to dealers who put it in cold storage.

Photographers who buy this film therefore catch it at its peak, and they in turn store the film in a refrigerator or freezer until shortly before exposure. After use, they process the film immediately.

Professional films produce superior results only if they are dealt with in this methodical manner. Used in a casual way, pro-designated emulsions will give no better results than ordinary films.

Between these two extremes, there are progressive trade-offs between speed and quality, and variations between brand to brand in terms of colour rendering. The balance of couplers in one make of film may favour flesh tones – whereas another type may render

COLOUR INFRA-RED *Ektachrome Infra-red has three emulsion layers – one sensitive to green light, a second layer to red light, and a third layer to infra-red radiation. Each layer gives a false colour. The colour effect depends on both the infra-red reflectivity of the subjects, and on the filtration. Here, a red filter (Wratten 25) gave red vegetation.*

FITTING THE FILM TO THE OCCASION

Type of film	Brand examples	Best uses
VERY FINE GRAIN DAYLIGHT ISO 25	KODACHROME 25 AGFACHROME 505 FUJICHROME 50	Static or slow-moving subjects, and when detail is important, eg architecture, landscape, still-life, studio subjects.
FINE GRAIN DAYLIGHT ISO 64–100	KODACHROME 64 FUJICHROME 100 EKTACHROME 100 AGFACHROME 100	General use: the standard films for all except fast action and dimly lit subjects.
MEDIUM-FAST DAYLIGHT ISO 200	EKTACHROME 200 AGFACHROME CT200 KODACHROME 200	Compromise film, giving better grain than the fast films but a speed advantage over standard films. Good for some candid street photography.
FAST DAYLIGHT ISO 400	EKTACHROME 400 SCOTCH COLOUR SLIDE 400 FUJICHROME 400	For low light and fast action, eg at dusk, in fluorescent-lit interiors (with fl filter), sports.
SUPER-FAST DAYLIGHT ISO 800–1600	EKTACHROME P800/ 1600 FUJICHROME 1600 SCOTCH 1000	For extremes of low-lighting and fast action. P800/1600 is variable in speed from ISO 400 to 1600 and is becoming the standard fast film for many professionals.
FINE GRAIN TUNGSTEN-BALANCED ISO 40–50	KODACHROME 40 EKTACHROME 50 AGFACHROME 50L	For static interior (tungsten-lit) and studio subjects.
MEDIUM-FAST TUNGSTEN-BALANCED ISO 160	EKTACHROME 160	Moving indoor (tungsten-lit) subjects, especially if lit with photographic lamps. In television studios and on movie sets.
FAST TUNGSTEN-BALANCED ISO 640	SCOTCH 640T	Candid photography in tungsten-lit interiors. Alternative: super-fast daylight film with 80B filter.
RE-PACKAGED MOVIE STOCK	EASTMAN 5247 EASTMAN 5293	Transparencies and negatives from same film stock. Colour balance unimportant. Good for uncertain conditions.
INSTANT FILM	POLACHROME CS	For testing or when slide is needed immediately.

greys and whites very neutral in hue. Generally, though, the characteristics of films remain relatively constant across film families: the colour balance of Ektachrome 400 bears a family resemblance to Ektachrome 100, but not to Kodachrome .

Choice of film depends, as with colour negatives, on personal choice, and on the job in hand. Ultimately, the only answer is to experiment and pick out the film that has the most personal appeal. Having selected one emulsion, though, it is prudent to use this one film whenever appropriate, and get to know its characteristics as well as possible. Constant changing from brand to brand simply produces inconsistent results.

USING FILTERS

Used for their intended purposes, filters form an important control for the photographer using monochrome film, and make it possible to alter, adjust and manipulate the reproduction of colours for corrective or creative purposes.

CONTROLLING HAZE AND REFLECTION

All film is sensitive to invisible ultraviolet radiation, but the two lower layers of film, sensitive to green and red light, are protected by a yellow layer that absorbs UV and blue

POLARIZED REFLECTIONS

Reflections from windows often limit the view inside, and reducing them is a common use of a polarizing filter. The pair of pictures below show the difference.

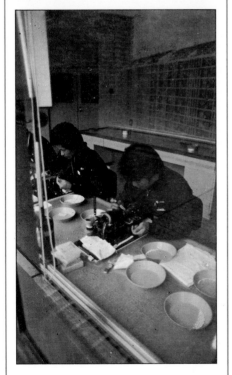

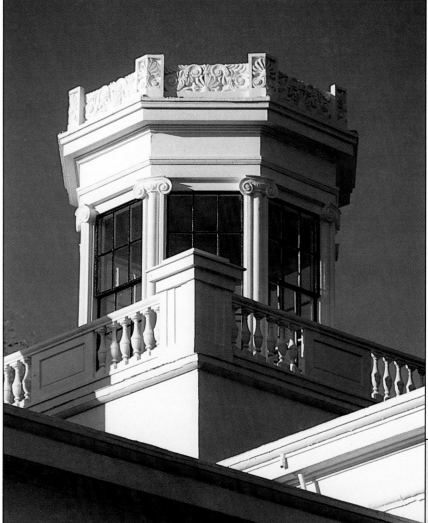

ABOVE *An overall blue cast adds mood to this Citroen brochure shot by John Claridge.*

ABOVE *A polarizing filter darkens the blue of the sky and can be used for both colour and black-and-white photography.*

RIGHT *A strong yellow Wratten 15 filter was used here to heighten contrast and lighten the appearance of the snow.*

light. However, the upper layer of the film, which makes a record of the blue light from the subject, is not protected. Consequently, in scenes that reflect a lot of UV radiation to the camera, this top layer receives more exposure than it should.

The practical effect of this is that pictures taken in a high-UV environment come out too blue. The cure is simple – just fit a piece of UV absorbing glass over the lens. This is the function of UV and skylight filters. Made from almost clear glass, these filters take out the blue tint from pictures taken at high altitude and near the sea, where UV radiation is a hazard.

Since such filters have no material effect on pictures, other than removing UV, many photographers leave them in place as lens protection at all times.

POLARIZING FILTERS

On reflection from most shiny surfaces, light undergoes a change. Normal daylight is made up of waves of light vibrating in all directions, but reflection from a surface cuts out some of these vibrations, so that the reflected light waves are vibrating in a single plane. This reflected light is said to be polarized.

To understand this concept more clearly, think of a child turning a skipping rope. One end is tied to a tree and the rope passes through vertical iron railings. At the other end, the child's arm makes circles. This sends spirals down the rope as far as the railings. But here, the left-to-right movements of the rope are stopped and only the up-and-down movements continue.

The significance of polarization becomes apparent on trying to photograph through a shop window, or a similar reflective surface. Reflections of the street outside obscure the view on the other side of the glass. A special kind of filter, called a polarizing filter, can cut these reflections out.

CONTRAST CONTROL

There are more opportunities for controlling contrast in black-and-white than in colour. The basic options are:

1 Use a high- or low-contrast film.
2 Use fill-in lighting or reflectors.
3 Shade concentrate, or diffuse, the light source.
4 Alter the processing: overexposure and underdevelopment reduces contrast, underexposure and overdevelopment raises contrast.
5 Reduce contrast by pre-exposing the film to a featureless light surface (such as the sky) then giving at least three stops less exposure than the meter reading.
6 Use degrading filters such as fog or diffusing filters to reduce contrast.
7 Use a coloured filter to alter relative values. In particular, outdoors, a blue filter increases the effect of haze and usually reduces apparent contrast, while a red filter will tend to deepen shadows under a blue sky.
8 Treat a negative in a reducer or chromium intensifier.
9 Print on a soft or hard grade of paper.

FILMS AND FILTERS

In skipping-rope terms, a polarizing filter is like a second set of iron railings, through which the waves in the skipping rope – the polarized light – must pass. When the second set of bars is vertical, the waves continue on to the tree. Turning the bars through 90°, though, blocks all movement of the rope.

In a similar way, turning a polarizing filter in front of the camera lens cuts out the reflection from the window. In one orientation, the reflections are clearly visible, but with the filter turned 90°, reflections vanish.

In a more homely form, polarizing filters are familiar to millions of motorists. Polaroid sunglasses are simply sheets of polarizing material with the axis of polarization vertical. Since glare from the setting sun on a wet road is polarized horizontally, the sunglasses remove the glare without blocking out the other unpolarized light.

Polarizing filters work best when the lens axis is at about 60° to the reflecting surface; the reflecting-cutting power is more evident with telephoto lenses; and they do not work at all when the shiny surface is metal – such as chrome work or polished silver.

However, polarizers have another important function besides cutting reflections. Foliage, paintwork and other common photographic subjects reflect glaring highlights which dilute and weaken colours. Polarizing filters, correctly orientated over the lens, can remove the glare and intensify the hues.

Blue sky is partly polarized and a polarizing filter will darken and enrich the sky colour. The area most affected runs in a band across the sky, in a plane at right-angles to the sun. A handy rule is to make a fist, with the index finger and thumb sticking out. Pointing the index finger at the sun, a twist of the thumb points out the arc of sky most darkened by a polarizing filter.

Haze polarizes light to a small extent, so a polarizing filter has some value in cutting through haze. The effect is limited, but clearly visible on turning the filter in front of the eye.

SPECIAL-EFFECTS FILTERS

Reality is frustratingly imperfect. Idyllic rural scenes are criss-crossed by power lines, and the faces of many portrait subjects are equally marred, by lines of a different sort. Special-effects filters help to gloss over things that are not quite right. Used with skill and restraint, they can make an interesting picture out of boring or mundane subject matter.

Softening the Edge By far the most popular types of filter are those that diffuse or soften the image. This has an obvious value in portraiture, where a sitter may not wish to be reminded of the effects of time on their features. By softening the edges, these filters also produce images which many people feel more closely resemble images in our memory than do the unmanipulated products of the camera. So softening filters are frequently used to create a nostalgic or 'times-past' mood.

COMBINING NEAR AND FAR *Often stopping down a lens gives insufficient depth of field to render both foreground and background sharply.*

A split-field close-up lens can solve the problem, as above, where a close wildflower and distant church tower appear focused together. Such filters are essentially half-lenses: half of the mount contains a close-up lens while the other half is empty. To conceal the dividing line, it helps to use a wide aperture and a camera lens that has a normal rather than a short focal length. Also, natural dividing lines in a scene, or featureless areas such as sky, help to disguise the trick. Split-field close-up lenses are available in ranges similar to conventional supplementary lenses, graded by diopters.

FOR DRAMATIC EFFECT *Filtration applied to an already dramatic view – of Lhotse in the Himalayas – has produced a landscape that appears almost unearthly (left). Japanese photographer Shirakawa, known for his painstaking and strenuous approach to the world's most impressive landscapes, has here pulled out all the stops to produce an image that sacrifices realism for drama.*

GRADUATED FILTERS *(far left) A graduated filter was used here to tone down the sky so that the buildings were not drowned by excessive contrast.*

GRADUATED COLOUR FILTERS

Although graduated filters are more conventionally used in neutral grey versions to control the tonal balance in a photograph, coloured varieties can be used for a more obvious pictorial effect, as for the pictures (below).

STARBURST FILTERS *These have a crossed pattern of etched lines on the glass. This etching interferes very little with most of the image, but produces a characteristic pattern of rays from bright, specular highlights (above). The number and angle of the rays depends on the etched pattern. The effect is enhanced at small apertures.*

DIFFUSING FILTERS

There are several types of these, each giving a slightly different visual effect. The fog filters used in both the pictures below soften contrast overall, diminish sharpness slightly, and give slight flare effects around highlights.

Though each works in a different way, all have one thing in common – they spread the picture's highlights into the shadows, reducing contrast. Where solid blacks are an important feature of the picture, the lens should be used unfiltered.

- *Mist filters* are usually etched with lines or scratches to spread the lighter parts of the pictures into the shadows.
- *Fog filters* have a similar, but more pronounced effect than mist filters.
- *Diffusion filters* simply soften fine detail, with less spreading of highlights. Diffusion, fog and mist filters are available with clear centres, so that only the periphery of the picture is affected.

DARKROOM PROCESSES

DARKROOMS COME IN many shapes and sizes, from a cramped cupboard under the stairs to luxury purpose-built complexes. The basic requirements of a darkroom depend on the kind of work undertaken. For those photographers who simply want to process their slide films, for example, a well blacked out wall cupboard, or even a wardrobe used at night, will be quite adequate. Here the film can be loaded into a developing tank; the wet process is carried out in the light. Colour printing need not be too space-consuming as the two main items, an enlarger and a colour print processing unit, do not need to be in the same place.

Colour enlargers must be used in the dark, but the processing unit can be used elsewhere. The only part of processing that needs to be carried out in the dark is loading exposed print into the tube.

Black-and-white printing takes up the most room as prints are processed in trays. Laid out in a row they will need at least four feet of 'wet' bench, unless the trays are stacked in tiers which saves space.

Although the kitchen and bathroom are often suggested as temporary spaces because they have running water, any room will do. All the water needed is a bucket or two to put fixed prints into; these can be carried out later for proper washing.

There are points worth considering when setting up in a temporary location. Avoid dusty rooms, and deal with any chemical splashes on walls or carpets immediately.

Wet and Dry Bench It is a cardinal rule of darkroom layout to separate 'wet' and 'dry' operations as far as possible. This helps to ensure that fresh paper and negatives are not affected by chemical splashes, helps separate electrical apparatus such as the enlarger from water and other liquids and makes the darkroom much easier to keep clean. In many darkrooms, the 'wet' bench, containing all the process chemicals, is a shallow sink that can be swilled out completely at the end of the day. If the enlarger and the chemical solutions have to occupy the same worktop, a free-standing dividing unit made out of plywood helps to prevent splashes from the trays going anywhere near the enlarger.

Permanent Darkrooms Few people have a spare room that can be fitted out permanently. But many people do have a shed, garage, attic, cellar or large cupboard under the

WET AND DRY

Accidental contamination is always a danger in a darkroom, and the greatest risk is of splashing onto dry materials. To minimize this risk, separate wet and dry processes in the room (see diagram below).

LIGHTPROOFING

In converting a room into a darkroom, the two areas that need special attention are the window and door. One way of light-proofing a window, is to fit a wooden board into the frame, holding it in place with clips (above right, centre). Alternatively, a special darkroom roller blind can be fitted (above right, top); the blind is made of black fabric and runs in a trough. To seal the gaps around the door, rubber flaps and black foam strips will usually be adequate.

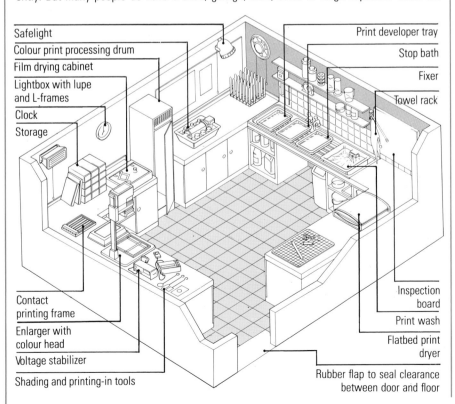

- Safelight
- Colour print processing drum
- Film drying cabinet
- Lightbox with lupe and L-frames
- Clock
- Storage
- Contact printing frame
- Enlarger with colour head
- Voltage stabilizer
- Shading and printing-in tools
- Print developer tray
- Stop bath
- Fixer
- Towel rack
- Inspection board
- Print wash
- Flatbed print dryer
- Rubber flap to seal clearance between door and floor

A CONVERTED STUDY

A slightly more sophisticated type of conversion, yet still temporary, is of an office or study. Even if there is no plumbing, processing solutions can be mixed and brought in from the bathroom, while a plastic bucket can be used for taking fixed prints out for washing. The room can be light-proofed with a wooden shutter that fits tightly into the window frame, and felt or rubber flaps around the door.

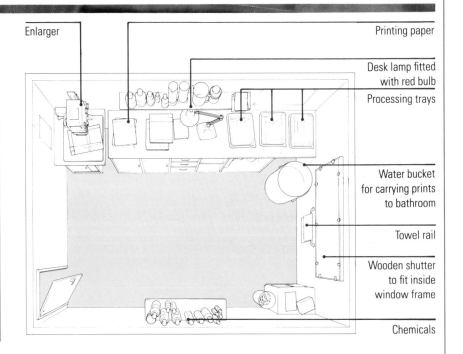

Enlarger

Printing paper

Desk lamp fitted with red bulb

Processing trays

Water bucket for carrying prints to bathroom

Towel rail

Wooden shutter to fit inside window frame

Chemicals

TEMPORARY DARKROOMS

Temporary darkrooms are set up in all kinds of places, but the best locations are dust-free and relatively easy to warm and ventilate. A water supply and drain are also useful though not essential. If one room is to be used regularly it is well worth spending some time making an 'instant darkroom kit' that can turn the room into a laboratory in minutes.

A proper blackout is essential, especially for loading films or printing in colour. Windows can be quickly blacked out with a sheet of plywood cut to fit over the glass exactly. Permanent clips can be put into the window frame to hold it in place.

The door needs light-proofing too. A curtain pole fixed over the door means a heavy curtain can be slipped into place whenever the darkroom is needed.

Benches can be made from plastic-laminated wood to fit instantly into place – over the bath, for instance.

stairs that can be turned into a permanently equipped darkroom. Large-scale darkrooms with running water can be expensive to fit out but offer tremendous scope for all kinds of work. A small bedroom with an existing sink is ideal. Kitchen units can be fitted down two walls for enlarging and print finishing, while a long, shallow sink can be fitted under the taps.

Special plastic sinks can be bought, into which four processing trays fit, allowing all the 'wet process' to be done in them. Three taps are useful in the darkroom – one cold tap can have a hose permanently fitted for washing films or prints while the other cold and hot ones can be used for mixing solutions or washing hands and equipment.

Darkrooms should be painted a light colour so that the safelight is well reflected around the room. A black section should be painted in around the enlarger, however, to prevent light from the lamphouse being reflected onto the paper in the easel.

Two safelights are a good idea in an average-sized room, one for general illumination hanging from, or reflected by, the ceiling, and one over the wet bench or sink to allow inspection of the print throughout the process.

A properly blacked out room may well be airtight, and good ventilation must be provided. Fumes from other chemicals can be unpleasant and, without fresh air, working in the darkroom gets very tiring. An electrical fan incorporated into a light baffle is ideal.

The room should be laid out in working order so that all the major facilities are within easy reach. Worktops should be very stable, particularly the one which supports the enlarger. It is worth strengthening the support of free-standing units by screwing the back into the wall with a batten in between.

All working surfaces should be non-porous and 'wipe-clean' to avoid chemicals getting into the surface – chemicals lodged in the surface may contaminate subsequent operations. Floors should also be washable but splashed water on vinyl or PVC floor coverings can be slippery and dangerous and a less slippery surface, such as quarry tiles, is better.

It is a good idea to have all the power sockets in one place. Four or five will come in useful and they should be wall mounted at bench level. All plugs should be labelled so that they can be read under safelighting.

Heating It is far easier to keep the solutions at the right temperature if the room temperature is warm and steady. Attics, sheds and garages are hard to keep warm in winter and to keep solutions warm, every tray may have to have its own heater and every solution be kept permanently in tempering baths.

Darkrooms should also be comfortable to work in and the printer's own need for warmth

PROCESSING EQUIPMENT

Materials and equipment The basic equipment for black-and-white processing is, shown at right: developer, fixer, stop bath and wetting agent, with a graduate, funnel, thermometer, developing tank and reel, timer, rubber hose for washing, clips for hanging rolls to dry, scissors for cutting the film, and a squeegee for wiping off excess water.

Agitation Regular agitation of the developing tank is needed to ensure that all the film receives equal chemical action. Follow the manufacturer's advice.

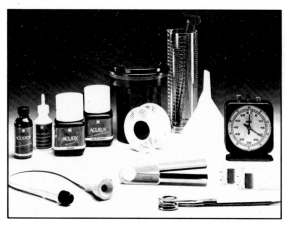

appearance. The fixing bath loosens these unexposed halides and makes them soluble in water so that they can be washed away to leave the visible silver image.

Washing The final washing of the film removes any traces of unwanted halides and residual chemicals. Most photographers prefer to add a small quantity of 'wetting agent' at this stage to reduce drying marks on the film.

Drying Films are usually hung up to dry in a dust-free place, sometimes using warm air to speed up the process. A weighted clip on the bottom end of the film keeps it straight.

DEVELOPING A 35mm BLACK-AND-WHITE FILM

LOADING A DEVELOPING TANK

A small tank for up to two films can be loaded in a changing bag – a light-tight, zippered bag with elasticated arm holes. However, tanks are available for loading up to eight or more 35mm films and five or six roll films. For this number, a properly blacked out room or large cupboard is usually necessary for comfort and efficiency.

Films are loaded onto spirals which allow developer to circulate freely over all the emulsion surfaces at the same time. The cap of the tank prevents light coming in but allows solutions to be poured in and out.

Instructions on the base of the tank give the amount of solutions to mix in order to cover the film properly. Insufficient solution will result in part of the film being above the surface of the developer causing uneven development and ruined negatives.

LOADING THE SPIRAL

This is the only stage that must be carried out in total darkness, and it is wise to practise loading a scrap film onto the spiral in daylight before attempting it with an important film in darkness.

Make sure that the spiral is absolutely bone dry before loading with film. If it is the least bit damp the film may jam in the spiral before it is completely loaded.

If the film has been rewound completely into the cassette then the cassette will have to be broken open in total darkness to get at the film. It is a wise precaution for the beginner

ALTERED PROCESSING

Black-and-white film can be given less or more development than normal very easily, and this treatment can be used to control contrast. In the examples (below), the same shot was made on three separate lengths of film. One was given normal development, another underdeveloped by one-and-a-half stops (the exposure was increased to compensate) and the third overdeveloped by the same amount (and underexposed). Underdevelopment gave low contrast, over gave high.

DARKROOM PROCESSES

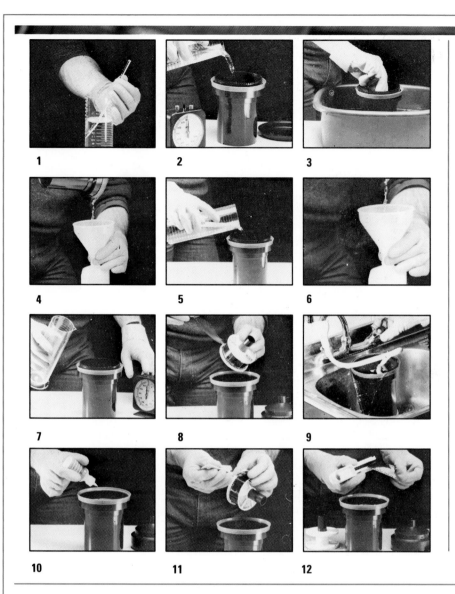

1

2

3

4

5

6

7

8

9

10

11

12

PROCESSING BLACK-AND-WHITE FILM

1 Begin development by preparing sufficient volume of developer at 20°C (68°F).

2 Pour the developer into the tank (loaded with film) and start the timer.

3 Keep the developer at a constant temperature in a 20°C (68°F) bath. Check manufacturer's requirements for developer as it may need agitation.

4 Empty the tank so that it is drained just as the development time finishes.

5 Pour made-up solution of stop bath into the tank. Agitate.

6 After about 30 seconds, empty the stop bath, conserving it for future use.

7 Pour in fixer solution, set the recommended time, and agitate as before.

8 Empty the fixer when the time is complete, and briefly inspect the film.

9 With the top of the tank removed, wash the film on its reel with a filtered hose. Place the hose deep into the tank and keep the flow gentle.

10 After washing for the recommended time, add a few drops of wetting agent to the remaining water, and agitate gently.

11 Remove the reel from the tank, gently attach a hanging clip to the free end, and withdraw the film carefully from the reel.

12 Just before hanging to dry, draw the rubber squeegee tongs gently down the length of the film, to remove drops. Beware of tiny particles of grit which can ruin the film.

to avoid rewinding the film completely before removing it from the camera – listen for the click as it leaves the take up spool and stop rewinding. If you use a motorised camera you may find that it automatically rewinds the film completely – you may be able to beat it by opening the back of the camera just before the leader disappears into the cassette, but this is tricky to time perfectly.

If you can rewind the film so as to leave the leader out you can begin the loading process in daylight. Cut the leader from the film, taking care to cut between the sprocket holes leaving rounded corners – this will make it easier for the film to slip onto the spiral. You can insert the end of the cut film a couple of inches onto the spiral before turning the light out to continue loading the spiral. Unreel the film about 12in (30cm) at a time as you wind it onto the spiral with alternate twists of each hand. Keep your thumbs on the pads at the mouth of the spiral as this will help to prevent the film twisting out of location. Even so, you may find that the length of film approaching the mouth of the spiral will twist itself into a corkscrew; if so you must carefully unwind it before proceeding.

If you are unlucky enough to have a film jam on the spiral when it is only part loaded, you will be able to rewind it into the cassette by rotating the end of the spindle which protrudes from the cassette.

If your camera dictates that you have to break the cassette open (a can opener is useful for this) to get at the film for loading onto the spiral, it is not a bad idea to have a bucket of water standing by in the darkroom. If the film jams on the spiral because the spiral is damp you can plunge your hands, plus spiral and film into the bucket and you will find that you can then complete loading the spiral.

Once the spiral is loaded you can then place it inside the developing tank and screw the

NEGATIVE CHARACTERISTICS

A close inspection of the negative through a magnifying glass can indicate just how it will print. The qualities to look for are:

Density A negative with shadows too thin (light) or highlights too thick or dense (dark) will print badly.

Tonal range is the contrast between the maximum and minimum densities.

Sharpness should be checked in areas of fine detail.

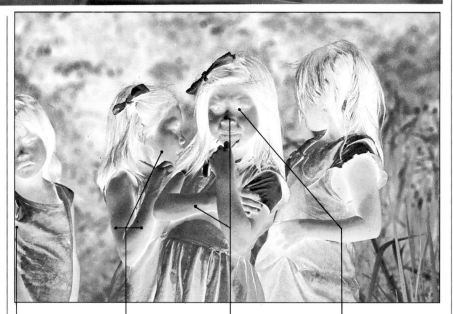

In the print, this girl would be cropped out to improve composition.

The key tones are the faces and the arms of the girl.

Care must be taken in printing to avoid blocking highlights in these areas.

The shadow detail in the eyes needs to be retained.

top on. The rest of the developing process can be carried out in daylight or full room light, as follows.

Be sure that you have the right quantity of stop bath solution and fixer solution mixed and ready before you start the developing sequence.

Although straightforward, the processing sequence is a rigid one, and you should follow each step under exactly the right conditions of temperature, timing and agitation. To avoid mistakes and delays, you may find it helpful to write down the sequence before you begin, and, before pouring the first solution into the tank, check that you have everything to hand.

DEVELOPERS

Four factors control the development of film: time; temperature; agitation; and developer activity. For predictable results, development time must be exactly timed. If development is cut short some of the latent image is left undeveloped and the resulting negative looks thin and pale. If development goes on too long, the subtle variations in silver density are lost; the negative is contrasty, dense and hard to print.

The temperature must also be consistent – usually around 20°C (68°F) for black-and-white films. Higher temperatures mean a more rapid reduction of the silver halides, and consequently a denser film. If the developer is too cold the recommended time produces a weak negative.

Developer quickly becomes 'spent' as it works on the emulsion, so agitation is necessary to make sure that 'active' developer comes into contact with the emulsion throughout the process. Failure to agitate the developer at regular intervals through the process will result in weak negatives, and sometimes dark and light 'waves' in the emulsion.

Developer Types The most economic type of developer is called 'universal'. This can be used to develop both films and papers. However, it is very much a compromise; a universal quality with all the various films and papers available. Each film has its own recommended developer, which is usually supplied by the same manufacturer. Most black-and-white films can be developed in a variety of developers, however, some of which produce quite different results with the same film.

In general, the manufacturer's recommended developer will provide a good tonal range for their film's speed or light sensitivity. Other developers will alter some of the character-

istics of the final negative, thus making it possible for photographers to 'fine-tune' their working methods and materials to produce a negative which suits their own style of photography.

Typical promotional claims for developers are: increased film speed; finer grain; high contrast; and high definition. However, these characteristics cannot be all achieved with just one developer. For example, increasing the film's speed will normally result in coarser grain and the developers which provide the finest grain normally reduce the film speed.

Fine Grain Developers Many developers are termed 'fine grain' and these offer a good contrast range without speed loss. These developers are especially suitable for enhancing textures in the subject. Very fine grain developers are available too but these require a sacrifice in film speed. On the whole, fine grain developers can be used with any speed of film, and most general-purpose film developers are now termed fine grain.

High Energy Developers These are designed for use with fast films for 'pushing': they allow an increase in film speed without increasing contrast, therefore they are suitable for low-light, high contrast subjects.

High Definition Developers For use with slow or medium speed films, high definition developers increase the apparent sharpness of the negative. Sometimes known as high acutance types, these developers create hard edges between areas of high and low density in the negative, helping to define an image crisply.

Contrast Many films are able to be fine-tuned during development to suit the two basic forms of enlarger, the condenser or the diffuser type. Often development times for film are given twice, one for normal contrast and one for higher contrast. If the negative is to be printed in a condenser enlarger then the normal contrast time is used. If a diffuser enlarger is to be used however, then the higher contrast range from the longer development time will be more suitable.

Characteristic Curves The type of developer used affects the range of tones in a negative. Some developers give equal emphasis to the complete tonal range, while others reduce highlight contrast, or emphasize mid-tones. The types of tones a developer gives a particular film is often expressed as a graph called a 'characteristic curve'. In simple terms, the density is measured in the upward direction of the graph and the exposure along the bottom. The developer controls the density that a certain exposure will give. The single upwards-sloping line indicates how the tonal range of the film appears in the negative. The steeper the slope, the higher the contrast in the negative.

The bottom part of the slope is called the 'toe' and this denotes the shadow areas. The top part is called the 'shoulder' and this represents the highlights.

Mixing Developers come as dry chemicals or concentrated solutions. The dry powder forms must be mixed by the photographer and stored, usually in quite large quantities. These 'stock solutions' are then either further diluted and used just once, or used at full strength; they can then be re-used to develop subsequent films. Amended development times are then needed to take account of the loss of activity which each developed film causes in the solution.

Many photographers, though, find it more convenient to use concentrates, which do not need lengthy preparation and are used in small quantities to make enough solution to process a few films, or a single film at one time.

In general, concentrates take up less storage space, can be bought in smaller amounts and are less complicated to prepare than powder types which need careful preparation and storage.

It is essential to store chemical solutions correctly to avoid shortening their effective life. Special 'collapsible' bottles are useful to keep the solution as airtight as possible. If the developer is exposed to air for a prolonged period, it becomes oxidized and consequently less active, thus causing poor results.

DEVELOPING TANK OPTIONS *Developing tanks come in different sizes enabling several films of the same type to be developed simultaneously.*

COMMON FAULTS

Most processing faults in black-and-white or colour can be traced to one source: the operator. The two commonest faults are over- or underdevelopment.

Overdevelopment (1) gives a dense negative which prints as a very contrasty image. It is caused either by leaving the film in the solution for too long or by too high a temperature for the developing bath.

(NB Do not confuse over-developed negatives with overexposed ones. These are more evenly dark and do not print contrasty images.)

Underdevelopment (2) is caused by low temperature, too short a development, or weak or exhausted developer. This type of negative looks thin, although unlike underexposed negatives they do have shadow detail.

Fogging in camera (3) If light gets onto the film while it is in the camera, or just the film cassette, opaque areas may be visible at the edges of the film, though the middle should be clear.

Scratching (4) Parallel scratches indicate grit either on the film cassette mouth or in the squeegee used to dry the film.

Fogging (5) Opaque areas that should be clean and clear, almost certainly due to light reaching the film while loading into the tank. All-over density throughout the film could also be fogging of a different sort. This could be the remains of silver halide still in the emulsion which has not been 'cleared' by fixing. A re-fix can cure the problem.

Undeveloped strip (6) down one side of film, caused by insufficient developer in the tank. All the film must be immersed under the developer. If one film is developed in a two spiral tank, it is possible for the single spiral to move upwards during agitation. Use the securing device supplied with the tank.

(1) (2) (3) (4) (5) (6)

Developing Equipment Most methods used to develop films involve some form of developing tank. The most common type of tank, and certainly the most popular with photographers who don't have a permanent darkroom, is the daylight 'universal' tank. Although these must be loaded in the dark, all other parts of the film process, from development to washing, can then be carried out in daylight.

Besides a tank, there are several useful and necessary items used in processing films. Timers come in many forms, from a simple wrist watch with a secondhand to expensive digital timers with LEDs that make a noise when the sequence is over. The only requisite is that it must show the time in seconds to allow for consistent timing of agitation and the beginning and ending of each step.

Drying marks (7) Dirty patches or 'runs' on the film side, caused by chemical deposits; they mean that the film was not washed properly.

(7)

Crescent-shaped marks (8) This is a particular problem with roll-film which is harder to fit into the spiral. It is caused simply by 'kinking' or creasing the film during handling before it is developed.

(8)

A thermometer is also essential. For black-and-white processing a simple spirit thermometer is adequate; colour processing demands the precision of a digital or mercury thermometer.

A tempered water-bath, kept at a constant temperature by a small heater and a thermostat is useful for keeping solutions up to temperature during the process. Even in black-and-white processing, fluctuations of temperature between baths of more than 42°F (5°C) should be avoided. This includes the wash, for plunging into cold water can cause 'reticulation' – crazy paving cracks in the emulsion.

Some means of measuring out solutions is also essential. Graduated measuring cylinders are normally used for measurement as well as for keeping the prepared solution warm prior to filling the tank.

COLOUR FILM PROCESSING

As in black-and-white film, a latent image in silver halide forms colour negative and colour transparency films on exposure to light. However, colour films have three layers of emulsion rather than one, and each layer records one of the three primary colours. During processing, the three latent silver images must be converted to three dye images in magenta, cyan and yellow. Then the unexposed silver halides must be removed as well as the images in black silver.

In colour negative film, the latent silver images are converted to negative dye image so dye forms exactly where the latent image is developed. In colour slide film, however, the dye image is positive and must form wherever the latent image is not. In other words, the latent image must be 'reversed' during processing. So colour negative and colour slide film each require quite a different processing approach. Two things both have in common, though, are an added complexity and a need for absolute precision in both time and temperature control – though this is less true than it used to be.

Colour Negatives Most colour negative films can be processed by the C41 process. This has six chemical stages although a number of recently launched kits have just three or four. The normal stages are: developer, bleach; water rinse; fixer; water rinse; and finally stabilizer followed by drying.

During development, not only are the three latent images converted to metallic silver, but also colour couplers form dye images in each of the three emulsion layers. Since the dyes are in complementary colours, the colours formed are the exact opposites of those in the original scene, just as the image forming silver halides show a reversed 'negative' image.

After the negative has been developed it is immersed in a bleach. This particular bleach removes all the silver image, by 're-halogenizing' it (turning it back into its unexposed state). After a wash, the film then goes into the fix, which removes any unexposed areas of

FILM DEVELOPERS

By matching films with certain developers, different negative characteristics can be enhanced.

Film Example: Ilford (150)	Normal speed	Developer	Effective speed (150)	Characteristics
FP4	125	Perceptol	64	Very fine grain
HP5	400	Perceptol	200	Very fine grain
FP4	125	Microphen	200	Good tonal range, sharpness, increase in speed
HP5	400	Microphen	500	Good tonal range, sharpness, increase in speed

Greater film speed increases can be achieved by extending development time in Microphen, with some loss of detail in shadows and highlights and an increase in grain size.

PROCESSING: TIME AND TEMPERATURES

'Kodak Ektachrome' Films (Process E–6)

Processing step	mins*	°C
1 First developer	7†	37.8 ± 0.3
2 Wash	1	33.5–39
3 Wash	1	33.5–39
4 Reversal bath	2	33.5–39
5 Colour developer	6	37.8 ± 1.1
6 Conditioner	2	33.5–39
7 Bleach	7	33.5–39
8 Fixer	4	33.5–39
9 Wash (running water)	6	33.5–39
10 Stabilizer	1	33.5–39
11 Drying	10–20	24–49

'Kodacolor 100' and 'Kodacolor 400' Films (Process C-41)

Processing step	mins*	°C
1 Developer	3¼	37.8 ± 0.15
2 Bleach	6½	24–40.5
3 Wash	3¼	24–40.5
4 Fixer	6½	24–40.5
5 Wash	3¼	24–40.5
6 Stabilizer	1½	24–40.5
7 Drying	10–20	24–43.5

*Includes 10 seconds for draining in each step
†See instructions for using solutions more than once

COMMON PROCESSING FAULTS

Colour negatives Exposure	**Colour positives Exposure**	**Colour positives Processing**

Underexposure	Underexposure	Overprocessed/normal

Normal	Normal	Overprocessed/normal

Overexposure	Overexposure	Overprocessed/normal

silver halide by turning them into solution chemicals which can easily be washed away. Fixing also removes the re-halogenized silver, leaving an image of coloured dyes.

The final bath is a stabilizer, which helps to protect the dyes against fading.

Colour Transparencies There are several different types of colour reversal film. However, the most common ones are based around the E6 process. This has nine stages, as follows: first developer; water rinse; reversal bath; colour developer; conditioner; bleach; fixer; water rinse; and stabilizer.

Transparency film reacts to exposure in just the same way as negative film. A black-and-white type developer is used first to form the black negative silver image without affecting the colour couplers. In contrast to colour negative processing, the development of the latent silver images (first developer) and the creation of coloured dye images (colour developer) are separated in colour slide film processing. And in between comes a reversal bath which chemically fogs all areas of the film which were not exposed when the picture was taken. (Some reversal film processes require fogging by exposure to light rather than by chemical.) This creates *positive* latent images complementing the already developed silver images. The colour couplers in the emulsion are only activated in the next colour development stage. Since colour couplers are activated by the by-products of a developing latent image, the coloured dyes form exactly where the positive latent images created by the reversal bath are being developed. So the coloured dyes give a positive image, corresponding to the colours in the original scene.

COLOUR TRANSPARENCY DEVELOPMENT

Left Equipment shown here is (left to right): squeegee tongs, funnel, collapsible chemical container, film reel, developing tank, rubber hose, timer, graduate and thermometer, processing kit and drying clips. Commercial processing kits are available for small quantities of film, which suits most amateur use, although for convenience many professionals use custom labs to develop their film.

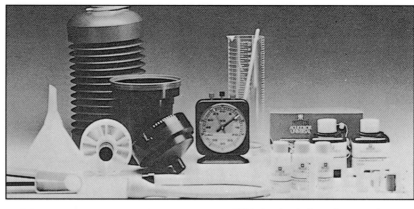

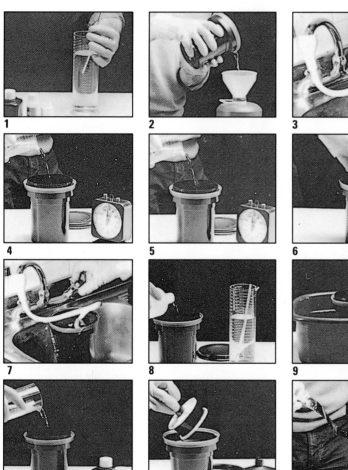

1 With the chemicals ready, pour colour developer into developing tank, and start timer. Agitate as necessary.

2 Near end of development time, pour developer back into its container. Add next solution and reset timer.

3 Add fixer in same way, and wash with hose and water filter. The bleach can be carried out with the tank lid removed.

4 Some processes require film to be soaked finally in stabilizer. After this, hang to dry in dust-free atmosphere.

5 The most widely used reversal processing kit is Kodak's E-6, shown here. Start by pouring developer into the tank. Start the timer.

6 Follow the recommendations for agitation. Empty the tank so as to finish at the end of the seven minute development time.

7 Wash for two minutes with a hose and filter, or else simply add water, agitate and drain, twice.

8 Drain the water, then add the reversal solution for two minutes. Re-check the temperature of the colour developer.

9 After returning the reversal solution to its container, add the colour developer. After six minutes, replace with stop bath.

10 Return the stop bath to its container after two minutes. Add bleach for seven minutes, and then fix for four minutes.

11 Wash for six minutes and then soak in stabilizer for one minute. Remove the film to dry.

12 Dry by hanging in a dust-free atmosphere. Replace the stabilizer in its container.

COLOUR TRANSPARENCY PROCESSING FAULTS

Image too dark, red cast
Inadequate first development time
Temperature too low
Overdiluted or exhausted developer
Entire roll black
Developers in wrong order
Film too light, blue cast
First developer contaminated with fixer

Colours pale, blue or cyan cast
Short colour development, temperature too low, weak developer
Green colour cast
Reversal bath exhausted

COLOURHEADS

Colourheads on modern colour enlargers, such as these two Durst models (left), the three colour filters and the light intensity can be adjusted by dials on the head.

Enlarger light sources The two most popular systems are diffusion and condenser. In a diffusion head, the light source is made even by a translucent screen; in the condenser system, two lenses focus the beam. Condensers deliver a slightly more contrasty result with black-and-white film but reveal defects. Diffusers are normally preferred for colour.

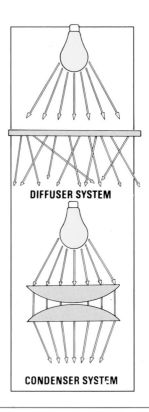

DIFFUSER SYSTEM

CONDENSER SYSTEM

After a 'conditioning bath', a bleach re-halogenizes all the silver, thus allowing it to be removed during fixing and washing, leaving the imaged formed by coloured dyes only on a clear background. Some manufacturers of processing kits make a bleach and fix that can be used at the same time (blix), which cuts out one stage in the process.

Finally, a stabilizer is used after a water rinse, as in colour negative processing.

BLACK-AND-WHITE PRINTING

Black-and-white prints are essentially photographs made in a darkroom, and the process has many similarities to taking a photograph in a camera and processing the film. The negative is projected onto light-sensitive printing paper by an enlarger. The image is then focused, exposure is calculated and the paper is exposed. The exposed paper, bearing a latent image, is then developed to turn the exposed silver halides in the paper emulsion to black, forming a positive image.

Any unexposed silver halides are dissolved in a fixing bath, leaving a permanent representation of the original subject in tones of grey ranging from black through to white. Because the whole darkroom is normally the 'camera' (though special enclosed enlargers do exist) the process must be carried out in semi-darkness.

FILM CARRIER TYPES

Film carrier types include an adjustable mask for different film formats (**1**), a glass carrier to hold thin film flat (**2**), and a hinged plate (**3**).

Enlarger An enlarger is a little like a slide projector. Its function is to project the miniature negative image onto a larger sheet of printing paper to produce a reasonably sized 'viewable' image.

The basic design of most enlargers includes a head which contains a light source; an optical arrangement for passing light through the negative; a carrier to hold the negative flat and parallel to the baseboard; a lens; and a focusing device for getting a sharp image of the negative on the baseboard or printing easel.

The head is usually mounted on a vertical column which allows the head to be moved up and down. The further away from the baseboard, the greater the degree of enlargement.

The column is usually fixed into a baseboard which balances the weight of the head and provides a smooth parallel surface to focus on, and a flat base to put the paper or easel on.

There are variations in enlarger design which are worth noting. The major variation is in the method used to transmit light through the negative. There are two basic systems: condensers and diffusers.

The condenser type is very popular for black-and-white enlargers. The condenser is a system of lenses that concentrate the light from the lamp onto the film plane, producing crisp, contrasty images and reducing exposure times. However, condenser enlargers tend to highlight any scratches or dust particles on the surface of the film.

With diffuser enlargers, the light is scattered, usually by some form of opal Perspex screen, before it hits the negative. This results in a softer image which does not show up blemishes to the same extent.

SAFELIGHT FOR BLACK-AND-WHITE PAPER
This safelight has an interchangeable shroud which is available in different colours to suit different types of black-and-white paper.

THE ENLARGER

The enlarger is used to project the image from the negative or transparency onto light-sensitive paper on the enlarger easel. The enlarger head can be raised and lowered to alter the size of print.

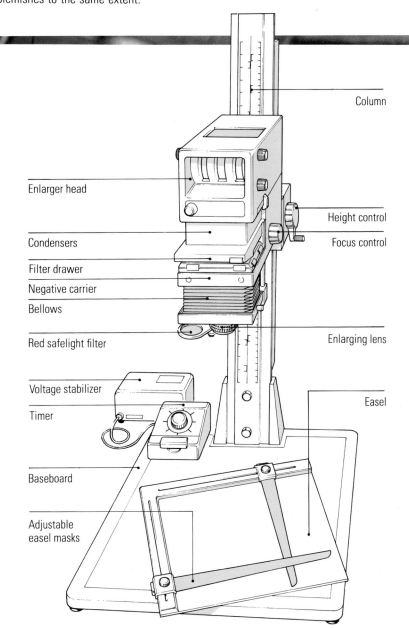

Column

Enlarger head

Height control

Focus control

Condensers

Filter drawer

Negative carrier

Bellows

Red safelight filter

Enlarging lens

Voltage stabilizer

Timer

Easel

Baseboard

Adjustable easel masks

PRINTING IN BLACK-AND-WHITE

With a black-and-white negative follow these steps:

1 If the enlarger is designed to take different formats of negative, check first that the correct condensers are fitted, and/or that the picture area is illuminated evenly (do this with an empty carrier).

2 Clean the negative with compressed air and/or an anti-static brush.

3 Adjust the size of the printing easel to take the paper format and picture size selected.

4 Using a sheet of white paper for a brighter image, focus at full aperture.

5 Use a focusing magnifier for the sharpest image.

6 Place a ruler as a position guide for the test strip.

1

2

3

4

5

6

NEGATIVE CARRIERS

Glassless negative carriers (above) are quite adequate for 35mm filter but larger formats need glass (below) to hold them flat.

Enlargers are available for printing negatives from all formats between 110 and 10 × 8in. No enlargers can print all film formats properly, but most 35mm enlargers will also print 6 × 6cm negatives with a change of lens and an adjustment to the position of the condenser.

Timers and Thermometers The exposure of the paper and the development both have to be timed accurately. Many enlargers now have electronic timers as integral parts of their system. These can be preset to switch the enlarger on and off for accurately controlled periods ranging in length from one second to 99 seconds. The latest types have LEDs which flash the time and emit an audible signal on completion.

Like many other items of darkroom equipment, thermometers are available in electronic forms as well as the traditional mercury or alcohol type. The electronic types have a probe which remains in the developer and a separate display which shows the temperature. If the temperature falls below an acceptable level, an audible warning is emitted.

Traditional mercury thermometers are perfectly acceptable, but they should be able to accommodate the very high temperatures required by colour processes.

Extra Equipment Washing trays or tanks for prints provide a constant flow of water to carry away chemicals. Generally they have a hose at the bottom connected to a tap and an overflow pipe which runs into a sink. Compromises based around this principle are often used, however, especially if there is no supply of water nearby.

Other items of value in the darkroom are a print easel and a focusing magnifier. Print

7

8

9

10

11

12

7 Select the lens aperture. With a negative of average density, the best resolution will be at about two f-stops less than maximum.

8 Under a safelight, cut three strips from a sheet of normal-grade printing paper. Place the first alongside the positioning ruler on the easel, and expose for the estimated correct time. Then expose the second strip for half of that time, and finally the third for double the time.

9 Develop all three test strips together for 90 seconds or two minutes (according to the paper and developer in use) at 20°C (68°F).

10 After development and a stop bath, fix the strips for the recommended time (resin-coated papers need less than fibre papers). Then examine the tests under bright room illumination and note the best exposure. If the contrast is too high, select a lower-number grade of paper; if too low, choose a higher-number grade.

11 Finally, with the necessary adjustment made to the timer, expose and process a full sheet of paper. For smooth development, slide the paper into the liquid quickly and smoothly, and rock the tray gently but continuously during the development. Fix and wash as recommended.

12 Dry the print as appropriate to the paper type and the effect required. Resin-coated paper can be dried in a rack or laying flat exposed to the air. Fibre papers can be dried between heavy photographic print blotters or in a flatbed or rotary dryer.

easels sit on top of the baseboard and hold the paper by its edges to ensure a perfectly flat and stationary surface for the image to fall on.

Drying Resin coated prints (see above) can simply be hung up to dry. Warm dryers are available which can do the job quickly. Fibre-based papers, though, take much longer to dry because they absorb more moisture. If left to dry naturally, fibre papers curl dramatically. To avoid this a 'glazer' is traditionally used. This is basically a heated metal box with a polished and curved metal top. The print is laid flat onto the warm metal, emulsion side down for a high gloss finish or upwards for a matt finish. A tensioned canvas blanket is then stretched over the print and fastened to flatten the paper while it dries.

Lenses The lens used with an enlarger is as important as the one used to take the original picture. A 50mm lens is the standard for the 35mm form format and an 80mm for 6 × 6cm negatives. The more expensive lenses have a wider maximum aperture, which provides a bright, easy to focus image on the baseboard.

Some easels allow an adjustable border of unexposed paper to be made around the printed image, useful for presentation as well as for easy cropping of unwanted details on the edges of the composition, or for drastic changes of shape of the final image.

Focusing the negative on the easel unaided is often difficult, particularly if the negative is very weak or too dense. A focus magnifier placed on the projected image acts as a type of microscope, enlarging the actual grain structure of the image, thus allowing it to be focused precisely.

PRINTING FILTERS

For enlargers that lack dial-in filtration, a set of acetate colour printing filters is needed. The standard set of Kodak CP filters includes the four colours cyan, magenta, yellow and red, each in four strengths (5, 10, 20 and 40), with an additional CP2B, the UV-absorbing equivalent of a Wratten 2B.

Filter sets are also available for variable contrast black-and-white printing papers such as Ilford Multigrade III which will give contrast grades from 0 to 5 in half grade steps with a single paper type.

LOCAL EXPOSURE CONTROL

It is quite common for certain sections of the print to need more or less exposure than the general time calculated by the test strip, especially in bright highlights and deep shadows. But localized exposure controls (dodging and burning) are quite simple in black-and-white printing. Many photographers use their hands or a black card mask to prevent light reaching the paper (top and second) on a particular part of the image, simply by interposing them between the paper and the projected image during exposure. Also, the hands can be held in such a way (third and fourth) that light reaches only a small section of the print to 'burn in' overexposed detail.

Safelights and Dishes Black-and-white printing need not be done in total darkness – 'safelights' can be used to illuminate the darkroom. Unlike black-and-white film and colour paper, black-and-white paper is not affected by yellowish/orange light. So it is possibsle to work in quite bright lighting conditions, providing that the light is of a 'safe' colour. Most brands of paper have a recommended colour of safelight written on the pack.

Most safelights contain a bulb and a coloured filter, although there are a few which are simply light-emitting diodes (LEDs). Some safelights can be screwed into existing light sockets, although ordinary coloured household bulbs are not safe.

The size and type of safelight will be determined by size of darkroom and the layout of the working areas. However, most photographers prefer a light over the trays for inspection and one close by the paper storage and cutting areas.

As total darkness is unnecessary, the print processing can be carried out in rectangular dishes rather than tanks. This allows you to see the developing image and decide development time visually.

Three dishes or trays are used for print processing, although a fourth is often used for washing. The three trays are for developer, stop bath (or simply a water bath) and fix. Trays may be plastic, stainless steel or enamelled. They come in sizes to fit each standard size of paper, although the tray used is usually at least one size larger than the paper size in use, to allow for easy handling. Trays are sometimes sold in sets, with each one a different colour to allow for easy identification of the solutions each one contains.

Developer in trays quickly becomes oxidized due to the large surface area. Fingers also cause a more rapid deterioration of developer and so print tongs are useful to lift prints out of the developer into the stop baths. Tongs are also valuable for the fix to keep hands clean and thus prevent accidental contamination of the print paper or negative.

BLACK-AND-WHITE PRINT PAPERS

Black-and-white papers may be either resin coated (RC) or fibre-based.

Fibre papers are the traditional type and come in two thicknesses, single and double weight. Single weight is suitable for all purposes although some photographers use it only for making contact prints, preferring the durability and better appearance of the thicker papers for exhibition or portfolio prints.

RC paper has a plastic base with a very thin coating of emulsion on the surface. RC papers require less chemicals to process them, and they also have shorter processing, fixing and washing times. RC paper is far more convenient to use and hence is more popular. Traditionalists tend to use fibre papers for exhibition prints although RC print quality is now excellent.

Both types of paper are available in the same standard sizes and similar surface finishes. Typical paper sizes are 7 × 5, 10 × 8, 14 × 11, 16 × 12 and 20 × 16. Other sizes are available but less common.

The surface appearance of both types of paper can vary, too, and is usually chosen according to taste. Some common types in both RC and fibre papers are as follows:

- Glossy: smooth, brilliant shine on RC, less so on fibre unless glazed during drying.
- Lustre: finely stippled or textured surface low shine.
- Semi-matt: smooth dull finish.
- Pearl: very fine texture, low 'satin' gloss.
- Pearl and glossy have a similar appearance from a viewing distance and these are the two most popular surfaces.

Contrast In terms of control over final print quality the most significant variable is paper contrast or 'grade'. Black-and-white printing papers either come in a selection of grades from soft (low contrast) to hard (high contrast), often numbered from 0 to 5, or a single pack of variable contrast paper will give all grades according to filtration.

Although each brand of paper has its own grade system, as a rule the higher the grade number the harder the contrast. One manufacturer's grade two will not necessarily be the same as another's.

These grades are designed to accommodate the variety of contrast ranges found in negatives. Usually, a paper grade is chosen to enable the widest possible range of tones

SELECTING THE NEGATIVE

Take care to select the best negative if there is a choice of exposures. A contact strip sheet is a useful selection guide and makes an at-a-glance file reference, but use a magnifying loupe when making the selection. Having chosen what seems to be the best frame from the contact sheet, make a more critical examination of the negative itself.

from a given negative to be reproduced in the final image. However, individual styles and tastes are the final veto on image appearance. As a rough guide, however, a high contrast or dense overdeveloped negative needs to be printed onto a low grade (soft) paper if the maximum number of tones from the negative are to be recorded. Conversely, a weak, low contrast or underdeveloped negative needs printing on a harder, higher grade paper to separate highlights and shadow areas from the mid-tones.

With experience, a darkroom worker will aim to produce standard negatives which will always produce pleasing results if printed on one particular grade of paper – usually the normal grade. This is a more economical approach as well as more efficient, as only a single grade need be stocked to accommodate fluctuations in negatives.

VARIABLE CONTRAST PAPERS

These are an excellent alternative to stocking several packets or boxes of different graded paper, and can be recommended to the novice for experimentation.

Variable contrast papers are available in both RC and fibre based types, of which the RC papers are far more popular due to their convenient and fast handling characteristics. Early versions of variable contrast papers were poor in terms of image quality, but the latest versions are every bit as good as graded papers.

Filtration of varying magenta strength is needed to increase contrast, and this can be achieved either by dialling in filtration on a colour head, or by placing one of the set of filters designed for the paper in the filter drawer of the enlarger. It is likely that graded papers will eventually be phased out as the quality of variable contrast paper improves.

Colour The image is ostensibly black-and-white, but print papers can actually vary considerably in colour. Most black-and-white papers have a bromide composition and these provide neutral black tones. There are a few papers still available called chlorobromide, which have a warmer (brown) black. Certain paper/developer combinations can provide blacks ranging from very cold, blue to warm, brown blacks.

Chemicals Although a 'universal' developer gives acceptable results with either RC or fibre papers, it is usually better to use the right developer for the paper.

Paper fixer is the same as film fixer but used at a different dilution. If care is taken in storage and during processing, fixer will keep for long periods and will work on many prints. It is useful to use a stop bath for this purpose, as it prevents too much contamination of the fixer with surplus developer from the print.

PAPER GRADES

The standard range of black-and-white printing paper is in five or six grades of contrast. Low numbers have the least contrast and are useful for contrasty negatives; high numbers are the most contrasty, and are used to compensate for a thin negative. The numbers, generally from 0 to 1 to 5 or 6, are not always comparable between different makes, but grade 2 or 3 is usually considered to be normal.

PROCESSING DRUM

For convenience, and to avoid performing all steps in darkness, a print tank can be used for colour papers. This makes economical use of the more expensive colour chemicals, and is designed to be rotated through a bath of water thermostatically controlled at a constant temperature.

DODGING AND BURNING-IN

Highlights so bright that they do not record any

detail at the same exposure as the rest of the print can be 'burnt-in' while shadows that would become too dense can be dodged while the rest of the print is given the full exposure.

The pair of prints (at bottom) show how local exposure control can bring detail into over-bright highlights even when contrast in the negative is high.

COLOUR PRINTING

Colour prints can be made from negatives or slides with any enlarger that has some facility for controlling colour as well as intensity and duration of light. The colour of the light is altered by filtration, whether filters are simple glass slides held just above the enlarger lens or 'dichroic' filters dialled into the light path in a colour head.

Colour printing papers have three layers, sensitive to blue, green and red which after processing give complementary coloured dyes – yellow, magenta and cyan – in the respective layers. As colour materials are sensitive to all colours of light, they must be processed in complete darkness. So, unlike monochrome prints, colour paper is processed

LEFT *Selecting the filtration and lens aperture for slide printing depends upon the brand of film. Kodachrome (left) will need less cyan and a little less magenta than will Ektachrome.*

PRINT FAULTS

Correctable but common faults that occur in printing are those that involve particles or deposits on the negative. Because of the degree of enlargement in most printing, particularly from 35mm film, blemishes that easily pass unnoticed when holding the negative up to the light can involve considerable retouching and spotting later on the print. Some of the most common effects are (right) fingerprints and hairs from anti-static brushes, and (below right) dust. Basic precautions are to inspect the negative with a loupe before printing, and then to hold it at a sharp angle to an intense light (underneath the enlarger lens, for example). With scratches in the film, it may be possible to minimize the effect by printing the negative wet, in glycerine, between two sheets of glass.

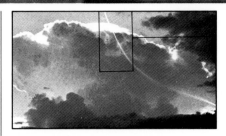

FILTER FACTORS

The density of a colour printing filter depends on both its colour and strength, as the tables (right) show (yellow has little density at any strength). Use the filter factor to calculate any change in exposure: divide the originally calculated time by the factors for any filter that is removed; multiply if the filter is being added.

Filter	Factor	Filter	Factor	Filter	Factor
05 Yellow	1.1	05 Cyan	1.1	05 Green	1.1
10 Yellow	1.1	10 Cyan	1.2	10 Green	1.2
20 Yellow	1.1	20 Cyan	1.3	20 Green	1.3
30 Yellow	1.1	30 Cyan	1.4	30 Green	1.4
40 Yellow	1.1	40 Cyan	1.5	40 Green	1.5
50 Yellow	1.1	50 Cyan	1.6	50 Green	1.7
05 Magenta	1.2	05 Red	1.2	05 Blue	1.1
10 Magenta	1.3	10 Red	1.3	10 Blue	1.3
20 Magenta	1.5	20 Red	1.5	20 Blue	1.6
30 Magenta	1.7	30 Red	1.7	30 Blue	2.0
40 Magenta	1.9	40 Red	1.9	40 Blue	2.4
50 Magenta	2.1	50 Red	2.2	50 Blue	2.9

in light-proof drums, like film developing tanks, not in open dishes.

There are two basic procedures for normal colour printing from negatives or slides, the 'subtractive' and the 'additive' methods.

Most colour enlargers are equipped for the subtractive method, which uses three sets of filters in the subtractive primaries: cyan, magenta and yellow. These filters are dialled into the light path to alter colour balance either singly or in combinations of two – combinations of three block out all colours of light and so act simply as a neutral density filter.

The additive method uses filters in the three additive primaries, red blue and green, or three separate light sources in these colours. Light is thus *added* to create the right colours in the print; in subtractive printing, the filters subtract colour from white light to achieve the same result. Colour balance is controlled in additive printing by increasing and decreasing the brightness of the light or the duration of exposure through each filter.

In a perfect world, a perfect colour negative or slide projected onto colour paper would give a balanced representation of the original. However, colour balance in the original is often less than perfect – especially with colour negatives – and the dyes used in film and papers are rarely a perfect match. Indeed, colour negatives have an inbuilt colour cast created by the amber colour mask. So for almost every colour film image, the colour of the enlarger light must be individually adjusted by filtration to produce an acceptable print – although the same filtration may well be applied to a number of similar images on the same film.

VARIABLE CONTRAST PAPERS

Ordinary papers are only sensitive to blue light, but variable contrast papers are sensitive to blue and green, allowing a print to be made from almost any negative. The blue part of the emulsion produces a high contrast print while the green sensitive part produces a low contrast image. By varying the proportion of blue and green light projected onto the paper, prints varying in contrast can be made.

A set of yellow and magenta filters are used either under the lens or inside the enlarger head. Magenta filters absorb green light and so will provide a contrasty print, while yellow filters absorb the blue, giving a softer image.

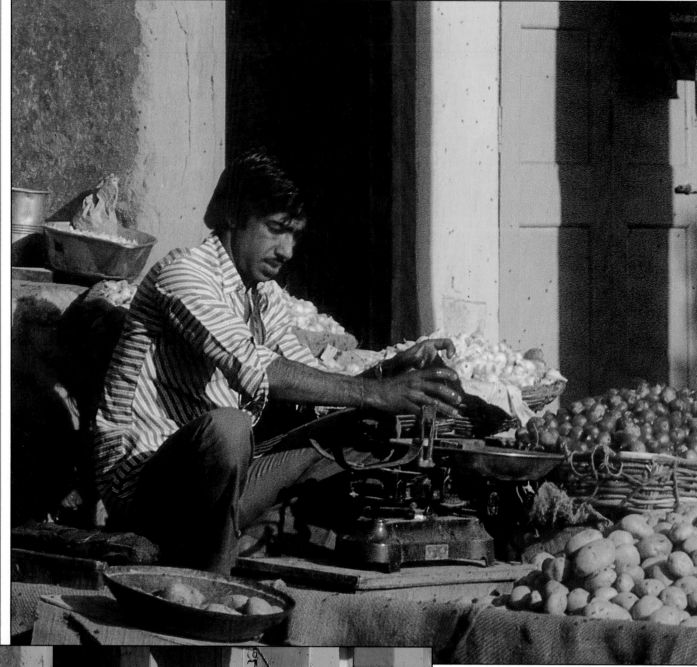

ENHANCING COLOUR *Colours can be made deeper when using slide film by underexposing slightly (main picture).*

BURNING IN *This is more than a simple technique – it's a creative tool. And remember that you need not use specialized tools; even your hand will serve as an adequate block between the light source and the printing paper.*

COLOUR ANALYZERS

Colour analyzers give an objective measurement of colour balance, once calibrated, and can save time and materials. Aesthetic judgements are up to the printer.

COLOUR REVERSAL PRINT PROCESSES

Reversal paper

Process	Time at 30°C
Pre soak	½ min
First developer	3 min
Wash	3 min
Colour developer	3½ min
Wash	2 min
Bleach/fix	3 min
Wash	3 min

Image transfer

Process	Time at room temp. (approx 20°C)
Soak in activator	20 secs
Migration of image	10 mins

Image diffusion

Activator	1½ min
Wash	5 min

Dye destruction

Process	Time at 24°C
Pre soak	½ min
Developer	3 min
Wash	½ min
Bleach	3 min
Fix	3 min
Wash	3 min

NB Times and temperatures may vary according to the kit in use. Check the instructions thoroughly before proceeding.

As a starting point, most new packs of paper will have a suggested filter combination to correct any colour bias which that batch of paper was found to have before it left the factory. This filter combination might be written as 20Y 0M 0C. This stands for 20 units of Yellow, no Magenta and no Cyan. By dialling in this amount of filtration or building up a filter pack in the right combination, the light source will be altered to suit the balance of the paper. However, subsequent adjustments normally have to be made to get the colour absolutely correct for each picture.

The choice of colour balance is inevitably subjective in part. Some photographers might prefer to see a slightly warmer colour range in the final print than actually appeared in the original scene, for instance. Absolute accuracy is often less important than a visually pleasing picture.

Judging which filters should be added and which removed to correct a certain cast can be difficult. But with colour negatives, the paper reproduces colours in reverse. So a cast is corrected by increasing the strength of filtration in the same colour as the cast, or by reducing filtration of the cast's complementary colours.

In colour slide printing, the colour correctiion is more obvious because the paper reproduces the same colours projected on it. So a colour cast is corrected by reducing filtration in the same colour, or increasing it in the cast's complementary colours.

When printing from a negative, then, a yellow cast is corrected by adding yellow filtration, or by cutting down magenta and cyan. But when printing from a slide, correcting a yellow cast means *cutting* yellow filtration or *adding* magenta and cyan.

PROCESSING COLOUR PRINTS

Print processing in colour follows a similar pattern to colour film processing, and the controls, time temperature and agitation, are just as critical. It is because of the need for precision and because colour prints must be processed in complete darkness that they are normally processed in print processing tubes – unlike black-and-white prints, which are usually processed in open dishes. Processing drums are very similar to film developing tanks, in that they are light-proof but have an opening which allows the various process chemicals to be poured in and out. However, the print paper is not held in a spiral, but wrapped around the inside of the drum.

The drum fits onto a base which should ideally contain a tempered water bath, as the temperature of the chemicals must not fluctuate during processing. Some bases are motorized so that the drum is turned constantly, maintaining an even distribution of chemicals over the surface of the print during processing. This operation can be done by hand, however, and a number of units have a manual crank handle – some are designed to be rolled across the bench.

PRINTING COLOUR NEGATIVES

The reversed colours and heavy orange mask make a colour negative hard to assess visually and it is advisable to make a contact sheet. Two contact sheets are usually made. The first one will be to judge the correct exposure time and the second the colour balance. The first will also give some idea of what major colour casts are to be dealt with. Unlike black-and-white paper, colour papers only come in one grade, so no decisions about contrast need be made. There are other aids, however, which may provide a good compromise, helping the inexperienced printer who does not want to rely on an analyzer to decide on the filtration needed. One very useful and direct method is to use print viewing filters made in percentages of cyan, yellow, magenta, red, green and blue. These give an idea of the effect of adding or subtracting specific percentages of particular colours, simply by viewing the test print through them.

There are two important points to consider when making decisions about colour filtration. Firstly, the colour of the ambient light – that is, the light in the room where the print is being assessed must not be allowed to prejudice judgement of colour values. Daylight is the correct light for checking your prints; household lights are the wrong colour temperature and will affect the way the print is perceived. Special 'colour corrected' fluorescent bulbs which operated at around 5500K are ideal for viewing; ordinary fluorescents make the print look green and household bulbs make it look yellow.

COLOUR PRINT PROCESSING

With a print drum, all actions can be performed in ordinary room lighting once the paper has been loaded. This means, for instance, that the exposure sequences can be undertaken in a dry darkroom, and development elsewhere. Although many of the steps shown here resemble those for processing black-and-white film, timing and temperature are more critical.

1 Fill the print-loaded drum with warm water to bring the contents to the recommended temperature.

2 Discard the water and add pre-warmed developer, starting the timer.

3 Roll the drum by hand or on a motorized cradle to ensure even development.

4 Towards the end of the recommended time, discard so that the drum empties as the timer comes to a stop.

5 Add the bleach/fix, roll the drum as in **3**, discard and refill with warm water.

6 Open the drum, pull the paper carefully out by its edge, and wash as recommended.

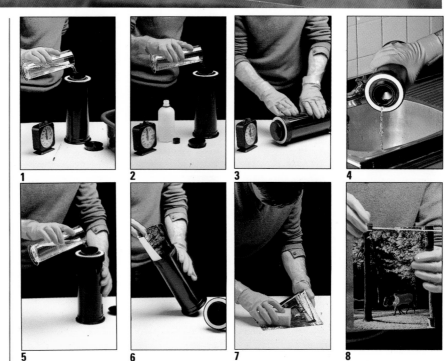

7 When the wash is complete, gently sponge excess water off the print.

8 Hang the print to dry in a room that is free from dust. Drying can be accelerated with a hairdryer.

The second important point is to make assessments mainly by looking at neutral areas of the print. Greys, pale colours, and skin tones are the best indicators of subtle colour casts. If there is a cast, these colours will show it.

COLOUR REVERSAL PRINTING (SLIDES)

Printing from colour slides goes by a number of names, including colour reversal printing and 'pos-pos' (positive to positive) printing. And unlike the colour negative process, there is a choice of print materials. There are, for instance, reversal papers which are like negative papers in as much as their colour dyes are formed during development. There are also dye destruction papers (Cibachrome) in which the dyes are already present and are destroyed during processing in proportion to the projected image. There have also been rapid print processes working on the dye transfer or dye diffusion principles, such as Ektaflex and Agfachrome-Speed but these have been discontinued.

COMPARATIVE EXPOSURE AND FILTRATION CORRECTIONS

Print	Pos/pos paper	Neg/pos paper
Too light	Reduce exposure	Increase exposure
Too dark	Increase exposure	Reduce exposure
Small area dark	Burn in	Shade
Small area light	Shade	Burn in
Too yellow	Reduce yellow filters	Add yellow filters
Too magenta	Reduce magenta filters	Add magenta filters Add cyan filters
Too cyan	Reduce cyan filters	
Too blue	Reduce magenta + cyan filters	Reduce yellow filters
Too green	Reduce yellow + cyan filters	Reduce magenta filters
Too red	Reduce yellow + magenta filters	Reduce cyan filters

POSTERIZATION

The first step is to make a series of tone separations. The original negative (below) was first contact-printed with line film at different exposures to give three line positives at different densities. These in turn were contact-printed with line film to produce three corresponding line negatives. Different combinations of these six pieces of film gave a variety of separated tones, each of which could be printed normally (either at different densities on black-and-white paper for a posterized version in greys and black, or through different filters on colour printing paper). From a basic set of line conversions a large number of interpretations are possible.

This type of image is half way between a continuous tone and a high contrast picture. There are tonal changes but they are abrupt rather than gradual, giving solid areas of tone or colour rather than gradations.

Posterizations are made by making several copies of an original in varying densities on lith film and then printing them in register on a single sheet of paper. Lith negatives must be the same size as the required final image as these will be contact printed, each one providing a tone of grey which will build up to a complete image in solid areas of black, grey and white.

Colour paper can be used in conjunction with filters to make posterizations in areas of flat colour rather than greys. Registration is essential for the best results and this is usually done with hole punches and pin bars. Registration holes are punched in the edges of the lith negatives. A pair of pegs or pins on a bar corresponding to the holes in the film are fitted to the enlarger easel to locate the lith film negative. After development, the bar with the pins can then be used to register each sheet of film on the paper in exactly the same position.

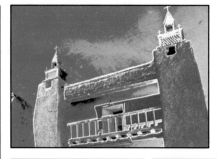
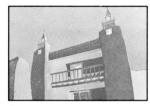

Original
Continuous-tone
negative

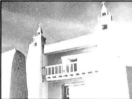
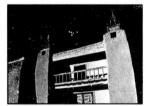

Low density
Line positive

Mid-range
Line positive

High density
Line positive

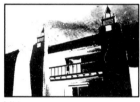

Low density
Line negative

Mid-range
Line negative

High density
Line negative

Yet despite this range, the basic procedure for exposure and colour balancing is the same as for colour negatives – though filtration values are reversed. Only the processing differs substantially.

In many ways, getting the colour balance right with slides is actually much easier because the image is clearly visible in the light colours on the enlarger baseboard, and there is always the original slide for comparison. But there are extra points to consider in pos-pos printing. Weak slides will rarely provide a good print but underexposed, well saturated slides print well. Very contrasty slides are also difficult without some form of highlight masking. Highlight masking is a complex process which involves making a weak negative copy of the slide which is then sandwiched with the original during printing.

Reciprocity law failure is also more common with reversal papers. Very short or long exposure times will result in colour shifts in the paper. It is better to standardize on an average exposure time such as 12 seconds, and increase or decrease the intensity of light via the enlarger lens apertures rather than increase or decrease times.

Colour reversal papers take roughly 20 minutes to process at a fairly high temperature while dye destruction papers take about 13 minutes at a slightly lower temperature. The dye transfer or diffusion processes take much less time and require far less control over time and temperature.

Ringaround Many printers make their own customized colour cast identification chart called a 'ringaround'. This is a series of prints at different, known filtrations made from a very well exposed negative, with good tonal range and a selection of bold colours and a neutral area or two such as a pale grey wall or well lit portrait.

To make a ringaround, start off with a 'perfect' print from the chosen negative, then make a series of prints, changing the filtration by units of ten progressively up to 30 or 40 units in each of the filter colours, including red, green and blue. Mark each print on the back for reference, ie 10Y, 20Y, 30Y, and ensure that the exposure time is adjusted to keep the density of each print the same.

Stick all the various colour progressions in sequence around the ideal print on a sheet of card and use this to help assess subsequent work. If each print is labelled with the amount of filtration it was given, then it is a simple task to compare the print in progress with the ringaround to see how much of any particular colour must be removed to get the print back to neutral. Obviously you need to make the comparison in good light.

Judging colour balance is an acquired skill, although there are various aids on the market to help you along. A colour analyzer is an electronic device for measuring the colour of light transmitted through the negative. However, to use an analyzer you must have already made one 'perfect print' for reference. The information about filtration gained from making this print is then used to calibrate the analyzer for making subsequent 'ideal' prints on the same batch of paper. This certainly helps in achieving consistent results, and may save time making test prints.

However, the very objectivity of colour analyzers can tell against them, for many printers feel that each print must be individually, and subjectively, matched to each negative. Some prints will have colours that need to be enhanced or subdued to give the most pleasing effect. All the electronics can do is tell what filtration to use for prints with identical colour balance every time.

SPECIAL EFFECTS

Conventional developing and printing techniques can be experimented with to produce creative or 'special' effects with either black-and-white or colour originals.

High Contrast Images formed solely from black-and-white with no intermediate tones can be quite dramatic. The simplest method of making a high contrast image is by using lith film. Lith film can be handled like black-and-white paper under a red safe-light. But it requires lith developer, two stock solutions which are mixed for use immediately prior to development. To create a positive high contrast image, the continuous tone negative must be copied onto lith film to make a film positive. This is usually done by contact printing the original onto 'line' film, processing it and then contacting the line positive again onto another sheet of lith film to give a high contrast negative. This can be cut out to fit into the enlarger and printed onto ordinary black-and-white paper or, through coloured filters, onto coloured paper.

Bas Relief This term stems from certain types of low profile sculpture, which is hung on a wall and lit from the side to enhance its three-dimensional quality.

The hallmark of a bas relief print is an illusion of 3D. A weak positive image is made on film by contact printing with the chosen negative. The two images are then sandwiched together on a light box. The negative and positive images should match up exactly, but the effect is produced by moving one or the other slightly to the left or right.

When the two images are very slightly out of register, hard shadows and highlight will appear around solid shapes in the picture. When the best effect is achieved, the two bits of film are taped together along the sprocket holes and printed to produce an illusion of 3D.

Posterization This type of image is half way between a continuous tone and a high contrast picture. There are tonal changes but they are abrupt rather than gradual, giving solid areas of tone or colour rather than gradations. See opposite for further explanation of the posterization process.

Sandwiches Two negatives can be printed simultaneously by sandwiching them together in the negative carrier of the enlarger. The idea is usually to sandwich two negatives which have opposing light and dark areas, that is, where one has a shadow area (a clear area on film), the other should have some interesting detail with plenty of highlights (dense areas on film).

Screens Combining a special texture screen negative with an ordinary negative can create interesting graphic effects. The screen and the image are printed together like a

PHOTOGRAMS

Photograms are images made without optics – by placing objects directly onto a sensitive emulsion and exposing to light. They are, in effect, shadow-pictures, and can be made on printing paper or film, in colour or black-and-white. The photogram (below) is of a flower placed directly onto 5 × 4in colour reversal film and exposed under an enlarger. Any light source can be used, from a flashlight to the room light, but an enlarger allows precise control for repeatable results.

CHROMOGENIC BLACK-AND-WHITE FILM

Most black-and-white films form images in metallic silver, but some variable speed types such as Ilford's XPI 400 form the image in coloured dyes, like colour films – the word 'chromogenic' simply means 'dye-forming'. The dyes in chromogenic black-and-white film are neutrally coloured. Like colour film, they also have three emulsion layers, although each layer is sensitive to all colours. Like colour negatives, chromogenic black-and-white films begin with silver, link up with a colour coupler and finally form the image by a series of dye 'clouds' rather than actual grains. This accounts for the grainless quality of prints made from chromogenic black-and-white negatives.

The chemical process for this type of film is very similar to C41. Indeed, a colour negative kit can be used to process one of these films, although the manufacturers recommend that the proper XP-1 developer be used for optimum results.

BAS RELIEF

The negative was contact-printed onto line film and weakly developed. The two pieces of film were then printed slightly out of register.

COLOUR FROM BLACK-AND-WHITE

Colour prints can be made from black-and-white negatives by printing through filters onto colour negative papers. Prints can be made either in a single colour or in various colours by selective masking, filtration and exposure. A normal test strip helps decide exposure times; a second with different filtrations shows the effect of different colours.

sandwich and the texture is superimposed all over the actual image.

Proprietary texture screens come in many forms, from fine parallel lines to grainy 'etched' effects, but home-made screens can easily be made by photographing interesting textures and developing a weak negative to cut out and use as a sandwich.

Sabattier Effect The visual qualities of the Sabattier effect are the result of chemical reactions. An ordinary print is exposed and partly developed, but at some point in the development it is very briefly re-exposed to light – usually a normal household bulb held over the print.

The bright areas of the print will still contain some unexposed silver halides after the first exposure under the enlarger. The second exposure turns these to metallic silver; the result is a darkening of what would have been highlight areas. Further manifestations of the effect appear as light lines between dark and light areas.

DUPLICATES AND CONVERSIONS

Making accurate duplicates of transparencies and negatives and converting one to the other are essential skills. The principal uses of duplicating and converting are:

Safety Any original photograph is susceptible to damage and deterioration and if only one piece of film exists of an important image, a copy is useful insurance. Duplication is also an important archival technique, particularly with colour film, because the coloured dyes are less stable than the silver in black-and-white film – colour images can be converted into three black-and-white silver images, called 'separations'.

FILM SUITABILITY

DUPLICATE TRANSPARENCIES

Film	Format	Type of copy	Comments
Ektachrome Slide Duplicating Film 5071	35mm 46mm 70mm	Colour transparency	E-6 process; tungsten-balanced
Ektachrome SE Duplicating Film SO-366	35mm	Colour transparency	E-6 process; balanced for electronic flash
Ektachrome Duplicating Film 6121	4 × 5in 8 × 10in 11 × 14in 12 × 15in 16 × 20in	Colour transparency	E-6 process; tungsten-balanced
Kodachrome 25	35mm	Colour transparency	Increases contrast, but very sharp results

SEPARATION NEGATIVES

Film	Format	Type of copy	Comments
Kodak Separation Negative Film 4133	18 × 24in 24 × 30in 30 × 40in 40 × 50in 50 × 60in	Set of three black-and-white negatives, recording red, blue and green images	DK-50 or DG-10 developer

INTERNEGATIVES

Film	Format	Type of copy	Comments
Vericolor Internegative Film 6011	35mm	Colour negative	C-41 process; tungsten-balanced
Vericolor Internegative Films 4112 × 4114	4 × 5in 5 × 7in 8 × 10in	Colour negative	C-41 process; tungsten-balanced

Simultaneous use In professional photography in particular, a picture may be needed for reproduction by more than one publication at a time.

Different use An image shot on negative stock may be needed for slide projection, or the photographer may want to use a negative colour printing process for a photograph that exists only as a transparency.

Correction Image values such as contrast and colour balance can be altered relatively easily during the process of duplicating.

Post-production techniques Techniques such as retouching, toning and dyeing, which may include some risk of irreversible damage, are more safely performed on a copy than on an original. Additionally, such techniques may be easier to perform on an enlargement.

COPY NEGATIVES

Negative materials reverse the tones of an image, while copying is a positive process. Consequently, special direct copy films are needed in order to make a duplicate of negative. For black-and-white copy negatives, Kodak's Professional Black-and-White Duplicating Film and Rapid Process Copy Film are ideal, but for colour negatives the choice is less satisfactory: transparency duplicating films will do the job, but without the orange masking in conventional colour negative stock, and printing may not be easy.

As with most copying and converting, there are a number of methods of duplicating negatives: loading the film in a camera and using a slide duplicating machine or simple slide holders; contact copying in a glass frame; or by projection in an enlarger. In-camera

FILM SUITABILITY

COPY NEGATIVES

Film	Format	Type of copy	Comments
Kodak Professional Black-and-White Duplicating Film (formerly SO-015)	4 × 5in 5 × 7in 8 × 10in	Black-and-white negative	D-163, DPC or DK-50 developer
Kodak Rapid Process Copy Film	35mm	Black-and-white negative	DX-80 developer has blue-tinted base
Any duplicate transparency film (see below)	35mm 46mm 70mm 4 × 5in to 16 × 20in sheets	Colour negative, but lacking orange mask	Reversal processing: E-6 if Ektachrome

NEGATIVE TO POSITIVE

Film	Format	Type of copy	Comments
Eastman Fine Grain Release Positive	35mm	Black-and-white positive transparency from black-and-white negative	D-163 or HC-110 developer
Vericolor Slide Film 5072	35mm	Colour transparency	C-41 process; tungsten-balanced
Vericolor Print Film 4111	4 × 5in 8 × 10in 16 × 20in	Colour transparency	C-41 process; tungsten-balanced

COPY NEGATIVE PROCEDURE

Using an enlarger, negatives can be copied up to the size of the required print on Direct Duplicating Film, and this copy negative can then be contact-printed. Place the original negative in the carrier just as for normal printing, and focus and frame the image in the same manner. Under red safelighting, make test strips, remembering that longer exposures produce a weaker image. Develop for two to two and a half minutes in Kodak D-163 or similar developer.

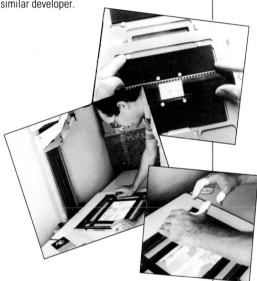

CONTRAST CONTROL

One of the inherent problems in copying an image from one piece of film onto another is the build-up of contrast, tending to wash out highlights and causing the shadows to block up – in both cases, detail will be lost. Only if the original lacks contrast will there seem to be an improvement in duplicating, there are three standard ways to treat this problem. One is to use a professional duplicating film, which contains its own inbuilt masking to reduce contrast. For conventional films, some slide duplicating machines contain mechanisms for fogging the emulsion very slightly. Thirdly, the development time can be reduced to lower contrast.

Film suitability Use these tables (left and far left) to select the most suitable film for the type of original that must be copied. Note that professional duplicating films are not always the best choice, as they are designed for specific techniques that may involve equipment that is unavailable.

GOLD TONING

Gold chloride is not only useful as an archival toner (to increase permanence), but also produces a range of attractive colour tones. Bromide prints tend to go blue-black, unless they have first been sepia-toned in a sulphide bath, in which case they will be warmer (below).

HAND-COLOURING

These hand-coloured prints by Sue Wilks (below) demonstrate that in this area of retouching, restraint is important. The delicacy of effect in the colours is achieved by building up the dyes very slowly. As the added colour increases the density of the image, the original print must be lighter than in those areas that will be coloured. For the top picture, the base print shown was made with a deliberately low contrast range and the head especially was held back in tone.

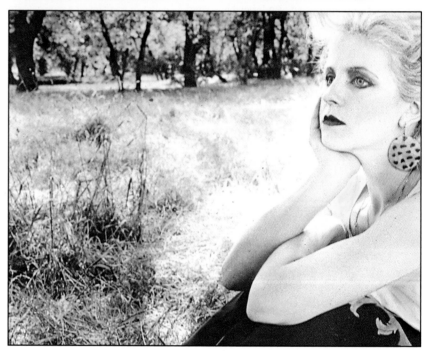

copying, using the 35mm Rapid Process Copy Film is convenient and makes it possible to reduce different formats to a common size. Enlarger copying is useful in allowing shading and other fine controls, as well as making detailed retouching possible. If the copy is made to the size of the intended print, contact printing can preserve image quality.

Contrast control is one of the major problems in copying. Altered processing, shading and printing-in during enlargement, and sandwiching a weak mask with the original are just some of the ways of reducing contrast. Shading and printing-in can be performed in the same way as for regular paper printing, except that the tones are reversed: this is a positive process, so that to make part of an image darker in the print, it must be weaker in the copy negative, and needs *less* exposure.

DUPLICATE TRANSPARENCIES

Transparency duplicating can be performed with the same equipment as the copying of negatives: slide duplicating machine, enlarger or contact printing frame. However, as the greatest demand is for 35mm slides for projection, in-camera use with a slide duplicating machine is often the best method. Some slide duplicating machines have a tungsten light source compatible with Ektachrome 5071 slide duplicating film, but most use electronic flash and for these Ektachrome SO-366 is the best film. Such specialist duplicating films contain their own masks to reduce the build-up of contrast that is normal in duplicating. The table includes Kodachrome 25, for although duplicates are likely to be contrasty, the film gives the sharpest results.

For all the films, careful filtration is essential for colour fidelity, and as the colour balance varies from batch to batch, it is best to buy in bulk, test one roll to discover the filter pack needed, and freeze the rest for future use. Standard test transparencies containing recognizable colours (such as flesh tones) are useful. Filtration will vary according to the dyes in the original transparency. Kodachrome and Ektachrome, for example, will need different filter packs.

INTERNEGATIVES

Although transparencies can be printed directly, using Cibachrome and similar processes, the more traditional technique of printing from colour negatives offers more fine control over image values. An internegative is simply a negative copy of a transparency. Internegatives can be made on the films listed above in the same way as negative copying and transparency duplicating.

SEPARATION NEGATIVES

For dye transfer printing, and also for archival storage, colour transparencies are converted into three black-and-white continuous-tone negatives. Each is copied through a different primary colour filter – red, blue and green – using respectively Wratten 25, 47 and 58 filters. The colour information, carried in permanent metallic silver, is thus separated, hence the name. Separation negatives must be made in perfect register and with highly accurate exposure. Step wedges are usually copied alongside the image as controls and measured with a densitometer.

POST-PRODUCTION TECHNIQUES

The photographic process can be divided into three distant areas: shooting, the dark room and the work room. Each is physically separate, but photographs are often planned with the later stages in mind. For instance, a photographer may shoot a high-contrast interior without fill-in lighting, knowing that the shadows can be opened up by printing controls in the darkroom. To an even greater extent minor miracles of alteration and adjustment are possible in the work room *after* the final image has been processed and fixed. These post-production techniques range from the minor cosmetics of spotting a black-and-white print to the kind of manipulations and additions that create an entirely new image. Because of the wide range of post-production techniques it helps to plan the work at an early stage, deciding at which point – negative, print or transparency – particular action is needed.

BLEACHING, TONING AND DYEING

Black-and-white prints can be subjected to various kinds of chemical treatment and to baths that add or remove tone or colour. These can simply be corrective techniques, such as retouching but they can also be used to enhance the appearance of the picture more dramatically – to alter the overall colour of the picture, for example. Certain kinds of toning also increase the permanence of the image, and are standard archival treatment.

BLEACHING

The standard bleach is *Farmer's Reducer*, a two-part solution of potassium ferricyanide and sodium thiosulphate. The strength of the solution determines the speed of working, but if

RETOUCHING

For the basic brush retouching of spots and blemishes from a black-and-white print:
1 Mix different tones of the retouching colour until the colour of the print is matched as closely as possible.
2 Dilute the mixed colour with water.
3 Pick up some colour on the brush, twirling the brush for an even soaking.
4 Draw the brush against your thumbnail to remove excess retouching colour. Ensure the brush is not so full that it leaves a pool.
5 Build up colour on the print in small touches until the density of the retouched area matches the surround print precisely.

1

2

3

4

5

LIQUID DYE

1 Moisten the re-touching brush by dipping it in a solution of water and stabilizer (such as Kodak Ektaprint 3 Stabilizer).
2 Transfer the dye or mixture to a palette.
3 To reduce colour intensity, add a neutral dye if necessary.

4 Load the brush with dye, then draw it across a piece of paper to form a point and remove excess.
5 Re-touch, making sure that no dye overlaps the edges of the spot (this would form a dark ring).

6 Use blotting paper to remove excess colour. It is safer to build up intensity with several applications rather than risk over-saturating the print.

concentrated can get out of control. To lighten the entire print, submerge it completely in the bleach bath, but to brighten the highlights alone, use a cotton wool swab soaked in reducer on a *dry* print, quickly washing it when the desired lightening has been reached.

TONING

There are a number of different toning formulae, each giving a subtly different hue, but all add a colour to the developed areas of a print, and some also give protection against any atmospheric contamination. Aesthetically, there is a major difference between the generally modest effects of toners such as selenium, gold and sepia, and the more strident and colourful results of multi-toners that use colour couplers.

The two most generally useful are *selenium* and *gold*. They are popular because they significantly increase the life of the print. The colour each gives varies considerably with the brand of printing paper. But this is not a problem, since the photographer can stop the process when the colour is right because both are single-solution toners. Selenium toning usually takes between one and ten minutes, and must be watched carefully. Sometimes split-toning occurs, with only the darker tones affected. Gold toning (with a gold chloride solution) can take up to 20 minutes. On bromide paper the effect tends towards blue-black, on chlorobromide paper, towards orange-brown. As with selenium, continuous monitoring is important.

Sepia toning gives a more distinctive colour, reminiscent of old prints. Most photographers use a two-bath solution to sepia-tone prints. The print is soaked in the first bath, a bleach bath, until the image has all but disappeared, and then rinsed. The second bath restores the image in brown. Less bleaching gives a darker brown result.

DYEING

Toners work only where there is developed silver in the print, so that in white highlights their effect is negligible. But dyes can be applied all over the print, and their effect is particularly pronounced in light, undeveloped areas. So by careful planning, the colouring of a black-and-white print can be split between toners and dyes.

Photographic dyes are transparent, and can be applied in a variety of ways, from an undiscriminating bath, which gives even coverage, to swabs, brushes and air-brushing, for controlled results. Dyes are solution in water, so that, at the time of application they can, to some extent, be removed quickly by a thorough wash.

RETOUCHING

The techniques of retouching are essentially those of an illustrator, including brushwork, airbrushing, shaving the emulsion with a knife, and various other means of adding and removing dyes, pigments and silver. The uses of retouching however, vary from the simplest tidying up of the picture to creating new images in the form of artwork. The key to successful retouching, though, is to blend retouched areas imperceptibly into the base photographic image. If the retouching is noticeable, it has not worked.

Retouching should be avoided if at all possible and it is worth taking time at earlier stages in the photographic process to reduce the need for retouching to a minimum. In particular, take care not to allow dust particles to reach film that is drying (inspec carefully), keep the enlarger clean.

BLACK-AND-WHITE PRINTS

A maxim of retouching is that the larger the scale the easier it is. Because of this print, retouching is usually the simplest, and has the added advantage that opaque can be applied as well as transparent dye. Black-and-white prints are far easier than colour prints to retouch. There are four basic techniques, and if more than one is to be used, they should be performed in this order:

● bleaching
● emulsion removal
● dye application
● opaque application

For local bleaching, pre-moisten the print to avoid hard edge-marks, and apply with a swab or brush, washing off between applications.

Pre-mix the dye from different colours (such as brown-black and blue-black) to match the exact colour of the monochrome image. Apply dye to the print gradually, starting with it very diluted and building up the colour slowly.

HAND-COLOURING BLACK-AND-WHITE PRINTS

Once, hand-colouring was the only way of adding colour to a photograph. Now it is used as an artistic device without any attempt at realism and the range of styles and method is considerable. Transparent dyes blend in with the underlying image, but opaque, and even oil-paint, can be added on top of the image. Because tone and colour are being added, it is generally easier to work on a print that is lighter than normal. If the print already has a full range of tones, the usual answer is to bleach and sepia-tone it.

To avoid edge-marks and brush-marks, pre-moisten the surface of the print, so that colour application will merge smoothly at its edges. It is easier to make several dilute washes and to build up the colour slowly than to attempt one concentrated application. Over-colouring is a common fault.

BLACK-AND-WHITE NEGATIVES

If the fault lies in the negative, it may sometimes be better to try retouching the negative rather than every single print made from it. However, for detailed work, a sheet-film size negative is needed, and if the original negative is 35mm format, it will need enlarging first.

A negative can be prepared for retouching by local reducing and intensifying with a swab in a dish. Knifing is possible, although risky if the negative is an original. An abrasive reducer is easier to apply, rubbing gently in overlapping circular movements.

As the actual colour of *added* tone is unimportant, dyes, opaque or pencils can be used, but in many ways a sharpened black-lead retouching pencil is easiest to use. It is safer to apply the pencil on the base of sheet-film rather than the emulsion side.

COLOUR PRINTS

Unlike the single silver layer on a black-and-white print, colour prints have three layers, making etching impossible. Indeed, scratches require colour retouching – the top layer of an Ektacolor print, for example, is cyan, under which lies the magenta, followed by the yellow, and the depth of the scratch determines its colour. The three standard techniques for colour retouching are liquid dye retouching, dry-dye retouching, and opaque retouching. If combined, they should be performed in this order. *Liquid dyes* penetrate easily, and are good for small blemishes. For large areas, however, *dry dyes* are easier to apply smoothly, and have the additional advantage that they set with moisture, so that they can be removed, if needed, during the early stages of the retouching. The disadvantage of both is that they can only *add* tone to the print. Bleaching is unsatisfactory with most colour prints, and to lighten areas, *opaque* is needed.

Apply liquid dye diluted and nearly dry on the brush. Dab dry after each application and build up to the desired intensity.

Apply dry dye by breathing on the cake in the jar and picking up a quantity on a ball of cotton wool. Rub this onto the print and then buff smooth with a clean cotton ball. Set the colours by steaming, over a boiling kettle. Dry the print thoroughly before adding any more dye. Opaque is applied the most smoothly with an airbrush.

COLOUR NEGATIVES

The more retouching that can be done on the colour negative, the easier life becomes when printing. This, however, is only practical when the negative is large, and is not worth attempting on 35mm. An alternative is to make an enlarged duplicate onto sheet-film.

As with all colour emulsions, the separate dye layers make etching impossible. The standard techniques are with black-lead and coloured pencils. The best side of the film to retouch depends on the make, Vericolour III sheet-film, for example, can be retouched on both sides. Working on both sides makes denser application possible. A black-lead pencil lightens the area of the picture without a colour change; coloured pencils also lighten, but

DRY DYE

1 Make sure that the print surface is absolutely dry.
2 Breathe onto the surface of the cake of dye and pick up a small quantity with a cotton swab.
3 Rub the dye-loaded cotton swab over the print in a circular motion.

4 Repeat with more dye of the same colour or greater intensity, or with a different dye for a mixed colour.
5 Buff with a clean cotton swab to smooth out the dye. This will also lighten the colour.
6 To remove excess dye from the printer's surface, use the cake of reducer in the same manner, breathing on it and then rubbing with a cotton swab. Afterwards, remove excess reducer from the print by buffing.

7 Make the re-touching permanent by holding the print about 10in (25cm) over steam from a boiling kettle for 5–10 seconds. You can tell when the steaming is complete by examining the print surface, waxy pap marks caused by applying the dye should have disappeared.
8 By alternatively dyeing and steaming several times, greater intensity can be applied. In each instance, dry the print thoroughly.
9 To remove steam-set colours in an emergency, use undiluted Photo-flo wetting agent with a cotton swab. Do not leave the Photo-flo on the print for more than a minute; remove completely by swabbing with water and stabilizer.

COLOUR PRINT RETOUCHING EQUIPMENT

Basic liquid and dry techniques can be carried out with a bottle of stabilizer (**1**), brushes (**2**), blotting paper (**3**), cotton swabs (**4**), and cakes of coloured dye (**5**).

add a colour cast that is the *opposite* of their own colour. The effect of a particular colour is therefore very difficult to judge, and only tiny blemishes should be retouched.

COLOUR TRANSPARENCIES

As with colour negatives, it is only worth attempting to retouch very *large* transparencies. Colour transparencies are usually retouched with three dyes – cyan, magenta and yellow – and a buffer solution to dilute them. Most slide films are processed by the E-6 process, and only E-6 retouching dyes should be used if the picture is to be printed. E-6 dyes penetrate well into the film base, although dye can be applied to both sides of the film. Transparencies cannot be etched.

First mix small quantities of the dyes to achieve the exact hue. Add all three for black, cyan and yellow for green, magenta and blue for red, and magenta and cyan for blue. Pre-moisten the surface with Photo-Flo. Apply the dye dilute, building up to the required colour with several applications. This is easier than trying to remove too much dye.

Dark shadow areas and dark spots can be bleached, and then retouched if necessary. There are total dye bleaches, which affect all three dye layers, and selective dye bleaches, which work separately, on the cyan, magenta and yellow layers. As these bleaches are applied to the emulsion side, the film must be dried before the effect is judged. Dye bleaches are generally unstable, and are supplied in separate solutions. Two methods of application, therefore, are possible: the solutions can either be pre-mixed, or, for more control, used one after the other. For large areas, the transparency can be covered with a waterproof frisket, which is cut to expose the areas to be retouched, and then soaked in the bleach. After bleaching, wash in running water for at least ten minutes, preferably with at least three separate baths, and finally rinse in stabilizer before drying.

SPECIAL EFFECTS

Although the image can be manipulated in various ways at the different stages of photography, it is usually more convenient, for a number of reasons, to work with 'straight' photographs that have already been taken and processed. There is a wide choice in post-production special effects and having a regular original for experiment allows different effects to be tried out at leisure. Also, performing effects in the workroom allows and demands much greater precision than is possible during the actual shooting.

MONTAGE

Montage is the simplest of all ways of combining different photographic images. Different prints are simply cut out and laid over a base to create the new combined image. The main problem is making a satisfactory visual fit. The technique works with both colour and black-and-white prints, and the progress of the work can be checked continuously.

A basic print is prepared – the background to the final image – and dry-mounted on board. The image that is to be added as an overlay is then printed, on *single-weight* paper if possible, and cut out with the tip of a sharp craft knife. If the combination is to look real, the separate elements of overlay and background must match in overall tone, contrast, colour and the apparent lighting. The chief difficulty at this stage is to hide the edges of the overlay; this is why it should be on thin paper and the edges should be chamfered at the back with fine sandpaper. The overlay is then stuck down in place on the base print. To help the illusion it is usually better to rephotograph the finished montage, and possibly retouch the edges of the join or add shadows where necessary.

SANDWICHING

An extremely simple, but effective, method of combining images is to take two transparencies together. The prerequisites for a successful sandwich are that the originals are overexposed (so that the combined base density appears normal, with fairly bright highlights), and that the position and tone of the subjects complement each other. There should, in other words, be sufficient pale areas (such as sky) in each for the darker subjects of the other to show clearly. Surprisingly effective combinations can be made simply by laying out a number of stock transparencies from the files on a lightbox and trying them out.

THE STUDIO

Studios usually have to conform to available space, and specially designed, purpose-built studios are an uncommon luxury. The minimum requirements of space and shape are determined by the type of work that will be done in the studio – less room is needed for still-lifes than for portraits or fashion. When using seamless rolls as backgrounds for people, leave sufficient distance between the subject and roll for wrinkles in the paper to be thrown out of focus.

A high ceiling is an advantage, as it allows a greater range of camera positions. If there are existing windows, they will need to be blacked out, either by painting over or with a light-tight roller blind. With the windows sealed, an extractor fan is advisable, particularly in summer. Keep the interior space as simple as possible, with movable rather than permanent fixtures for greater visibility.

The principal items of studio equipment are lighting and background. Once again, the type of studio work will suggest the particular equipment. The larger the subject, the more the lights will need to be diffused; greater light intensity may also be needed. Backgrounds vary from seamless paper rolls – the basic staple in most studios – to esoteric settings for specific still-life shots, such as pieces of slate or unusual cloths. In addition to lighting and backgrounds, a wide range of tools is also necessary – many shots require on-the-spot improvisation.

STILL-LIFE

The still-life image is the essence of studio work, where the photographer's ideas are imposed on a single object or a group. It is the most completely controlled type of image, and needs a rigorous and measured approach. Although the majority of professionals use view cameras for this type of work, most of the principles apply equally to 35mm cameras.

Its motivation may be commercial or personal, and its purpose may be as varied as to display a piece of merchandise, to evoke a period or mood, to create a new image for an everyday object, or to depict an abstract idea through a carefully chosen juxtaposition of objects and lighting. The flexibility of still-life work makes it a favourite vehicle for conceptual work, for example, on magazines, book and record album covers.

What is important is the sequence of building up a still-life composition. Even if the photographer starts with a given subject, so much control can be exercised over the outcome that it is easy to get lost in all the possibilities, or worse still, to miss the best opportunities. So, the most reliable approach is to work step-by-step.

Begin by defining the purpose of the shot, whether to focus on one object, for example, or to express an idea. Conveying a concept needs, by definition, a more intellectual approach and more forethought.

Try to work out a mental image of the shot in advance. Still-life photographers work in different ways, as this is a very idiosyncratic field. Some prefer to have a precise layout in mind at the start, even to the extent of sketches, while others would rather rely on their intuitive ability in the studio. To start with, it is best to have one or two basic ideas in advance, without being too rigid.

Collect together, with the object or objects that you are going to photograph, all the props that might be suitable. It is better to have too many props than too few – you can select them in the studio.

Decide on the background. You may choose to construct one purely out of props, or indeed fill the frame with the subject. Otherwise, you will have to lay down a background: should it be relevant to the subject or should it be abstract and isolate the subject? Should it dominate in colour or texture, or should it be unobtrusive?

At this stage you can begin the arrangement. Because of the enormous control possible over the subject, there is normally little use for extreme lenses, although this by no means invalidates them. Decide on a basic lighting set-up, but don't worry too much about it at this point, as it is simply a temporary working arrangement; the final adjustments, and even major changes, can be made later, when you have defined the composition.

BASIC STILL-LIFE LIGHTING

For small objects without backgrounds, a simple set that gives consistently good results can be built with a table, clamps and a smooth, flexible white surface such as formica. The white sheet propped against the wall so that it falls into a natural curve, gives an even, seamless background to the shot.

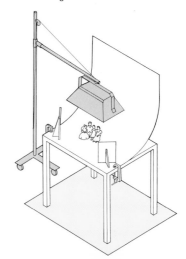

This image of a crown and letters being cut into a sheet of steel was simple, but the mechanics were a little involved. Because of fire regulations, it was eventually easier to move lights and camera to the welder's works. The basic light was a diffused flash, with an extra $1/15$ second exposure for the sparks. The shot was used to illustrate an article on state nationalization of industry.

THE STUDIO

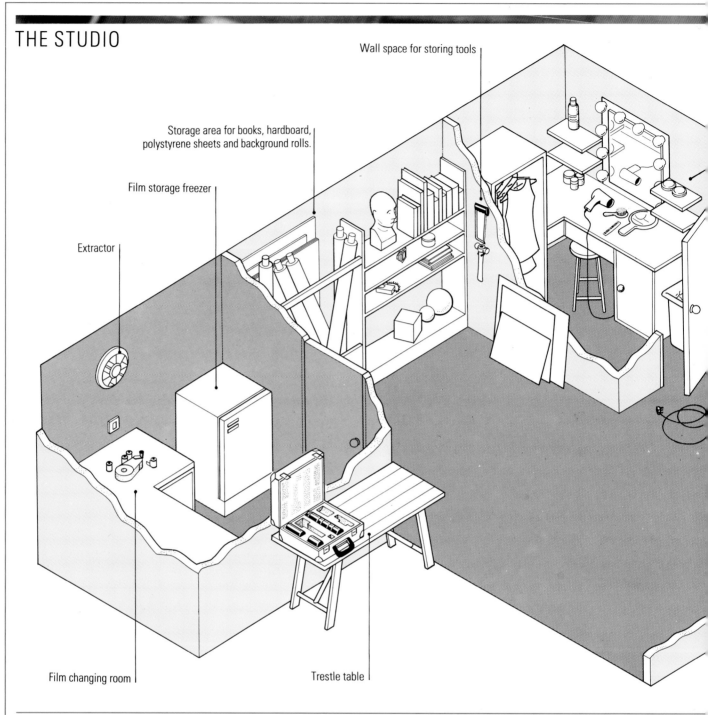

Wall space for storing tools

Storage area for books, hardboard, polystyrene sheets and background rolls.

Film storage freezer

Extractor

Film changing room

Trestle table

If there is one key object in a group, start by positioning this. Play around with different arrangements, constantly checking the results through the viewfinder. Consider proportion and lines – you might use diagonals, for instance, to converge on a focal point of the composition, drawing the eye to the main element. You can use the distribution of lighting to do the same. If you are working with just a single object, examine it carefully and decide which are the qualities you most want to bring out.

One compositional tip: at some point remove the camera's prism head and examine the two-dimensional image on the ground glass screen. The elements of the composition will appear closer than they will in the final photograph.

Make the final adjustments to the lighting, bringing in reflectors or secondary lights to brighten shadow detail that you want to preserve. The whole process is therefore one of refinement, starting with many possibilities and narrowing them down to one preferred choice. As the still-life process is one of continuous decision, it is common for still-life photographers to deliver only one image at the end of the day (among advertising photographers the session commonly does take a full day, and sometimes longer).

Dressing room

Seamless background roll

GIN ADVERTISEMENT *Although familiarity with the brand name and product is a precondition for the success of such images, this close view of condensation on the outside of a bottle of gin conveys, without any extraneous clutter, two important sales features of the advertised product – it is refreshing, and it is pure. The information is carried sensually rather than literally. The obliquity in this advertisement (the word 'gin' does not even appear, nor does any actual gin) is justified by the fact that this version had been preceded by a long-running campaign that had already built up consumer awareness.*

LIGHTING

Lighting techniques are as many and varied as the still-life subjects themselves, and depend as much on the taste of the photographer as on the technical requirements of the object in front of the camera. It may be 'correct' to use diffuse side-lighting for a wine bottle, but in the last analysis it is the photographer's own ideas that take precedence. The techniques on this page are some of the few that are well-defined, but one of the joys of still-life work is to be able to invent new combinations. Any light is admissible.

TOP-LIGHT WINDOW

There is one extremely useful and basic lighting set-up that can be used as a starting point for many situations. This is the top-light window, often combined with a white laminate scoop. This set-up can cope with a surprisingly wide variety of subjects and has good technical credentials.

A window diffuser for a studio flash head can easily be built or improvised. Photoflood lamps cannot be used – because the window encloses the light (in order not to spill unwanted light) it can quickly build up excessive heat if used with a photoflood lamp; even with a flash head it is better to use a low-wattage modelling lamp. Position the light directly over the subject, pointing straight down. This directional but broad light source gives a generally pleasing range of highlights, and soft shadow edges, and a white surface underneath the subject will throw considerable light back into the lower shadow areas. If the white surface (laminate such as Formica is a good choice because of its even structure and lack of texture) is curved back to form a scoop, it can give the impression of an infinite background, heightened by the pooling of light from the window. When the subject is

It's got to be Gordon's

ITALIAN-AMERICAN LIVING ROOM

This 1930s set was assembled by the Museum of History and Technology in Washington DC. The care that went into selecting the props is reflected in the authenticity of detail. The window and door were included in the shot, lighting them from outside the set with powerful diffused tungsten floods. The wide-angle lens was stopped right down to render foreground detail sharp.

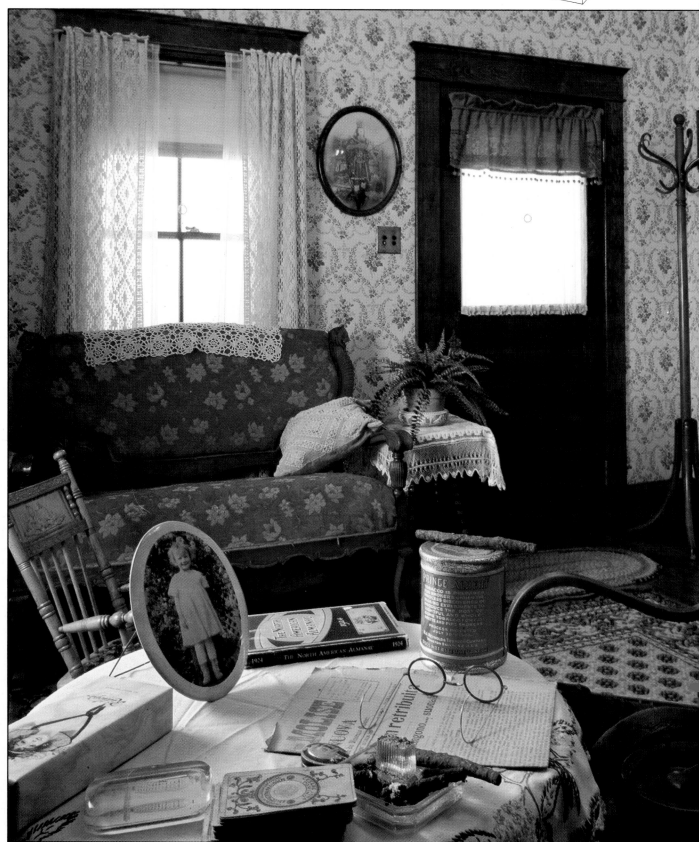

taken from a low angle, its top highlights will appear outlined against the dark background that grades smoothly from the white foreground. Pieces of white card and small mirrors can be used to reflect light and fill-in shadows.

Small movements of the light can create quite significant changes – move it back, angling to point forward, for stronger highlights and more drama; bring it forward over the camera for a frontal illumination that brings out more information from the subject. For more information on studio lighting check out the studio photography in Part 3.

ROOM SETS

Sets are simulated interiors that, in many ways, need the same treatment as architectural interiors discussed in Part 3. Exterior sets are beyond the scope of most still photography. For a specific shot which has to follow precise details of layout and content, sets have the advantage over existing rooms in that they can be designed for any camera viewpoint and for ideal lighting.

The most obvious problems of set photography are the time and expense involved in building them; perhaps less immediately apparent is the problem achieving realism. Most sets are, after all, intended to mimic real interiors, so a lot of attention must be given to achieving authenticity of props, structure and overall atmosphere. Paradoxically, the more ordinary the setting is intended to be, the more difficult it is to create. This is partly because good, 'ordinary' furniture and props are less easy to find than objects kept because they are special or unusual – an antique clock would be quite simple to locate, but a pristine 1930s pack of cigarettes might stretch the talents of even a professional stylist.

A second reason why the plain and homely is difficult to recreate is a natural tendency to be too perfect and tidy in the design. Most family living rooms, for example, are mildly chaotic, with idiosyncracies of decoration and possessions. If you are designing a set, collect as many references as you can for the visible part and try to work in some of the peculiarities that give real rooms their character.

Set-building requires major carpentry work, and to save cost you should decide whether you can incorporate part of an existing room into the set. Before undertaking any construction, first draw a layout as precisely as you can. Work out the exact area to be photographed bearing in mind camera angle and lens focal length. Anything that might fall outside this area can be entirely structural. You must also include on your plan the lighting positions. If you are going to use a daylit window or open doorway, you must leave space 'outside' the room to provide simulated daylight. As with real interiors, the most effective window lighting technique is to shine a light through a large sheet of translucent material covering the window area.

By definition, sets allow infinite control over viewpoint, composition and lighting, so that there should be no real problems beyond design. As for props, a set is virtually a large scale still-life, but demanding even more attention to detail by virtue of its actual size. Fortunately, objects at a distance from the camera do not need to be perfect, and the normal stock of film and television prop-hire companies may provide sufficient props.

LOCATION PHOTOGRAPHY

SIMULATED SUNSET *Graduated filters are a simple and effective way of controlling the level and colour of light on location (above).*

MIXED LIGHTING

In this portrait in a restaurant in the Dordogne (right), heavily diffused photographic tungsten lighting is dominant, but pitched at a level that allows daylight and room lighting to contribute. Extra warmth was given to the picture by only partially balancing the light to the daylight colour film.

MOST PHOTOGRAPHY on location simply makes the most of prevailing conditions. But there are occasions when the photographer needs the kind of control normally achieved only in the studio. Controlled location photography tends to be expensive and is used almost exclusively for advertising work, where money is rarely limited and results must be precisely regulated.

Controlled location advertising shots fall into three categories: dramatization, reconstruction and imaginative creation. These can often be achieved through other means – studio photography, photocomposition and retouching – but there are times when controlled location photography is the only answer.

Dramatization Story lines are popular in advertising shots and photographers are often asked to take a whole troupe of actors, actresses and props to an appropriate setting to dramatize the image. Humorous and historical situations are common.

Reconstruction of a particular scene is another popular approach in advertising photography, for it is a highly effective means of creating an image for the product. The idea has some similarity to constructed reportage shots, but the end is different. The aim is to create a situation which sells the image, even if such a situation never really existed. It tends to exploit archetypes, such as the 19th-century rustic romanticism of an English country pub. Since such archetypes rarely exist in exactly that form, the solution is to take the best setting available and improve it, by using props, lighting and actors. As reconstructions must be based on reality, detailed knowledge of how things *should* appear is important. Experience of actual reportage situations can be a great advantage.

NIGHT SHOOTING

Shooting after dark may enable the photographer to alter the appearance of an entire building with a large-scale lighting set-up. In the photographs (right), the subject is the London house of Dr Johnson – which looks rather dull by day. The combination of a large amount of photographic tungsten lighting and water hosed in to catch reflections, recreated at least some atmosphere of the period.

LOCATION FINDER

As it is difficult to find a specific location at a moment's notice, it is worth maintaining a scrap-book of possible sites for future use (left). Attractive or useful locations visited in the course of other assignments or trips can be snapped quickly – only a reference shot is necessary – and pasted in a book with notes of relevant details; it is worth including the all-important but often neglected one of permission to shoot. Taking a simple shot for personal use is one thing, but professional location photography may be restricted.

8/82 Kenwood, London. Need written GLC permission (allow 3 weeks).

7/74 Richard's cottage, Norfolk. Good for 'Rose cottage - type' exteriors. Best in summer. View from windmill

6/75 St. Pancras Hotel – now British Rail offices. Need BR permission. Natural daylight OK with fast film.

9/80 Monument Valley. The classic view from car park! Sunset. Needs permission. (Tribal Reservation.)

Imaginative Creation covers those types of picture that make no attempt to mimic real conditions and can include fantasy, illusion, and visual hyperbole.

LOGISTICS

In practice, the main effort in most controlled location photography is put into organization: assembling the various ingredients, choosing location, props, actors and models, and arranging the necessary equipment, which includes both lighting and atmospheric devices such as rain sprinklers and fog machines. The scale of location shooting is, naturally, greater than in most studios. It is the sheer scale that creates the logistical complexity and expense, making this kind of photography highly specialized. Even finding the right location poses a considerable challenge and advertising budgets usually include a fee for special

MIXED LIGHTING

For static, small-scale subjects, such as the Japanese dish (below left), a location lighting kit is perfectly adequate. Here a 750-joule flash, collapsible area light, hired lighting stands and foil reflector gave enough light for a tightly controlled food still-life.

In the wide-angle treatment (below right), the location is put to work to evoke atmosphere. The light from a low, later afternoon sun, bounced from the camera position with aluminium foil, eliminates the need for separate lighting. A neutral gradated filter balances the tones in the upper and lower halves.

LIGHTWEIGHT LIGHTING

Size, weight and portability are necessary considerations when organizing lighting for a location shoot. Standard minimum kits include two heads, reflector dishes, barn-doors, umbrellas and stands. Two such kits are shown here (below) – the flash lighting on the left is slightly bulkier than the tungsten lighting on the right. Gauze and dichroic filter are normal with tungsten lamps.

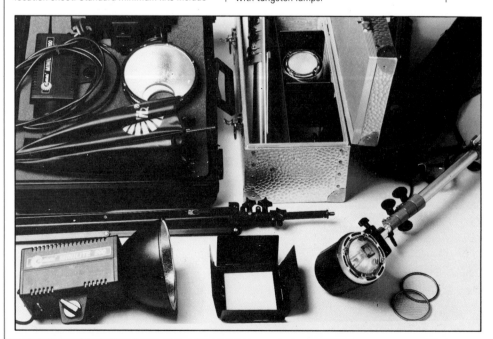

location services which find suitable settings for planned shots. Photographers who specialize in location shooting also maintain a file of settings which might be useful on future occasions.

Props can vary considerably, from small domestic items to vehicles, historical costumes and such odd items as telephone kiosks, animals and specially constructed items. Selection can be sub-contracted to professional stylists, or undertaken by the photographer and staff. In cities that have a large community of advertising photographers or motion picture and television production, props hire companies can supply many items; otherwise supply may have to be negotiated directly with stores, manufacturers and individual artists. Actors and models are usually employed through theatrical and model agencies but direct recruitment is not unusual. Still photography often places greater demand on appearance than on acting ability; experience is not essential.

If lighting is needed on location – and it often is – it must usually be in large amounts and may need its own power supply if the location is far from a mains outlet. Two likely needs are portable generators and portability of the basic equipment.

Petrol-powered generators are the usual choice if the closest mains outlets are too far away to run an extension cable. Power can also be drawn from the generator on some four-wheel drive vehicles and certain recreation vehicles, and for small-scale lighting, a car battery may be sufficient for DC-adapted units. Judicious choice of equipment can keep it portable and light. Some units, for example, are very compact yet accept standard 800-watt to 1000-watt lamps, and umbrellas make good, lightweight diffusers.

Natural lighting itself can still be modified on a small scale (such as one or two models) by using reflectors and diffusers. Weather conditions can also be simulated to some extent with overhead sprinklers, fog-making machines and large fans. Certain kinds of filter, such as gradated fog filters, can make effects appear to extend in depth.

Real weather is less manageable and can create enormous problems. One solution is simply to shoot in locations that have reliable, predictable weather, so that shooting can be planned ahead – this is one of the principal reasons why the American motion picture industry moved to Hollywood. Despite travel costs, this may be less costly than waiting for the weather to change in another location.

EXTRA LOCATION EQUIPMENT

Larger and more efficient reflectors (right) are needed outdoors. Crumpled tin foil pasted down onto board can be supported on a heavy-duty stand. Large polystyrene sheets are adaptable and disposable.

In most situations a generator (below) is essential. Check that the capacity is sufficient for the quantity of lighting being used.

USES OF SMOKE

A straightforward use of smoke gave atmosphere to this shot of a felled tree (far left). An oil-fired smoke generator was used, positioned upwind in the background and out of frame. The result was a delicate separation of planes giving a more definite form to the trees and shrubs.
Nikon, 24mm, Panatomic-X, 1/8 sec, f16.

Symbolizing an uncertain future, this photograph (left), for a magazine cover, called for dense smoke spreading over a sign in the road. Dry ice (frozen CO_2) tipped into a pail of warm water gave the precise effect (bottom left); the vaporizing CO_2 hugs the ground, spreading outwards. A diffused flash head suspended over the dry ice made it appear luminiscent.
Nikon, 55mm, Kodachrome, 1/60 sec, f8.

197

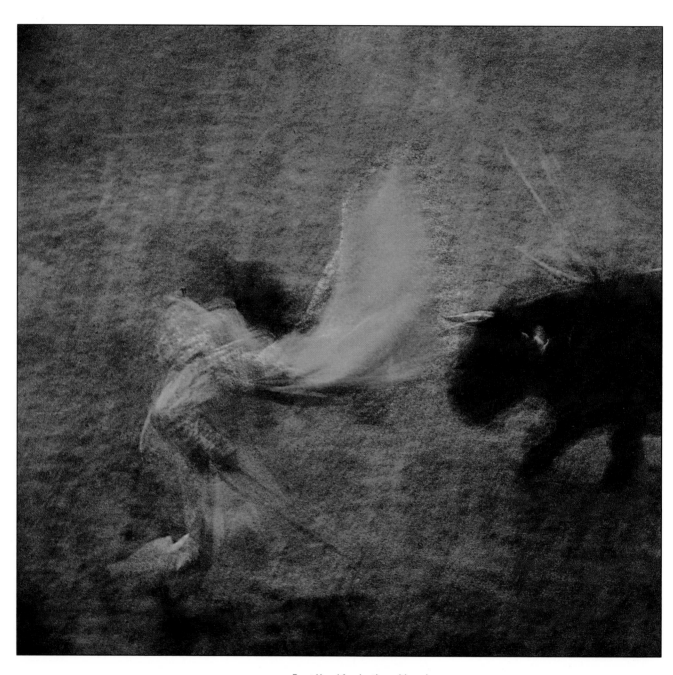

BULL FIGHT *Ernst Haas' fascination with and exploration of colour led him to experiment with long exposures of subjects that would seem to call for short ones – bullfights, football games and rodeos. The movement of both camera and subject, destroys detail and line at these shutter speeds (many at one-tenth of a second). What remains, however, is enhanced colour.*

THEMES AND VARIATIONS

ARMED WITH the knowledge of the basic skills and the confidence that brings, the world is now your photographic oyster! It is entirely up to you which field of photography you choose to work in, and it is true to say that most photographers who become successful do so because they are specialists in a chosen field.

It is quite likely that, bursting with knowledge and confidence, you will want to photograph anything and everything – to prove that you are a versatile and competent photographer. You may, indeed, resent any attempt to pigeonhole you in any one category of photography but if and when you can focus your attention on one particular area, then you have the potential to become a marketable photographer.

That word 'marketable' may strike a chord of loathing in you; it may be anathema to you as an artist with a camera. But the fact is that photography is quite expensive, even as a pastime, and if you hope to have someone else foot the bills for equipment, film and processing then your work will need to be marketable to some degree.

One of the beauties of photography is the sheer variety of themes open to you. In addition to the mainstays such as advertising, portraiture, commercial and industrial photography, and weddings, there is a host of more specialized fields, some of which are other people's hobbies or pleasures, which have their own industries crying out for good photographs to illustrate magazines and brochures – everything from scuba diving to food and drink. Each field has its own special requirements in terms of equipment and expertise: some will call for location work in any part of the globe you care to name, while others call for technical prowess in the studio, in a way that gives a photographer a solid base of operations and an environment he/she can control to a finely tuned pitch.

If you can shrug off the reluctance to be pigeonholed and concentrate your skills in a clearly-defined area of expertise, you may well find publishers or advertising agencies beating a path to your door. They tend to think in terms of horses for courses but are not likely to ring up a sports photographer if they need a picture of some obscure insect!

Your choice of specialization is likely to be coloured by your own interests or lifestyle – if you spend every weekend climbing rocks then you could explore the market for rock climbing pictures. In that particular case you will have far less competition to contend with than, say, in travel photography, but a correspondingly smaller market for your pictures. The romance of travel photography is very appealing to many young photographers but the reality is often harsher than the dream – hassles with customs men over equipment; a punishing schedule set by the travel firm which has hired you and wants interior shots of every villa on its books in three days; unco-operative weather; biting insects and so on. But if travel and sun are in your blood you'll probably do it anyway and take the rough with the smooth.

This section of the book may open your eyes to some of the many options open to you, and outlines some of the specialist skills needed for specialist photography. It is by no means an exhaustive list of options but it may help focus your attention and give you an idea which path you could choose to follow. It could be the beginnings of a career in photography.

AERIAL PHOTOGRAPHY

A LIGHT AIRCRAFT offers an unprecedented opportunity for fresh images. Familiar landscapes take on a new appearance, and some subjects are only obvious from the air. Preparation is essential – flying time costs money and is easy to waste if you have not already discussed with the pilot exactly what you want.

Sunshine is nearly always preferable, although not easily guaranteed, and acceptable weather conditions are visibility in excess of 10 miles (16 kilometers) with a clear sky or no more than scattered clouds. A light 10–15 mph (16–20 kph) wind will blow away smoke and smog and normally the early morning or late afternoon are the best times of day – the low rays of the sun bring out texture and add warmth to the picture. If you have to fly during the middle of the day, when the lighting is flat, look for subjects that already have strong shapes or colours. Generally speaking, oblique aerial views are the most easily 'read', but vertical photographs, while confusing orientation, often offer the best graphic possibilities.

FLYING TECHNIQUE

A single-engined, high-winged aircraft is ideal – a Cessna, for example. Helicopters can be used, but offer only slightly superior manoeuvrability (at roughly ten times the cost); in any case, hovering sets up vibrations that make picture-taking impossible without a sophisticated damping support. Whether you use an aircraft or helicopter, however, you should remove either the window or door so that you do not have to photograph through glass.

Ask the pilot to fly low, preferably between 1000ft and 2000ft (300m and 600m) above ground level. There will always be haze present, so the closer you can get the stronger the colours and the contrast, exactly as in underwater photography. Make sure that the wing support strut does not intrude into the picture.

For near-vertical shots, the pilot can side-slip the aircraft by reducing throttle, banking slightly and slipping it towards the target. This reduces vibration and slows down the aircraft. The disadvantage of this technique is that the wing-tip is dipped; if you want to include the horizon in the photograph, the aircraft must bank the other way, allowing you time only for one or two shots.

ACROPOLIS, ATHENS *For this shot (right) the photographer particularly wanted to show the sprawling city. This required a low sun to bring out the shapes of the buildings, and as the city's atmospheric pollution is at its worst in the late afternoon, the photographer had to fly early in the morning.*
Nikon, 35mm, Kodachrome, 1/500 sec, f4.

GRAND PRISMATIC SPRING *From the air, the Grand Prismatic Spring in Yellowstone National Park (bottom) presents a remarkable mixture of colours. In order to emphasize this, the photographer used a polarizing filter to cut down reflections. The picture (below) was taken into the sun as the plane circled the Spring. It is often possible to use the sun's reflection like this from the air to make a more abstract image, but the colours are lost.*
Nikon, 180mm, Kodachrome, 1/500 sec, f2·8.

35mm SLR EQUIPMENT CHECKLIST

1 Two camera bodies, both fully loaded to cut down film changing time in the air (if you have an assistant or friend to load and unload film, so much the better). Single lens reflexes are preferable for precise framing.
2 Motor drive for one or both bodies if not built in.
3 Lenses: A normal lens (50–55mm) and a wide-angle lens (possibly 24mm or 28mm) are the most useful. A moderate telephoto lens such as 135mm can be used on occasions, but it needs a high shutter speed, and sometimes registers areas of soft focus on the film due to rising pockets of moist air.
4 Neck or hand strap – in either case, attach to the waist rather than the neck.
5 Lens hoods.
6 Filters: *B/W* – Yellow, deep yellow and red are the most useful for minimizing haze. *Colour* – UV and Polarizing filters also to cut down haze and increase colour content.
7 Film: Most aerial photography is in colour, but there are of course, equally good possibilities in B/W. In either case, a fine-grain film is important for preserving detail. An exception to this is infra-red film, which records more detail through haze than the eye, and at a higher contrast. 35mm infra-red colour film was originally designed for aerial survey work and can produce some remarkably beautiful images, particularly of forests.

MOTHBALL FLEET *Sometimes the patterns that man creates are only obvious from the air. These are warships of the mothball fleet (left) lying in San Diego harbour. They are arranged with strict military precision – sealed, boxed, and painted grey.*
Nikon F2AS, 180mm, Kodachrome, 1/500 sec, f5·6.

ZEA HARBOUR, GREECE *The white yachts moored in the marinas of this resort harbour contrast with the water to make a strong pattern. The aerial viewpoint emphasizes the graphics more than the usual oblique-angle.*
Nikon, 35mm, Kodachrome, 1/500 sec, f4·5.

CAMERA TECHNIQUE

A motor-driven 35mm camera is perfect, allowing fast composition and shooting as the aircraft flies over the subject. Don't use any part of the aircraft as a support – it will transmit vibrations to the camera – and always use a strap to avoid the expensive consequences of having your camera whipped out of your hands by the slipstream. Most lenses can be used – use either a wide-angle lens to cut down the loss of contrast caused by haze, or a fast medium telephoto lens to pick out selected subjects. On most aircraft it is just possible to use a 20mm lens without including the wing-tip or wheels. Use a UV filter to minimize haze, and, if there is sufficient light, a polarizing filter, which noticeably increases colour saturation. Haze is least apparent when shooting away from the sun, although with the sun directly behind you, there will be little modelling in the view. Cross-lighting is a common compromise.

Depth of field is never a problem, even at 1000ft (300m), so leave the aperture wide open and use the fastest shutter speed possible. A speed of 1/500 sec is very safe, especially with a wide-angle lens. However, with a telephoto lens considerable care is needed, even at 1/250 sec.

ARCHITECTURE

ALL BUILDINGS are constructed with a purpose; it may be as simple a function as providing shelter, or it may be to celebrate the majesty of a god in such a way as to inspire awe. The intention may be to house an industrial process with no regard to appearance, or the architect may be pursuing some aesthetic ideal. The first step in architectural photography is to analyze this purpose.

Take time to walk around the building and study it from different angles. If it is an historic monument, there will usually be a guidebook that might suggest some interesting aspect of its design. Decide on the building's essential qualities, those you want to emphasize; these will direct the techniques you use. You may decide to follow the architect's intention and make a literal interpretation of the building's purpose – for instance, by showing how a French cathedral dwarfs and dominates the surrounding town and countryside, as it was intended to do – or you may exploit some particular graphic qualities. Don't restrict yourself to an overall, all-encompassing view. Hunt for details that can enhance your interpretation of the building – constructional details, like the carved joints in a natural stone wall, or design details, such as the gargoyles on a cathedral's buttress.

There is a danger, however, that, in searching for a new interpretation of the subject, you may mask its essential qualities – you must find a balance between a plain record and too subjective an interpretation. There may be more freedom in handling modern architecture with less rigid rules of design but, generally speaking, architectural photography is not the most obvious vehicle for expressing strong personal style.

OAK ALLEY PLANTATION, LOUISIANA *This shot was taken in the late afternoon when the sun silhouetted the oak trees to create a pattern.* Nikon, 20mm, Kodachrome, 1/125 sec, f11.

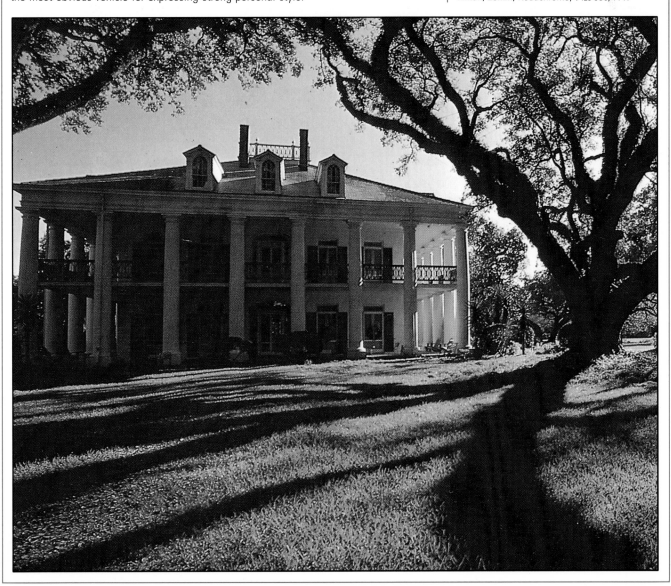

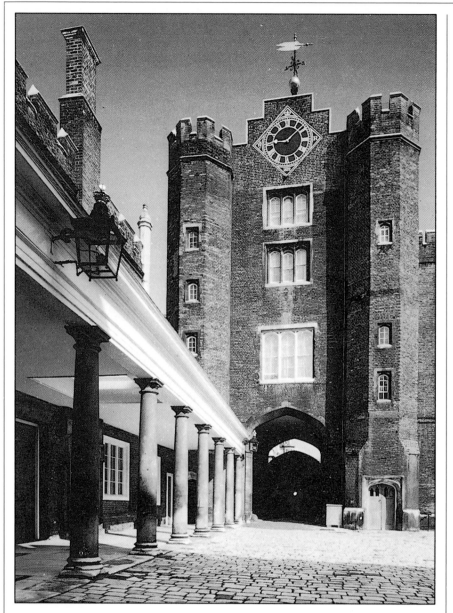

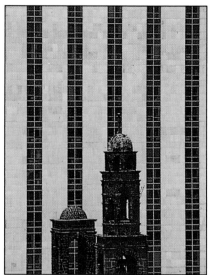

SANTIAGO CHURCH, MEXICO CITY *The contrast between this colonial church and a modern office block (above) appeared even more emphatic through a long-focus lens. To prevent the vertical lines from converging, the camera was set up on the roof of a building across the plaza.*
Nikon, 400mm, Kodachrome, ⅟₁₅ sec, f22.

ST JAMES'S PALACE, LONDON *Inclusion of the pillars (left) of the clock tower made the composition more interesting.*
Nikon, 28mm pc, FP4, ⅟₃₀ sec, f14.

USING A PERSPECTIVE CONTROL LENS

Normal lens

Corrective lens

To avoid converging verticals, use a perspective control lens. The camera is first levelled horizontally to remove the distortion. Then part of the lens is shifted upwards, to make use of its extra covering power.

Different lenses will give different interpretations of a building's setting. With a wide-angle lens you can move in close and sometimes isolate the building from the immediate cluster of surrounding houses, or, by using a long-focus lens from a distance, you can show its true proportions.

With lighting you must deal with the vagaries of natural light in the same way as in landscape photography. Usually, the low sunlight of early morning or late afternoon will bring out form and detail. Unlike landscape photography, you may be so restricted in your camera position that this alone will determine the time of day for the shot. Silhouetting the building against the sun, and catching the sun's reflection in windows (particularly with modern office blocks) are two obvious ways of using natural light for a dramatic effect. At night, the floodlighting on many historical buildings – particularly if there is a sound-and-light show – is often to a high standard, and may offer the best lighting of all.

A technical problem specific to architectural photography is converging verticals. Holding the camera at an angle by, for example, pointing it upwards to get the top of a building into the picture, means that the film is also at an angle to the subject and this results in distortion of the image. Unless the camera is level, parallel lines in your picture frame will converge. This effect appears at its most disturbing when the vertical lines of a building converge upwards in a picture taken at ground level. Although this is just the way any building appears to us when we look upwards at it, the brain accepts this distortion from experience, except when it is presented as a two-dimensional image. Deliberate and extreme convergence can be acceptable for effect or compositional reasons; more moder-

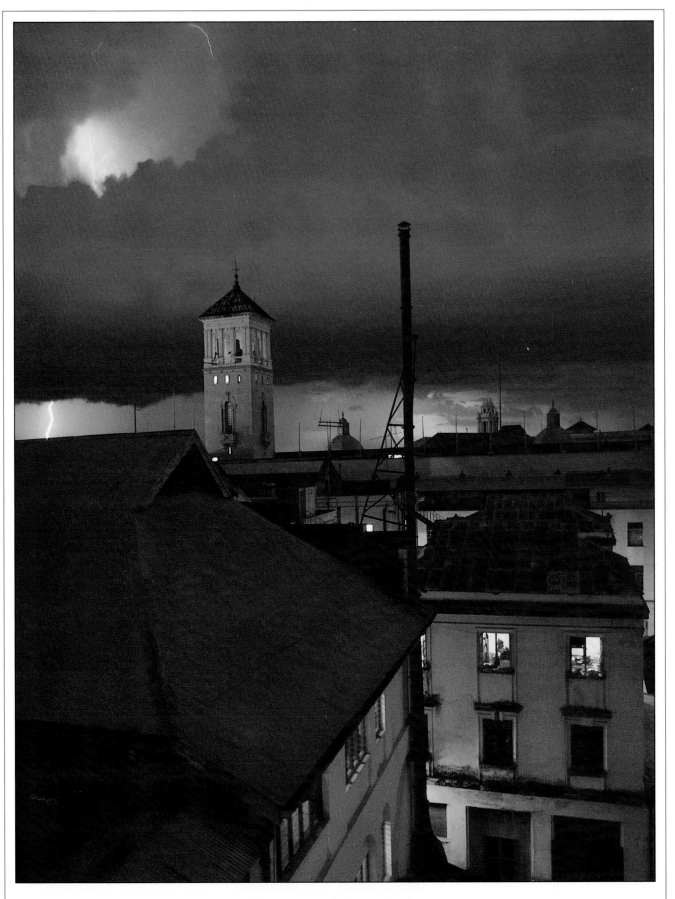

RANGOON ROOFTOPS *In a late evening view across the rooftops of Rangoon, the combination of colours comes from reciprocity failure (the exposure was 30 seconds), green fluorescent and orange tungsten light (both unfiltered on daylight-balanced film), a residual sunset and lightning.*

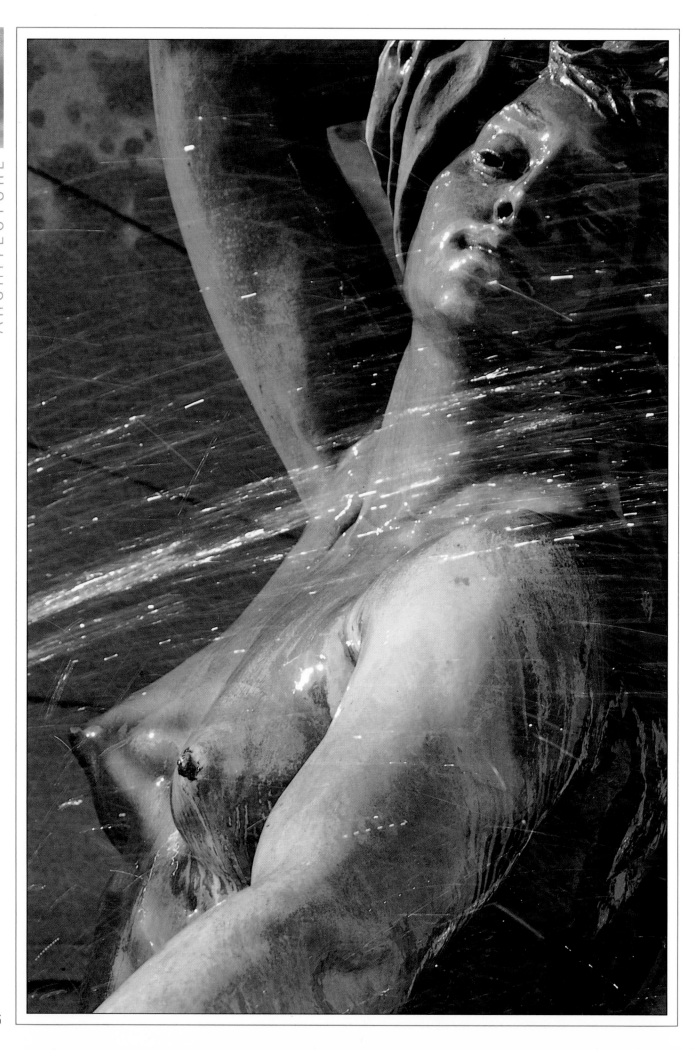

HIGH DETAILS *Close views add variety to architectural shots, although getting in close to details can be difficult. A telephoto lens is useful, but high details, as left, may not always look their best from an upward looking perspective.*

ate angles can appear unintentional or be less effective.

There are different solutions to this problem: move further away and use a long-focus lens: use a higher camera position opposite the building: compose the picture with a wide-angle lens aimed horizontally so as to include the foreground and remove distortion: or finally, use the specialized perspective-control or shift lens, which mimics the rising front movement of a technical camera. A 5 × 4in technical camera is an excellent tool for professional architectural photography.

EXTERIOR DETAILS

Textures, patterns and embellishments can make interesting studies; as with photography of interiors, they provide a visual relief from the expected overall views of complete buildings. As only a few exterior details are close to ground level, a long-focus lens is usually necessary to be able to isolate them. Large areas of glass can sometimes show interesting reflections such as these in downtown Washington DC (bottom). The figure of a saint was set in the wall of a small village chapel (below). The carved wooden figures gracing the façade of a Tudor building in Chester (above right) are a well-known feature of the city's architecture. The texture of brickwork is best conveyed by raking sunlight (right). The church gargoyle (below right) was accessible by standing on an adjacent parapet.

CORRECTING CONVERGENCE WITH AN ENLARGER

For an enlarged print, converting verticals can be corrected by tilting the enlarger and print for the exposure. The technique is similar to the shape-changing camera movements so useful in view camera work. Tilting the easel up at the base of the picture enlarges the top of the picture more than the base, spreading out the converging verticals. When the angle of the easel is just right, the sides of this building appear vertical (as in the photograph below left). Unfortunately, tilting the easel also causes keystoning of the whole picture, and it puts most of the image out of focus. This keystone shape can be cropped – providing there is sufficient room – and the picture can be re-focused by tilting the lens in the opposite direction to the tilt of the easel. The diagrams (below right) show how.

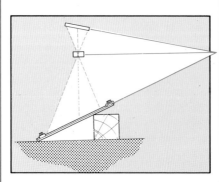

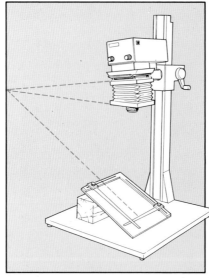

INTERIORS

Working inside buildings is often more of a challenge than photographing their exteriors. Even an extreme wide-angle lens can show only part of an interior, and can introduce some startling distortions, while the balance of lighting, particularly in large interiors, is often very uneven.

Choose your camera angle with care. You cannot include everything in one view, so select a position from which you can see the most important elements, and from which you can convey the right sense of space (if the room feels claustrophobic, there is no need to make it look like a warehouse, but if it has empty, open spaces, show these). It is usually difficult to include both the ceiling and other parts of the interior – it may be better to photograph the ceiling separately, if it is important. In any case, you will almost certainly need a wide-angle lens. As with architectural exteriors, deliberate and definite converging verticals can work very well, but slight convergence looks like carelessness, which it often is. If you can, rearrange furniture and other movable objects to give the best composition. To our eyes, a room usually appears tidier than it really is, and unless you want a cluttered impression, a little cleaning is worthwhile.

A SHIFT LENS

A shift lens contains a geared mechanism that shifts the lens elements laterally to project different areas of the lens image onto the film. So the top of even a tall building can be framed without tilting the camera upwards.

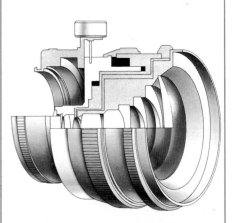

TRANS-AMERICA BUILDING *The sides of this well-known San Francisco building actually do converge to a point; a close wide-angle view merely exaggerates this convergence.* Nikon, 20mm, Kodachrome, 1/30 sec, f5·6.

LIGHTING

Lighting must be carefully considered at the start. The imbalance of lighting in most interiors creates a high contrast, with pools of light and areas of darkness. If the walls are dark, the illumination given by a window will fall off rapidly away from it. However, before immediately bringing in supplementary lights to fill in the shadows, consider the mood of the interior. Perhaps the very unevenness of the lighting gives the interior a special atmospheric quality. This is particularly true of many historical interiors; before electricity or gas-lighting, a good architect designed interiors to work as well as possible with existing window light.

Given that the style of lighting is subjective, there are several ways of altering the balance. Assuming that natural window lighting is the basic light source, there will hardly ever be sufficient light to work without a tripod, particularly as maximum definition is nearly always desirable, and this requires a small aperture. Compensating for reciprocity failure will enable you to increase the exposure time, and exposures of several minutes are quite possible. One coincidental advantage of this is that the movements of people can become so blurred during exposures of several seconds that they do not even record on the film; this is a real help in public places like churches and museums.

With supplementary lighting, one cardinal rule is not to allow these additional lights to be obtrusive. If, for example, you aim a direct spotlight into a shadow area from outside the picture frame then the hard shadows will 'point' to the extra light, and the effect will be artificial. Supplementary lighting from outside the picture frame is better when it is diffused, and therefore less noticeable. For parts of the interior that you cannot light in this way, place concealed lights that could appear to the viewer to be part of the existing lighting. In a church, for example, lights can be placed behind the pillars facing away from

PLANTAGENET HOUSE, SUSSEX *The open bible was an essential part of the 15th-century bedroom (above). In this position it filled in the otherwise empty foreground, and balanced the image of the bed. The principal illumination was daylight, with an added diffused light aimed downwards at the bible.*
Nikon, 20mm, Kodachrome, ⅛ sec, f5·6.

SWIMMING POOL, CHESTER *The cheerful clash of colours in this public swimming pool (above), makes a sharp contrast with the other, traditional interiors shown on these pages. The principal lighting was fluorescent, but the colour scheme is so flamboyant that the slight green cast is hardly noticeable.*
Nikon, 30mm, Kodachrome, 1 sec, f3·5.

ST PANCRAS HOTEL, LONDON *For this interior shot (above) of a Victorian hotel the only illumination was daylight through the windows. Supplementary artificial lighting might have added detail but the photographer felt it more important to preserve the atmosphere. To compensate for the reciprocity failure, a CC10 filter was used.*
Nikon, HS Ektachrome, 20mm, 8 sec, f16.

the camera. If you do not have enough lights for a large interior, make a multiple- or time-exposure, moving one light from one place to another. This technique is sometimes called 'painting with light' and is especially easy with a portable flash unit.

Opening doors can also help lighten dark areas, as can switching on the existing tungsten lights. Blue-coated bulbs can be used to replace those in existing lamp-holders, to restore the colour temperature to that of daylight film, although, when tungsten lighting is *subsidiary* to natural daylight (such as a small table lamp), it can look quite acceptable without correction.

It is very difficult to include the main window in the picture and overcome the enormous contrast between the outside scene and the interior, even with the help of supplementary lighting. One tricky solution is to make a double exposure – first exposing for the view outside, and then covering the window completely with black velvet and exposing for the interior with artificial or existing light. Striking the right balance takes experience.

SAXON CHURCH, ENGLAND *The small interior of this old church was adequately lit by daylight, with the door behind the camera to the right opened to fill in some shadows. The candlelight was purely decorative, but by avoiding extra artificial lighting the historical sense of the church was maintained. By elevating the camera to the full tripod extension, the photographer was able to shoot horizontally and avoid converging verticals while keeping a tight composition. If the camera had been lower, the top of the window frame would have been cropped off, and empty floor would have filled the lower part of the picture.*
Alternatively, a perspective control lens could have been used.
Nikon, 28mm, HS Ektachrome + red filter for reciprocity failure, 60 secs, f22.

35mm SLR EQUIPMENT CHECKLIST

1 Camera body, preferably with a removable prism head.
2 A ground-glass screen etched with grid lines, for aligning verticals and horizontals.
3 Spirit level, for levelling the camera.
4 Lenses: A wide-angle lens or, even better, but very specialized, is a wide-angle perspective control lens, with shift movements. For isolating details, and for working at a distance, a long-focus lens.
5 Tripod and cable release.
6 Filters: Yellow, orange, red and polarizing filters for controlling sky tones on black-and-white film; a set of colour correction filters for adjusting colour temperature in interiors and to compensate for reciprocity failure.
7 Film: Fine-grain film, in both colour and black-and-white, meets the need for high definition, but fast film may be needed in poorly lit interiors.
8 Lighting: A complete set of tungsten lights if you are going to work completely in artificial light. Otherwise, a pocket flash for fill-in or 'painting'.
9 Masks to shade lens from bright light sources; white card reflectors; large diffusing sheet and black velvet, both for covering windows.

INTERIOR DETAIL *A horse-shoe studded gate (above top) in the Indian palace of Fatehpur-Sikri and some fine Victorian tilework (above bottom) are two examples of interesting architectural details that can be found in interiors. Here they provide a useful change of pace from the normal scale of interior views. Both: Nikon, 180mm.*

CUPOLA ROOM, KENSINGTON PALACE
Photographers wishing to use daylight-balanced film under tungsten lighting can avoid the green cast with the use of a simple filter, as shown here. Major filter manufacturers can supply a fluorescent-correction filter, which has a strength close to CC30 on the Kodak Wratten scale.

CLOSE-UP

CLOSE-UP PHOTOGRAPHY, simply defined, is the photography of things at less than the normal close distance of a normal lens. The relative size of the image on film and the real subject is important, and different degrees of close-up photography are often described in terms of magnification. In terms of magnification, close-up photography extends from images about $\frac{1}{7}\times$ (one-seventh times life size) up to about $20\times$, at which point the optical system of a microscope is usually more efficient and resolves more detail. There are nevertheless, no hard and fast limits: the definition is essentially a practical one. According to another method of definition, close-up photography extends up to life-size magnification ($1\times$) only. Enlargements that are greater than those of photomicrography are considered to be the province of 'photomacrography'. The reason for this is that greater-than-life-size photography involves certain additional techniques, including reversing the lens – partly be-cause beyond $1\times$ magnification, the lens is closer to the subject than it is to the film. Here, the entire range is considered.

TYPES OF SUBJECT

Close-up photography is, strictly speaking, a technique, but the subject matter is usually very distinctive. There are 'close-up' views of people or, indeed, whole mountains, but close-up photography is generally concerned with tiny subjects.

CLOSE-UP EQUIPMENT: PRACTICAL COMPARISONS

Equipment	Advantages	Disadvantages	Best uses
Extension tubes	Simple, rugged, allow FAD use, known lengths make calculations easy	Non-variable, bulky for long extensions	Field use and moderate close-ups
Bellows extension	Variable magnification, large extension, some models have swings and tilts	Relatively fragile for field use, may prevent FAD use or need double cable release	Indoor close-ups, especially at high magnification
Ordinary lens & reversing ring	Improves optical quality at magnifications greater than lifesize	Cannot use FAD	Occasional high-magnification use
Close-focusing lens (usually macro zoom)	Uncomplicated	Close-up image quality poorer than at larger scales	Non-critical use
Macro lens	Designed for best optical performance in close-up, focuses unaided to $\frac{1}{2}\times$, good for general purpose photography also	More costly than ordinary lenses, relatively small maximum aperture	All close-up photography: alone up to $\frac{1}{2}\times$, more with extensions
Supplementary lenses	Quick to fit, light, need no exposure adjustment	Limited magnification, image quality not high	Fast field use up to about $\frac{1}{8}\times$, and for fixed-lens cameras
Medical lens	Easy to use, fast changes of magnification, built-in light	Expensive, bulky, ring-flash may not suit all subjects	Medical, insects
Supplementary telephoto lens	If both lenses already available, needs only a coupling ring	Bulky, limited magnification	Emergency field use

MAGNIFICATION AND REPRODUCTION RATIO

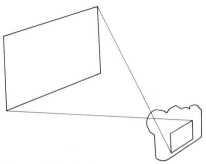

Because the basis of many calculations and settings is the degree of enlargement of a close-up image, this is the fundamental measurement. In practice, there are two related and interchangeable ways of expressing it. One is magnification, in which a lifesize image is unity ($1\times$) and all other magnifications are proportionately less or more ($\frac{1}{2}\times$ is half lifesize, $2\times$ is twice lifesize). The other is reproduction ratio, in which the degree of enlargement is given as a ratio to the size of the subject; lifesize is 1:1, twice lifesize is 2:1, and so on. The two forms of measurement are shown in the table opposite.

Magnification is calculated as the ratio of the picture area to the film size.

EXTENSION AND FOCAL LENGTH

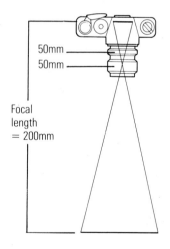

50mm
50mm

Focal length = 200mm

The magnification of the image depends not only on the length of the extension, but also on the focal length of the lens. To achieve a given magnification, lenses of different focal lengths must be extended proportionately: for $1\times$ magnification (lifesize) a 50mm lens must be extended by 50mm – its own focal length – and a 100mm lens by 100mm. So, a simple means of achieving high magnification is to switch to a shorter focal length.

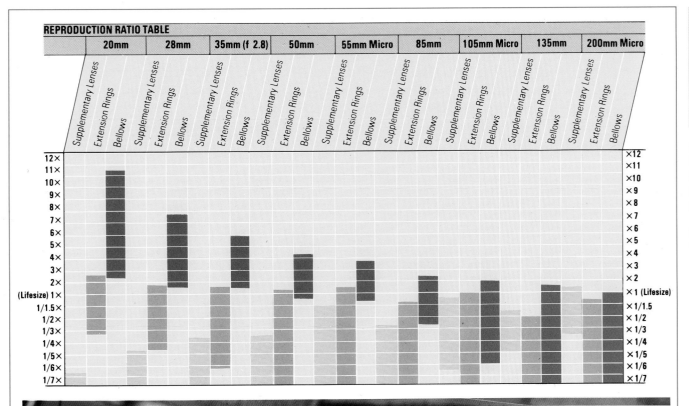

REPRODUCTION RATIO TABLE

	20mm	28mm	35mm (f 2.8)	50mm	55mm Micro	85mm	105mm Micro	135mm	200mm Micro

Each lens column is subdivided into: Supplementary Lenses, Extension Rings, Bellows

Vertical scale (magnification):
12× · 11× · 10× · 9× · 8× · 7× · 6× · 5× · 4× · 3× · 2× · (Lifesize) 1× · 1/1.5× · 1/2× · 1/3× · 1/4× · 1/5× · 1/6× · 1/7×

Right scale: ×12 · ×11 · ×10 · ×9 · ×8 · ×7 · ×6 · ×5 · ×4 · ×3 · ×2 · ×1 (Lifesize) · ×1/1.5 · ×1/2 · ×1/3 · ×1/4 · ×1/5 · ×1/6 · ×1/7

SCALES OF MAGNIFICATION

Different close-up equipment is needed, depending on the degree of magnification. For the photograph at left of a butterfly measuring 2in (50mm) wingtip-to-wingtip, an unaided 55mm macro lens could handle the magnification. The series of pictures here show different degrees of magnification.

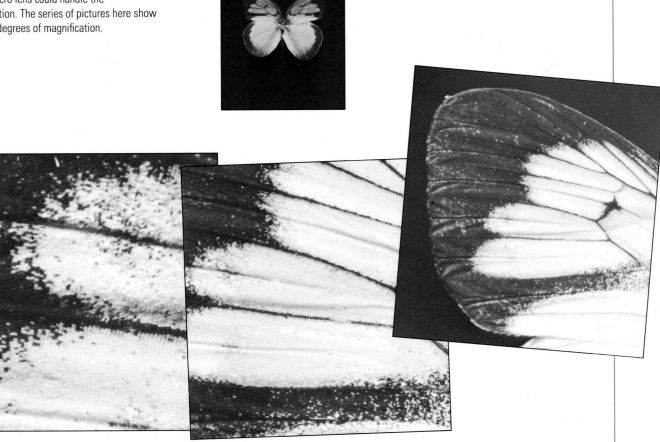

Miniature Natural Objects Small plants, insects and individual details of larger things – the scales of a fish, for example, or the texture of tree bark – offer an almost limitless choice of close-up subject. Not surprisingly, therefore, the most widespread use of close-up photographic techniques is in nature photography, and some of the specific methods for treating insects and flowers are dealt with in the wildlife section. These are often interesting precisely because they are not normally noticed by the eye, so the most common treatment is realistic, using lighting, viewpoint and depth of field to show the maximum amount of information as accurately as possible.

Miniature Man-Made Objects Miniaturization in various fields, including electronics and engineering, provides a rich modern source of close-up images. Circuitry, components, and, as in close-up nature photography, the surface details of larger, more familiar things, are important subjects.

Unusual Treatments Precisely because small-scale views are unfamiliar to the unaided eye, many close-up subjects offer opportunities to experiment with unusual and sometimes dramatic treatments. These often involve a careful selection of viewpoint and lighting techniques.

Abstract Images Visual experiment can also produce images that are so unfamiliar that they become abstract. For purely graphic pictures, with no hint of the content, close-up photography excels.

EXPOSURE

Any close-up system that involves lens extension reduces the amount of light reaching the film. In practice, this means that the greater the magnification the more exposure is needed. Exposure is increased either by extending time, or by widening the aperture, or by increasing the amount of light (moving the light source nearer or boosting the light output).

TTL metering removes the problem of tedious calculation, when working by available light. And many SLRs now have off-the-film flash metering to solve the problem when working with flash. Where it is not available, the precise settings must be located in tables or calculated. Additional compensation may have to be made for reciprocity failure with long exposures.

As with telephoto photography, a magnified image also magnifies camera-shake, and all the usual precautions must be taken with continuous light photography: a rigid support, cable release, shelter from wind and locking up the mirror.

DEPTH OF FIELD

Depth of field decreases with magnification, and is always shallow in close-up photography. At high magnifications, even the smallest aperture may not give enough depth of field to keep all of the subject in sharp focus. This is not necessarily a problem. Out-of-focus blur in the background or foreground may actually help to make the main subject appear to stand out sharply. Normally, though, the lack of depth of field means that precise focusing is critical. A point to bear in mind is that at normal distances there is more depth of field beyond the sharpest focus than there is closer to the camera. At close distances, the difference is almost irrelevant.

The smallest apertures may not give quite such sharp results as optimum apertures, but the extra depth of field means that the picture may be sharper overall. Repositioning either the camera or the subject can help to align the important parts with the plane of sharpest focus. The swings and tilts on some bellows extensions can be very useful to redistribute the sharpness.

Another, highly specialized, means of increasing the apparent depth of field is slit-scan lighting, described below.

LIGHTING

In close-up photography extra lighting is needed for a variety of reasons: to compensate for the light loss in the extension; to allow small apertures; and to introduce illumination

BASIC MACRO SET-UP

For controlled conditions indoors, a basic arrangement for macro photography centres on a copystand or equivalent. Shown below is a monorail that clamps to a horizontal surface such as a desk-top. The camera mount can move freely up and down, and a separate, movable frame below acts as a macro stage. This can be fitted with an opaque plate or a translucent sheet as needed. Adjustable arms and small mirrors (dental mirrors are ideal) can be used either to introduce main lighting or shadow fill.

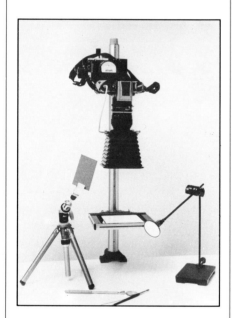

into the small confined spaces of a tiny subject. In addition, the small size and structure of close-up subjects means that many are translucent or transparent, so that back-lighting (or 'trans-illumination', as it is sometimes called in photomacrography) is useful.

Light sources used in normal-scale photography appear larger and so more diffused when used closer with small-scale subjects. Consequently, it is usually easy to achieve soft lighting, though of relatively low intensity. Close-up lighting equipment, therefore, tends to be miniaturized in keeping with the reduced scale, and small flash heads and miniature spots are commonly used. Fibre optics are also useful for directing light into exactly the right place – and to light subjects which may be sensitive to heat sufficiently brightly.

When the working distance is very small, the best lighting position may actually be just where the camera is. One answer is to use a 'ringflash', a circular tube that surrounds the lens to give virtually shadowless illumination. Medical lenses contain their own built-in ringflash. Macro lights have a number of small tubes surrounding the lens. The tubes can be switched off and on independently for different degrees of modelling effect. Another answer is 'axial lighting', in which a semi-reflecting mirror is placed at 45° to the lens axis in front of the lens. Light is aimed at right angles from one side, and half of the beam travels along the lens axis. This technique can be useful with coins as it permits some diffusion.

For most of these miniature lighting systems, close-up brackets are needed. Some brackets attach to the base of the camera, others to the hot-shoe, and others screw onto the front of the lens. Most are jointed to allow more manoeuvrability.

The two most common methods of trans-illumination, useful with thin subjects that are at least purely translucent, are 'brightfield' and 'darkfield' lighting. Brightfield lighting is usually created by placing the subject on an opal plastic base and aiming light up through this. In darkfield lighting, the subject is usually placed on a clear glass base, over a black background. One or more spotlights are then aimed diagonally upward from the sides.

A highly sophisticated lighting system is the slit-scan technique, in which the subject is moved towards the camera at a fixed rate, illuminated only by a narrow band of light from the sides. As the band of light is fixed relative to the camera and is narrow enough to fall within the depth of field of the lens, an apparently spectacular depth of field is possible – matched only by other scanning systems.

CONTROLLING REFLECTIONS

Most of the techniques in lighting shiny surfaces apply in close-up photography, yet it is important to be flexible. In the photographs of a cowrie shell (above) , the difference between naked, undiffused lamps and the same lights diffused through a cone of tracing paper is obvious, yet the diffused version is so flattened as to give an inaccurate impression.

EXPOSURE CALCULATIONS

For non-TTL metering cameras, the two most usual ways of calculating the exposure increase needed are:

$$\left\{ \frac{\text{lens focal length} + \text{extension}}{\text{lens focal length}} \right\}^2$$

or

$(1 + \text{magnification})^2$

For example, if a 100mm lens is extended half its own focal length – 50mm – to give a magnification of ½×

$$\left\{ \frac{100 + 50}{100} \right\}^2 = (1.5)^2 = 2.25$$

and

$(1 + 0.5)^2 = 2.25$

This means that the film needs to receive 2¼ times more light, which can be achieved by increasing the exposure time by a little more than twice – in practice, halving the shutter speed from say, 1/125 sec to 1/60 sec – opening up the lens aperture by 1 or 1½ stops, or by moving the light closer by about 1/3 of its distance.

Magnification	Depth of field at f/11	
	A	B
0.2×	30mm	15mm
0.5×	6mm	3mm
0.8×	3mm	1.5mm
1×	2mm	1mm
1.2×	1.5mm	0.7mm
0.3mm	15mm	7mm
1.5×	1mm	0.5mm
2×	0.8mm	0.4mm
3×	0.4mm	0.2mm

ABSTRACT PATTERNS

Close-up photography is very good for creating abstract images. While at most scales photographs have a strong tendency towards realistic representation, at magnifications greater than the eye is accustomed to, pictures may seem a little difficult to place. The photograph directly below, apparently an aerial view of drainage channels, is in fact a large magnification of pigments trapped in a damaged Polaroid print. More recognizable are the arrangement of feathers (below left), and the pattern of bubbles in a liquid (below right).

TECHNICAL CLOSE-UPS

Unlike the pictures opposite, the photographs on this page are meant to inform. In each case, there is a technical need to show a magnified view of something small. Illustrating an article on malaria research, the photograph at bottom left combines two disparate scales – mosquito and human researcher. At bottom right, the subject is the method of threading pearls onto strands. The large photograph at left combines scales in another way – by focusing on the small quartz sphere and using its refraction to show part of the laboratory. The photograph (below), of teeth, uses a medical lens equipped with ringflash to make a clear, shadowless record of hard-to-reach locations.

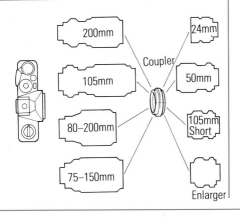

LENS COUPLING FOR CLOSE-UPS

One ingenious method of achieving good magnification with little extra equipment is to add a short focal length front-to-front with a medium telephoto. Typical lens combinations are shown at right. Besides the lenses, the only extra item needed is a male-to-male macro coupler.

200mm

24mm

Coupler

105mm

50mm

80–200mm

105mm Short

75–150mm

Enlarger

COMBINING IMAGES

IF YOU HAVE YOUR OWN DARKROOM two or more negatives can be printed onto the same sheet of paper to create surrealistic images or simply to add interest from one negative to a dull area of the other.

Landscapes with featureless skies but interesting foregrounds can have dramatic clouds added to them to create more interest. The original scene is printed and left in the enlarger easel. The negative is removed and the cloudscape is put in. With the red filter under the lens to prevent further exposure of the paper, the sky is positioned roughly to cover the area of empty space in the original image. An overlay with a rough outline of the horizon is often used as a compositional aid.

During the second exposure, a mask with one edge cut to resemble the shape of the horizon is held over the already exposed area of the print, thus preventing further exposure.

SURREAL COMPOSITE IMAGES *These can be created by skilled composite printing. This fine example (right) is by Jerry Velsmann.*

COMPOSITE PRINTING

To print the image of trees hanging over a seascape, five separate exposures were made onto one sheet of paper: one of the seascape, one of the nearer tree and another of its 'roots', and finally the same pair but smaller.

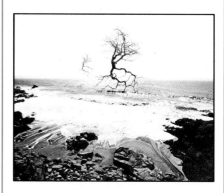

Composite printing:
1 Select the negatives
2 Block out unwanted areas
3 Sketch the images onto a sheet of paper on the easel
4 Make the first exposure
5 Store the sheet
6 Load the second negative
7 Position the second image
8 Expose on original sheet

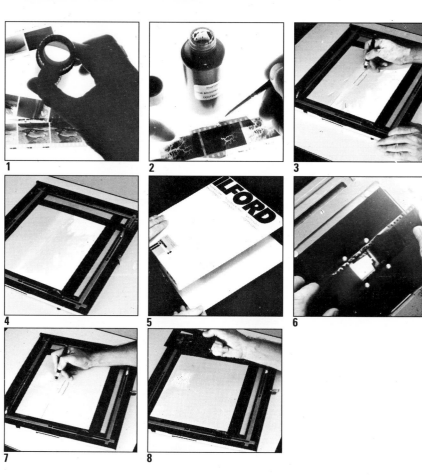

SLIDE COPIER

The slide copier excels at image combination, bringing a precision to the technique that, even in the small 35mm format, allows very close refined juxtapositions. Sandwiches can be duplicated in the normal way on a copier, the normal increase in contrast range of the sandwiched originals. Multiple exposure is done by the same process described on page 000, but with less uncertainty, as rerunning the film is not necessary.

PHOTO-COMPOSITES

The most exact method of combining images on film is photo-composition. Essentially, this involves combining a number of separate elements, usually transparencies, on to one piece of film in register and masked (to exclude the unwanted parts of each transparency). With this technique there are, at least in theory, no restrictions such as needing to position a bright image against a dark one; masking in register allows images to be combined in any relationship. In practice, however, a large film format is needed for the more complicated combinations (35mm transparencies can be enlarged first on to sheet-film, but this involves the explanation of procedures which are beyond the scope of this book).

A register system enables you to position each element with great precision. The standard equipment consists of a Kodak Register Punch and Register Bar. As a working surface for the slide copier, tape the register bar securely to a sheet of glass (the smallest bar, with pins 2½in (6cm) apart, is the most convenient, and will fit onto a sheet of film measuring 5in × 4in (12 × 9cm); then tape this glass over the copier's filter drawer. This replaces the copier's slide holder (an alternative is a sheet-film holder, available with some makes of slide copier). Use the register system by taping each transparency to a larger piece of discarded film, arranging the position of each on a light box visually, and then carefully punching register holes in the edges. Whenever one of the mounted transparencies is slipped on to the pins of the register bar, it will always be in the same position.

PIRANHA *To add life to this close-up of the dead, preserved fish (above), an eye was added. First, the fish was photographed and then, separately, a false eye was photographed, backlit and masked. The two transparencies were then combined using a slide copier. Combining during duplication allowed precise control of the way the eye would look.*

TELEVISION TIME COSTS

For an article on the costs of screen time on television, a sliced watch and coin needed to be combined on the screen of a television set (below). The two objects were first photographed individually, the screen having been painted black. A piece of black card was then cut into a wedge-shape, and this was laid over the transparency of the watch before duplicating (centre right). To give a three-dimensional sense, a small strip of brownish clear acetate was also added. The same technique was used to mask off all but a slice of the coin (bottom right), and all these shots were copied onto one frame.

SATURN FROM RHEA *This intricate photocomposite (left) involved nine separate original transparencies of subjects, ranging from real landscapes to models and artwork, and for ease of working these were enlarged onto sheet-film. The need for extreme precision was reduced by making use of shadow areas in which to drop other images.*

DISEMBODIED HAND *To realize this surrealist image of a disembodied hand for a record album cover, extensive and skilled re-touching was necessary. The blending of glove into hand was crucial, and the re-touching had, above all, to be completely undetectable. A dye transfer strip-in technique was used.*

CONSCIOUSNESS

This photograph was taken for a magazine cover to illustrate a feature on levels of consciousness. (The idea of a rising sun superimposed on a head seemed appropriate.) First, the image of sunrise over a lake was constructed by sandwiching together two transparencies. To ensure that the image would follow the contours of the head, the transparency sandwich was placed in the carrier of a dissembled enlarger and projected. The head, a phrenology model, had been sprayed to a matt white finish, .and was separately backlit.
Nikon, 55mm, Kodachrome, f22.

HARD AND SOFT MASKS

In order to prevent unwanted parts of each transparency from being recorded, each transparency must be masked. This means nothing more than blacking out, and can be done rather crudely by retouching. For an exact mask, contact-expose the transparency with line film, such as Kodalith Ortho type 3. This produces a black-or-clear negative image with no graduated tones. To facilitate re-touching, more than one line contact derivative will probably be necessary. The final mask, when taped to the original transparency, isolates the element you want against a black background. Then a further line derivative from this final mask will produce the complementary mask to be exposed with the second transparency. Line film is simple to use; trial-and-error exposures are normal technique and development can be by inspection under a red safelight.

The limits to this technique result from the film size. Any inaccuracies in masking and register are increased with enlargement, so that it is better not to be too ambitious on 35mm film. One method of overcoming slight problems with register is to use a soft mask rather than the hard one just described. This can be made in exactly the same way, but a sheet of translucent diffusing material should be sandwiched between the original transparency and the hard mask. This will soften the edges. Even softer masks, which can afford to be more imprecise, can be made by cutting shapes out of black paper and taping them under the flashed opal of the slide copier light source.

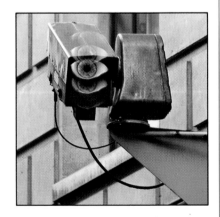

SECURITY CAMERA *To illustrate a feature on bank security, this camera focused on a bank's loading bay was a good starting point, but to give it life, an eye was added. A backlit false eye was separately photographed using a step prism filter, and the two images were then combined by double-exposing with a slide copier.*

MAKING MASKS

1 Contact-expose a sheet of line film with the first transparency. (It may be necessary to experiment a few times in order to get exactly the right amount of masking.)

2 Re-touch the black areas you want to remove from the image of the resulting line negative with opaque or black paint.

3 Contact-expose the line negative with another sheet of line film, to produce a line positive. The black area can once again be re-touched very simply.

4 From this positive mask, a final negative complementary mask is made through the usual contact-exposure procedure.

5 Mount the negative in register, mask with the first transparency attached to a punched, discarded, large sheet of film.

6 Then mount the positive mask in register with the background transparency. Expose each pair in the slide copier on to the same frame of film. A sheet of glass will hold the masked originals flat.

USING THE REGISTER SYSTEM

1 Cut a hole in a sheet of discarded film to the size of the transparency. Punch one edge of the sheet with register holes.

2 Fix the sheet onto the register bar on the light box, and mount the first transparency with dimensionally stable tape.

3 Repeat process with second transparency. Mount it in exactly the position you want in relation to the first transparency. Check with a magnifying glass. The transparencies will now remain in register.

SETTING UP THE REGISTER BAR

1 Tape the smallest (2½in/63mm) size of Kodak Register Bar to one end of a 5in × 4in (12 × 9cm) sheet of glass.

2 Tape the glass over the slide copier's light source, securely.

3 Tape a second, identical, register bar to the surface of a light box.

COPYING ARTWORK

PHOTOGRAPHING FLAT ARTWORK – paintings, art prints, documents, typesetting and photographic prints – can be very demanding technically. Usually the aim is to reproduce the original as accurately as possible, and the approach needed depends on the nature of the artwork.

There are three main kinds of flat original: continuous tone, halftone and line. In continuous tone artworks, tones and colours merge gradually into each other, even at magnification. Halftones are produced by photomechanical reproduction and are composed of a pattern of dots of solid ink, fine enough to appear continuous – the photographs in this book are of this type. Line originals such as type are solid ink on a toneless background.

FIDELITY

Copying always involves some loss of image quality, however small. These losses occur in three areas – detail, tonal range and colour. A fine-grained film, particularly in a large format, helps to preserve detail and avoids adding a texture of grain. Careful processing, with most films except Kodachrome, provides some control over the tonal range. Contrast can be increased by pushing, or reduced by pulling, the development.

Colour is more of a problem. This is because the dyes in the film do not react to the dyes or pigments in the original in the same way as our eyes react. Imperfect colour response does not usually matter in normal photography, as the differences are usually quite small, but a side-by-side comparison of an original and its photographic copy will show up any inaccuracies clearly. The best that can usually be done is to filter for the most important colours. For photomechanical reproduction, it helps to include in the copy shot a standard colour reference, such as a Kodak separation guide; the printer can then adjust to this.

In black-and-white copying, filtration offers some control over staining. The yellowing of paper, for example, can be dealt with by using a yellow filter.

ALIGNMENT

The easiest way of making sure that the lens axis is exactly at right angles to the original is to copy vertically, and use a spirit-level. An even more precise check is to place a hand mirror flat against the centre of the original, and focus the lens on its own reflected image: the alignment is exact if the image of the lens is precisely in the middle of the viewfinder.

With a large painting, however, this may not be possible. To copy *in situ*, the angle at which the painting hangs must be measured (with a clinometer), and the camera adjusted to the same angle. Alternatively, and more laboriously, a cross-grid viewfinder screen shows if the opposite edges of the painting's frame are parallel.

LIGHTING

To illuminate the artwork evenly, two lights can be positioned at either side, each aimed towards the *opposite* edge of the original. In this way, their beams cross. The evenness of illumination can be checked with several incident light readings from different parts of the original, or with spot readings from a plain white or grey card placed in different positions over the original. A pencil held perpendicular to the original in the centre will provide a rough guide – if light is even, the two shadows of the pencil should be identical in length and intensity.

To avoid reflections from the surface of the original, the lights should be at a fairly acute angle. However, if the angle is too extreme, they may cast shadows from the frame. An angle of 45° to the original is usually the best. Still, the lens should be shaded from the lamps to reduce flare.

If the original is covered by glass, there are two ways of cutting reflections of the camera itself. One is to black out the camera, by hanging in front of it a large sheet of black cloth or paper with a hole cut just large enough for the lens. The other is to polarize the light, with polarizing sheets across the lamps and a polarizing filter over the lens.

COPYING ARTWORK FROM BOOKS

The basic requirement for copying artwork is a flat base for the original and a firm camera support. The copy stand must be aligned so that the lens axis is perpendicular to the base. Books, unfortunately, rarely lie completely flat, and the following alignment technique (below) is useful: raise one side of the book to help flatten the page being copied (top); focus on the reflection of the lens in the mirror (bottom) and adjust either book or camera until the image appears centre (centre).

VERTICAL COPYING

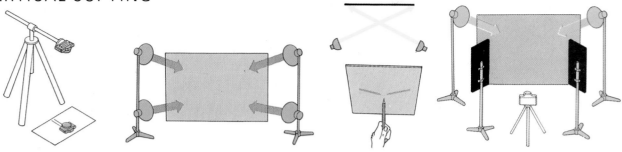

For vertical copying (above), a horizontal arm keeps tripod legs out of the way. A lamp at each corner (above right) is the ideal lighting.

Using two lamps (above), a flat surface can be evenly lit by aiming each at the opposite edge. The strength of the two shadows cast by a pencil held up to the surface will show if the

illumination is equal. Shade the camera lens (above) from the direct lamp light with large pieces of card.

COPYING PAINTINGS IN SITU

While it is always easiest to bring a painting to the camera, it is not always possible. With oil paintings in particular, their size and the way they are hung may make it necessary to photograph them in place – in this example the height of the painting made it hard to remove. The lighting problem can be solved by using lighting stands that extend to ceiling height: at least two are positioned so that their beams strike the painting at an angle of about 45°, and they themselves are shaded from the camera lens to reduce flare. The verticals can only be maintained parallel by using a shift lens (on a small camera) or rising front standard on a view camera, as shown here. Allowing for the small angle at which the painting is tilted is more difficult, especially if it is too inaccessible to be measured.

35mm SLR EQUIPMENT CHECKLIST

1 Camera body: single lens reflex, preferably with removable prism head.
2 Ground glass screen marked with rectangular grid, for alignment.
3 Masking tape, black and white card.
4 Tripod and cable release; a copystand for a more permanent set-up.

5 Clinometer, tape measure, spirit-level, hand-mirror.
6 Filters: colour correction filters when working in colour; in black-and-white, using coloured filters (eg red, green blue) will allow you to alter tonal relationship in a coloured original.
7 Film: fine-grain film for maximum definition.

8 Lighting: two or four tungsten lights with stands.
9 Ultraviolet and heat filters for each lamp.
10 Polarizing sheets for each lamp, and polarizing filter for lens.

EXHIBITION AND DISPLAY

THE TWO TRADITIONAL ways of displaying a photograph are in a mount and in a frame. Both share some of the same techniques. The advantages of a plain card mount are that it can be sized and cut to suit the individual photograph, that it is the least distracting of displays, and that it can be used as basic protection when storing. Frames provide extra protection through their acrylic or glass cover, and add a sense of value and importance to an image.

MOUNTING

For archival permanence, refer to the section on copying. The two main parts of a mount are the backing board and the overmat. Both should be identical in size. The ideal material for the backing is museum board, although it is often only available in white; it can be bought from most artist suppliers. The print can be attached permanently to the backing board by means of dry-mounting, or it can be made removable by using corner mounts. Dry-mounting will hold the print perfectly flat against the board, although whether this is needed or not will depend on the size of the print and the type of paper (resin-coated paper normally lies flat, and the overmat will also help to prevent edge curling).

Dry-mounting *can* be performed with an ordinary iron, but as the temperature, evenness and length of time of pressing are all critical, it is much better to use a heated dry-mounting press. The principle is straightforward. Dry-mounting tissue is cut to the size of the print, tacked on it in several places with the tip of a tacking iron, and then the print, tissue and board all heated together.

A loose-fitting alternative is to use corner mounts, or diagonal corner slits cut into a backing sheet of acid-free paper. The mounts should be acid-free, and can be made easily by folding strips of archival paper. Then, the mounts or the backing paper can be stuck to the board with archival linen tape.

On top of the print, a second sheet of board is placed, cut with a 'window' a little larger than the image area. This is the overmat, and serves the double function of providing a raised protection for the print, and setting it off with an attractive surround.

PRINTS FOR EXHIBITION

Prints for exhibition need to be presented properly if they are to have maximum impact. This does not only mean taking time and care over mounting; it means designing the mount in relation to other pictures in the exhibition – so that the exhibition as a whole has the desired effect. Also important are such considerations as caption information. For the pictures shown here a broad space was left between the captions and the picture, so that the text did not distract attention from the picture.

MOUNTING A PRINT

1 Measure the picture area that is to appear when mounted, and mark the frame lines on the borders of the print in pencil.

2 Mark these dimensions on the back of a sheet of thick card, and, using an angled mat cutter cut each of the lines up to the corners. Trim with a scalpel.

3 On a second sheet of card – the backing for the mount – position the print and mark round the corners in pencil.

4 Having sprayed or brushed a light, even covering of glue onto the back of the print, roll it down onto the backing card using a sheet of tracing paper to avoid making marks.

5 Apply glue to the edges of the backing card, position the top piece of card, and press down firmly.

6 The mounted print is ready for display, but handle it carefully until the glue is completely dry.

FRAMING

As a frame encloses the print, special care should be taken to avoid contaminating materials. Aluminium, stainless steel and baked enamel frames are the safest. Check also the composition of the backing board in a proprietary frame. Either acrylic or glass is suitable for the front cover; both give UV protection, but acrylic is more effective.

MAKING A FRAME

Frames can be made with lengths of moulding from a framing shop using basic wood-working tools – but a mitre clamp is vital.

1 Use the clamp to hold the moulding while you make 45° cuts with a tenon saw.

2 Glue the exposed ends and press together in the clamp.

3 Drill small holes and hammer in pins at a

shallow angle to secure the joint.

4 When the joints are secure, rest glass, print and backing in place. Hammer in brads just above to secure.

5 Alternatively use heavy-duty stapler.

6 Cover the edges and backing board with strong sticky tape.

The choice of frame is obviously largely aesthetic but there are strong arguments for simplicity. Unlike many oil paintings, for example, most photographs have no significant surface texture; black-and-white prints, in addition, have at most a subtle colour component. Few photographs, therefore, tend to go well with ornate or dominating frames – plain metal or else clips on a simple block are the most generally successful.

The size of the frame relative to the print, its shape, and the *position* of the image within its surround all need careful consideration. These choices can make subtle but important differences. A small print within a large frame tends to concentrate attention and add a sense of specialness to the image; a narrower print border tends to increase the important of the centre of the image.

VIEWING CONDITIONS

The lighting and hanging conditions are important in the appreciation of displayed prints. A high ultraviolet content will promote fading, and prints should be hung away from windows and fluorescent strip lighting. also, direct sunlight can cause expansion cracks in the emulsion.

The lighting should be as uniform as possible over the area of each print. This means that the light should not be close to the photograph. Ceiling-mounted spots are very suitable. To diminish reflections from the surface of the print and the glass, spotlights should be directed at a sharp angle.

The overall tone of the background also has an effect on viewing. For the most accurate translation of tonal values, a mid-grey background is the most suitable; if the walls are of a different value, one method of achieving this is to hang prints on larger grey panels. The precise effect of this, and of the association of other prints nearby is best judged by experiment, trying out different positions and layouts within the room.

CARING FOR TRANSPARENCIES

Make sure, above all, that transparencies are adequately protected and properly identified. Develop a system for logging in transparencies, stamping your name, copyright mark, date and description on them. Many films are normally cut and mounted at the processing laboratory. Use a transparent slip-over cover. If a publisher uses a transparency for reproduction, it will have to be removed from the mount, so be prepared to re-mount used transparencies.

Filing A convenient system is to use transparent sheets, containing individual pouches. These will fit into a standard filing cabinet.

For projection A red spot in the lower left-hand corner of the mount (above left) facilitates assembly for projection. To signify a sequence, rule a diagonal line (above right) across the edges.

FOOD AND DRINK

THE DEMANDS of the commercial world have transformed the photography of food and drink into a highly specialized art that demands a combination of very particular still-life techniques and a knowledge of cuisine. Food and drink could be approached in the same way as any still-life, but the over-riding need for food and drink to look attractive when a photograph accompanies a recipe or advertises a food product has educated us to expect food to look almost unnaturally appetizing in photographs.

The greatest obstacle to making food and drink appealing in a photograph is the loss of its prime ingredients, taste and smell. The skill of the food photographer lies in using a combination of setting, careful preparation, lighting and colour to suggest these missing ingredients to the viewer.

SETTING

In many ways, the setting is crucial in establishing the mood and appeal of the shot. Very few food shots do not have some kind of suggestive setting, even if it is only a knife laid ready to cut the food. Commercial food photographers go to a great deal of trouble to make sure the setting is just right. Most employ a stylist (also known as a 'home economist') to do precisely this.

Details, such as wooden pepper grinders, proper chef's knives, sprigs of herbs and so on are all arranged within an appropriate country kitchen set complete with well-worn wooden table and chopping board. Or candles, silver cutlery and sparkling wine glasses are combined on a perfect lawn tablecloth for an elegant dining table. A common ploy is to surround the food with the raw ingredients and utensils needed to prepare it. High value is put on authenticity. Tradition is very much to the fore, because tradition plays such an important role in people's expectations of food.

PREPARING THE FOOD

Preparing the food is perhaps the most difficult part of food photography and demands considerable care and attention. Food should always look perfect, so photographers buy only top-quality fruit, meat and vegetables. Then they may spend hours sorting through to find blemish-free and perfectly coloured examples. Chopping and slicing must be equally meticulous and should only be done with the proper, sharp knife.

If the food is to be cooked, adequate kitchen facilities are essential. However, cooking and photography mix poorly, as liquids, heat and fumes and oil droplets in the air can damage equipment. Professionals usually have a separate kitchen attached to the studio with rapid access to the working area. But working at the far end of a large, well-ventilated kitchen may be just as effective.

Food generally looks better slightly under-cooked and photographers will often add almost raw vegetables to dishes such as casseroles at the last minute, so that both their shape and colour is perfect. But it is important that hot dishes should look hot and cold dishes cold. The working area should be cool, so that hot food steams and cold food does not shrivel or melt. A dark backdrop shows off steam well.

There are various tricks to make food look appetizing, although editorial and advertising ethics limit what substitutes can be used for commercial work. Common tricks are: using

BRUSSELS SPROUTS *Labyrinthine problems were encountered in achieving this apparently straightforward image (above). First, the container needed to be large and plain; the only suitable vessel turned out to be a medical specimen jar. Then, it was found that the sprouts tended to fall to the bottom of the container; the answer was to insert a large, stubby candle, studded with short, thick wires into the jar, and carefully arrange the sprouts on the ends of the wires. The next problem was that, in boiling water, the chlorophyll would run out of the sprouts. The only solution was to use cold water and insert an air-line, attached to a compressed air gun, to create bubbles. Even this created new problems, as the bubbles tended to erupt violently. To encourage a few surface bubbles, a little washing-up liquid was added, and frothed up. Finally, to reproduce steam over the cold water, cigarette smoke was blown over the surface through a straw.*

SET PIECES

A classic food photograph is a fully arranged still-life setting including suitable utensils, associated objects, and some of the raw ingredients. For the food to appear fresh, the normal procedure is to prepare the set and compose the picture in advance, using an empty dish of the same size. As soon as the set is ready the food is prepared and put in place.

A PROFESSIONAL STUDIO

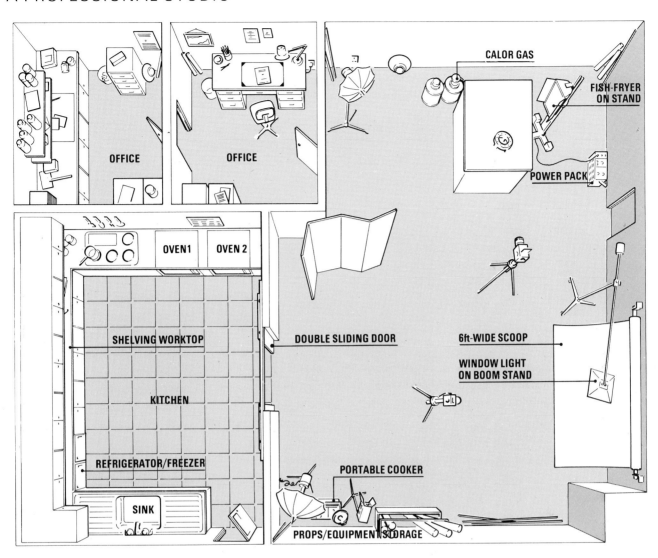

OFFICE

OFFICE

CALOR GAS

FISH-FRYER ON STAND

POWER PACK

OVEN 1

OVEN 2

SHELVING WORKTOP

DOUBLE SLIDING DOOR

6ft-WIDE SCOOP

KITCHEN

WINDOW LIGHT ON BOOM STAND

REFRIGERATOR/FREEZER

PORTABLE COOKER

SINK

PROPS/EQUIPMENT STORAGE

CLOSE-UP *Closing in on graphic details of shape and texture can be an effective way of photographing certain foods. This kiwi fruit was sliced thinly and arranged carefully on a sheet of glass. This was then backlit by a diffused light source, and the surfaces of the fruit kept moist by brushing them with glycerine.*

PICKLED ONION AND CHEESE

The purpose of this shot was to illustrate home-made pickling. The jar, therefore, was a critical item in the picture and the cheese merely a complementary addition. Side-lighting gave both good definition to the jar and showed off the texture of the cheese well. To bring the pickling vinegar to life, a piece of stiff foil was cut to shape and carefully angled behind the jar to throw reflected light through the liquid. For maximum contrast, a black background was used.

Nikon, 55mm, Kodachrome, flash sync, f32.

smoke from a cigarette as a substitute for steam; painting sausages and other foods with glycerine to give them an attractive sheen and to prevent them drying out; soaking fruit in lemon juice to stop it going brown; substituting shaving foam for whipped cream; spraying salads and green vegetables with droplets of water (or water and glycerine) from a garden plant spray to make them look fresh.

LIGHTING FOR MOOD AND TEXTURE

Careful lighting is especially important because the taste and smell can be suggested by the skilful handling of texture, colour and atmosphere by the photographer. This is why light is often shone at a low angle across the surface of the food, to reveal the detailed texture. A light positioned to face slightly towards the camera, overhead and a little beyond the picture area will make the most of and pick out different surface textures. Although at the expense of colour saturation some foreground shadow fill is often necessary. A third method, which removes some detail and increases the sensual, atmospheric impression, is to use quite hard directional lamps at a raking angle, and achieve diffusion by using filters over the lens rather than translucent materials over the light housings.

SIMPLE TABLE SETTING *The simplest of all food shots is a single dish in a plain table setting (above). When both food and tableware are strongly designed, as with many traditional Japanese dishes, such a treatment is ideal. To make the most of the textures in this photograph, an area light was placed over and beyond the picture area, aimed slightly towards the camera to provide a visible reflection.*

In commercial food photography, lighting tends to be rather conservative – largely because people have very fixed expectations of what food should look like; a photographer can only make food appetizing by conforming to these expectations. Gentle, diffuse lighting, more or less overhead, is probably the most traditional and natural-looking, and it features strongly in food photography.

DRINKS

Drinks photography can be as difficult to light as any reflective subject and calls for similar solutions. Dark and opaque liquids (such as some red wines and milk) need to be treated only for reflections in the glass and surface. But some form of back-lighting is commonly used for light-toned translucent drinks, such as whisky or lemonade.

Back-lighting is simple to arrange and will intensify the colours if you expose accurately. But it may distract from other elements in the subject. If drinks are combined with other food, a local back-light can be arranged by concealing a shaped bright reflector, such as a small mirror or crumpled tin foil, behind the glass.

Movement, by stirring, pouring, or introducing bubbles, gives not only a sense of action to the shot, but also helps to give form to the liquid and even conveys some impression of its viscosity. For this, flash is essential, and you usually have to take a number of shots to guarantee one attractive arrangement.

In a deep container, such as a full-bodied glass, it may be necessary to dilute the liquid slightly to ensure an intensity of colour that *looks* authentic. Common substitutes used in photographing drinks are acrylic ice-cubes (which are well-shaped and do not melt while the drink is being arranged) and glass bubbles for both eye-level views of clear liquids and downward shots of opaque liquids (such as bowls of soup).

GRAPHIC ARRANGEMENTS *Where the form of the food, or natural style of presentation is appropriate, another style of photography is to adopt a formal design. This could be symmetrical and geometric, as in the photograph of Korean food (above).*

SUBSTITUTE PROPS

Two of the more common substitutes in drinks photography are for ice and for bubbles. Real ice melts and changes it shape in much less than the time needed to arrange it for shooting. Moreover, in active shots that involve pouring or stirring, real ice means the glass and set must usually be cleaned for each shot. Acrylic ice cubes solve these problems, although unlike real ice they do not float (right). Small, hand-blown glass 'bubbles' (below) last indefinitely and can be positioned carefully.

COOKING IN THE STUDIO

An on-site cooker is valuable, not so much to replace kitchen facilities as to ease the problems of photographing food as it is being cooked. A simple trolley can be made by bolting together angle struts into a frame. A calor gas ring can be located on top, with a lower level for the gas container. Finally, a suitable background surface (non-flammable) can be cut to fit over and around the ring.

LANDSCAPE

LANDSCAPE PHOTOGRAPHY is at the same time one of the easiest and most difficult subjects to approach. It is easy because landscapes are so familiar and accessible – they are all around us, and by now most of the obvious scenic views are catalogued tourist attractions with established viewpoints. In addition, landscapes are permanent; they don't move, and so all that is necessary is to get there with a camera. Finally, for the simplest shot, there are no extreme technical difficulties.

Despite this, there is an outstanding difference between the ordinary 'postcard' views and the finest creative landscape photographs. Many casually conceived photographs of interesting views that stimulated the photographer turn out to be disappointing, failing to capture the essence of the scene. This is precisely because landscapes are such familiar, accessible subjects. Many photographers do not put a great deal of effort into a shot, yet to lift a landscape photograph out of the ordinary requires considerable perception and technique.

The first major problem is that most people react to a scene in an intuitive way – without being able to pinpoint exactly what elements appeal to them, they form an overall impression of which the visual element may be only a part. The wind, the sounds, the smells, the relationship of distant mountains to nearby rocks – all these things are the

LAKE DAL, KASHMIR *This shot (above) was taken in the early morning. Exposures need bracketing to avoid under-exposing, rendering mist a neutral grey.*

ST MARY LAKE, MONTANA *In late summer, the weather in Glacier National Park was just beginning to turn (left). The photographer chose to focus attention on the sky and used a neutral graduated filter to darken the upper half of the picture and exaggerate the threatening clouds. Nikon, 24mm, Ektachrome, 1/125 sec, f9 plus graduated filter.*

landscape, but the task of the photographer is to isolate the important ones and somehow convey them in a purely visual way. A casual snapshot usually fails in this. Apart from any other faults, it may include too much in its frame, cluttering up the scene, or it may exclude elements that forethought would have indicated were crucial.

The first step is to decide precisely what it is about a particular landscape that characterizes it, defining the nature of the subjective impression – what Ansel Adams, probably the finest of landscape photographers, called 'the personal statement'. Here there are no rules. It may be the inherently spectacular nature of the view – the Grand Canyon, for instance – or it may be simply the play of light and shade. It could be the lushness of fields and copses in summer, or the transience of a spring shower over the desert. What is important is to maintain a logical approach. In most cases the scene is not going to change in a few minutes, so it is worth taking time to think about it; Adams emphasized the importance of what he called 'visualization' – anticipating the shot even before setting up his camera.

APPROACHES

There are many ways of composing a landscape photograph, and to attempt to categorize all of them would be to trivialize the subject. There are, however, some common approaches which are useful to consider. At opposite extremes, a landscape photograph can be

WHITE RIMS OF GREEN RIVER CANYON, UTAH This naturalistic treatment of an evening landscape (below top) was taken with a medium long-focus lens. Choosing the right time of day was essential as the river, scarcely visible during the afternoon haze, clearly reflected the sky after sunset.
Nikon, 180mm, Kodachrome, 1/30 sec, f2·8 plus Polarizing filter.

TRIANGLE A clever visual pun, John Pfahl's photograph (bottom) is a landscape joke which refreshingly jars with all the traditional concepts of the field of photography. Although not in any way similar to other original work, Pfahl's 'altered' landscapes have in common with a number of other modern photographers a challenge to accepted notions of fit subject matter. Most landscape photography has always been a fairly serious, considered activity – and probably always will be – but iconoclasm like this, however short-lived, is a valuable antidote to pretension.

MIST AND FOG These are made up of suspended droplets that are larger than haze particles, and so cannot really be filtered out. But with a careful choice of viewpoint, mist can make atmospheric photographs. Early morning is the most common time of day for these conditions, particularly close to water or over marshy ground. This picture of water-meadows in the east of England (above) was taken just after sunrise.

THROUGH THE DAY

Through the day, sunlight continually changes the way a scene looks. The sea-arch off the Spanish coast demonstrates the sheer variety of natural light in clear weather in any one place at different times of day. Notice how the texture and colour of both the rock and the sea change quite dramatically from one hour to the next.

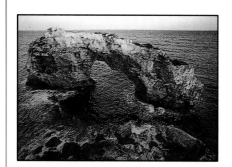
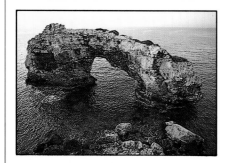
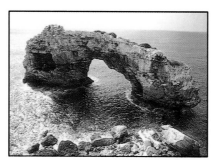

NATURAL LIGHT CONDITIONS

CONDITION	GENERAL FEATURES	EFFECT ON CONTRAST	EFFECT ON SHADOWS	FAVOURED SUBJECTS
High sun	Difficult to add character to a shot	Low with flat subjects, high with subjects that have pronounced relief	Tall and angular subjects cast deep shadows underneath	Subjects that are graphically strong in shape, tone, pattern or colour, eg some modern architecture
Low sun	Great variety, depending on direction and weather; may be unpredictable; warm colours	High towards sun, medium-low facing away	Strongest with sun to one side; least with sun behind camera	Most subjects suitable, particularly scenics
Twilight	Low light level only distinguishable when sky is clear	High towards light; low facing away	Shadows usually weak	Reflective subjects, eg automobiles
Haze	Enhances aerial perspective, weakening distant colours & tones; bluish over a distance	Slightly weakens contrast	Slightly weakens shadows	Some landscapes, some portraits
Thin cloud	A mild diffuser for sunlight	Slightly weakens contrast	Slightly weakens shadows	Some portraits, some architecture
Scattered clouds	Dappled lighting over landscape, causing changing local exposure conditions	Slightly weakens contrast	Fills shadows slightly	Many landscapes
Storm	Unpredictable	Variable	Variable	Landscapes
Snowfall	Low light level; dappled, foggy appearance	Weakens contrast considerably	Weakens shadows considerably	Landscapes, natural & urban
Moonlight	Very weak light, but quality similar to sunlight	As sunlight	As sunlight	Many subjects that would look too familiar in daylight

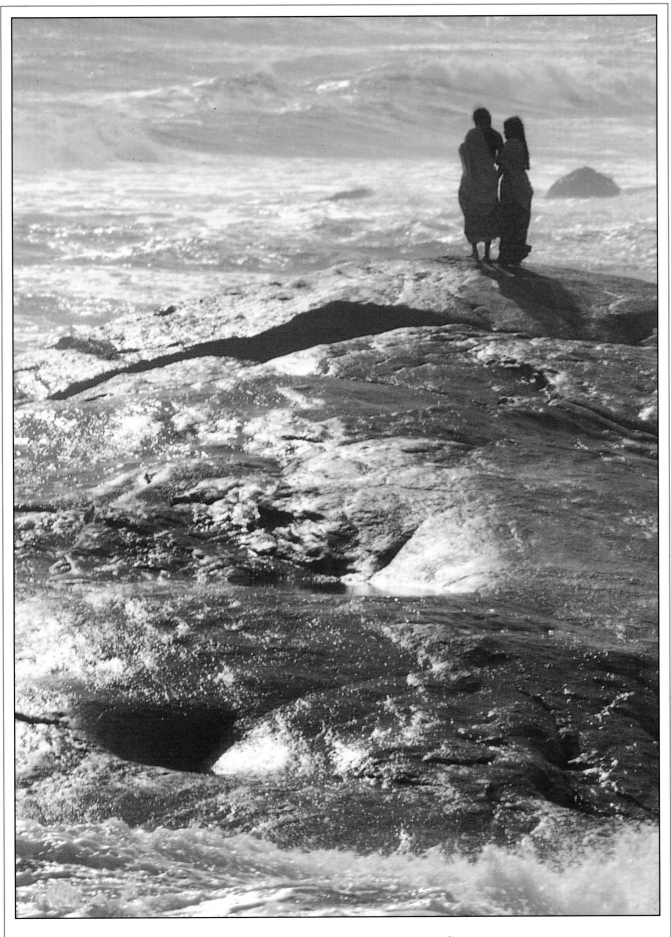

CAPE COMORIN, INDIA *Two women stand on a promontory overlooking the sea at Cape Comorin. Backlighting and a heavy sea wetting the rocks gives a consistency of tone and* *texture to the setting that, in effect, isolates the figures as a single point in the design. This point is off-centred for logical reasons: the women are looking in one direction, and their* *position in the frame places them in relationship to the sea rather than to the land. Placing them to the right gives visual weight to the sea at left.*

SUNSET OR SUNRISE?

There is no objective visual distinction between sunrise and sunset, and to a viewer unfamiliar with the geography, any of these photographs could have been taken at either time.

representational or abstract. A representational photograph attempts a faithful evocation of the subject that conveys a great deal of information. An abstract approach selects strong graphic elements from the landscape, and tends to be more subjective. In the past, photography, and particularly landscape photography, has drawn heavily from the traditions of painting, and has not explored the potential offered by the new medium.

On a more practical level, there are some useful compositional techniques. The relationship of nearby objects to a distant scene, such as ripples in a sand-dune to a desert horizon, is often extremely interesting. It involves the viewer, and can bring a completeness to the landscape. By using a wide-angle lens and a low viewpoint, this can be conveyed in a wide-field view (it is a pity that the tilting fronts and backs of view cameras, which are the classic way of achieving great depth of field on a plane, have no equivalent in 35mm cameras, but the depth of field of most 35mm wide-angle lenses is considerable). Parallax problems make composition with wide-angle lenses on direct viewfinder cameras more difficult than on a single lens reflex.

A telephoto lens can be used to isolate given elements, and will compress perspective, making distant features more dominant in relation to nearer objects. It can give a more remote, detached feeling, and is often excellent for selecting items to give abstract patterns.

DELICATE ARCH, EASTERN UTAH *This late afternoon view is a celebration of the great beauty still to be found in wild places. There has always been a conflict of opinion among those concerned with protecting the environment as to whether the cause is better served by showing the beauty that remains or the ravages that have been wrought – to inspire or warn.*

TROPICAL LIGHT *Tropical light is notable for its extremes: from high, brilliant sunshine in the middle of the day (top) to the brief but frequently spectacular twilight (above). Because the sun rises and sinks so quickly during a 12-hour day, the useful shooting times in early morning and the evening are very short, and high sun occupies most of the day.*

WHITE SANDS, NEW MEXICO *In the early morning sunlight the dune crests (right) appeared naturally graphic. A wide-angle lens and vertical format made it possible to include the close foreground as well as the horizon; the effect is an unusual sense of scale, with the distant mountains no larger than the ripples in the sand.*
Nikon, 20mm, Kodachrome, 1/60 sec, f16.

DAWN AT MONUMENT VALLEY, USA *With an interesting dawn sky over one of the world's most famous natural skylines, it was an easy choice to place the horizon line at the bottom of the frame. The strong shapes of the mesas and buttes constantly draw the eye back down to the bottom of the picture.*
Nikon, 35mm, Kodachrome, ¼ sec, f4.

239

EVENING STORM, WEST SCOTLAND *This unpredictable combination of sky and horizon developed in minutes and disappeared as quickly. The focus of interest is the weather itself rather than the skyline.* Nikon, 400mm, Kodachrome, 1/125 sec, f5·6.

In landscape, as in other forms of photography, a simple rule can be applied in most instances – 'less is more'. That is, a detail can sometimes convey more than an overall view. It is, however, easy to overdo this approach, and it often works best when detail photographs are set alongside more open shots.

The relationship between the land and the sky is an important factor – the horizon is probably the strongest line dividing up the picture frame – and in interesting weather conditions it is worth experimenting with different proportions of sky to land. With dynamic clouds dominating the composition, over just a thin strip of land, an entirely different feeling is created, often more majestic. These sky-land variations can also be applied to water and land, and to water and sky.

EQUIPMENT AND MATERIALS

Partly because the appeal of representational landscape photography involves a large and detailed informational content, and partly because the photographer can normally take his time in shooting, classical landscape photography has frequently been on large format cameras with fine-grain film. In comparison, 35mm cameras can be at a slight disadvantage, but with good lenses, careful technique, and the use of fine-grain films with fine-grain developers, good results can be achieved. And, as the rules are not fixed, the very coarseness of the grain in a fast film can be used for its graphic effect. In adverse weather conditions the speed and facility of the 35mm camera make it ideally suited, and results can be realized that would be impossible with a view camera.

Whether colour or black-and-white film is used is largely a personal decision, although certain conditions favour one or the other. Simply because of the importance of colour in some scenes, black-and-white film could be inadequate. This should not be confused with the *quantity* of colour in a landscape, which can swamp the view, and can be treated effectively in black-and-white. In any case, black-and-white film focuses attention on tone, shape, and shadow, and where these are dominant, it may be the better choice.

Because careful composition is central to landscape work, a tripod is useful. It is essential with a telephoto lens, or in a wide-field approach where obtaining maximum depth of field requires a slow shutter speed. More often than not, sharpness is desirable across the whole field, especially in a representational photograph.

35mm SLR EQUIPMENT CHECKLIST

This ideal list would serve for almost any conceivable shot under normal conditions.
1 Camera body: an SLR, perhaps with a spare body.
2 Spare ground glass screen marked with grid lines, for levelling horizons.
3 Lenses: in terms of priority, a wide-angle lens would probably be the first choice, perhaps a 24mm or 28mm, for wide-field views. For a telephoto approach, a 200mm would be a useful all-rounder, with a 400mm, 600mm or longer for really compressed perspectives and distant details.
A normal or macro lens for detail work.
4 Tripod or monopod and cable release: the most useful tripod is one that permits the legs to be spread for a very low position.
5 Neck strap.
6 Lens hoods.
7 Lens caps.
8 Lens cleaning tissues and blower brush.
9 Filters: B/W – yellow, deep yellow, red, green, blue. Colour – UV, polarizing, graduated neutral, colour correction filters for warming/cooling and for reciprocity failure.
10 Film: B/W – fine-grain for detailed work, fast film for grainy effect and for poor lighting conditions. Colour – ditto.
11 Camera case: preferably airtight and reflective.
12 Spare batteries.

Special options for adverse conditions:
A Bad weather:
1 Plastic bags, film wrap and rubber bands, for enclosing cameras.
2 Lint-free handkerchiefs for wiping equipment.
B Mountains:
1 Small camera system, eg Olympus Nikon FM.
2 Gloves, inner and outer (also for snow).
3 Well-padded case suitable for back-packing, or individual padded bags to go in a mountaineering stuff-sack.
4 Motor-winder for use with gloves on.
5 Selenium-cell lightmeter (less affected by cold than cadmium-sulphide cells).
C Deserts:
1 Plastic bags, film wrap and rubber bands, for enclosing camera.
2 Airtight reflective case, or reflective material for covering.
D Rainforest
1 Fast film.
2 Silica gel.
3 Airtight case.

COMPOSITION AND POSE

Composition is one very obvious technique for controlling the portrait, and does not need the close involvement of the subject. Clearly there is more scope for strong composition when the scale of the picture is different from the more usual full-face or head-and-shoulders portrait. Close-ups can be striking, so that the subject's face fills the frame, although the intimacy of this approach and the 'warts-and-all' detail will not necessarily suit every sitting. Pulling back from the subject gives more choice of composition. One of the greatest exponents of the strongly composed portrait is Arnold Newman, whose striking and graphic compositions lead the viewer's eye forcibly around the picture. One of Newman's most favoured techniques has been to use props relevant to the subject as the key element in the composition.

PORTRAIT OF MONDRIAN *Photographer Arnold Newman deliberately chose to compose his 1942 picture of the painter Mondrian, in the painter's own unmistakable style.*

PORTRAITS

GENERALLY, STUDIO PORTRAITS differ from environmental portraits in that they tend to be more deliberate, more formalized and more controlled. The subject is being brought to a location of the photographer's choosing, and most of the photographic elements, in particular the lighting, can be perfected.

For the beginner, the initial confrontation with the subject can sometimes be a little unnerving; the person who is sitting for you is waiting to be directed and is, in effect, expecting you, the photographer, to make all the decisions. To become accustomed to this kind of situation, it is usually a good idea to start by photographing people you know quite well.

As with environmental portraits, you should make some rudimentary decisions about what you want the photograph to show, in other words, what aspect of the subject's personality or appearance you want to depict. You can then approach the session more decisively. The success of the outcome can depend on a mix of elements, including the relationship between you and your subject, the composition, the subject's pose and the lighting. Technical matters such as choice of lens and film also have an obvious effect, but these are normally straightforward enough to be less of a consideration than the chemistry of the session itself.

In choosing the theme of the portrait, look for anything notable in the subject's outward appearance, a craggy face, lithe figure, or a high cheekbone structure, for example. Generally speaking, if he or she has strong features, you will have less difficulty in making a strong portrait. Many people, however, have less obvious characteristics and you may have to resort to some devices in order to bring life and interest to a bland face.

Perhaps more than anything else, the level of rapport between photographer and subject – or lack of it – determines the general content of a portrait. This is especially true of people who have no experience of sitting for a photographer (actors or public figures have usually learnt the skill of striking attitudes at will, which can sometimes be at odds with the photographer's intentions). Some portrait photographers exert a very definite influence over their subject in order to create what they want; and the fact that they are on home ground, the studio, makes this easier. Richard Avedon's portraits are often unsettling in the depths that are revealed with apparent simplicity. They are rarely reassuring or comfortable, and he has stressed the importance of the studio as a means of isolating the people he has photographed. Another device is to put subjects at their ease by making light conversation, or by encouraging them to talk about themselves.

PORTRAITS BY ARNOLD NEWMAN *The portrait photography of Arnold Newman has a strong unmistakable style, owing as much to his studied approach to the personality of the sitter as to his often striking composition. A particularly well-known technique of Newman's is to integrate his subjects with settings relevant to their work or activity. British sculptor, Anthory Caro (bottom), becomes a controlled element of his own work in the kind of geometric composition for which Newman has become recognized. By contrast, the high-key grainy portrait of Marilyn Monroe (below) contains no outside elements, focusing exclusively on a precisely captured expression of vulnerable beauty.*
Photos: © Arnold Newman.

PHOTOGRAPHING THE AKHA *The direct and distinctly formal photograph is the only type of portrait composition acceptable to the members of this Southeast Asian hill tribe. Reminiscent of Victorian portraiture, it shows the entire figure in a dignified pose. The tribeswoman is holding a Polaroid picture of herself, given to her by the photographer. Such gestures are important strategies for winning confidence and good will*

EXPRESSION IN A CROWD *This view of a crowd at a Scottish football match focuses on the mixture of expressions as a penalty is missed. Tight cropping, by using a telephoto lens makes a stronger, more enigmatic picture.*

The mountain photographer does not have to be a mountaineer, but without rock- and ice-climbing skills, many shots will inevitably be missed. UV scattering at high altitudes is considerable, and a strong UV filter is essential. A telephoto will clearly suffer more than a wide-angle lens. The bonus of high altitudes is clear air and fine visibility (but not all the time!), and a viewpoint that often permits shots down onto clouds. The physical difficulties of mountaineering preclude heavy equipment, and professional mountaineer/photographers such as Chris Bonington carefully select their cameras for weight. At high altitudes, just moving can be a great effort. The low temperatures can affect the mechanical operation of the camera, and it may be worth having the lubricants, which become more viscous at low temperatures, removed before a long trip. Also a motorized camera will allow gloved operation and prevent frostbite!

Snow, even at low altitudes, is a special photographic problem. Realistic rendering is quite difficult, and both over- and underexposure are common errors, particularly when using a through-the-lens meter. Remember that a centre-weighted averaging TTL meter delivers a reading equivalent to an average (18 per cent) grey. Snow crystals are also good reflectors of UV light, and snow in shadow under a blue sky will be recorded a distinct blue on colour film. Low-angled sunlight is best at bringing out texture in snow, and backlighting can give a sparkle to the crystals.

SAN ANDREAS MOUNTAINS AND WHITE SANDS, NEW MEXICO *A long-focus lens compressed the planes of dunes and mountains to make an abstract image. By waiting until dusk it was possible to combine the sunset colours with the cool reflections of the sky in the white sand.*
Nikon, 180mm, Kodachrome, ¼ sec, f16.

VARIETY FROM ONE VIEWPOINT

Panoramic viewpoints, which in scenic areas are often well-known, usually offer more than one broad sweeping picture. There may only be one, or possibly two, wide-angle shots, but longer focal lengths can be used to probe for alternative views. From Zabriskie Point, overlooking a part of Death Valley, one camera position yields a number of different photographs, using lenses ranging from 20mm to 40mm. Note that the changing angle of the sun, from dawn to about one hour after sunrise, affects the composition of the different pictures.

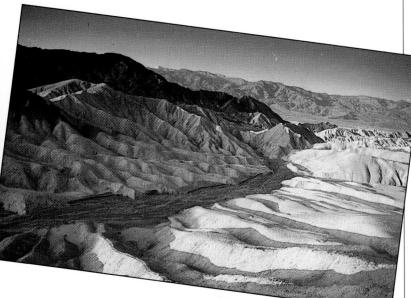

© Michael Freeman

United States

6 151

ADVERSE CONDITIONS

Landscapes do not always present themselves under perfect photographic conditions. Bad weather may be immensely frustrating to a photographer who can well imagine how things would appear at a better time, but adverse conditions can provide a challenge and an opportunity for unusual and original photographs (after all, driving hail or a dust storm are precisely the conditions when most photographers pack up and leave). Also, from a purist's point of view, such conditions are an essential element in the landscape's profile.

Bad weather, rain, hail, snow and dust, show the landscape in its more violent moods, but for the photographer who is looking for an original treatment of a well-known scene, they offer many possibilities. The image can change constantly and rapidly under these conditions, and fast reactions are needed. Here, therefore, the 35mm camera comes into its own, and through-the-lens metering is particularly useful. The one essential precaution is to protect your equipment.

Earth's extreme environments such as mountains, deserts and rainforests, are the least accessible, yet they offer the most dramatic landscapes. In particular, the absence of people gives more scope to the photographer. To anyone seriously interested in landscape work, a visit to one of these regions is essential, and can give a concentrated opportunity to develop ideas. Each has its special photographic problems, and all of them, as harsh environments, need to be approached with commonsense and caution.

LARGE-FORMAT LANDSCAPES

View cameras have a special place in landscape photography, following in particular the tradition of American photographers such as Ansel Adams and the Westons. The two most obvious advantages of a large-format camera are the wealth of detail recorded on the film, and the possibility of using camera movements to adjust the distribution of sharpness in the picture. This scene in the Canyonlands of Eastern Utah was photographed with a 4 × 5in studio view camera, and the picture demonstrates both virtues. Not only is the quality superb, but the lens is tilted forward to ensure that everything from the foreground to the horizon is pin-sharp.

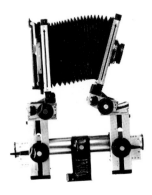

LONG TELEPHOTO TECHNIQUES

The apparently compressed perspective given by very long focal lengths makes them especially useful in landscape work. Steadiness on location is, however, a problem, compounded by wind vibration and by the need for smaller apertures to give better depth of field (and so slower shutter speeds). A second tripod is often needed to support the front of the lens. Since lenses are not fitted with tripod bushes at the front, the simplest method of attachment is a strong elasticated band. Lock up the mirror on an SLR to reduce vibration still further.

Filters have an important role in landscape photography, and in black-and-white allow a large measure of control over different elements. The most frequent need is to darken a blue sky, very often to emphasize cloud patterns. Red gives the darkest rendition, but it does carry the double disadvantage of a high filter factor and a strong effect on green vegetation; orange gives a close approximation to actual tones without serious side-effects. The relationship between colours in a landscape, such as grass and red rocks, can also be manipulated with appropriate filters. A polarizing filter can reduce reflections, and with colour film is the only way of darkening a blue sky (apart from graduated filters, which can only be used with a straight horizon line). UV filters reduce haze in distant and mountain views.

TIMING

The beauty of landscape work is in its variety – even one viewpoint can provide infinite possibilities, depending on the weather, time of day, and season. Usually, the photographer has a limited choice in this respect; few people can afford the time to make several visits to a location in order to capture the right conditions. Nevertheless, within the constraints, the photographer should anticipate the appearance of a scene at different times, and try to work to the preferred one. As a general rule, sunrise and sunset are good times. Then, a wide variety of lighting conditions are obtained in just one or two hours, giving warm colours and low-angled lighting that shows up textures. The flat lighting of the midday sun, particularly in the tropics, is often hard to cope with adequately, and is usually more satisfactory with inherently strong shapes, tones and colours. Dull, overcast skies are an even more severe problem, for although the diffuse lighting gives accurate colour rendition to everything, the quality of light is formless, and the contrast between sky and land is too high to record both at a proper exposure. A graduated filter or print shading in the darkroom may compensate for this extreme contrast, or use of a polarizing filter will darken the sky considerably provided that the sun is in the right position relative to your viewpoint.

The pose can be studied or unconscious but, whichever it is, you should keep it under your control. Left to themselves, most people fall into a specific attitude; if you allow this to happen, make sure that it is suitable for what you want. Where you place the subject at the start will influence their natural pose – sit someone on a high stool and their shoulders will naturally slump forward and they will tend to feel uncomfortable; stand them against a wall and they will probably lean against it; put them in an armchair and they will normally spread out and relax; tables and desks encourage hands and elbows to rest on them. If you intend to control the pose yourself, it is better to encourage attitudes silently by providing these kinds of props rather than to ask subjects to arrange themselves in precise positions. A self-conscious pose usually communicates itself through the photograph.

LIEUTENANT GENERAL SHOJO SAKURAI *The strength of this portrait of the Japanese general who fought the British in Burma in the Second World War is in the timing of the shot. The interest clearly lies in the man's past, and the photographer, Snowdon, managed to capture a deeply-felt moment of reminiscence. 'The war was wrong,' said Sakurai, 'because we couldn't have won it. We should have stopped with Manchuria.'* Photo: Snowdon.

247

FRONT PROJECTION

Using axial lighting and a special highly reflective screen, front projection equipment is basically a sophisticated version of ordinary slide projection. But it allows a bright image of any slide to be projected onto the background screen, without any visible effect on people or objects in front. It works in the following manner. A flash-powered slide projector is positioned exactly at right angles to the axis of the camera and lens. A half-silvered mirror in front of the lens diverts the projected image along the lens axis towards the screen. The screen itself contains many very small transparent beads which reflect the light back in one direction only – towards the lens. From even a few inches to one side of the camera, the projected image is invisible, and the skin

and clothes of the subject reflect nothing.

The screen material is 3M Scotchlite, and this can be bought separately to make larger screens. If different sheets are attached together, they should overlap away from the centre, so that no shadow lines show.

LIGHTING

Because it is easy to demonstrate, lighting is often treated as the main element in portraiture. However, it is possible to become too caught up in the minutiae of light positions – lighting should be subservient to your overall treatment of the subject.

If you use several lights, only one should be dominant. Secondary lights or reflectors can then be used either to control shadows and contrast, or to accent particular parts of the subject, such as the hair. The examples on these pages use a variety of techniques demonstrating that there is no ideal method, merely alternatives.

Studio light sources can be natural daylight, studio flash or tungsten lamps. Daylight, particularly if diffused by a large north-facing window, has attractive qualities, being soft enough to keep facial shadows gentle, yet being directional at the same time. It is, however, difficult to control and with colour film you should monitor the colour temperature carefully. Artificial lighting is generally easier to deal with, and more consistent. Even though the precise effects of the light cannot be judged before exposure, studio flash units are preferable to tungsten, which can heat up the studio uncomfortably and which normally require fairly slow shutter speeds. Umbrella reflectors are particularly useful as all-round light sources; silver-coated ones give the highest light output, but are rather harsh, while translucent umbrellas can be used either to bounce light, or, by pointing them towards the subject, as diffusers. The larger the umbrella and the farther it is from the flash tube, the more diffused the light and the lower its intensity.

The human face has a relatively complex set of planes, projections and recesses, which in hard lighting can obscure expression. The interest of most portraits lies more in the personality conveyed than in the graphic design of the photograph. As a result, diffuse lighting from a conventional position – above and fairly frontal – is standard for the majority of portrait photographs.

The technical problems in lighting a face include: recessed eyes, which can give a disturbingly expressionless look if strongly shadowed; cross-shadows cast by a prominent nose; over-bright highlights on the upward-tilted planes such as the forehead, cheekbones and bridge of the nose, particularly if the skin is shiny; and a tendency towards high contrast. For clear, uncomplicated lighting that gives more prominence to the expression than to the sculpting of the face, all of this suggests moderate diffusion – sufficient to take the edge and intensity off shadows. At the same time, totally shadowless lighting would give a flat, formless treatment, and the usual compromise is to rely on one principal light source.

To avoid blurred facial movements, flash is much more commonly used than tungsten, and the most convenient diffusing attachment, at least for head-and-shoulder shots, is an umbrella used from about two or three metres. Alternatives for a diffused main light are an area light, bounced lighting from a flat, or, in a daylight studio, a north-facing window.

WORKING WITH SINGLE-LIGHT

frontal lighting

back lighting

top lighting: *spot*

top lighting: *'window' diffuser*

top lighting: *umbrella*

¾ lighting: *spot*

¾ lighting *'window diffuser'*

side lighting: *spot*

side lighting: *'window' diffuser*

side lighting: *umbrella*

To illustrate some basic possibilities of lighting the full-face head shot, the model head was photographed with a single light in five different positions and with varying degrees of diffusion.

Refinements to this basic, conservative lighting include shadow fill and effects lights. The function of shadow fill is to lower the contrast range, and so depends first on whether the photographer wants to show all the facial details (the aim may be a graphically strong image with dramatic lighting), and then on the degree of diffusion in the main lighting and on its position. The softer it is, and the more frontal, the less need there is for shadow fill. Side-lighting, however, will give quite high contrast between the two sides of the face, hence one name for it – 'hatchet lighting'. Reflectors include white card, crumpled foil, smooth shiny foil, mirrors, and secondary lights, in increasing order of efficiency. For the most natural effect, shadow fill should be approximately one quarter of the level of the main illumination. Secondary shadows from a strong shadow fill are usually distracting.

The two most common effects lights added to this basic set-up are back spots and catch-lights. Back spots give an intense beam, and are usually located directly behind the subject or else behind and just out of frame; their effect is to light the edges of the hair (or the face in profile). With fair hair, the effect is that of a glowing halo.

Catch-lights are small spots, or even a mirror used as a reflector, that give small bright reflections in the eyes. These can help to enliven the expression and compensate for any tendency for the eyes to fall back into shadow.

Pulling back for large-scale portraits – full figure and groups of people – usually calls for more lights and more diffusion. For an even illumination, a standing figure needs a strong element of side-lighting, and the most common lighting techniques are two or more umbrellas mounted vertically, a tall trace frame, a white-painted cupboard used to bounce the light from two or three lamps, or a very large area light. Under most circumstances, the size of the light should be approximately that of the figure – about 7 × 3ft (2 ×1m). Shadow fill is generally necessary, unless the studio is small and painted white.

GROUP PORTRAITS

Group shots need a special approach: one composed principally of good organization and stage direction. It is important to give your group some visual rationale or identity – people form groups for a specific purpose, whether they live or work in the same building, perform the same job or share the same interest, and you should usually try to include a visual reference to the thing or things that bring them together. Seeing every face is the principal mechanical problem; if you arrange the people into a tight group, you will either have to shoot from a high viewpoint in order to record, or have some kneeling, sitting or standing. After arranging the group, take several frames – on many of them you will find at least one face turned away, blinking, yawning or scowling.

SHADOWS *To emphasize the girl's hair as much as possible, a single top light was used, fitted with a 'window' diffuser to give definite but softened shadow edges. The shadows below were filled-in very slightly with a white card placed on the floor. Finally, to make the hair glow, a soft-focus lens was used.*
Nikon, 105mm, FP4.

PRISONERS *Ask yourself if this picture (below) would have worked so well if all the 'prisoners' had been looking straight at the camera?*

TABLEAU In Michael Joseph's carefully staged tableau a special virtue is made of the great effort and planning needed. The period banquet scene, an advertisement for port, invites the viewer not only to examine the minutiae of expression and action, but also to admire the photographer's organizational ability.

CANDID PORTRAITS

You may not always want to become involved with the people you photograph, and some involvement is necessary for any portrait. Although a posed shot may create strong eye-to-eye contact, it lacks the spontaneity and interest of a secretly observed action. In a way, candid photography is similar to wildlife photography – the photographer tries to capture the natural behaviour and expressions of his subjects as unobtrusively as possible.

At times there is a certain element of risk, as people vary in their reactions to discovering that they are being photographed. In some Middle Eastern cities the photographer is likely to have things thrown at him, whereas in parts of India the only risk attached to being discovered with a camera is to be surrounded by an instant crowd, each member of which wants to be in the picture. In countries where political tensions run high, candid street photography can be very dangerous. To start practising candid photography, you might choose, for instance, a museum or market where people's attentions are occupied with other things.

If you are noticeable, because you are carrying a large gleaming metal camera case or because you are dressed outlandishly, you will disrupt all the natural activity that you set out to photograph. Keep your camera out of sight – an old carry-all, or even a shopping bag will be better than a customized camera case.

Avoid pointing the camera in anticipation – sooner or later your subject will see you. Instead, wait for the moment that you think is right and then raise the camera.

AWARENESS OF CAMERA *Portraits may still be classed as 'candid' even if the subject is aware of the camera. Closely cropped portraits of black people are likely to be overexposed if you rely on a TTL light reading: compensate accordingly.*

OLD MAN IN CAFÉ, COLOMBIA *The subject was standing at the counter quite close to the photographer's table and he had already seen him. It would therefore have been impossible to take a natural-looking shot in the normal way. Instead, having taken a reading with a hand-held meter, the photographer set the camera on the table, removed the prism head and made a show of cleaning it. In this way, it was possible to take several shots without the old man being aware of it, by using the ground-glass screen.*

Your choice of equipment can help you stay out of sight. Henri Cartier-Bresson, for instance, was so adept at being unobtrusive that he had no trouble taking close shots with a normal lens, but most reportage photographers find that a medium telephoto lens can put a useful distance between them and their subject. For even more freedom in choosing your shots, practise hand-holding a long telephoto lens, such as a 400mm, at speeds down to $1/125$ sec.

One useful trick for taking pictures at close range is to remove the prism head, if possible, and then shoot by focusing directly on the ground-glass screen. By not holding the camera to your eye, you do not have to look at the person you are photographing.

Pre-set as much of your equipment as possible. Take a series of exposure readings for the locality you are in – the sunlit and shaded areas, interiors of doorways etc, – and keep the lens set at the reading you think you will be most likely to use. If an unexpected picture presents itself, take one shot immediately and then follow up rapidly with bracketed exposures. A motordrive is very useful for this purpose. If you have a little time, take a reading off another similarly lit area before pointing the camera at your subject. Some photographers carry an 18% grey card which will give an accurate reflected light reading, but in some circumstances you will be able to take a reading from your own hand. The most important thing is not to miss the shot through worrying about exposures.

BATHING GHAT, INDIA *Under certain circumstances, the broad coverage of a wide-angle lens can be exploited to include people in the foreground of a shot without their being aware.*

THE PAPARAZZI *Lauren Hutton, looking quite unlike her intentional public self when groomed for cosmetic advertisements, reacts to paparazzi photographer Alan Davidson with a frontal assault (below), while her friends have more success in preventing another photographer from taking pictures. The word paparazzi comes from a character invented by Fellini for his film La Dolce Vita – an annoying photographer, Paparazzo, whose name reminded Fellini of a similar Italian word for gnat, a buzzing, annoying intrusion.*

HUNGARIAN CHILD *Werner Bischof had a natural, unaffected manner with children. This portrait of a Hungarian child in 1947 is one of the most well-known of several memorable pictures, and demonstrates the Swiss photographer's knack of producing images that capture general sentiments.*

PEOPLE AT WORK

Some of the best opportunities for photographing people occur when they are thoroughly absorbed in some form of activity. At work, most people are too preoccupied with the job at hand to pose consciously for the camera or be distracted by it. They tend to be less self-conscious about their working lives than they might be during more private moments, so you may find it easier to capture natural expressions and gestures then. Also, people at work often show a close relationship with their surroundings and their society. A dock-worker in a Greek port, and a Bengali construction worker in Calcutta both reflect certain aspects of the places in which they live as well as revealing something about themselves as people.

You can either use the working environment as a convenient place for taking candid shots, or you can try and show something of the work itself. Many jobs are highly specific to a place or a particular kind of society, and can be interesting because they are unusual. Most of us are fascinated by what other people do, and few activities are clearer than work and the way in which people do it. It is rarely enigmatic but it can be revealing.

WORK-RELATED PORTRAITS

Two alternative portrait treatments, shown below, involve arranging for the subject to be busy with some relevant project, even if only for the sake of the camera. Simulating work in progress, as in the photograph of a university professor undertaking research in a library, is legitimate if the activity would normally appear that way. The more formal 'man-with-his-wares' approach, as in the photograph of a French chef, is more suited to activities that have tangible and interesting end products – in this case, *nouvelle cuisine* dishes.

PEOPLE AT WORK

Shots of people involved in their work can be virtually candid. For a clear view, working close with a wide-angle lens is probably the most common method, as in the photograph of the Indian fishermen (right) and a bell foundry (bottom). Where the location permits, however, a high camera position from a distance can be used with a telephoto lens, as in the shot of a council meeting in the City of London (below).

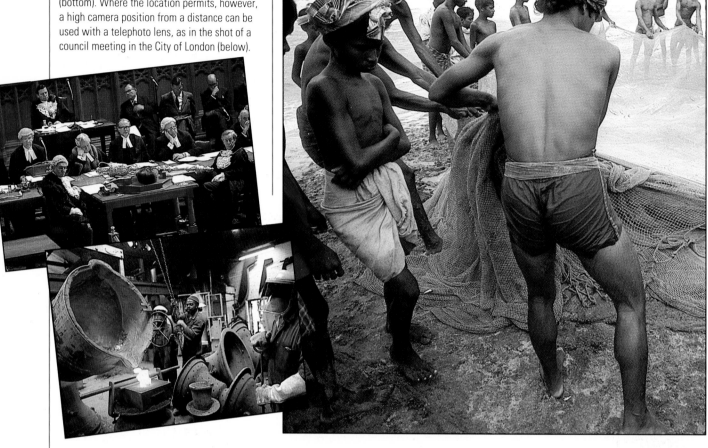

WORK SEQUENCE

Certain types of work, which involve a sequence of actions, may need several pictures rather than one. In the Parisian fashion house of Chanel, shown here, a medium dress-making shot, a close detail of stitching and a picture of the finished product are the smallest set of shots that can show the range of activity.

ABOVE *Even the most inactive work can be pre-occupying. Sitting by his roadside stall in the evening sunlight, this salesman was lost in thought. His stock of gaudy metal cases was clearly not attracting too many customers, but he seemed accustomed to the slow turnover.*
Nikon. 180mm, Kodachrome, 1/250 sec, f5·6.

PORTRAIT OF ALFRED KRUPP *Arnold Newman, whose reputation as a portrait photographer has been built very much on his method of showing his subjects in the context of their life or activities, made this menacing portrait of the German industrialist Alfred Krupp in 1963. Newman's deliberately unsympathetic treatment earned his subject's enmity.*

SHIP PAINTER, PIRAEUS *Suspended from the ship's rail, a painter was putting the finishing touches to this brilliant white Greek island ferry (left). In the bright morning sun, the man's shadow was cast so clearly on the hull that it conveyed every important detail of what he was doing. It therefore made a more interesting and less obvious picture to concentrate on the shadow rather than on the man himself.* Nikon, 400mm, Kodachrome, 1/250 sec, f9.

CONSTRUCTION WORKER, CALCUTTA *The workman (below) was carrying bags of cement, and although this in itself was not particularly interesting, his appearance contrasted sharply with the new construction – for Calcutta a rare sign of industrial progress. To compress the background a telephoto lens was used supporting it against a fence.* Nikon F2AS, 400mm lens, Kodachrome 1/125 sec, f5·6.

REPORTAGE

THE RICH AND DIVERSE field of reportage photography as it exists today owes more to the development of the 35mm camera than to any other single factor. Being essentially concerned with transient human events, it demanded the development of an unobtrusive, fast-operating camera that could react almost as quickly as a journalist's eye, in order to become the major field of photography that it is today. When the inventor of the Leica, Oskar Barnack, realized the potential of a camera that could utilize sprocketed 35mm motion picture film, he revolutionized hand-held photography. Photo-journalism has not looked back since then.

While few photographers are in any doubt about the broad scope of reportage photography – or photo-journalism as it is also known – it does not lend itself as readily to precise definition as do such self-explanatory fields as fashion, still-life or landscape. Perhaps the most important link between the different kinds of reportage picture is the underlying theme of journalism, an inquisitive and often interpretative interest in people's actions and activities, individually and in social groups.

This journalistic undercurrent need not necessarily be news journalism, reporting current events at great speed. In fact, the logistical problems of meeting urgent deadlines and using wire services often preclude in-depth picture coverage. Some of the strongest single photographs have been hard news pictures, but one of the most highly-developed photographic forms – the picture story – is principally a product of the less urgent format of feature journalism.

At the heart of reportage photography lies an interest in people; this in itself broadens the scope of the subject considerably. Individuals may be subjects because of some uncommon interest – they may be famous or unusual personalities – or for precisely the opposite reason because they may be typical of a quality that the photographer wants to convey. The range of actions and activities in which people become involved is so great that there is always opportunity for fresh pictures.

One important alternative to the portrait of the individual is the interaction between people and their society, their environment and other individuals. The involvement of one person with another is one of the most fascinating areas of interest for practically

SMITHFIELD MARKET, LONDON *A medium telephoto lens makes it possible to work comfortably some distance away for full-length shots of small groups of people. The photographer usually has sufficient time to wait and observe without being conspicuous as in this shot of Smithfield Market, London.*

TERROR OF WAR, BIAFRA *Most photographs with depth in the subject contain some areas that are out-of-focus, but this can be turned to good effect. In Terror of War, Biafra, (below) Romano Cagnoni has focused beyond the obvious first point of interest in the scene and the result, like the subject, is disturbing.*

everyone, and in the frozen instant of a still photograph, the shifting currents of these relationships are ideally captured. By means of composition and juxtaposition, the camera is also perfectly suited to showing the relationship between man and his environment, the extent to which he controls it as well as the way he is influenced by it. The image of, say, an individual dwarfed by a giant construction project, can show at the same time both man's ability to shape his environment at will, and the amount by which it can come to dominate his life.

COMPOSITION AND INTERPRETATION

The degree of interpretation and comment can vary widely from subject to subject. The photographer is not necessarily committed to making a social statement in every picture, although some of the best reportage pictures usually succeed in making the viewer aware of something more than the simplest visual components of the scene. Because photography has the potential to be a strongly graphic medium, the pictorial qualities alone may be sufficient reason for using the camera.

Photography does more than simply convert a journalist's interest into a picture; it is never merely the visual equivalent of the text. The camera's inherent qualities determine the treatment – one of the key elements in photo-journalism is a sense of moment, the aptly phrased 'decisive moment'. The still photograph inevitably freezes action, and the captured momentary image can either sum up the complete flow of events, or show an unusual instant that the eye might easily disregard.

This decisive moment is often the central feature of a single picture; indeed individual images were the chief concern of the earliest photo-journalists. However, the desire to treat a story in depth, of which *Life* magazine was such an outstanding pioneer, led to the development of the idea of a *series* of photographs presented together. The picture story, as it became known, was in every way a product of reportage photography and, although other photographic fields now use it, it is still most closely associated with journalism.

EXTENDED COVERAGE

By spending time with a group of people, a degree of intimacy can often be achieved. For this assignment – a week spent documenting the life of one family in Normandy – familiarity with the photographer allows the subjects to relax and continue their normal activities.

Art directors soon learnt that, with a picture story, the layout can be just as important as the photographs themselves. The way in which a number of pictures are arranged on a spread can determine the way in which they are seen. A skilful layout can even lead the reader's eye around the page. Even more important is the relationship between pictures. By juxtaposing photographs, their meaning can be reinforced or even substantially altered. Comparisons and contrasts can be drawn between a pair of pictures that go beyond the contents of two photographs viewed individually.

The power of juxtaposition is no less for being unintentional; Ed Thompson, for many years managing editor of *Life,* tells the story of how he lost the advertising account of a large national canned soup manufacturer in just this way. A regular editorial feature, which customarily ran opposite the soup manufacturer's advertisement, was a full-page single photograph of unusual interest. In one issue, the picture in question was a pair of Siamese twin babies being breastfed together, one from a woman's left breast, the other from her right breast. Unhappily, the canned soup advertisement that happened to be running opposite in that issue showed a child rushing into the house, with the headline, 'Hi, Mom! I'm home and hungry!' The advertiser was less than amused.

EVENTS

In reportage photography, one of the hardest things for most photographers to overcome is shyness. It is quite understandable and entirely normal to feel embarrassment at intruding on other people's lives. With time, of course, one inevitably becomes inured to it, at least to some extent. This is not necessarily a good thing; a completely thick skin breeds an insensitivity that is at odds with good reportage photography.

Nevertheless, some situations are more approachable than others, and an easy entry into reportage photography is to cover an event. This catch-all term includes all those

THE LORD MAYOR'S SHOW, LONDON

Know the right route in advance. Standing on a footbridge gave this nearly-vertical shot (above) of the coachman, using a medium telephoto lens for very tight framing.
Nikon 180mm, Kodachrome, ¹⁄₁₂₅ sec, f2·8.

Flanked by pikemen, the new Lord Mayor of London waves to the crowd during his inaugural parade through the City's streets (left). Only on this one day of the year does the coach make an appearance, and a picture like this is clearly a key photograph in covering the event. For this close view, walk alongside the parade using a wide-angle lens. Even without a press card or authorization, it is usually possible to get close to the action on relaxed occasions like this. Just behave as a press photographer would.
Nikon, 200mm, Ektachrome, ¹⁄₁₂₅ sec, f5·6.

situations where people get together to take part in ceremonies, celebrations and parades, whether it be St Patrick's Day in New York, the Bun Festival in Hong Kong, or the Lord Mayor's Show in London. On occasions like these, people are actually putting themselves on display, and the photographer has an open hand. They may not be typical of everyday life, but they nearly always provide good visual material and they are invaluable for building confidence.

By definition, events are not hard to find, usually being well-publicized. Planning ahead, however, is the key to success. There are two main preparations to make in advance – find out exactly what is going to happen and at what time, and find the best locations to be in. Events have organizers, who are normally only too willing to answer these kinds of questions. If you are able, an early visit to the site will give you an idea of what to expect. A view from a height – a balcony along the route of a procession, for instance – will give an overall shot, but is little use for interesting details and close-ups, and can limit the variety of pictures you are able to take. In front of the crowds, where press photographers are usually found, is often an ideal location and may not be too difficult to reach, with perseverance. Permission to be on the official side of barriers is more readily given than you might imagine, particularly if you ask a few days in advance. But, although it may be tempting to follow the local press photographers in order to find the best site, their aims may not coincide with yours – they are usually after little more than a superior spectator's

THE LORD MAYOR'S SHOW, LONDON

Off-stage, there are unguarded moments and small details that can make even more interesting pictures than the main show. An alderman's hurried cigarette (below left), or a stick of chewing gum for a Doggett's Cap and Badge oarsman (below) make interesting anachronisms. The proprietorial air of a member of the Honourable Artillery Company (bottom) as he surveys the beginnings of the parade perhaps reflects the fact that, beneath all the pomp and circumstance, the participants *do* collectively control a huge financial club. A miniature Tower of London and a finely-worked royal insignia on a bugler's coat (bottom left) are two details that could easily be missed during the actual parade.
All Nikon, 180mm, Kodachrome.

eye view of the climax of the event.

Some of the most rewarding picture possibilities are the ones that many photographers tend to ignore – behind-the-scenes preparations and the unselfconscious expressions of spectators. Off-duty participants can be a rich source of interest, whether you manage to take a candid shot or persuade them to pose for you. When the event is under way, you can take pictures of the spectators very easily and obtain a variety of unposed natural expressions – rapt, bored or excited. The pictures on this page were taken at the Lord Mayor's Show in the City of London which takes place on one day each year, at the beginning of winter. Although the weather is unreliable, the parade is concentrated and colourful, lasting half a day, and is full of the regalia and pomp of the City's long traditions. A normally rather secretive and restrained financial community, the City of London lets its hair down at this annual event.

The plans and route are well-publicized – the show is organized around a winding procession through the city streets, with the new Lord Mayor in his ornate gilded coach as the focal point. The only permission needed was to be present when the coach was made ready in the early morning, and this was readily given.

A mental list of the key shots desired, was made: the coach being hitched to its team of horses in the old brewery yard where it is kept; the participants in the parade at the assembly point, just before the start; the scene at the parade's first halt, the Guildhall, where the Lord Mayor and other dignitaries enter their coaches; the parade itself; a close wide-angle shot of the Lord Mayor in his coach waving to the crowds; various ceremonial details. From this, the route could be worked out, which would involve some running, the minimum equipment needed, and the type and quantity of film.

In some walks of life – politics, for instance – posed photography is an accepted and expected routine, but generally people are more likely to be intrigued or puzzled by a request to photograph them. Clearly, the relationship between the subject and photographer is most important in this kind of reportage. This can only be worked out in the particular situation, depending on your own feelings and on the appearance and behaviour of the person in front of the camera. You may decide to treat your subject very formally; alternatively you may try a more unobtrusive, naturalisic approach, showing the normal, everyday behaviour and environment of your subject.

What is important, as with studio portraiture, is to present something more than a simple outward, physical likeness. This is not to say that every photograph you take of a person should have deep psychological insight. Nevertheless, even after a short while, you must have formed some feelings about their character and personality. The lack of a studio reduces your control over the final image, but in its place you have the infinite possibilities of a natural setting. Photographing people where they live and work, in familiar surroundings, not only tends to put them more at ease, but it can also provide insight into their life, feelings and attitudes. Making your subject feel relaxed and natural may, at first glance, seem to be the ideal approach (it certainly is the most common), but the relationship between a subject and the camera is more complex than that. Even in the less predictable area of reportage, for example, it may be more revealing deliberately to isolate the subject either through techniques, such as flash, or through an unfamiliar location. The formality of this kind of approach, where no props are available to diffuse the person's character can, at its best, produce remarkably open, and occasionally disturbing portraits, such as those by Diane Arbus.

Quite apart from the different degrees of involvement of subject and camera, you can consider whether to photograph the person's private or public moments. The exuberance of the City of London's Lord Mayor shows this man at his most outgoing; he is probably as delighted and gregarious at this moment as he has ever been. How different is the kind of photograph that shows someone involved in their private thoughts and personal rituals. Neither moment is necessarily more revealing than the other – they are simply different sides of one character.

THE 'HEAD SHOT' *This is the most common of all types of portrait to maintain attractive facial proportions; a long focal length lens of around 105mm is used.*

PERSON AND PRODUCT *Another standard treatment is to combine the subject and the things they want or are involved with (below).*

CIRCUSES

Circuses and other performing arts are colourful and lively as these pictures (above, and right) demonstrate – both were taken at the 1977 Circus World Championships in London. But it is essential to make sure that there are no restrictions governing the use of cameras.

REPORTAGE PHOTOGRAPHY IN USE

The way in which the media use photographs has an importance out of all proportion to the number of pictures taken, and published photography strongly influences approaches to photography. Photography is a very public activity, and the standards of taste in this popular field are largely set by what people see in magazines, newspapers, books, posters and to some extent on television.

Magazines and newspapers are the major media for reportage photography, but each makes different demands on photography. Newspapers use normally single images, poorly reproduced in black-and-white. This picture must be newsworthy rather than necessarily high-quality. So the emphasis is very much on capturing that single potent image and despatching it to the newspaper in time for printing deadlines.

Capturing a single image that sums up a story is a demanding task, and press photography is a specialist field. Being on the spot at the right time is often as important as photographic technique. As Robert Capa once said, 'If your pictures aren't good enough, you aren't close enough'. Press photographers are renowned for their courage in getting right into the thick of the action.

FULL PAGES AND DOUBLE-PAGE SPREADS

The two standard treatments in magazine and book layouts for large picture are a full-page 'bleed' and a double-page spread, also bled. The term 'bleed' signifies that the entire page area is occupied by a photograph, right up to the edges of the paper – that is, it bleeds off the edge. Clearly, a large picture usually has a strong image, but it must often also be of the right format. As most reportage photography is shot on 35mm film, pictures are either strongly vertical or strongly horizontal. Typically, a professional photographer will shoot both horizontal and vertical treatments of a subject if it seems to have potential for prominent use in a magazine, and if it lends itself to both formats. These two photographs illustrate just such an occasion. In a normal seated position, the coachman made a vertical shot, leaning forwards he could be treated horizontally. Note that in the horizontal photograph the coachman is off-centred in the frame – another professional precaution to allow for the inevitable loss of some of the picture in the gutter.

Whatever the quality of the picture, however, it must reach the newspaper quickly if it is to have news value. Films must be processed rapidly, or the photographer must use high-quality instant picture materials to bypass the processing stage. In the future, more and more photographers may use the electronic still cameras based on video technology, such as the Canon cameras used at the Los Angeles Olympics in 1984. These enable the picture to be phoned directly to a newspaper's picture desk seconds after it is taken.

MAGAZINES AND LAYOUT

Magazines encourage a different approach from the photographer. Pictures must be of higher quality and generally in colour, and the photographer has far more time to take the pictures. Commonly, magazines will use a series of pictures to illustrate a story, rather than just a single image. It is the photographer's task to build up this sequence of pictures to give a balanced coverage of the subject. Interesting combinations of photographs are the basis of the picture story form, developed by magazines in the 1920s and 30s.

Thorough research and planning are usually essential and whether they are to be on location for months or just a few hours, photographers will generally try to work out in advance precisely what pictures they need. A crucial consideration in planning the assignment is the way the photographs will be used in the magazine. Variations in the way pictures are laid out and sequenced page by page and altered in size and shape have a significant effect on the impact of each shot and the photographer must be aware of this.

GATEFOLDS

The purpose of a gatefold is to add visual drama to a magazine and to use photographs as large as possible. To work well in this form, a photograph must not only be suitable for cropping to the long format, but must also offer some surprise as the second and third pages are folded out. In the example here, of flamingoes on Tanzania's Lake Ngorongoro, the surprise is one of sheer numbers. The photograph (below), of a southern Indian rice field, is typical of pictures that have such large areas of even tone that they can carry headlines and type right over the image without illegibility.

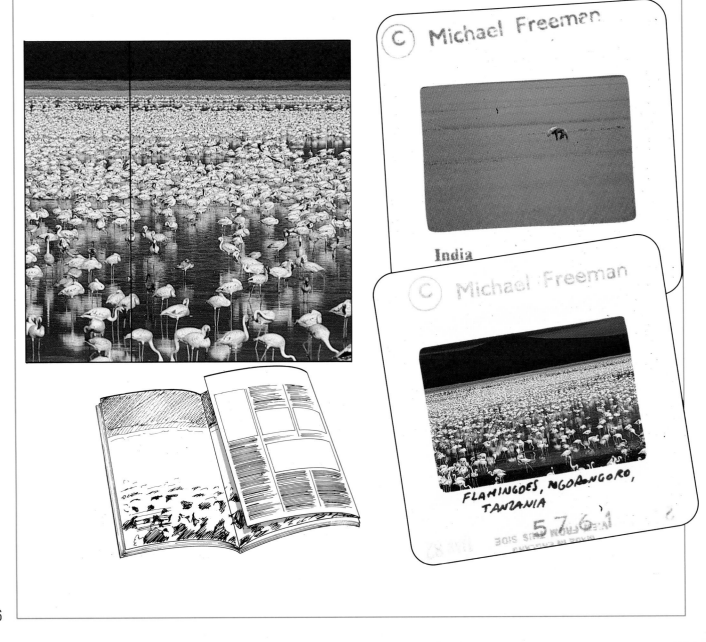

India

Flamingoes, Ngorongoro, Tanzania

COVERS/HEADLINES

Certain elements of a magazine cover cannot be changed – the masthead in particular. However, not all the photographs that an editor might want to use conform to this; in addition, the full-face portraits often used by fashion magazines may look awkward and unbalanced if the masthead has to clear the top of the head. A common solution, shown here on an invented magazine cover, is to overlay part of the photograph on part of the masthead. This only works when the name of the magazine is well known. When photographs are shot specifically for a cover, the layout can be allowed for. It may even be worth making the position of the masthead and other areas directly onto the camera's viewing screen. Tasters or 'teasers' may also be overlaid onto the picture.

PICTURE STORY LAYOUT

The opening picture (right) does not always have to be the strongest in the story, but it must have an immediate impact and indicate what the story is about, in this case, the pearl harvest. The second spread actually starts the story, underwater.
The picture is strong enough to run across two pages, but shortage of space makes it necessary to combine photographs.

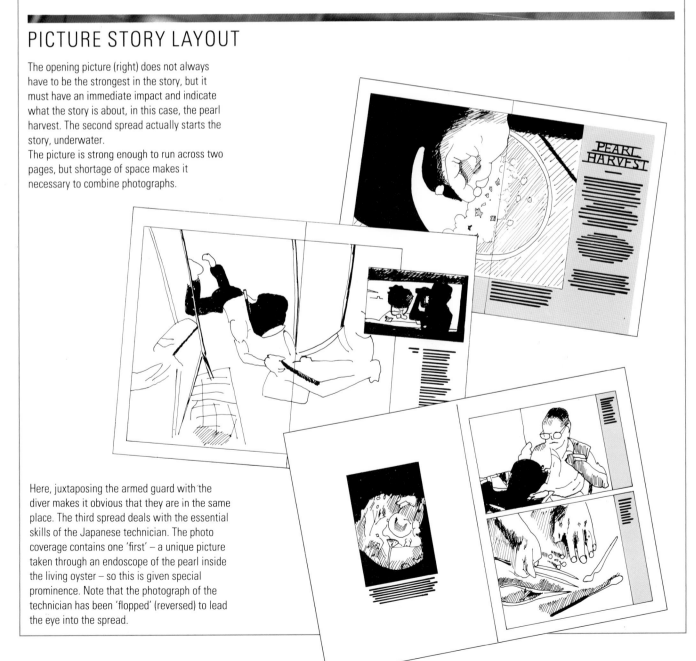

Here, juxtaposing the armed guard with the diver makes it obvious that they are in the same place. The third spread deals with the essential skills of the Japanese technician. The photo coverage contains one 'first' – a unique picture taken through an endoscope of the pearl inside the living oyster – so this is given special prominence. Note that the photograph of the technician has been 'flopped' (reversed) to lead the eye into the spread.

SPORT AND ACTION

AN ESSENTIAL FEATURE of photography is its intimate and special relationship with action and movement – the still photograph takes a narrow slice out of the sequence of events in front of the camera and freezes one moment of time. From the beginning, this has been one of the most fascinating attributes of the camera, which on occasions has even given an entirely new view of the anatomy of fast action. Eadweard Muybridge's famous sequences of animals in motion, taken in the 1880s, were done to settle a bet with his sponsor as to whether or not all four legs of a galloping horse were off the ground at the same time. That it took the advent of photography to describe the actions of an animal known to man for thousands of years shows how the photographic process can actually be used to analyze and dissect experience.

By the nature of the process, the camera cannot fail to capture motion in a single permanent image. However, fast action, particularly in sports, has special characteristics, and to treat it with real insight requires fast reactions, a knowledge of the ways in which camera and film respond to subject movement, and an appreciation of the structure and tensions of the action itself.

The most basic quality when photographing action, whatever equipment and techniques are being used, is anticipation. Fast action requires the photographer to be prepared, and this in turn depends on familiarity with the action. Sports photography is perhaps more concerned with action than any other field and the most successful sports photographs, noticeably, so, are taken by those who have a close knowledge of their subjects.

TIMING

Thinking of action as a finite sequence of events, there are certain instants within the sequence that convey better than others either the sense of movement or the qualities that are special to the particular action. For instance, in a sequence of photographs of someone talking, the photographs taken when the person's mouth is closed usually appear more static and less immediate than those that show the mouth partly open. In violent action, the timing is more important, and the idea of the 'decisive moment' becomes vital. In any one sequence of events there is rarely a single 'decisive moment' – such moments do not exist independently of the photographer, who always brings a subjective decision to choosing the instant to shoot. For example, here are four distinct 'decisive moments' (they are not the only ones):

1 The moment that is crucial to the nature of the action, such as the scoring of a goal, or a knock-out punch. This is the most obvious moment, and, in a sense, represents the peak of the action.

2 The momentary pause in the middle of violent action, for example just before a runner leaves the starting blocks. This kind of moment, full of tension, is natural to certain types of action where the energy is stored up like a coiled spring, ready to be released in a sudden explosion of movement. Because this pause is a slightly less obvious moment, it can have particular dramatic power.

3 The unpredictable moment, where an unusual or unexpected occurrence shows itself in the expression or movement of the subject. With this kind of picture, which reinforces the uniqueness of all action, chance and quick reactions are all important.

4 The moment away from the action. Searching behind the scenes before or after a race or a fight can produce some revealing images. The expressions and attitudes of contestants in a sport can show catharsis, anxiety, exultation or despair, sometimes providing a greater insight into a sport than the peak of the action itself. This is because the extremes of human action often draw on the extremes of human emotion.

Inherent in the choice of timing are composition and viewpoint. Both can contribute to the sense of movement, and both must be chosen to coincide with the moment of picture taking. Compositional rules are generally more restrictive than helpful, which is why they are not treated specifically in this book. Try to choose a viewpoint which simplifies the background.

THE MOMENT

1

2

3

1 The classic steeplechasing shot shows the horses clearing a jump, in silhouette. To take this shot, George Selwyn set up his camera before the race, using a wide, 24mm lens and Kodachrome 64. He fired the shutter from a distance using an infra-red trigger.
2 The clack of an SLR's mirror can put a golfer off his stroke, so the standard shot shows the moment after the stroke. Shooting from a distance, as in this shot of Severiano Ballesteros, through a 300mm lens, reduces the chances of distracting players.
3 Zooming the lens during a long exposure – here 80 to 200mm at ¼ second – gives a dramatic, though uninformative, view of a tennis player.

DOWNHILL RACING *This spectacular shot of an Olympic skier precisely captures the excitement and spontaneity that many sports pictures lack, yet it was conceived and planned well in advance. The close streaking view was achieved with a wide-angle lens fitted to a motorized camera partly buried in the snow, and triggered with an extension cable. The problem was that, as the skier was travelling at about 60mph (85kph), he would be moving about 4.6m (15ft) between each exposure (Six frames per second). This was too fast to be certain of capturing the whole image on film. The solution was to use four cameras. They were placed at 1m (3ft) intervals and were triggered simultaneously. They all had fresh batteries and were running at approximately the same speed. Yet even with so many variables involved, success was by no means guaranteed. As the photographer, Anthony Howarth, recounts: 'Each run used up about ten frames on each camera, so after 20 runs we had used a total of more than 20 rolls of film. The whole operation took about five hours. When the films were processed, we found one virtually perfect picture (shown right) plus a couple of others that were usable. The rest were just shots of blue sky and snow, occasionally with bits of skis in them.'* Nikon, 20mm, Kodachrome, 1/250 sec, f11.

USC vs UCLA, Los Angeles. The action at this football game is heightened by the compressing effect of a 500mm mirror lens. Photo: Walter Iooss.

FAST SHUTTER SPEED

With the right film lens, freezing action into a single frame is something the still camera is ideally suited to. Several factors determine the shutter speed necessary to stop motion – the extent to which the moving subject fills the frame, its actual speed, and its angle of movement relative to your viewpoint. It is important to concentrate on stopping only those elements that are essential. For instance, in a photograph of a racing cyclist, the wheel spokes may be blurred, even though the movement of the bicycle and cyclist is stopped. If there is rapid movement across the field of view, there are two alternative methods of focusing. One is to follow the focus, constantly checking it by moving the focusing ring from side to side.

The problem is essentially that of photographing birds in flight, and can be difficult. If the action follows a pre-determined path, such as a race track, it may be more reliable to pre-set the lens to a known point which the action will pass. Generally speaking, for fast human and animal action, speeds of 1/500 second to 1/2000 second are needed. The effective limit for most focal-plane and leaf shutters is 1/2000 second, and even this is often not accurate. For greater speeds, specialized high-speed cameras are necessary, the fastest of which, using electro-optical shutters, can record images at speeds greater than a millionth of a second. Few subjects, however, are bright enough to record images at even a few thousandths of a second, and the most common route to ultra-high-speed photography is through high-speed flash. Ordinary photographic flash units are limited by the ability of their capacitors to discharge energy quickly enough and a pocket flash on normal setting or an average studio flash unit have flash durations only of about 1/1000 second. Specially developed high-speed flashes, however, can now give a high output with durations shorter than 1/50,000 second.

WEIGHTLIFTER

Two decisive movements show both the strain and deep concentration in weightlifting, a sport that distils action into a sudden violent burst. With a fine sense of timing, photographer Gerry Cranham caught first the charged pause before the snatch, then, seconds later, captured the peak of the action as he held the weights aloft (below).
Photos: Gerry Cranham
Nikon, 300mm, Kodachrome.

HIGH DIVER *This diver appears as graceful as a bird in flight. The camera position is the key factor in the success of the shot. Photographer John Zimmerman considered a number of*

positions before choosing the 50 meter diving board above the 30 meter board used by the diver.
Photo: John Zimmerman.

THE SPORTS

Good reflexes, organization, motor-drives and long lenses apart, nothing contributes more to the success of sports photography than a feel for and an intimate knowledge of the particular game or event.

Football As a field team sport, football's action can range over a considerable area, so that shooting opportunities are difficult to predict. Most of the important action is likely to be concentrated close to either end. In soccer, the goal mouth will attract the critical action, but a camera position right behind, favoured by many professionals, actually has a restricted view. Goals and touchdowns are important for professional photographers, but a photographer shooting for his own pleasure may find more opportunities from a mid-field touchline position. Less important and friendly games give more open access to photographers. As the distance from the action is unpredictable, and varies, a zoom lens (such as 80–200mm), can be useful, or else a combination of two cameras, one with a medium telephoto (such as 100mm or 150mm), the other with a medium-to-long telephoto (300mm to 400mm).

A ground-level position often gives the least complicated views with a telephoto lens, setting players against the unfocused background of stands and spectators. A motor-drive is useful.

Cricket The distances over which cricket is played are great, and a 600mm lens is ideal. Because of its weight and the long periods of waiting between action, a tripod is virtually essential. Changes in the placing of fielders will suggest where a catch is most likely to occur – or to be attempted. Shooting from almost directly behind the batsman will give good on-coming pictures of the bowler. Minimum shutter speed, as with most other sports, should be 1/500 second.

Track athletics Key positions are the start and finish, but head-on to a bend from outside the track gives opportunities for shots of bunched athletes. The field is most closely packed at the start, although the most exciting action usually occurs later in the race. For head-on shots of short distance events, such as 100m, make sure that the combination of lens focal length and camera position gives a *wide* enough view of the runners at the finishing line, or else have a second camera ready with a more moderate telephoto. An inside position on the track gives the most freedom of movement, but will require permission. A telephoto lens from a distance allows more time for shooting than a standard or wide-angle lens from close to the track. Shutter speeds of at least 1/500 second are needed. A motor-drive is useful.

Field athletics These vary considerably in the opportunities they offer for photography, but in most there are exact places, such as the bar of a high-jump and the take-off point for a long-jump that can be pre-focused on. How close a camera position is allowed depends largely on the status of the event, and it is best to check beforehand, as this will determine the focal length of lens that is needed.

Swimming Races are confined to lanes, and this makes it relatively easy for follow-focus. As most of a swimmer is submerged, it is usually important to time the shot for when the head breaks clear of the water – this can be anticipated after watching only a few strokes. Most events are indoor, calling for fast film and a fast lens. A medium telephoto is likely to be the most useful focal length unless access to the poolside is restricted. Underwater shots are an interesting alternative, especially at the turn at one end – these would have to be staged rather than taken during a competitive event.

Golf The distances in golf involve a considerable amount of walking. The best opportunities are likely to be powerful drives and putts, but at the latter in particular, the noise of a camera may be unwelcome, a motor-drive or winder should not be used. The split-second *after* contact is made with the ball is often the most effective moment to shoot.

Horse racing Opportunities depend on how much access there is to the track. Under special circumstances, it may be possible to rig a remotely controlled camera with motor-drive and a wide-angle lens close to a jump, for example, for very dramatic shots. Ordinarily, however, head-on shots of a bend or panning shots side-on to a straight line are the usual positions.

Motor racing For safety and security, access is usually restricted, and it is worth taking considerable trouble to obtain a photographer's pass, for it will allow access to camera positions on the inside of the track, and close to it. Most races last a sufficient time to allow movement between different camera positions. A grid start always has possibilities of excitement, while parts of the track that are known to be likely passing places are also worth watching. A long telephoto can give good compressed views head-on to a curve. Panning shots, even at slow shutter speeds, are another alternative.

Sailing and power-boat racing The best camera position is nearly always on a boat, and one or more of these may be available for photographers and reporters at a major event (although a special pass will usually be needed). A variety of lenses is useful, as are waterproof bags and some provision for drying and cleaning equipment in the event of a spray soaking. An amphibious camera held at the waterline close to a sailing boat can give unusually dramatic pictures.

STILL LIFE

DESPITE THE EXTENSIVE USE of still-lifes in editorial and advertising photography, still-life remains the form in which photography seems to be most capable of approaching fine art. It demands an input of time and effort from the photographer that few other fields of photography do. The photographer must carefully select the elements that are to be included and then, slowly and deliberately, create a design – gradually altering a composition, lighting, colour and so on until the desired effect is achieved. In contrast to candid, and most other forms of photography, a still-life image is not seized as an opportunity, but gradually built up.

To David Hockney, a painter who has also experimented with photography, this is crucial, for he believes that the time and effort the artist puts in are essential qualities of an image. He argues that most photographs, unlike paintings, take very little time to make and so cannot hold the viewer's attention for long. 'Look at a Rembrandt for hours and you're not going to spend as much time looking as he spent painting – observing, layering his observations, layering the time.' By contrast. 'The reason you can't look at a photograph for a long time is because there's virtually no time *in it*.' If there is a valid argument here – that the effort and consideration show through in the finished image – the photographic still-life should reward closer observation than most other forms. Certainly, the details and arrangements in a still-life image are deliberate rather than accidental. A photographer has full control over a still-life, from the choice of objects to the method of treating them.

CONTROLLING FLARE

In this close-up of a cherry in a wine glass, what mattered were the composition, the precise positioning of objects to control the refraction effects, and elimination of flare (achieved with a professional bellows lens shade).

BACKGROUNDS AND SETTINGS

In still-life photography, the background is a vital element of the picture design and demands as much consideration as the choice of subject – even if the background is to be subdued or neutral. The variety of possible background materials is immense and the choice must inevitably depend on whether the background is to act merely as a backdrop for the main subject or whether it is used to create an elaborate setting.

One of the most popular simple backdrops is a featureless 'limbo' setting, which allows the subject to 'float' visually against it. The best materials for this kind of background are colourless – white, black or grey – and textureless. For light-toned backdrops, plastics and laminates such as formica are ideal because they are so smooth – many papers have a texture that is noticeable in close-up, and paper is also prone to wrinkling and creasing. For a completely 'dead' black, that kills all shadows and has no recognizable tone or texture, good-quality black velvet is excellent.

ORANGES *This powerful still-life image relies largely upon colour for impact; the eye sees the rich orange as strong and aggressive, lending the image a dimension which, relying on composition alone would be lacking.*

The appearance of these floating backdrops can be altered dramatically by the lighting. Back-lit translucent plastic will give a completely white setting that carries no shadows. A curved white background – sometimes known as a *scoop* – partially lit from overhead gives a horizonless gradated zone (see Basic lighting style below). A gradated scoop can actually do more visually than just provide a limbo setting. Used with a particular camera angle to suit the subject, as in the example, the upward change in tone from light to dark can be made to coincide with the downward gradation from light to dark in a typical object that is lit from overhead. In this way, the tones of an object stand out much more clearly.

Other simple backdrops are those that contrast with the appearance of the subject, and those that are complementary to it. This applies not only to tone – an ivory carving, for example, has quite a different appearance when seen against a light or a dark background – but to colour, pattern and texture. As a general rule, the *less* neutral the background, the more important it is to be sure why it is being used. Attention-grabbing backgrounds chosen indiscriminately can overwhelm a subject and appear tasteless. Whether a background is selected for contrast or similarity is a matter of personal taste: either can work well, the one through enhancement, the other through restraint.

Atmospheric settings are often chosen for their association rather than simply their appearance but can complement or contrast with the subject. Certain smooth, shiny surfaces, such as stainless steel and plastic, for example, tend to be associated with precision, science and technology, and may even appear a little 'cold' – an obvious complementary background for a piece of equipment. An example of the use of a contrasting background might be a delicate piece of jewellery photographed against a roughly hewn block of stone. Contrasting associations probably have more scope for an interesting and imaginative interpretation of the subject.

Backgrounds need not be plain and consistent, or even a single surface. Many still-life photographs use what is basically a set, constructed to create atmosphere or to simulate a location, either contemporary or period. If the shot is tightly framed and the camera angle kept sufficiently high not to take in a large area of background, convincing reconstruction can be made with quite modest props, carefully selected.

CAMERA ANGLE

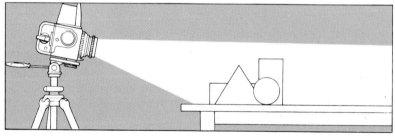

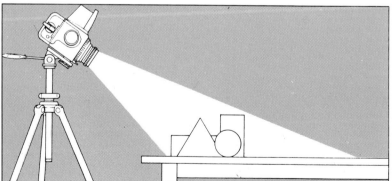

The area of the picture occupied by the background surface often depends simply on the camera angle. As the diagrams (above) show, the more horizontal the lens axis, the larger the area of background. It often makes little difference to the look of the shot to tilt the camera down slightly, but can save a great deal of background preparation.

SCOOP BACK-LIGHTING

If the base of the subject has to be included, the simplest of all back-lighting techniques is to use a scoop – a flexible surface that curves from a horizontal base to nearly vertical behind. But the back-light is an area light positioned either just beyond the subject and aimed back towards the upright part of the scoop as for the shot immediately below, or, if the scoop is translucent, behind, as below.

Exposure for transparent objects Where the subject is either transparent or light toned, the key for exposure calculation is the background. If the subject is back-lit, it is the light source that must be measured by taking a direct reading. To get the exposure for the subject, add 2 or 2½ stops to the reading.

Eliminating the horizon Unless a scoop is used the edge between the level surfaces and the vertical back-light will appear as a kind of horizon. An easy way to eliminate it is to use a shiny surface and a low camera angle, as in the photograph of the antique perfume bottle (below). The camera angle increases the visible reflection, which becomes bright enough to merge with the light source.

SHINY SURFACES

The over-riding principle for lighting very shiny surfaces is to plan the reflection over every square inch of surface area very carefully. Essentially, the reflected surroundings are being photographed as much as the subjects themselves. The classic technique is to use a light source that is large enough to cover most of the reflective surfaces, as in the photographs top and right. The proportions of subject area to light area are extreme – in the close-up of the gold bar below they are in the order of 1:20 – and the light source is as close as possible. In addition, the angles of the surface of the subject and the camera are arranged to catch as much reflection as possible. For the picture of the gold bar, the illumination was a tent light (above). For the pearls and mother-of-pearl shells, illumination was a natural light from a north-facing window on a cloudy day.

BASIC LIGHTING STYLE

Even more than in studio portraiture, lighting is crucial to the success of a still-life. When a person is the subject, the fairly consistent shape of the head and body, and the need to show recognizable facial expression, set limits to lighting style. But with still-life there are many different styles of lighting, and fashions are forever changing. Whatever the style, though, lighting for still-life needs to be efficient. It must clearly reveal all the relevant aspects of the subject, form, shape, texture, colour. With a simple subject, for which the aim is to do little more than make an accurate record, lighting efficiency may indeed be the only consideration. But where there are more interesting aspects to take into account, such as the atmosphere and impression of the shot, efficiency may be compromised.

With most still-life subjects, lighting usually benefits from some diffusion – enough, at least, to kill the hard-edge dense shadows thrown by a naked lamp that tend to confuse the appearance of most objects. Extreme diffusion, however, shows the *form* of an object poorly, as some light/shade contrast is necessary to show the contouring. In practice, this is not usually a problem, as it is hard to create the kind of enveloping light that gives the effect outdoors within a studio. The usual compromise for 'straight' still-life lighting is one main lamp diffused through a sheet of material rather larger in area than the subject. A single main light is simple and practical and its clear, uncomplicated effect resembles natural light, whether from the sun outdoors or from a window.

It is the *relative* size of the light compared with the object that controls the amount of diffusion: it can be increased, therefore, by making the light area larger, by moving it closer, or by photographing a smaller subject from closer. Overhead lighting positions tend to be considered as normal and traditional, and so are relatively common. Overhead diffused lighting on a scooped background, if positioned relatively low and forward, as shown in the diagram (opposite), has a useful gradated effect, creating and increasing shadow backwards and upwards. If the camera is low, this combines well tonally with the appearance of objects placed on the surface. But the best direction and position for the light depends on the shape and characteristics of the subject. To light an upright bottle, evenly, for example, it is usually easier to aim the light more horizontally than vertically.

As lights in still-life photography are often used quite close to the subject, lens flare is a common problem. While flare can sometimes be used intentionally to soften an image, it is usually better avoided. The position of the lights is crucial, but there are many other ways of cutting down flare. The camera lens can be provided with a lens hood, for instance, and

CONTROLLING SHADOWS

Reflectors These are necessary to fill in shadows without adding more lights. Hand mirrors of different shapes throw back the most light, but their effect is often very obvious. Crumpled tin foil glued to rigid card gives slightly weaker reflections, and plain white card gives even less but is least obtrusive. Shadows can even be deepened with black card.

Masking for flare To improve contrast as much as possible with a standard still-life set, all parts of the background can be masked with black paper or card right up to the edges of the picture area. Small pieces make precise control easier. Check their placement visually through the camera's viewfinder. In a set like the one illustrated here, the shape of the picture area on the background will be roughly trapezoid.

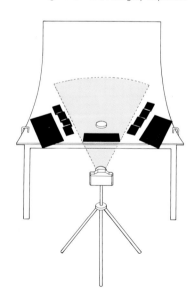

DEGREES OF DIFFUSION

The amount of diffusion or concentration of light has the most profound effect on the quality of illumination, and can be varied from an enveloping light that appears to be directionless and casts shadows to an intense single beam from a spotlight. The reasons for using a particular level of diffusion may be practical or aesthetic.

Two extremes are shown. The lighting for model building made of pearls is heavily diffused by surrounding it with a large area of diffusing and reflecting material. In contrast, the antique lighters in the lower photograph are lit in the most intense way possible: a tiny lamp in a small parabolic reflector aimed from a distance.

ACRYLIC CUBES

A jacket illustration for a book entitled 'The Life Game' (bottom) called for two specially constructed 'dice', each containing an animal. As the dice were transparent, backlighting was a natural choice. By laying a large sheet of opalescent Plexiglass (below) on two trestles, the light could be aimed upwards from floor level.

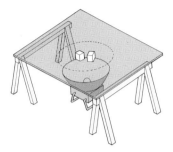

OIL WEALTH

This illustration (below) called for a model pipeline. Even so, to have the nearby coins and far derricks both in focus was beyond the capabilities of even a wide-angle lens at minimum aperture. The solution was to create a false perspective by building the nearest pipe as a cone. The exact proportions were found by trial-and-error to suit the camera angle. Two lights were used, one overhead to illuminate the coins, the other covered with orange acetate placed beneath the set to bounce off the white wall behind.

LIGHT TENT

Although normally practical only for small objects, the subject can be completely enveloped in diffuse light with what is usually called a light tent. The aim is to surround the cone-shaped area that is visible through the camera lens, but just out of frame. Any neutrally coloured diffusing material will do, provided that it can be supported firmly; here, ordinary tracing paper is used. The cone is first rolled to the dimension of the lens (at smaller end) and the picture area (at larger end).

the lamps shaded with French flags and barn doors. It is important to remember that flare may come not only from light spilled directly from the lamps, however, but also from bright reflections from in and around the subject. This is why many photographers cover the bright metalwork on their cameras and lighting equipment with black gaffer tape, and sometimes hide the camera behind black card, leaving only a small hole for the lens. Coping with reflections can be particularly difficult to spot even when working with flash without modelling lights – even with modelling lights, bright spots that are obtrusive with the flash may not be obvious while the shot is being set up. So many photographers shroud every possible source of unwanted reflection in black.

The final element in efficient lighting is shadow fill, to control contrast. The normal shadow fills are reflectors of white card or paper, tin foil, mirrors, or a second lamp, also diffused. The degree of shadow fill is largely a matter of taste, although if very obvious it can appear distracting. This is more likely to be a danger with a fill light than with reflectors. It is difficult to assess the level of fill needed by eye and the most accurate method is to measure the different levels with a meter. Shadow fill is most likely to be needed with a degree of back-lighting, when the light is aimed towards the camera, and least likely when the lighting is frontal, from the camera position to the subject.

Even with basic still-life lighting, using one main diffused light, there is scope for different effects, and relatively small changes in position and direction can make a significant change to the appearance of a photograph. When the lighting possibilities are extended to include the many other style, with spotlights, multiple lights, degrees of lens diffusion and the many types of light modifier, it is easy to create a distinctive and unusual lighting design.

WILDLIFE

THE GENERAL INCREASE in environmental concern has encouraged more photographic interest in nature than ever before, and it is now an extremely popular field among amateurs. Improvements in cameras, have had a particularly important effect, simply because many nature subjects do make heavy technical demands. Optically, the important special need in nature photography is magnification: close-up enlargement for the large numbers of small subjects such as flowers and insects, and the magnification of distant views for full-frame pictures of wary animals. The development of relatively inexpensive macro and telephoto lenses has made more nature subjects accessible to more people. Automatic metering and more sophisticated flash units have simplified exposure and lighting, while motor-drives make it easier to deal with active subjects.

ARROW-POISON FROG *This tiny frog earned its bizarre name from an Indian technique of using its venomous secretions to coat the tips of hunting arrows. It was photographed with a* pocket flash unit held directly overhead and wrapped in a white handkerchief to diffuse the light.
Nikon, 5mm Macro, Kodachrome, f22.

Perhaps because it is so difficult even getting near the subject, let alone taking good pictures, wildlife photography tends to lean heavily towards the documentary rather than the interpretative or lyrical. This is not to say that wildlife photography is limited to a kind of record-keeping; there are as fine examples of individual, interpretative treatments. But the foundation of consistently good wildlife photography is experience and long fieldwork.

In a field dominated by technique, there are two basic working methods: stalking and photography from a concealed position. In one, the photographer actively seeks out the subject and must use a high level of fieldcraft to approach closely; in the other, the photographer hides near a regular haunt of the creature, such as a nesting site or a water hole, within clear camera view. A third method, highly specialized and much less often used, is remote control, in which the camera alone is positioned close to the site and triggered from a distance or by an animal's arrival.

EQUIPMENT

The long-focus lens is the basic tool of wildlife photography, and a lot of the techniques revolve around its use. It is needed mainly because the majority of wildlife subjects are shy and elusive, and rarely allow close approach. A long lens has the additional advantage of being able to isolate an animal from a frequently confusing tangle of foliage by means of

35mm SLR EQUIPMENT CHECKLIST

What equipment you carry depends on how specialized your involvement is. This basic list covers the majority of subjects and their environments down to moderate close-ups. Tripod and cable release.
Lenses: The longer focal lengths are the most important, but exactly what you take will depend on your budget and how much weight you are prepared to carry. Lenses of 600mm and over are very effective but invariably need a tripod. An alternative may be a 300mm or 400mm which, with practice, can be hand-held at speeds as low as 1/125 (just!) A monopod is a worthy substitute for a tripod, and much lighter to carry. A more moderate focal length, of around 200mm, may be useful for more approachable subjects, and a wide-angle lens can be used for overall environmental shots. For close-up work, a macro lens with a set of extension rings will cover everything down to the scale of quite small insects.
Special options
1 Motor-drive if not built-in.
2 Flash unit.
3 Flash intensifier – by mounting the flash unit to point *backwards* into a specially-designed parabolic mirror, its light can be concentrated into the small field of view of a long-focus lens, increasing its effective range to as much as (164ft) 50 metres.
4 Remote control device, either radio or infra-red controlled.
5 Soundproof blimp for working by remote control or in a hide close to the subject.

LONG-FOCUS LENSES

1 Medium telephotos, from 85 to 200mm, are useful hand-holdable lenses.
2 Mirror or reflex designs use a combination of mirrors to fold the light path into short, light barrels.
3 Long telephotos, from 300mm to 800mm, give large magnifications but must usually be used on a tripod.

180mm Long-focus lens

its shallow depth of field. Practise holding and using a long lens until you can improve the lowest speed at which you can achieve a sharp image. Use trees, bushes, rocks as cover in the same way that your prey does, and don't hesitate to shoot through intervening foliage – the shallow depth of field will throw it out of focus, and the resulting blurred foreground may help convey the excitement of stalking in the final photograph.

Constantly check and adjust the camera and lens settings, anticipating the lighting conditions under which an animal may appear. At the fleeting sight of a deer bounding across a clearing, you may not have time to make any adjustments. Keep a careful eye on the film counter. If there are only a few frames left, it may be a good idea to change film. Also, don't be afraid to risk a few frames when the light is too dim.

A motor-drive is well worth its weight, not only because it can cram the maximum amount of pictures into the short flurry of activity common with many wildlife subjects, but also because it removes the distraction of manually winding the film. If there is any doubt about the correct exposure in a situation where there is no time to check it, use the motor-drive to bracket the exposures – whilst firing a continuous sequence, rotate the aperture ring. When stalking a particularly skittish or alert animal, however, use the motor-drive with discretion. It is noisy, and will startle the animal more easily than the manual shutter release. In fact, it often happens that the first time the shutter release is pressed the prey will bolt, and some fine judgement must be exercised as to the best moment to shoot.

Successful stalking calls for an unobtrusive, and perhaps camouflaged appearance, and the ability to move silently and smoothly over rough terrain. Skill in fieldcraft is essential if the photographer is to get close enough to the subject animals for a satisfactory shot. However, a telephoto lens removes some of the need for a really close approach.

Most animals define for themselves a perimeter of safety and, provided that this is not crossed by a potential threat, they may not bother to take evasive action. The size of this perimeter varies, naturally, according to the species, its activity at the time, the terrain, and so on. Nevertheless, a noise made by a photographer at, say, 100m may not count as a threat, whereas the same disturbance at 50m may be reason enough to take flight.

Stalking can have certain stages: the first is likely to be patrolling to find some sign of the animal's presence; the next, following the trail until the animal is in sight; and the last, making the approach to a shooting position. Finding animals depends on knowing their habits, being familiar with the marks they leave, such as tracks and droppings, and, often, on specific information about the location. For all these reasons, an experienced guide is extremely valuable.

Camouflage works best when it takes into account the principal senses of the animal. While sight is the most important for a human being, many mammals rely heavily on smell so scent concealment, silence and stillness may well be the most important aims of camouflage when stalking mammals. A smooth walking action also helps.

Sunlight must be avoided where possible. So must making a silhouette on skylines. The photographer may sometimes have to make use of natural cover, or even crawl. If the animal is alerted at close range, the photographer must freeze and stay motionless, avoiding eye contact, until it resumes its normal behaviour.

CAMOUFLAGE

For fair-skinned people, the face and hands may be clearly visible parts. Military face paint is one answer, but messy. An alternative is camouflage netting and gloves. The netting, which doubles as a scarf, is draped over head and camera when necessary.

Camouflage for stalking: concealing appearance Cover or darken anything bright – face, hands and chrome camera parts. Use dark face paint for the skin and black tape for the chrome. Remove unnecessary bright objects, such as watch and sunglasses. A shapeless cap, camouflaged netting and a few sprigs of leaves will help to break up the body's recognizable outline.

Concealing scent Wear long sleeves and full-length trousers. The less exposed skin, the less scent. Use no commercial scents such as deodorant or after-shave. Movement propels scent molecules. Stay as still as possible.

Concealing noise Remove anything that rattles, such as coins or keys. Wear cotton rather than synthetic fabric.

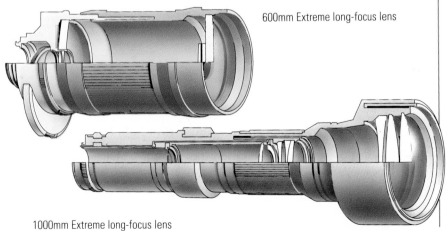

600mm Extreme long-focus lens

1000mm Extreme long-focus lens

Photography from Vehicles For many animals that live in the open, a vehicle is likely to be the best camera platform. Not only does it speed up the search, but it acts as a kind of moving hide – few mammals seem to identify a vehicle as a container for human beings. It is also the only safe method of approaching large, dangerous animals such as buffalo, lions and rhinoceros.

The vehicle should be suited to the terrain – a Land-Rover, Jeep or other 4WD vehicle is ideal. The best shooting positions are usually from a roof hatch or through the interior windows, although some professional wildlife photographers prefer a custom-mounted bracket on the door. Without a bracket, a soft support, such as a folded cloth or a bean bag, protects the lens from scratching and gives some steadiness.

As with other kinds of wildlife photography, a long focal length and wide maximum aperture are the ideals for a lens, although certain large animals may allow such a close approach in a vehicle (lions particularly) that a medium telephoto is also valuable.

Photographing Animals from Hides The most common site for a hide is a watering place; in the dry season, if pronounced, visits by animals may be predictably regular. Freshness and quantity of trails at the water's edge give an indication of use. Early morning and late afternoon and evening are often the busiest times at a water hole.

Remote Control Many mammals are so wary that only a remotely triggered camera is practical. In addition, for small mammals a camera position of only a few feet away is necessary – too close to allow a photographer as well. At a site where the animal is expected to cross (a trail close to the entrance of a burrow, for instance), the camera is fixed in position, focused and camouflaged. The shutter can then be triggered either by the photographer (watching from a distance), or by the arrival of the animal.

Baits for Small Mammals A good, general-purpose bait mixture for small mammals is: roughly equal parts of suet, peanut butter, raisins and oatmeal. Never handle any bait without gloves: most mammals are very sensitive to human scent and will avoid such food. Proprietary scents are available for some game animals, particularly deer. Anise oil attracts bears and some deer. Catnip attracts some cat species. If the bait is to appear in the photograph, it is usually worth making it look as 'natural' as possible. Animals rarely respond instantly to baits and continued baiting over a few days is usually essential.

BIRDS

Just as wildlife is distinct from other nature subjects because of the special photographic techniques involved, so different groups of animals tend to be categorized by the way they are most easily photographed. In the number of photographers they attract, birds are by far the most popular subject. This is probably due in part to a loose aesthetic appeal – birds appear naturally elegant and are usually highly active – and in part, to their visibility, which contrasts with the stealth and secretiveness of most mammals. Such facilities as exist for wildlife photography – organized sanctuaries and permanent hides, for example – are more common around bird colonies and other regularly visited sites.

Range of Techniques Stalking is less commonly used than a hide; virtually all birds can fly, and so are not bound by the terrain as is the photographer. The small size of most birds also makes a visible approach unlikely. Nevertheless, in certain situations it may not be necessary to stay concealed: dense vegetation in forests sometimes offers opportunities during a nature walk, while large colonies have so many individuals and are so noisy that a human presence is often tolerated. Species vary in how wary they are of humans.

Most serious bird photography, however, requires a hide, and the techniques for using one are fairly specific. Permanent hides exist at certain bird sanctuaries; otherwise a hide must be built and introduced to a site, which requires care and judgement. For very close camera positions and nervous subjects, remote control may be necessary.

Photographing Birds from a Hide By far the majority of successful bird photographs are taken from a hide or with a remote-controlled camera. Hides are camouflaged covers that

ELECTRONIC LURES

Animal calls can be used to attract subjects by recording them on tape and then playing back later. The basic equipment for this is a highly directional microphone such as the shotgun design shown here (**1**), a good quality portable tape recorder (**3**) and headphones for monitoring the recording (**2**). Using this method, however, calls for experience and thought for the animals – alarm calls recorded on one field trip, for instance, may create stress in the subject.

NIGHT EQUIPMENT

Many mammals are active only by night, and photographing them demands special equipment and materials. At stalking distances and with the modern maximum apertures available on most telephotos, for instance, the majority of portable flash units can only be used with fast film.

Flashlight A flashlight on a head-strap or taped onto the lens frees the hands to operate the camera, and is useful not only for focusing but for finding animals at a distance – eye-shine (reflections from the retina) is strong from many animals and can reveal their presence even at a distance. A flashlight can also mesmerize some animals, making them easier to approach.

Tele-flash A parabolic mirror attachment or a condensing Fresnel lens concentrates the beam of a flash unit. This can increase the illumination over a small angle by up to three stops. The mirror unit must be calibrated for greatest effect.

Infra-red Black-and-white Kodak High Speed Infra-Red film, although grainy, can be used in situations where an animal may react to visible light. A regular flash unit is masked with a visually opaque filter, such as a Wratten 87. The infra-red emission is unaffected.

MOUNTAIN GOAT, SPERRY GLACIER *Within a mile of some overnight cabins in Montana's Glacier National Park, this Rocky Mountain goat showed no signs of alarm when approached close enough for a full-frame portrait shot. As it was still posing obligingly moving away provided a view that showed it in relation to its habitat (near right).*
Both shots: Nikon, 180mm, Ektachrome, 1/250 sec, f11.

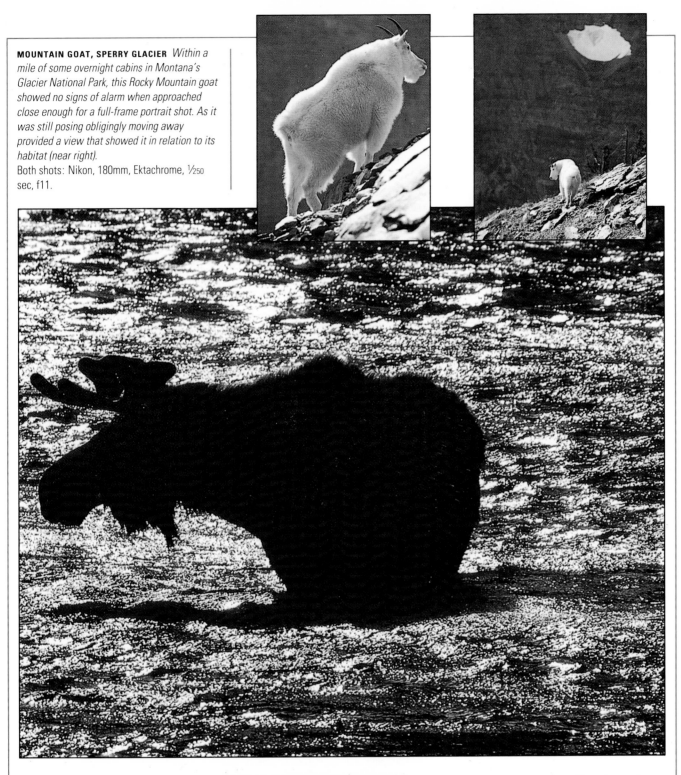

MOOSE, MADISON RIVER *Browsing on river vegetation in Yellowstone National Park, this bull moose (above) was only a matter of yards from the highway. In this well-organized park, many animals have become relatively accustomed to humans.*
Nikon, 400mm, Kodachrome, 1/500 sec, f11.

THIS BRAZILIAN GIANT OTTER *is an endangered species as well as the largest of the world's otters. Unlike many rainforest animals, the otter is active by day. Its behaviour is confident and playful. The photographer's problem is therefore to find it rather than having to exercise stealth and caution once it is spotted.*
Nikon, 400mm, Ektachrome, 1/250 sec, f8.

allow the photographer to work very close to the birds without being seen. Some bird sanctuaries have permanent hides, equipped with double-glazing and central-heating, but elsewhere hides must be carried carefully to the site and erected without disturbing the birds. Typically, hides are set up near a nest or feeding site where the birds regularly appear. Occasionally, though, birds may have to be lured to the hide with food.

Success with a hide depends very much on the birds accepting it as part of their surroundings. If their normal routine and behaviour is upset, it may not only prevent the photographer getting any photographs; it may also drive the birds away from their feeding and nesting sites. So hides must not only be camouflaged and positioned carefully so as to avoid disturbing the birds; they must also be moved into place gradually so that the birds accept the new feature in their environment. If ever the birds' behaviour seems disrupted, the hide must be withdrawn some distance or not used for a while. Once the hide is set up, the photographer must time arrival and departure carefully so as to cause the minimum disturbance. Permanent hides administered by a park ranger will already be accepted by the birds.

Hides are generally tailored to meet the circumstances and the location of the hide must be selected with care. Not only must it offer a clear view that is close enough for a reasonably large image – this depends on the focal length of the lens, which normally needs to be at least 400mm – but you also need to have an eye on the background to the shot and the direction of the light falling on the subject at the important times of the day. From the birds' point of view, the hide should blend with the background, such as the edge of a thicket, and should never appear silhouetted against the sky. Upwind locations should also be avoided, since the birds will be just as alarmed at a strange smell, as at unfamiliar sights or sudden movements.

There are two principal ways of introducing the hide to the site. In one, the hide, fully assembled, is moved closer each day from a distance. In the other, the hide is gradually erected, day by day, on its chosen site. In both cases, it is important to move when the birds are absent, and to pay special attention to any changes in behaviour.

Birds in Flight Some of the best opportunities for photographing birds are, naturally enough, when they are flying. Technically, the problems of shooting any travelling action are compounded here by the lack of reference points – focusing on a predetermined spot is not possible.

INSECTS AND SPIDERS

The sheer abundance of insects makes them, and other groups of small creatures, such as crustaceans and arachnids, one of the easiest animal subjects to find. The principal specialization called for is close-up technique. Recent electronic improvements in the integration of flash and camera circuitry have made this considerably easier.

Finding and Handling A diligent search on a nature walk should reveal quite large numbers of species in most habitats. Generally speaking, the more variety of micro-habitats, as in a forest, the more species, and high summer is the peak period in a temperate seasonal climate. Forest litter, such as dead leaves and rotting wood, are particularly likely places for searching. At low temperatures, insects are more sluggish; early morning is a good time to photograph species that would otherwise take flight easily.

Basic design for a hide

This multiple-use hide is constructed from sectioned aluminium poles of the type used for tents, covered with a camouflage material. The material, which can be bought from a camping supplier, should be waterproof and strong enough not to flap in a wind. The camouflage pattern is optional and can be dyed into plain, drab material. A box-frame construction is the simplest design; if the uprights are sectioned as shown, with a *short* lower pole, it will be easier to erect on a slope.

HIDES

Hides are the standard technique for almost any comprehensive coverage of a particular species – especially nesting birds, such as these egret with chicks at right. A portable, tent-like hide, as described right, can be used in different locations, or a sanctuary may already have a permanent structure.

Precautions in use

1 Enter and leave the hide out of sight and hearing of the subjects. This usually means when the birds are absent. A concealed approach to the back of the hide is an advantage.

2 If birds are present, enter with a companion, who then leaves. Few birds appear to be able to count.

3 Avoid touching the walls, once inside; and stay quiet.

4 Movement of the front of the lens may alert the birds. When the lens is removed at the end of the day, replace it with something that looks similar, such as a bottle.

5 Extra comfort makes it easier to stay quiet and still. A folding chair, food and drink may be worth taking.

Specialized hides

For certain different kinds of habitat, such as forest and wetlands, a specific design may be necessary.

Baits and lures

Food, water, recordings of appropriate calls, and even decoys can be used as an inducement to encourage birds to land at a certain site, and can be used in conjunction with a hide (there may be legal restrictions in some countries). For efficiency food is best when offered when it is scarce in nature (winter, for example, rather than spring). Any bait or lure, however, should only be put down with full awareness of likely disruptive effects: regular food offerings may cause a bird to delay migration too long, or alarm calls may cause stress. Place baits in a location that is open enough to be visible, but which offers some close cover (few animals like to eat in an unprotected place).

Seed-eaters: Use cereal grains (make sure that they are untreated and non-toxic), sunflower seeds.

Fruit-eaters: Fresh fruit, raisins.

A small artificial pool can be made from a weighted plastic sheet in a scooped-out hollow. A water-drip overhead will make this especially attractive to small birds.

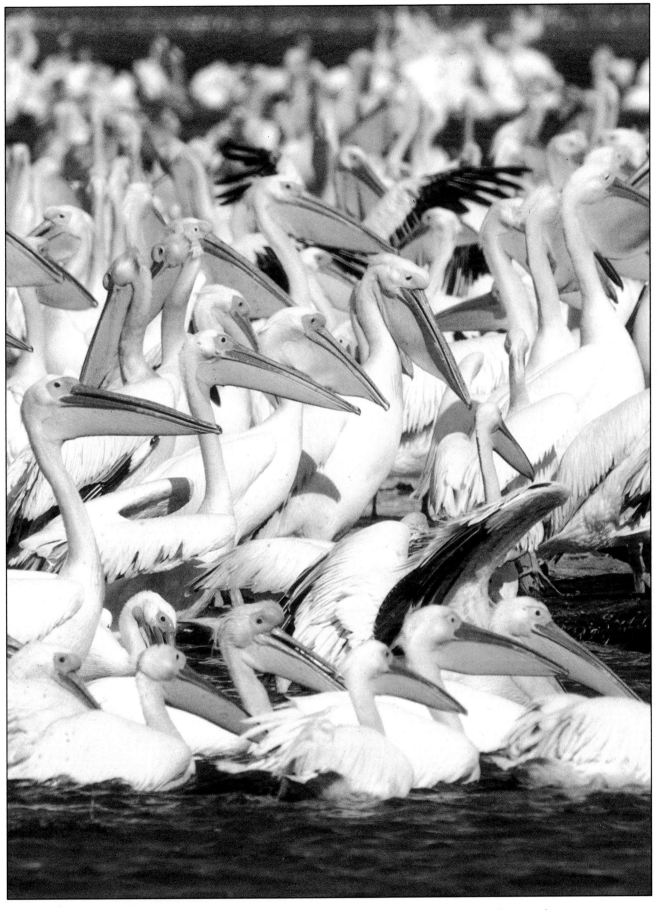

WHITE PELICANS OF LAKE MANYARA, TANZANIA *Another aspect of wildlife photography's documentary nature is the display of the spectacular. Certain features of the natural world, such as large congregations of animals,* *are inherently impressive. Massed images such as this photograph are always imposing. To enhance the impression of great numbers by producing a compressing effect, a long telephoto lens – 600mm – was used.*

AUTOMATIC TRIGGER

One way to get high-quality pictures of birds in flight, like the picture of the starling on the right, is to arrange for the bird to trigger the camera itself. Camera and flash are set up to photograph the bird on a known flight path – typically the entrance to a nest. Flash is essential both to freeze all movement and to allow the photographer to stop down the lens for maximum depth of field. Then a photo-electric tip beam (visible or infra-red) is set across the bird's flight-path to trigger the camera.

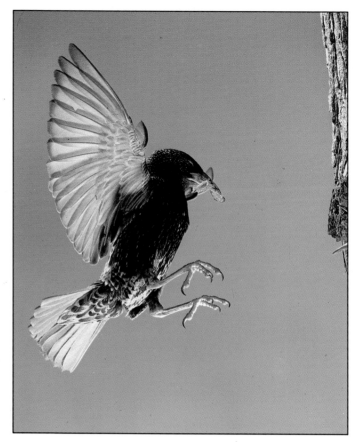

Alternatively, insects can be attracted to a particular site. A sugar mixture, such as one made of beer, treacle and rum, will attract butterflies and moths. Salt licks can also be used, and at night a lantern behind a white cloth will net large quantities of winged insects.

Using baiting and luring techniques, it may be easier to collect insects and photograph them later under controlled conditions, with some of the natural vegetation.

Close-up Equipment Most insects and spiders in temperate habitats are so small that they need a magnification of at least ½× for an image that fills a reasonable area of the 35mm frame. Supplementary close-up lenses are rarely powerful enough; a close-focusing macro lens with a selection of extension rings is usually needed. Extension rings are more sturdy than bellows for fieldwork, and retain the FAD capability of the camera. There is some advantage in using a longer focal length of macro lens – 105mm or 200mm, for example, with a 35mm camera – as the working distance is greater and so less likely to disturb the insect. Increasing the magnification with a longer lens, however, calls for a proportionately greater extension, and in this case a bellows may be more useful.

Camera Technique For most photographs of insects in the field, the camera is, of necessity, hand-held. At typical magnifications – ½× and greater – it is nearly always easier to focus by moving the entire camera bodily backwards and forwards rather than to try and adjust the focusing ring on the lens. With flash, pre-setting the focus also makes it possible to pre-set the aperture confidently.

Depth of field is always shallow at magnification, but the depth needed varies according to the circumstances and the style of the picture. The usual ideal is just enough depth to show most of the insect sharply, but to leave the background smoothly blurred. In practice, there is normally less depth available than the photographer would like. Stopping down

HORNED SPIDER *This unusually protected spider (below) was photographed slightly larger than life-size with a bellows extension. To bring out some interesting reflections from the carapace, a ringflash was used.*
Nikon, 55mm Macro plus 80mm bellows extension, Agfachrome, f16, ringflash.

MACRO LENS *Fit a macro lens and a whole new world of strong colour opens up before you. Using a close-up lens helps isolate one or two strong colours, and careful composition helps eliminate potentially distracting hues from the scene.*

BLACK-NECKED STORKS, INDIA *Normally solitary and secretive, these birds are difficult to stalk. As with most animals and birds, they are most active in the early morning, and the photographer surprised this stork after sunrise in the marshy acacia forest of a bird sanctuary in central India. There was time only for this one shot.*
Nikon, 180mm, Kodachrome, ¹/125 sec, f2·8.

285

MULTIPLE FLASH

A standard set-up for field photography of insects is two small flash units mounted close to the end of a macro lens, calibrated beforehand:

1 Choose a number of fixed magnifications.
2 For each, focus the lens and aim the flash units at the point of focus.
3 Set up a flashmeter (right) and move the camera until the dome is sharp in the viewfinder.
4 Trigger the flash and take the reading.
5 There will be aperture setting for each magnification. In the field, just move the pre-focused camera until the insect appears sharp in the viewfinder.

improves depth of field but the reduction in light means a higher flash output, or a slower shutter speed in daylight. Depth of field can also be used more efficiently by photographing the shallowest part of an insect (side-on to a dragonfly or other long insect, for example).

Close-up Flash Because of the problems with depth of field and subject movement, portable flash is the usual lighting in insect photography. A dedicated flash system automatically compensates for the closer flash distance and extra lens extension, but otherwise a small manual flash unit is convenient – the sensors in ordinary automatic flash units are not designed for work at close range. To simplify the calculations for flash exposure, the surest system is to devise a standard arrangement, as shown (opposite). Once tested and calibrated for a few likely magnifications, it can then be used without adjustment in the field.

It is important to mount flash units close to the subject, to give some modelling and to avoid throwing the shadow of the lens onto the insect. Various proprietary brackets and mounts allow this. Specialized alternatives are a ringflash and purpose-built macro-flash.

TREES AND FORESTS

Trees and smaller plants are technically among the easiest class of nature subject, and as a result are both popular and open to a variety of interpretative treatment. Some specialized knowledge may be needed to find good specimens, but the photographer still has considerable scope for experiment. Documentary realism is not the only approach; flowers in particular can make attractive abstracts.

The complex shapes and outlines of most trees, and the fact that most grow together, makes it generally difficult to produce clear, simplified designs in photographs. Even pictures of trees *en masse* usually benefit from a definite visual structure – in a woodland interior view, this means the photograph must have a distinct focus of attention. An important first stage therefore is to find good and accessible specimens, whether individual trees or complete stands, and for this some knowledge of natural history is useful. At the least, it helps to be able to judge the standard and condition of a particular species.

For individual specimens, a clear view is valuable, and some means of isolating it visually. This isolation may be through viewpoint (against a relatively plain background), setting (a tree standing apart from the edge of a forest), or lighting (for example, sunlight picking out one individual).

For masses of trees, shooting across an open space, such as a river or from one hillside to another, is a standard procedure. In this kind of shot, the texture and pattern is more important than the shapes of individual trees and the whole effect is almost graphic. Lighting and colour are therefore key ingredients. Forest interiors are more difficult, but often helped by overcast light (which reduces the contrast) and a wide-angle lens. A tripod and time-exposures may be necessary in such low light conditions.

FOREST INTERIOR *Although the interior of a tropical rainforest can be very impressive in its silence and gloom, it is normally too dense and confusing to make a good overall view. One answer is to use a wide-angle lens and photograph the canopy from ground level. This regal Ité Palm acts as the focus of the shot to add symmetry to the composition.*
Nikon, 28mm, Agfachrome, ¼ sec, f4.

WILDFLOWERS AND SMALL PLANTS

Photographing small plants, fungi and flowers involves mainly close-up techniques, and a macro lens, or at least a close-focusing lens, is the most common equipment. At this scale, movement of the subject can be a problem but the plant can be protected from gusts of wind by makeshift shielding. So time-exposures are quite feasible. Unlike insect photography, which also needs close-up methods, the choice of flash lighting can be made for its visual effect rather than from necessity.

Photographing flowers by natural light usually calls for long exposures both because many flowers grow in the shade, and because very small apertures are often needed for good depth of field close-up. A tripod is essential but as most small plants are ground-dwellers, the most useful types of tripod are a pocket tripod, a regular tripod with wide-spreading legs, or a regular tripod with a reversible centre column. With colour film, long exposures cause colour shifts due to reciprocity failure, and the appropriate colour compensating filters are part of a field photography kit for flowers.

Flash can be used to simulate sunlight, to fill in shadow detail in a natural-light shot, or simply to provide basic, overall lighting. In conjunction with a tripod, one or more flash units can be used off the camera with cable extensions for a variety of lighting effects. Holding the flash over the plant imitates sunlight; aiming it through a sheet of diffusing material gives more even lighting with softer shadows.

The most common types of plant photography taken on location are full-frame portraits, very close details of parts of the plant, and 'environmental' shots of plants in their wider settings. Consequently, although a standard close-focusing lens is basic, different focal lengths have their uses.

ORCHID *One solution to the problems of a confusing background is to close right in on the flower (below), so that it fills the frame completely. Inevitably, at this magnification parts of the flower will be out of focus, but if the composition is effective, this need not be a disadvantage.*
Nikon, 55mm Macro, Kodachrome, f32.

FOREST LIGHT

Interior forest views are among the most difficult to carry off successfully. One obvious difficulty is that the tangle of density of vegetation tends to produce a messy and confused image, but this is compounded by the high contrast from bright sunlight. The chiaroscuro effect obscures detail and, for a typical scene, colour film has insufficient contrast range to keep shadow and highlight detail (printing controls and a soft paper grade give a slightly better result with black-and-white film). In this kind of light, the usual technique is expose – and compose also – for the brightly lit areas, leaving the shadow areas black. Often a framed view, looking past dark, silhouetted branches and trunks to a path of sunlight, is the most successful. Easier still, however, is to photograph on a cloudy day, when the contrast range is lower, and more even colour and tone help to blend the different elements of trees, shrubs and so on (below).

CALADIUM LEAVES *These large caladium leaves were shot against the sky after a rain shower. Backlighting and a close viewpoint emphasized the characteristic veining of these plants.*
Nikon, 55mm Macro, Ektachrome, 1/60 sec, f3·5.

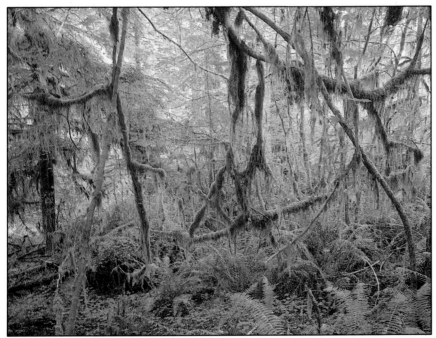

FASHION PHOTOGRAPH FOR BRITISH *VOGUE*
(April 1950) *The model is Norman Parkinson's wife Wenda Rogerson. She is dressed in Molyneux's caramel satin evening dress against a 1907 Silver Ghost in the Rolls Royce* showrooms. *The use of a silver Rolls to show off the luxury of the satin dress is a good example of Parkinson's restrained yet sumptuous use of colour where the subject requires it. The inclusion of a red rose in the* model's hand is the only concession to an *otherwise rich monochromatic colour scheme. The photograph was taken with a Linhof studio camera on ½ plate Ektachrome daylight film.*

PART FOUR

THE GREAT PROFESSIONALS

PERHAPS the greatest achievement for any photographer is to evolve a style of work which is instantly recognizable. The number of photographers who have managed to do so in the 150 years since William Henry Fox Talbot invented the negative/positive method of photography is really extremely small. And it's getting harder.

We owe a great deal to the pioneers of photography, such as Julia Margaret Cameron who set out to photograph the greatness of the man within the man, and Eadweard Muybridge who brought us new understanding of the sequences of movement and hence of life. What we tend to forget is how difficult, how time-consuming and how technical photography was in its youth. Emulsion speed was incredibly slow by modern standards, with an exposure of several seconds needed for a portrait. It was an accomplishment for both photographer and sitter to produce a portrait with any degree of sharpness, showing fine detail let alone conveying the personality of the sitter.

Ansel Adams was and is unquestionably the world's most famous landscape photographer who evolved his zone system of exposure control as a route to perfect negatives and perfect prints. The detail he managed to record through his painstaking attention to detail may make some of Bill Brandt's pictures seem heavy handed and very contrasty at first glance, but Brandt's harsh printing technique was perfectly suited to conveying atmosphere, and he is rightly regarded as one of Britain's greatest.

In a long and illustrious career, the 'decisive moment' has been the watchword of Henri-Cartier-Bresson who has become the guru of candid portrait photography. His lesson is that the seeing eye can compose a harmonious composition in a split second, and anticipate the precise moment to press the shutter. Today's photographer may use a motor-drive and still not get one picture as decisive as a Cartier-Bresson, plus the candid nature of the photography would be destroyed: Cartier-Bresson has taken most of his photographs by discreet use of a Leica rangefinder 35mm camera.

No photographer could claim to have achieved more style than Norman Parkinson, or 'Parks' as he is affectionately known. He evolved an elegant style of fashion photography which says more about beauty than many so-called glamour photographs. His career has spanned five decades.

Snowdon earns the admiration of many for his love affair with natural light, even for studio portraiture when all around him are using flash. He also has little time for gadgetry in photography, and admits that he often asks an unsettling question of his sitter to get a truth of expression and personality which would otherwise remain masked.

These and other great photographers have many lessons to teach the aspiring novice, not least that experimentation and the occasional happy accident, such as Man Ray's discovery of the sabbatier effect in monochrome printing, can lead to new ways of seeing, and new ways of making a memorable photographic statement. With a sound knowledge of photographic technique as your foundation, it is for you to find the way to express your feelings and opinions in your chosen medium. Photographs are not taken with cameras, they are taken with eyes and brain.

JULIA MARGARET CAMERON
British/1815–1879

'I hope to be recording faithfully the greatness of the inner as well as the outer man.'

Born in 1815 and raised in India, married at 23 to a rich and highly placed English administrator in that country, Julia Margaret Cameron had always been surrounded by servants and had probably never done any kind of physical work, even housework. Yet in her late forties she was to take up – and master – that most difficult, dirty and cumbersome of nineteenth-century hobbies – photography.

After Charles Cameron's retirement to the Isle of Wight he and his wife often returned to their property in Ceylon. During one such visit, late in 1863, his daughter (also called Julia) and her husband gave Mrs Cameron a camera to occupy her loneliness. A typically Victorian wooden box-like affair, it had a French 'Jamin' lens, with a focal length of 12in and a fixed aperture of about f·6 or f·7. Such a lens would have made it virtually impossible to get a whole portrait on the 11 × 9in plate sharp, but that did not matter to Julia Margaret Cameron: '. . . when focusing and coming to something which to my eye was very beautiful I stopped there, instead of screwing on the lens to the more definite focus which all other Photographers insist upon.'

Mrs Cameron worked hard at her new hobby. She had to teach herself to mix chemicals from the jars which stood in her improvised darkroom; to spread the resulting treacle-like 'wet collodion' over a polished glass plate; to put this in a holder and take a photograph

LA MADONNA RIPOSATA (RESTING IN HOPE)
(albumen print/1866) *Mary Ann Hillier, daughter of a Freshwater shoemaker, lived in the Cameron household as a maidservant for 13 years, and was probably photographed by her mistress more often than any other model. This is one of many religious studies in which Mary assumed the role of the Madonna. The child is Percy Keown, youngest son of a Master Gunner at the nearby Coastal Artillery fort.*

CARLYLE LIKE A ROUGH BLOCK OF MICHAEL ANGELO'S SCULPTURE (albumen print/1867) *Mrs Cameron took this photograph of the eminent historian and lecturer at Little Holland House, London, 'to which place I had moved my camera for the sake of taking the great Carlyle'. Though she also took a profile on the same occasion, the full-face portrait is one of the most powerful portraits ever taken by her – or any other photographer.*

while the solution was still damp (when dry, it lost its photo-sensitivity); to develop and fix the negative with other home-made formulae; and from it, to make a print. None of this was easy for a clumsy Victorian lady of her age and, to the end of her career, Mrs Cameron's negatives were often uneven and carelessly developed.

At last, on 29 January 1864, Mrs Cameron overcame the pitfalls of the awful process. Her first portrait, of nine-year-old Annie Philpot, still survives, as does a proud covering note: 'Given to her father by me . . . My first perfect success in the complete Photograph . . . This Photograph was taken by me at 1 pm Friday Jan. 29th. Printed – toned – fixed and framed and given as it now is by 8 pm on this same day.' In those seven hours, Mrs Cameron had started her climb to becoming one of the greatest portraitists of the nine-teenth-century.

However hard and successfully Mrs Cameron worked, she would never have achieved fame had it not been for the fact that her friend and neighbour in Freshwater was Queen Victoria's Poet Laureate, Lord Tennyson. Tennyson soon submitted himself to Julia Margaret's camera and persuaded other celebrities to do the same. It was an ordeal. Professional portraitists were reducing the size of their plates and increasing the amount of light on their sitters in order to cut down exposure times. The *carte de visite* was the universal 1860s portrait, tiny (about 4 × 2¼in), often full-length and usually devoid of originality or character. Mrs Cameron's 11 × 9in photographs (later increased to 15 × 12 in) were 'close-ups', like those of the amateur photographer, David Wilkie Wynfield, who gave her her only lesson. She lit them from one side only (some of her profiles of Julia Jackson used only firelight), and she reckoned her exposure times in minutes rather than seconds. There is scarcely one of her pictures in which some sign of movement cannot be detected.

When Mrs Cameron was photographing Tennyson and his eminent friends, she hoped to be 'recording faithfully the greatness of the inner as well as the features of the outer man'. It was this, perhaps, which led her to take so many profiles. The Victorian 'science' of phrenology was at the peak of its popularity and she possibly felt that, by delineating the exact shape of the heads of writers, painters and scientists, she might distil the essence of their intellectual gifts. It was also presumably easier for them not to have to gaze at a great brass lens during the outrageously long exposures she demanded. Thomas Carlyle, however, outstared her camera triumphantly and *Carlyle like a rough block of Michael Angelo's* [sic] *sculpture* (1867) gains great strength and presence from his visible, almost tangible, willpower.

In 1875, the Camerons went to live permanently in Ceylon. Though Mrs Cameron took some photographs, mainly of Tamil workers on her husband's plantations, her time was mostly taken up with her family. Nursing her son Hardinge when he became ill, she herself caught a chill and died in 1879. An obituary in *The Times* recalled her outstanding portraits of Lord Tennyson. Sir John Herschel and Joseph Joachim, among others, describing them as 'the most picture-like photographs . . . which have been given to the world'.

PETER HENRY EMERSON
British/1856–1936

'The modern school of painting and photography are at one; their aims are similar, their principles are rational, and they link one to the other.'

Pedro Enrique Emerson was born in Cuba in 1856 on his father's sugar plantation. In 1869 he moved from Wilmington, Delaware, where he had been at school since the age of eight, to his mother's native England. He enjoyed a brilliant academic record as a medical student at King's College, London, qualifying in 1879, and studied further at Clare College, Cambridge, before returning to King's College Hospital as Assistant House Physician, a post won by competitive examination.

Peter Henry Emerson, as he now called himself, brought to photography an extraordinary personal energy which characterized all his endeavours. Like a comet moving across the rather dull sky of late Victorian photography, the power of Emerson's vision – had by 1886 transformed the aesthetics of photographic picture-making.

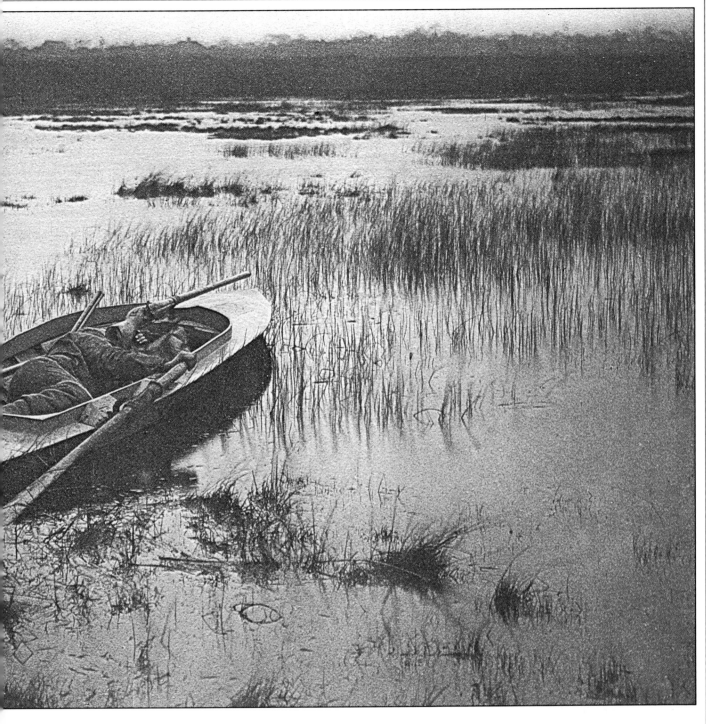

GUNNER WORKING UP TO FOWL
(platinotype/1886) *This picture appeared in the book* Life and Landscape on the Norfolk Broads. *Its co-author T F Goodall introduced the gunner as working his way up to a flock of birds on the Broads in the grey morning light which the tone of the plate so well renders.*

Emerson scorned the work of the fashionable English photographer Henry Peach Robinson, criticizing not only the artificiality of the poses used and his spurious sentimentality, but also Robinson's combination printing from multiple negatives. Emerson was in fact critical of all handwork, even re-touching, believing in the purity of the unmanipulated print and 'straight' photographic vision. Emerson's own credo was presented in *Naturalistic Photography,* his major theoretical work first published in 1889. Emerson was influenced by recent theories of colour and developments in French painting especially the work of the Impressionists. For Emerson, 'true art' involved a sensitive, accurate response to natural incident. Painting might be unsurpassed for its chromatic potential, but photography, so absolute in 'line' and faithful to tonal relationships, was the unequalled medium of artistic expression.

From his great burst of activity in 1885 and 1886, Emerson chose the pictures for his first four photographically illustrated publications: *Life and Landscape on the Norfolk Broads* (1886), *Pictures from Life in Field and Fen* (1887), *Idylls of the Norfolk Broads* (1894) and *Pictures of East Anglian Life* (1888). Although the common theme was the work and

environment of the East Anglian peasantry – and for this he must be considered one of the finest early documentary photographers – subject matter was always subordinate to style, and a number of distinct artistic attitudes make their presence felt.

In the abstract, undeniably modern image of *Gunner Working up to Fowl*, subject matter disappears, the image presents a dynamic form moving through an atmospheric space in a world generated solely from a narrow range of dark grey tones. The 'dark picture', later invented by Emerson, became a key element of the Photo-Secessionist style, though Emerson was critical of the pigment printing techniques the Photo-Secessionists used to achieve that end.

At the transitional point of his artistic development Emerson made a radical decision to use his technique of differential focusing – whereby only one plane in the field of vision is in sharp focus – for an interior shot, thus 'throwing away' the bottom third of the picture.

A WINTER'S SUNRISE (photo-etching/1895) (left) *At the outset Emerson explained Norfolk life. By 1895 he simply reproduced snatches of tales and descriptions of the changing seasons without seeking to instruct or inform. His implication is that things happen indifferently and that man has no option but to accept life as it comes.*

SNOW GARDEN (photo/etching/1895) (bottom left) *Emerson printed 16 images in* Marsh Leaves *in which he describes the return of spring. Occasionally his eye would settle on some marsh farm, seen behind a decorative fringe of reed tassel, palpitating in its blue envelope of transfiguring mist. In 1895 Emerson, increasingly fatalistic, found consolation in such incidental beauties as these.*

Two years after publishing *Naturalistic Photography*, in 1890 Emerson recanted his views in a pamphlet entitled *The Death of Naturalistic Photography*. The implications of certain experiments taking place concerning sensitometry – the precursor of the light meter – led Emerson to the curious conclusion that photography, being a purely mechanical process, could not aspire to the status of art, the point being that the photographer could not alter tonal values by an act of aesthetic will. Even in his finest and final work, Emerson incorporated outside artistic influences: *A Winter's Sunrise* bears a resemblance to works of the British landscape artist Samuel Palmer (1805–1881), while *A Snow Garden* resembles an oriental ink drawing.

WEEGEE
Polish-born American/1899–1969

'All over the world people ask me what is the secret of your formula? I just laugh; I have no formula, I'm just myself.'

'Weegee – the Famous', self-styled 'World's Greatest Photographer' would surely have elicited smiles of incredulity if encountered in the pages of cheap crime fiction of the 1930s or 1940s. Yet this larger-than-life character was for real – tough, cynical, cocky, shabby, but above all, human. His best photographs present a unique insight into the seamier facets of New York life. They are images of violence and tragedy, of hardship, suffering and the bizarre. They are very often photographs which required guts, tenacity and diplomacy on the part of the photographer, but Weegee was fearless, completely devoted to his task and he trod boldly and promptly where less assured photographers would so often have held back. They are photographs filled with life and emotion and Weegee's humanity provides the necessary counterpoint to his voyeurism.

Weegee, whose real name was Arthur Felig, came to New York as the son of poor immigrant parents at the age of 10. In a 1965 interview he recalled his early years in America: 'I had very little schooling . . . In them days you could quit school at 14, which I did, and went to work. One day, I saw an ad in the mail-order catalogue which I sent away for: a tintype camera, and I decided to go into photography.

After working in various studios and undertaking a period of darkroom work at Acme Newspapers in about 1920, Weegee struck off on his own as a freelance news photographer. He soon earned a reputation as the first on the scene, the first with the picture and story and he impressed editors with the strength of his work. In the mid-1930s *Life* magazine

TENEMENT FIRE (1942) *Weegee has captured the essence of a human tragedy by concentrating on the tortured faces of the two women whose loved ones have perished in the fire. Neither the flames, nor the destruction which they have caused are shown but the emotion on the faces of these two women tells the entire story.*

presented a feature on him, but the true confirmation of his reputation came in 1945 with the publication of his first book, *The Naked City*, an anthology of his best work, and with an exhibition of his work at New York's Museum of Modern Art.

The Weegee that will always be remembered is the pre-1945 Weegee, sleeping fully clothed, police radio by his pillow, ready to wake and respond to news of gangland killing or tenement fire; the unshaven, swearing, cigar-smoking Weegee whose car boot was his office and storeroom, complete with typewriter to crash out a story, spare film and flash bulbs. Photographic history has reserved a place for the Weegee who was friend of policemen and gangsters alike, who found sympathy for the losers, the freaks, the down-and-outs of the Bowery, the flotsam of society as well as the ordinary folks whom he

encountered in extraordinary situations. His greatest asset was his police radio and the exclusive privilege of having it installed in his car. His uncanny ability to arrive on the scene, often before the emergency services, is the explanation for his name. Weegee, derived from ouija board, regarded as a source of the psychic power of prediction.

Weegee's concern was subject, not style, though his images have a directness, a frankness which is unmistakably his; and his beloved subject was people, caught off-guard.

Weegee kept no secrets. In *The Naked City* he explained his equipment and techniques. 'The only camera I use,' he wrote, 'is a 4 × 5in Speed Graphic with a Kodak Ektar Lens in a Supermatic shutter, all American made. The film I use is a Super Pancro Press Type B.' He continues to explain in great detail the stops he uses for different distances and that he always uses a flash bulb for his photographs, regardless of whether it is day or night. Weegee would never waste endless sheets of film where one timely exposure could suffice and his system of working to a fixed focus meant he was always ready for that timely shot. 'All over the world,' he said in the 1965 interview, 'people ask me, what is the secret of your formula? I just laugh; I have no formula, I'm just myself, take me or leave me. I don't put on an act. I don't try to make a good or bad impression. I'm just Weegee.'

LASZLO MOHOLY-NAGY
Hungarian/1895–1946

'Photography as a presentational art is not merely a copy of nature. This is proven by the fact that a 'good' photograph is a rare thing.'

The illiterates of the future, said László Moholy-Nagy in 1928, will not be those who are ignorant of writing but those who are ignorant of photography. Of all the great photographers it was Moholy-Nagy who had the greatest hopes and ambitions for the medium. As someone who worshipped the modern world, he saw photography as its first great art form, an art form which could not have existed outside the modern world. He had no time for the 'clickers' or 'shutter snappers' as he called those photographers who were content to try and capture a moment in time. He accused them of trying to imitate painters. For Moholy-Nagy the photograph should be carefully considered and thought about. Above all, the camera should be itself and should not pretend to be an extension of the human eye.

Born in 1895 in Hungary, Moholy-Nagy went to Germany as a young man. During the 1920s, while he was working at the Bauhaus, Moholy-Nagy undertook an extensive series of photographic experiments. The Bauhaus preached the importance of materials exclusive to the modern world, the importance of technology and progress. Not only did Moholy-Nagy experiment with new materials, he also searched for new ways and directions in which to develop the photograph.

What made photography different from other art forms for Moholy-Nagy was that it dealt with light directly and not at second hand. Indeed. the photograph could be said to be made entirely of light, or rather the result of the action of light on light-sensitive paper. The 'reality' which other photographers searched for was illusory; only the light itself was real. A photograph is not made up of fragments of light. The camera, he said, 'is constructed on optical laws different from those of our eyes'. Photography has its own laws and effects and should not be judged on the laws of other media.

The photogram was Moholy-Nagy's key to a real awareness of what a photograph was. In these photograms he worked directly onto photographic paper, manipulating the light at first hand and doing away with the camera altogether. His first experiments took place at the beginning of the 1920s and he described them as primitive attempts. Using lenses and mirrors he passed light through assorted fluids like water, oil and acids, and cast it directly onto the sensitive plate. The self-portrait of Moholy-Nagy and his first wife, Lucia, was produced later when he began to experiment with daylight paper and watched how the sun would darken the paper around the forms he introduced between itself and the light source. The results were in fact a series of negatives. Moholy-Nagy liked the original brilliant white of the paper and the sharp contrasts he achieved with the deep blacks. He also enjoyed the 'differentiated play of light and shadow' which could be achieved by photography without a camera.

THE CRITIC (1943) *This is Weegee's most celebrated photograph. Two ageing socialites arriving at New York's Metropolitan Opera House, are caught in the harsh light of the photographer's flash gun. Their smugness and the almost caricatural opulence of their jewels contrast with the pinched expression and poor clothes of the woman who watches them.*

These photograms could in fact be developed but the photographer felt that the posit-ives were spoiled by 'harsher, frequently ashy grey values'. The permeating light effects, the deep silhouettes which he created, tended to be flattened in the positives. In many ways these photograms are closer to the abstract paintings he was producing at the time than they are to traditional photography. But by treating the photographic paper as a clean sheet on which he could make sketches with light, he opened up the way for photographers alike to work more directly with light.

Just as he continued experimenting with the photograms, so Moholy-Nagy found him-self dissatisfied with 'realistic photography'. He began using multiple exposures and building up his images in layers. Even with his most traditional photography, produced as illustrations for such books as John Betjeman's *An Oxford University Chest* or Mary Benedetta's *The Streetmarkets of London,* he refused to be tied by photographic conven-tion, by conventional perspectives and light effects, by conventional viewpoints and angles. There was no room in the modern world for Renaissance perspectives; the modern photographer could look down on the world from an aeroplane or a skyscraper. There was no need for the top of a building to disappear into the distance if the photographer could reach its roof by the lift. Renaissance perspective was full of unattainable goals, symbolized by the speck on the horizon. For Moholy-Nagy there were no unattainable goals. Everything could be reached in stages.

His theory of simultaneous complexity, of the camera's abililty to focus on everything at once, is best illustrated in his description of a shop window, much like the window of the Bexhill Pavilion, seen from a car: '. . . the windows of this car are transparent. Through them one sees a shop, which in turn has a transparent window. Inside, people, shoppers and traders . . . in front of the shop walk passers-by. The traffic policeman stops a cyclist. One grasps all that in a single moment, because the panes are transparent and everything is happening in the line of sight . . .' According to Moholy-Nagy the growth of the modern city and the technical developments which encouraged it, had sharpened the city dweller's senses but only the camera could really take in all this information at once.

As a painter and sculptor as well as a photographer. Moholy-Nagy, like Man Ray, brought an awareness of current artistic activity to photography. The emphasis on move-ment in his work (he was one of the first to use long exposures so that a car's journey was preserved as an unbroken trail of light) was inherited from the Futurists. The combination of metal and glass which could be found in modern architecture, like the Bexhill Pavilion, allowed him to see right into a building and out the other side, just as you could with his Constructivist sculpture. Yet he also pioneered the use of scientific photography which enabled him to look inside a beehive and photograph a drone clinging to a honeycomb.

Maholy-Nagy worked in so many styles at once, made so many different experiments, that he seemed to embody his own theory of simultaneous complexity. His photoplastics, or photomontages as he later called them, were yet another attempt at showing how the photograph could keep track with everything happening at once, his 'railway track of ideas'. Above all in these stirring, satirical collages he wanted to show how 'imitative' photography could be cut into little bits and then reassembled as something more purpose-ful and creative.

MAN RAY
American/1890–1976

'I paint what cannot be photographed, something from the imagination . . . I photograph the things I don't want to paint, things that are already in existence.'

Man Ray was an artist who felt free to use both photography and painting as media to express his dreams and fantasies. Unwilling to restrict himself to one or the other, he often said, 'I paint what cannot be photographed. I photograph what I do not wish to paint.' His willingness to break the rules and investigate darkroom accidents enabled Man Ray to develop several inventive photo-graphic techniques.

PHOTOGRAM (c.1930) *Moholy-Nagy believed that photograms like this one reflected the 'unique nature of the photographic process' and were 'the key to photography', because they dealt so directly with light. Such photograms were produced by shining light onto ordinary objects, placed on sensitized paper and they allowed Moholy-Nagy to experiment with abstract designs.*

HANS ARP (c.1930) *This portrait (above) with its strong use of light and shadow, is a typical example of the many that Man Ray made of influential artists and friends. Man Ray came into contact with the French sculptor through his associations with the Dada movement.*

Man Ray's origins are slightly mysterious. He was born in Philadelphia, Pennsylvania, possibly as Emmanuel Rudnitsky, in 1890 and at the age of seven decided to become an artist. After briefly studying architecture and engraving, he went to New York where he attended life drawing classes and began to frequent Alfred Stieglitz's gallery '291' where he saw work by the most progressive painters and photographers of the day, responding to the new ideas with enthusiasm.

One of Man Ray's closest and most influential friendships began in New York, with acquaintance of Marcel Duchamp, a young French artist whose Dadaist paintings and constructions were to be among the most controversial works of the twentieth century. The two men remained close friends and collaborators until Duchamp's death in 1968.

Man Ray began taking photographs because he needed pictures of his paintings for the press and collectors and, rather than pay a professional photographer, decided to do it himself, buying a camera and the filters necessary to translate colour into black-and-white. The results were excellent, and, as painting was not proving especially remunerative Man Ray began to photograph other artists' work and portraits.

After mastering the camera, Man Ray discarded it temporarily, in order to try and combine painting with darkroom techniques. Cliche-verre was a process developed around 1820 and used by, among others, Corot, Delacroix, and Millet. The original technique consisted of a drawing being scratched onto a smoked glass plate with a needle. This was contact-printed onto a sheet of light-sensitized paper. The clear outlines of the drawing appeared black on the paper, and any number of prints could be made. Man Ray adapted this technique by exposing a glass plate negative to light and then scratching his drawing onto the negative's emulsion, sometimes drawing directly onto previously exposed negatives. His earliest Cliche-verres date from 1917, and he returned to the technique several times over the years.

Man Ray left New York in 1921 and settled in Paris. He aligned himself with the Dada and Surrealist movements and took part in numerous exhibitions and publishing ventures. In order to support himself he began to take on commercial assignments, becoming a successful, highly paid portraitist, and also doing some fashion work. Several photographers who were to become well-known worked as Man Ray's assistants including Berenice Abbot, Bill Brandt and Lee Miller. His sitters came primarily from the art world and included painters and sculptors like Picasso, Leger, Braque, Derain, Matisse, Gris, Brancusi, and Giacometti; and writers and poets such as Virginia Woolf, T S Eliot, Joyce, and Hemingway.

Although Man Ray usually controlled and planned portrait sittings according to his vision of the individual involved, he occasionally found it difficult to dictate to his subject. One such case was a session with the Marchesa Casati, a formidable aristocratic poetess. Summoned to her hotel, Man Ray set up his equipment and immediately blew all the fuses. Having to work only with the available dim lighting, he asked the Marchesa to hold still for the long exposures needed. She failed to do so and her portraits, which Man Ray considered a total failure, were blurred. Demanding to see them, the Marchesa declared that one of the photographs, in which she appeared to have three pairs of eyes, was a portrayal of her soul and ordered dozens of prints.

In 1921 Man Ray made a fruitful discovery. While developing some fashion photographs for the designer Paul Poiret, he accidentally put an unexposed sheet of paper into the developer. After several minutes no image had appeared, and, placing a funnel, measuring jug and thermometer on the wet paper. Man Ray turned on the light. An image of the silhouettes of the objects appeared against a dark background, slightly distorted due to the varying diffusive qualities of the light through the objects. Man Ray achieved dimension and tone with multiple exposures and by varying the distance of the object from the paper.

Excited by the possibilities of his new discovery, Man Ray began to create his 'Rayographs', as he later called them, using all sorts of different objects. Bits of paper, nails, a gun, gyroscopes, parts of the human body – all were subject to his whims; and as Man Ray said, 'Everything can be transformed by light. Light is an instrument as subtle as the brush.' The Surrealists were greatly excited by his 'Rayographs', and suggested that he publish some of them in a portfolio. Thus in 1922, *Les Champs Délicieux* was published in book form.

Another darkroom accident prompted Man Ray's use of the Sabattier effect, or solariza-

LEE MILLER (1930) Man Ray's use of the Sabattier effect, in which light and dark tones are reversed, was inspired by an accident in his darkroom. He applied it most effectively in this portrait of Lee Miller (below). She was a young American who worked as Man Ray's assistant for several years and then went on to become a successful photographer herself.

tion, which is achieved by re-exposure of a negative or print during development. The re-exposure causes a reversal of light and dark tones, and creates a dark line around the subject's contours. Man Ray used the technique brilliantly but sparingly in portraits, nudes, and still-life studies, producing subtle variations in tonality.

Man Ray left Paris in 1940, with the coming of the German Occupation, and went to Hollywood, California, where he remained until 1951. He then returned to Paris where he lived until his death in 1976. Technique was of little interest to Man Ray, what counted was the end result. A sense of play, of magic and a fascination with visual perception characterizes all of his work.

'Steichen influenced me in a particular way: he forced me to use a different camera, an enormous camera, not my little Kodak.'

Born into a privileged milieu, Cecil Beaton was well-placed to record the styles, fashions, and concerns of an influential era. Best known as a flattering portraitist of the upper classes, Beaton actually worked in many styles, often pursuing subjects which would seem to have little appeal for one so obsessed with fashion.

Beaton's favourite subjects were his two sisters, Nancy and Baba. In his pursuit of fantasy, elegance, and sophistication. Beaton utilized all sorts of household objects. He swathed his patient sitters in yards of lace, sheets, and oriental carpets, strewed flowers everywhere, and painted special backdrops to enhance the period settings. Although he could work for hours devising complicated costumes and environments, Beaton was confounded by the technical aspects of photography, and for much of his career he used only a simple box-camera.

The unconventional use of settings and props climaxed in the pictures he made of debutantes and celebrities. The special qualities of each sitter, be they beautiful or eccentric, were highlighted by the use of appropriate backdrops and points of view. Some of these portraits seem dated and unconvincing to the contemporary eye, but at the time they were a decisive break with the static conventions of the past.

Beaton's ability and desire to flatter knew no bounds. Truth in a portrait was purely subjective, and beauty could be conjured up with a re-touching brush. Unsightly bulges and mottled complexions disappeared instantly, and society matrons, with the help of Beaton's charitable art, were once again svelte and young.

In 1929, Beaton was finally on the verge of fulfilling his dreams of fame, success, and glamour. He was offered the opportunity to work for American *Vogue*, and in November of that year left for New York. After a disappointing start, Beaton portraits of luminaries such as Fred Astair and Gertrude Lawrence, began to appear in the pages of *Vogue*, and he was soon under contract to the publisher.

The years that followed found Beaton playing the role of court photographer to the 'smart set'. He photographed in Hollywood, where he met Greta Garbo, the great love of his life, and travelled wherever and whenever he could. When released from the confines of the studio, Beaton worked in a more instinctive manner, choosing to record offbeat,

HAT CHECK GIRL (1946) *After serving as a photographer for the Ministry of Information during the war, Beaton returned to the United States to continue working for Vogue. This image was one in the series in which he photographed bored, elegant mannequins in highly artificial sets. Beaton was able to create slickly, controlled, commercial images which were ironically devoid of reality.*

EDITH SITWELL (1962)
Among Beaton's favourite friends and collaborators were Edith Sitwell and her brothers. They were champions of his photography and the eccentric poetess, clad in flowing robes, would often pose in exotic settings for Beaton's camera. This portrait, concentrating on her unusual profile and her fingers heavily bedecked with rings, conveys her forceful personality.

sometimes surreal subjects. Beaton was summoned to France in 1937 to photograph Edward VIII and Mrs Simpson on their wedding day and two years later, was called upon to photograph Queen Elizabeth, the wife of King George VI. Throughout the years he continued to be the favoured portraitist to the British royal family.

Beaton was finally forced to use a more cumbersome and heavy 8 × 10in camera, which forced him to work in a more thoughtful way but gave greater clarity. He was now able to see exactly what the picture would look like on the ground glass camera back, and corrections in composition and perspective were much more easily made. Thus Beaton was able to make photographs which were better organized and less a product of chance.

The Second World War put an end to the glamorous world which Beaton and his friends had constructed. In 1940, having spent six weeks in New York on commercial assignments, Beaton returned to England where he was appointed photographer for the Ministry of Information. He was instructed to take pictures of London during the bombings, which were used for propaganda purposes both in Britain and abroad. During the war Beaton also photographed military operations in England, Egypt, and the Far East.

After the war, Beaton returned to commercial photography as a means of support. Working for *Vogue* in 1946 he created a series of fashion photographs entitled 'The New Reality'. The pictures were anything but realistic, showing chic models engaged in mundane tasks. Although the series was a great success, within several years Beaton found himself and his work out of date. He returned to his first love, the theatre, and won awards for his sets and costumes for the films *Gigi* and *My Fair Lady*.

In the 1960s and 1970s, Beaton once again aligned himself with youth and vitality, photographing friends like pop star Mick Jagger and artist David Hockney. He occasionally took on commercial assignments until he suffered an incapacitating stroke in 1974. A partial recovery allowed him to begin work again, and just before his death in 1980 he photographed the Paris collections for French *Vogue*.

NANCY BEATON (1926) *A fantasia rather than a true portrait, this picture of Beaton's sister is typical of much of his early work. Along with a faintly absurd head-dress, much use has been made of crinkled cellophane. Beaton took the portrait with a primitive Kodak box-camera which he often used throughout his career and from which he often coaxed astonishing results.*

HENRI CARTIER-BRESSON
French/born 1908

'We are passive onlookers in a world that moves perpetually. Our only moment of creation is that 1/125 of a second when the shutter clicks.'

Henri Cartier-Bresson was born in Chantaloup, France in 1908, originally studying painting until becoming seriously interested in photography in 1930. After travelling until 1936, Cartier-Bresson returned to France and became involved in film-making, making among others, a documentary on the Spanish Civil War. From the late 1940s, the name Henri Cartier-Bresson has been virtually synonymous with photography. His reputation was fully confirmed in 1952 with the publication of his first major book *Images à la Sauvette (The Decisive Moment)*. In 1955 *Les Européens (The Europeans)* was published, and in the same year his photographs were exhibited at the Louvre. Shortly afterwards came books on Moscow (*Moscou,* 1955) and China *D'Une Chine à l'Autre,* 1955 (*Photographs of China*).

Cartier-Bresson is a 'human interest' photographer, and was the first to give a full account of his practice. In his foreword to *The Decisive Moment,* he strongly emphasizes the importance of being in the middle of things, absorbed by events. He virtually disclaims responsibility and suggests that it is the events themselves which provoke 'the organic rhythm of forms'. According to Cartier-Bresson, a photographer able to work in unison with this rhythm will find a moment when form fits its subject matter. In this respect he is following Surrealist procedures; they too believed that the artist should be absorbed in the 'creative process' and carried along by the organic rhythm of forms.

At the same time, 'the decisive moment' had a prototype in photography itself. During the late 1920s, manoeuverable lightweight cameras such as the Ermanox and the Leica, which Cartier-Bresson uses, made possible a new and dynamic type of sports photography. Reporters scrutinized sporting events for 'the psychological moment' and watched for 'effort at the moment of maximum intensity'. These phrases are taken from the sports pages of *Vu* magazine, the French illustrated weekly paper founded in 1928, in which

PLACE DE L'EUROPE (1932) *A sprightly figure leaping lightly on a poster mocks this bulky figure about to lurch into the wet. Henri Cartier-Bresson delights in insight. Here, he shows that the marooned man has done his best even if hopelessly to escape the flood.*

BELOW *A classic and well-known photograph by Cartier-Bresson, this view of a family picnic on the banks of the Marne (1938) demonstrates this photographer's consistent ability to make cohesive compositions quickly from candid situations. Most of Cartier-Bresson's best-known photographs contain moments of action, as here, even if they are small ones such as pouring a bottle of wine.*

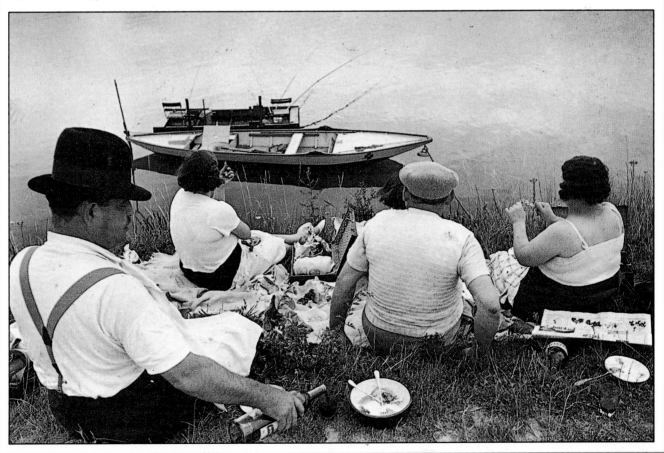

Cartier-Bresson published his first pictures. He took the idea of 'the psychological moment' and applied it to society at large, and, in so doing wrought a great transformation in the role of the photojournalist, who formerly had been expected to work according to well-established pictorial stereotypes. Surrealist beliefs, lightweight cameras and new ideas in sports photography all helped to liberate photojournalism. Cartier-Bresson also brings the peripheral into the foreground; he works with the audience rather than with the parade, and watches for incidental details which might be symptomatic of some greater cultural whole.

Moreover, Cartier-Bresson comes from a society which attaches importance to psychological realism in its art, and thinks in terms of insight into others. For example, the stories of the French realist writers like Guy de Maupassant show people as knowable, as possessors of secrets, aspirations and cherished habits. Cartier-Bresson's photographs are elaborate essays on this same understanding but in a different and newer medium. Some of his greatest pictures are extraordinarily revealing. One such, published wherever the photography of Cartier-Bresson is mentioned, is *Sunday on the banks of the Marne,* 1938. Two family groups picnic on the shelving bank of the river. They look towards the water and their elegant boat and, with their faces hidden, give nothing away. Yet the picture is redolent with clues. Costume, position and gesture all point to a rich story. The foreground figure, in a dark hat and braces, on a warm summer's day, is an embodiment of prudence, positioned towards the crest of the bank, safe from spillage and inconvenience.

Cartier-Bresson relishes such signs of prudence. His people manage as best they can, keeping their wits about them and avoiding difficult situations. They defer to uniforms and to Party bosses and, even when in the tender throes of love, make sure that lighted cigarettes are kept out of harm's way.

Cartier-Bresson's greatest achievement might well have been the creation, or at least establishment, of a particular image of France as a land peopled by singular personalities; crabbed and lined peasants, shrewd *bourgeoisie,* vivid children. During 1936 and 1937 he worked as an assistant director to the film-maker Jean Renoir in the making *Une Partie de Campagne* and *Le Règle de Jeu (Rules of the Game).* Renoir's vision of France, and of human nature, was in many ways very like Cartier-Bresson's.

Perhaps more importantly, Cartier-Bresson gave Europeans suffering from the ruination of war a rich vision of what settled domesticity could be like. His France is a land of milk and honey, vines and orderly farms. Moreover, it is a strongly traditional land in which café life flourishes and the business of small towns proceeds in a classical and undisturbed environment. Cartier-Bresson brought the same message from abroad, finding signs of worship, devotion and tradition wherever he went, be it China, India, Indonesia or the Soviet Union. Overseas, however, he had less access to psychological and social truths. In the East he found great formal beauty, but few of the intensely revealing signs which mark his French pictures.

BRASSAI
French/born 1899

'I want my subject to be as fully conscious as possible – fully aware that he is taking part in an artistic event, *an act.*'

Exciting, charged with creative energy, a place which draws artists from all over the world, Paris has served as inspiration for many great talents. Brassaï, born Gyula Halász in Transylvania, Hungary, has been described as the 'eye of Paris' by his friend Henry Miller, having adopted the city as his own in 1923. After studying painting in Budapest and Berlin, at the age of 24 Brassaï went to Paris where he quickly established close friendships with other artists and writers. Fearing that his given name was too difficult to pronounce, he changed his name to Brassaï, in honour of his native town Brasso, when his first essays were published.

Brassaï's early years in Paris were unconventional. Fascinated by city life after dark, he spent the days sleeping and walked all night; he wandered over all of Paris, savouring the

THE BANKS OF THE LOING (SEINE ET MARNE) (c.1965) *Photographers did not invent a modern idea of Frenchness all by themselves. They were part of a movement which included film-makers René Clair and Jean Renoir. Yet they were enormously important in establishing an idea of the French as a fundamentally traditional people, under their modern trappings. Cartier-Bresson's city men attend absorbed to their angling, despite the imminent ruination of a pair of shoes.*

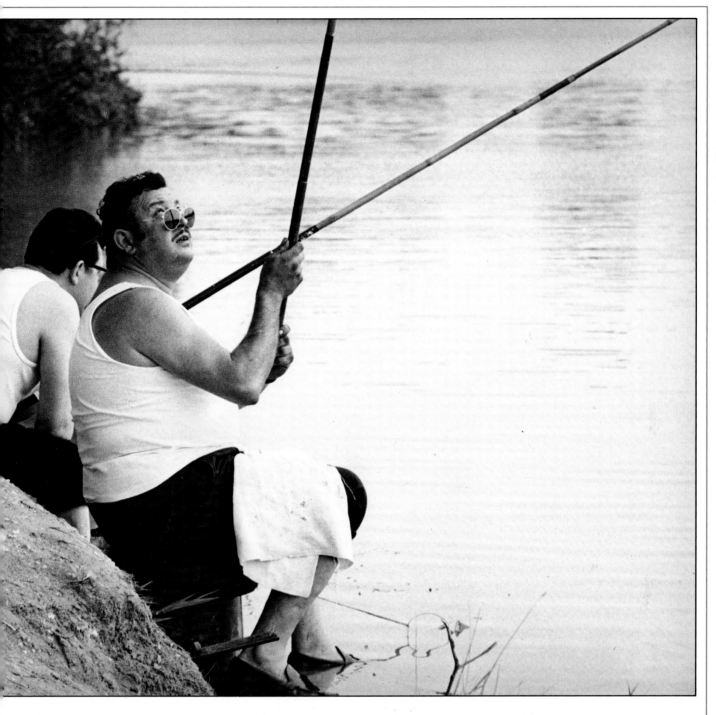

hidden areas, drawn to an unfamiliar way of life which flourished only under cover of darkness. Although he had previously scorned photography, Brassaï soon realized that the camera was the ideal means with which to capture the fantastic scenes he observed on his nocturnal rambles and, encouraged by Andre Kertesz, he began to photograph the underworld in about 1930.

Sometimes with a friend, but usually alone, Brassaï photographed prostitutes, transvestites of both sexes, lovers, sewer cleaners, and street toughs. He went backstage at the Folies-Bergère, attended the annual *Bal des Quat'z Artes,* and even accompanied cesspool cleaners on their midnight rounds. Brassaï believed that the customs and activities he observed were rooted in traditions reaching far back into the city's past and he was fearless in his pursuit of the elusive characters who peopled this secret society. Access to their world was very often difficult and dangerous. He was threatened, had his wallet stolen, and on one occasion, after a particularly successful night of picture-taking at a dance hall, his bag filled with exposed negatives disappeared.

Using a 6·5 × 9cm Voigtlander camera on a tripod, Brassaï made his nocturnal photographs with a flashbulb if the available light was too dim. Today night photography is

nothing special, but in the 1930s it was considered impossible. By these simple means Brassaï made a collection of images which recreate, with unsurpassed intimacy, a world beyond the tourist's grasp. A collection of these, *Paris de Nuit (Paris by Night)* was published in France in 1933.

Brassaï's approach to photographing people was never devious or concealed. He regarded the taking of a photograph as an artistic event and wanted his subjects to be fully aware of the act. He encouraged complicity and disagreed with those who sought to catch their subjects off-guard. In a radio interview, discussing his technique, Brassaï said,

PICASSO, RUE DE LA BOETIE (1932) *Like Brassaï, Picasso was inspired by Paris and he lived and worked there for many years. Here, the photographer has captured Picasso in an informal pose, with a cigarette in his hand. The lighting focuses the viewer's attention onto his face rather than onto the cluttered background of paints and palettes.*

'When I do a picture of someone, I like to render the immobility of the face, of the person thrown back on his inner solitude. The mobility of the face is always an accident . . . But I hunt for what is permanent.'

Although his photographs function on one level as documents, Brassaï has never seen himself as a photojournalist or documentarian. In an interview in 1976 he explained that a reportage photograph was usually shown with an explanatory caption and unable to stand alone. For Brassaï, 'The structure or composition of a photograph is just as important as its subject. This is not an aesthetic demand but a practical one. Only images powerfully grasped – streamlined – have the capacity to penetrate the memory, to remain there, to become, in a word, unforgettable. It is the sole criterion for a photograph.' Brassaï's images are carefully composed and fully utilize the expressive possibilities of light and shadow.

Like many of his colleagues, in order to support himself, Brassaï occasionally took on commercial assignments. In 1938 he began to work for the American magazine *Harper's*

PROSTITUTE PLAYING RUSSIAN BILLIARDS
(c.1932) *Brassaï used a camera on a tripod and artificial lighting to take this photograph of a prostitute in a bar on the Boulevard Rochechouart in Montmartre. Her bold glance and open-faced acknowledgement of the photographer's presence exemplifies the rapport which Brassaï achieved with his subjects.*

Bazaar where he was originally asked to photograph fashion but refused. Instead, he made portraits of prominent cultural figures, and made a series of pictures of artists in their studios.

Brassaï's talents and interests are varied. He spent 25 years collecting photographs of wall graffiti, and in 1960 published *Graffitti*, a book of 105 black and white photographs. His friendship with Picasso led him to produce two books, *Les Sculptures de Picasso* (Picasso's Sculptures) (1948) and *Picasso and Company* (1966).

Although he has excelled at everything he has turned his hands to, it is Brassaï's belief that photography has been his best means of expression. His photographs of an older, different Paris – many of which remain unpublished and unknown to the public – are unique in the history of the medium. The personalities and events of Brassaï's Paris live on.

BILL BRANDT
British born/1904–1984

'Composition is important but I believe it is largely a matter of instinct . . . I feel the simplest approach can often be the most effective.'

Brandt stands out as arguably one of the greatest forces in twentieth-century photography. His work is multifarious, covering all aspects of image-making; yet throughout, his photographs maintain a strong individuality in both technique and composition.

Born in London in 1904, Bill Brandt lived part of his youth in Germany and Switzerland, and it was not until his early twenties that he became interested in photography. Strongly attracted to the school of modern French photography which had just been accepted by the Surrealist movement, Brandt went to live in Paris where for a short period around 1929 he became a student at Man Ray's studio. The photographers he particularly admired at this time were Atget, Man Ray, Brassaï and, later, Cartier-Bresson and Edward Weston.

In 1931 Brandt returned to London, and, until the beginning of the Second World War, set about chronicling the various social stratas that made up the English class system. In *The English at Home,* 1936, a complete resumé is given of the English people and their environments, from the Depression-torn existence of the working classes in London's East End and northern mining communities, to the lavish excesses of the aristocracy.

Throughout these images there remains an integrity for the subject far beyond mere reportage. Adding to the dramatic content, strong, deep blacks begin to appear in Brandt's photographs, brought about by full printing on high contrast papers. On printing Brandt was later to write in *Camera in London:* 'Intensification of my effects is often done in the process of printing. Each subject must determine its own treatment. I consider it essential that the photographer should do his own printing and enlarging. The final effect of the finished print depends so much on these operations.

During these pre-war years Brandt contributed to various international publications including *Illustrated, Picture Post, Verve* and the Surrealist magazine *Minotaure.* In 1938 his first one-man show was organized by the Arts et Métiers Graphiques, resulting in his second book *A Night in London,* published the same year.

Between 1940 and 1941 Brandt was commissioned by the Home Office Records Department to record the effects of the blackouts on London and its inhabitants. By moonlight he photographed the city skyline with the dark silhouettes of buildings precisely delineated by exposures of 20 or even up to 30 minutes; the large terraced buildings and people in the Underground air raid shelters and basements. The photographs were published by the magazine *Lilliput* in 1942.

The 1940s also heralded many of Brandt's finest landscapes, *Top Withens, West Riding, Yorkshire,* the setting for Emily Brontë's *Wuthering Heights,* taken in the depths of a 1945 winter, is no accident of composition. The wild, threatening sky and frosted gale-blown grasses encapsulate perfectly the tensions of Brontë's novel and underline Brandt's careful sense of timing. Brandt would explore and contemplate the correct setting for his landscapes before attempting a single shot, returning to a venue months or years later to

FRANCIS BACON WALKING ON PRIMROSE HILL, LONDON (1963) *Fully printed on high contrast papers, as with many of his images, the dramatic effect of Brandt's portraits of mid-twentieth-century writers, artists and poets is heightened by the fact that he rarely shows his subject smiling.*

NORTHUMBRIAN MINER AT HIS EVENING MEAL
(1930s) *During the 1930s Brandt chronicled all
aspects of the English class system and these
photographs were published in 1936 in this first
book* The English at Home. *Although not
reproduced in the book, this image is typical of
his early portraits. Brandt was not against his
sitters being aware of his presence or even for
them to adopt a formal pose. He was concerned
however that the subjects and their
surroundings should harmonize.*

achieve the correct elemental conditions. Brandt feels that, for him, composition is largely
a matter of instinct, and to follow the 'rules' is to limit the imagination. On seeing his
subject, Brandt has a definite, preconceived idea of the effect he wishes to achieve. This,
in turn, determines his approach, as he states in *Camera in London:* 'To give the impression of
the immensity of a building, I approach close to some small architectural detail, photo-
graphing it from such an angle that the lines of the building run into the far distance, giving
a feeling of infinity. I may want to convey an impression of loneliness of a human figure in
an outdoor scene. Taking that figure close to the camera and on a path stretching away
behind him to a distant horizon intensifies the effect of solitude.' Brandt feels that the
simplest approach is usually the most effective and that a subject is most forcibly presented
when set squarely in the picture frame, without fussy or distracting surroundings.

Throughout his career, Brandt compiled a large selection of portraits of contemporary
poets, writers and artists. He always tries to locate his subjects in surroundings synonym-
ous with their work, achievements or life-style, and some of his earliest portraits done in
the 1940s and 1950s – Dylan Thomas, Robert Graves, E M Forster, Edith and Osbert
Sitwell, Graham Greene and Henry Moore – clearly illustrate this point. Printed with high
tonal contrast, the dramatic effect in these portraits is emphasized by the fact that Brandt
would rarely photograph his subjects smiling or laughing, preferring them to concentrate
on the more serious aspects of life. There is no set format for positioning the sitters in his
portraits, for example those of Georges Braque, Jean Dubuffet or Francis Bacon present
the sitter towards the extremities of the picture, emphasizing background detail and giving
depth and perspective to the images. Using a Rolleiflex or Hasselblad, Brandt would shoot
12 shots in rapid succession, not allowing his subject to adopt a stock pose, illustrating his
feelings that 'composition should never become an obsession'.

Marjorie Beckett writes of Brandt's portraits in Brandt's book *Shadow of Light* that
Brandt makes extensive use of rooms and backgrounds, working quickly and with intense

concentration. He seeks to capture more than a fleeting impression of a snapshot and 'thinks a good portrait should have a profound likeness'.

Inspired by Orson Welles' film *Citizen Kane* and its unusual use of interior sets, Brandt's fascination with rooms became a major force as a backdrop to many of his nude series of pictures. He acquired an old Kodak whole-plate angle camera and began photographing nudes in the mid-1940s. The camera, fitted with an extreme wide-angle lens, had what would seem to be a fairly limited usefulness in that it would exaggerate perspective by increasing the size of foreground objects disproportionately to those in the distance. And yet the photographer must have jumped for joy on the realization of these effects, after the first experiments with this camera. By masterful positioning of the camera, the model in these early pictures is wildly distorted into the confines of the environment. Using a less cumbersome Hasselblad, Brandt moved his model to a beach, blending the body's form to become an integral part of the landscape. In 1961 his book *Perspective of Nudes* was published, but this in no way marked the end of the project with *Brandt Nudes 1945–80* being his last book.

It is conjecture to label these images as extensions of Brandt's earlier associations with the Surrealist movement as the equipment used contributed, to no small extent, to the remarkably distorted effects. It is Brandt's overriding empathy with his surrounds and subjects, whether it be reportage, landscapes, portraits or nudes, that is the key factor behind his success.

ANSEL ADAMS
American born/1902–1984

'My approach to photography is based on my belief in the aspects of grandeur and of the minutiae all about us.'

Ansel Adams is the author of America's most stately landscape photographs. The best known of these may be *Moonrise, Hernandez, New Mexico 1944,* an image of a straggling village, church and cemetery on a dark plain backed by a distant mountain range, and all aligned in narrow bands under a vast sky. His images are mainly of the American West, of mountainous and unpeopled landscapes in California. Wyoming, New Mexico and Arizona. Sometimes his work has taken him further afield, to Alaska and Hawaii in 1947 and '48 to photograph National Parks, but his main subject has been Western landscape.

Other, and very distinguished, American photographers have worked with these same landscapes, most notably Adams' friend EDWARD WESTON, with whom he photographed in the High Sierra in 1937. Yet Adams' pictures have characteristics all of their own. He searched for, and achieved, largeness; he found forms which do justice to immensity. His horizons were distant, extended and topped by large skies. Often he underlined immensity by the inclusion of small but significant details on nearer ground; a horse, for instance, grazing by trees in a patch of sunlight under a range of jagged mountains, or the delicate buildings of Hernandez in their huge setting.

Adams worked with a special regard for balance. His America may be large and largely unspoiled, but it can hardly be described as wild. He found and showed terrain in which the severities of rock and snow are mitigated by the mildness of still water and vegetation. His skies only rarely open onto the infinite; mists and drifting clouds intervene and bring with them intimations of caprice and imagination. He envisaged America as something very close to paradise, rich in rivers, woods and wind-blown grass, and decorated by such natural beauties as that of the dawn light touching springtime woods.

Adams' photographs are in sharp focus, brilliantly realized. The images tend to depict microscopic details of stone, woodgrain, bark, ice, lichen and drifted sand. He called this 'a clean, straightforward approach to photography', but argued that it involves far more than technical exactitude. What it really does involve he is reluctant to say and the last time Adams associated his work with the term 'pictorial' was in January 1931 when he exhibited 'Pictorial Photographs of the Sierra Nevada Mountains' at the Smithsonian

BOARDS AND THISTLES (1932) *At the beginning of the twentieth century photographers made pictures of distinguished subjects which declared natural harmonies clearly. But in the 1920s, inspired by the new idea of 'photographic seeing', derived from the teaching of Alfred Stieglitz, they began to scrutinize commonplace material, arguing that, it too, if rightly looked at, was beautiful. Writing retrospectively in 1940, Adams stated that 'Stieglitz would never say that certain objects of the world were more or less beautiful than others – telegraph poles, for instance, compared with oak trees. He would accept them for what they are . . .'*

MOUNT MCKINLEY AND WONDER LAKE (1947)
In 1947 Adams photographed in National Parks in Hawaii and Alaska, where he pictured the landscape as big, beautiful and orderly. He mitigated bulk by distance, rock by water, and generally established spatial continuities across rippling prairie grass, the surfaces of lakes and the flanks of mountains. Yet at the same time as he celebrated the original landscape he made complicated pictures, like this in which he plays with a normal order of things, showing a white mountain in a dark sky, and matching snow in an even whiter lake.

Institution, Washington DC. By 1931 he was dissatisfied with his pictures from the 1920s and decided to begin all over again, committing himself to 'the simple dignity of the glossy print', putting aside textured photographic papers. He became, in his own words, acutely conscious of 'the continuous beauty of the things that are', and remained so.

In 1932 he helped found the well-known Group f·64, which took its name from the smallest stop available on a large format camera. At f·64 the aperture produced images with great clarity and depth of focus. The group of 11 photographers including Imogen Cunningham, Edward Weston and his son, Brett, exhibited only once together, in San Francisco towards the end of 1932, and continued to meet informally until 1935.

His writing in 1932 is that of a romantic who feels deeply in front of the earth's beauties: 'A spirit of unearthly beauty moved in the darkness and spoke in terms of song and the frail music of violins'. His photographs, such as *Boards and Thistles* – made in 1932 and exhibited at the f·64 show in that year – often invite a more dispassionate response. Adams wrote about this in an undated note, cited by Nancy Newhall: 'If I have any credo, it may be this: if I choose to photograph a rock, I must present a rock . . . the print must augment and enlarge the experience of a rock . . . stress tone and texture . . . yet never, under any conditions, 'dramatize' the rock, nor suggest emotional or symbolic connotations other than what is obviously associated with the rock.'

Photographic purism of the sort practised by Adams was a minority interest, supported in California and by the aged Alfred Stieglitz in New York. That the purist tradition in landscape survived and gathered strength into the 1950s is, in some measure, Ansel Adams' doing. After Stieglitz he is probably the most influential of all American photographers, as lecturer, technician and artist. Harry Callahan, a major artist in photography over recent decades, admits apropos his formative years: 'Ansel is what freed me.' He freed others too, and more importantly moved landscape to the centre of American photography, where it has remained more or less up to the present.

NORMAN PARKINSON
British born/1913

'I like to make people look as good as they'd like to look, and with luck a shade better.'

Born in 1913 Norman Parkinson's photographic career began in 1931 when he left Westminster School, London, to become apprenticed to the 'court photographer', Speaight of Bond Street. For the payment of a £300 premium, he learned the fundamental skills of photography, assisted in the darkroom, and focused the cumbersome studio camera, all for £1 per week. Parkinson served only two of his three year apprenticeship, because he felt restricted by the rigid techniques and unimaginative methods of the studio.

At the age of 21, backed by his great aunts, he opened his own studio at 1, Dover Street just off Piccadilly, London. Here he mounted his camera on wheels and devised a flexible arrangement of lights based on the system used in film studios; the moveable spots and floodlights could be angled to produce shadows and effects which made major and time-consuming re-touching of the finished portrait unnecessary.

Most of Parkinson's sitters were young debutantes, and although he experimented with specially constructed settings and backgrounds, after a short while the work became limiting and unsatisfying. Fortunately, in 1935 he was commissioned by the British edition of *Harper's Bazaar* to photograph a series of hat fashions out of doors. Parkinson bought a 5 × 4in Graflex for £17 and, finding freedom away from the confines of the studio, produced an entirely new concept of fashion photography which has since been called 'action realism'. This approach was pioneered by Martin Munkasci and Jean Moral, but as Parkinson was unaware of their work, he created his own instinctive style.

Parkinson's first photographs showed girls walking in pairs in Hyde Park, strolling past Buckingham Palace or striding purposefully up and down the streets of Edinburgh. His aim was to take moving pictures with a still camera and this approach showed fashion in a newly accessible and credible light. Parkinson's work contrasted sharply with the indoor,

JOHN HUSTON (1955) *Taken on assignment for* Vogue *magazine on the set of the film* Moby Dick, *which was being made in Britain at that time, this portrait was captured with a Rolleiflex and lit by a 2000 watt bulb which illuminated the scene from the top left corner.*

Parkinson took the photograph by positioning his camera at ground level to convey the massive looming presence of John Huston, who almost totally fills the composition, a study in intense concentration as he plays cards for high stakes with the film's stunt men.

flower-strewn concoctions of elegant artifice which had previously been the norm of studio work. 'My women behaved differently . . .' he recalls, 'my women went shopping, drove cars, had children, kicked the dog . . .'

In the 1940s, Parkinson's fashion photographs of models in natural settings such as railways stations, against London landmarks or in the Royal Crescent at Bath had a far-reaching influence on other photographers. His New York colour photograph *Park Avenue* showing a model in profile against the speeding blur of a yellow taxi set a trend in the United States for outdoor fashion photography. Over the years, the various locations used in Parkinson's fashion photographs have grown steadily more exotic, always keeping one step ahead of tourist hordes, with memorable locations including anywhere from the steppes of Russia to the arid deserts of Monument Valley in Utah.

Parkinson spent the war years working on his farm in Gloucestershire, which he combined with reconnaissance photography over France with the Royal Air Force. After the war, Parkinson began work for Conté Nast, specifically for the British and American editions of *Vogue*, to which he continued to contribute throughout the years. His work has also appeared in a wide variety of international periodicals such as *Life*, *Look* and *Town and Country*.

Gradually, Parkinson's style has become familiar through his use of a number of recurring trademarks. One favourite approach is to shoot *contre-Jour* (against the light) using a fill-in foreground flash. 'Most of the pictures I take into the sun, then I can control the light. Work the other way round and you're lost.' Another trait found in his earliest pictures which he still uses from time to time, is the placement of a blurred foreground figure at the edge of the composition which adds depth and increases the viewer's involvement in the scene. Parkinson's pictures always have spontaneity, lightness of touch, and frequently an

FASHION PHOTOGRAPH FOR THE COVER OF BRITISH *VOGUE* (March 1949) *The arrangement of the two figures both looking out of the picture frame in opposite directions produces an effective dynamic tension to the composition. The man in the background is deliberately out of focus to give the scene depth and to suggest an imagined storyline and relationship between the two figures. The handling of the colour and the use of a limited range of browns and white shows Parkinson's confident restraint and provides the ideal background to Wenda Rogerson's bright red lipstick which becomes one of the focal points. The photograph was taken in the Vogue studios using natural light.*

amusing scene taking place in the background; the elegant model's dogs are rather too friendly, a pile of hat boxes are precariously balanced in a footman's arms as he tried to keep up with his ladyship, or, in a famous 1960 photograph, three laughing, black-grimed miners hold aloft a startled model in her best new dress.

Parkinson is now known primarily as a colour photographer. His first colour work, taken on 35mm Kodachrome film, appeared in *Harper's Bazaar* in the 1930s. Although he occasionally produces dazzlingly complex colour schemes, in his best work the colour is restricted to a limited tonal range. These pictures are impressive in their purity and restraint, as when, for example, in a 1980 edition of the French *Vogue,* a model in a pure white draped dress is posed beside a cream marble sculpture from Olympia against a background of cool grey.

Before each shot Parkinson will shoot several packs of Polaroid film in order to adjust the exposure and frame the subject; 'I haven't used an exposure meter for 20 years,' he commented recently. On all assignments he carries two sets of large and small format cameras to cover all eventualities. For carefully composed shots Parkinson will use a tripod-mounted Hasselblad, preferring the 2¼in transparency when time allows, but using a motor-driven Nikon when greater speed or spontaneity is required for the 'snatch' shot.

As early as 1935, in a series of photographs of the liner 'The Queen Mary', Parkinson experimented with the effects produced by double exposures, and since then has from time to time returned to this with varying degrees of success. One of the best series of double exposures were taken to show the 1961 'Dior look' for *Queen* magazine, of which Parkinson was an associate editor from 1960 to 1964. For the Dior pictures he first exposed the film of the night lights of the Place de La Concorde, and then photographed the dresses in the studio on the same film.

Known mainly as a fashion photographer, Parkinson nevertheless has achieved a certain reputation as a portraitist, a field to which he devotes about one tenth of his working hours. 'I try to make people as good as they'd like to look, and with luck a shade better . . . If I photograph a woman then my job is to make her as beautiful as it is possible for her to be. If I photograph a gnarled old man, then I must make him as interesting as a gnarled old man can be.' While these two statements may sum up Parkinson's attitude, they belie the wide variety of portrait studies he has made. Always dismissive of the claims of photography as an art: 'Photography is not an art! . . . a photographer is an engine-driver – get there on time! A poet maybe, a do-it-yourself chemist – mostly in the dark, a diplomatist with the client who has been given a wonderful picture and can't see it, a journalist who uses his nut, and quickly. If a photographer is all of these things, then he is moving on – success is with him, or just around the corner.'

HELMUT NEWTON
German born/1920

'Newton will not accept anything less than absolute professionalism.'

Over the last decade, Helmut Newton has earned a reputation – and attracted a certain notoriety – for his brilliance in an area of photography which he might well be said to have invented. Newton is a fashion photographer, a creator of images of female beauty and eroticism, an astute and amused observer of the mores, the habitat, proclivities and poses of a privileged sector of Western society. His uniqueness stems from his being all of these things at once, with the result that his 'straight' fashion photographs often have an edge of eroticism or cynical wit, and his nudes the poise and stylishness of top fashion models. His erotic portraits are of celebrities of the *beau monde,* and his scenarios, however seemingly bizarre or fantastic, in fact derive their impact from reality, in things observed and judiciously recorded in notebooks for future reference.

Newton has only scorn for the 'fine art' school of photography and for what he sees as its misguided devotion to form rather than content. For Newton, subject matter is all, and formal concerns are pursued only to give full value to the content of his images. He

dismisses discussions of good and bad taste by refusing to admit the existence of a distinct division between the erotic and the pornographic, and readily admits elements of vulgarity which fascinate him and give spice to his work. For Newton, banality would represent a more serious accusation than vulgarity. He dismisses such discussions and the accusations levelled at him by those shocked by his work with the assurance of one whose vision is mature, shrewd and pin-sharp, and whose instinctive visual sophistication is the surest riposte.

Newton was already distinctive as a fashion photographer of the 1960s, but the turning point in his career came in the autumn of 1971 when, after recovering from a near-fatal heart attack, he emerged with a new set of priorities, determined to take more photographs for himself and carry through the themes and undercurrents apparent in his work of the 1960s. There was to be no more frenetic and exhausting coverage of the couture collections and through the 1970s Newton has accepted only work which has amused or excited him, or allowed him to create images of a fashion-conscious, glamorous, often perverse world which so intrigues him. The crystallization of his mature style has attracted considerable attention. He has published three books, held one-man shows in various cities, has inspired countless imitators, and been the subject of heated debate and controversy.

Newton's style is unmistakable. He has admired a number of photographers including Penn, Avedon, Brassaï and Sander, but he has emerged with qualities unique unto himself. His style is supremely sophisticated, diamond hard, and his images are flawless because, as a perfectionist, Newton will not accept anything less than absolute professionalism. He will say, self-deprecatingly, that he is not a great technician, but this is untrue. He is in perfect control of every stage of his image-making from the choice and disposition of lighting, film, camera and lens, to the meticulous preparation of his models. He works with the most skilled hairdressers and make-up artists, is aware of every nuance towards the attainment of his distinctive look, directs every gesture to inject the tension he desires, and watches every subtlety of light and shade.

In dismissing his abilities as a technician, Newton is in effect saying that technique is the silent partner to his real assets: imagination and sharp observation; technique should be noticed and appreciated only as an afterthought. For Newton, the challenge is that of constantly injecting new ideas and vitality into his fund of imagery and maintaining his justly-earned reputation as a photographer with the ability to arouse and fascinate. Newton has created images for the 1970s as powerful and relevant as those of Penn and Avedon were for the 1950s.

IRVING PENN
American born/1917

'Penn makes everything extremely hard for himself. He employs no gadgets, no special props, nothing but the simplest lighting.'

Irving Penn's photographs have lasting qualities and his approach to the art is a timeless one. Whatever he may choose to photo-graph, Penn's overriding concern is for the absolutes which are the true subjects of photography, its essence when the superfi-cialities of style and fashion are stripped away. Despite Penn's obvious fascination with the people and things before his lens, his images are also about the qualities of light and the analysis of form, pattern and tone. In a career which has spanned four decades, Penn has set his own exacting standards, single-mindedly and passionately pursuing the photographic truths which concern him. The impressive body of work which is the fruit of his labours demon-strates the consistency of his vision, the measure of his earnestness, and has earned him wide acclaim as one of the most distinguished photographers of all time.

Irving Penn was born in New Jersey in 1917. Between 1934 and 1938 he studied at the Philadelphia Museum School of Industrial Art, Pennsylvania, and his drawings were published in *Harper's Bazaar*. Between 1940 and 1941 he worked as advertising designer for a New York department store before embarking in 1942 on a painting trip to Mexico.

LISA TAYLOR AND JERRY HALL (1974)
A fashion shot for American Vogue, *illustrating the erotic swimsuits designed by Rudi Gernreich, has become the basis for a stylish and memorable image. Newton has returned to a favourite theme of women fighting in this highly stylized shot of models Lisa Taylor and Jerry Hall on the sands of Key Biscayne, Florida.*

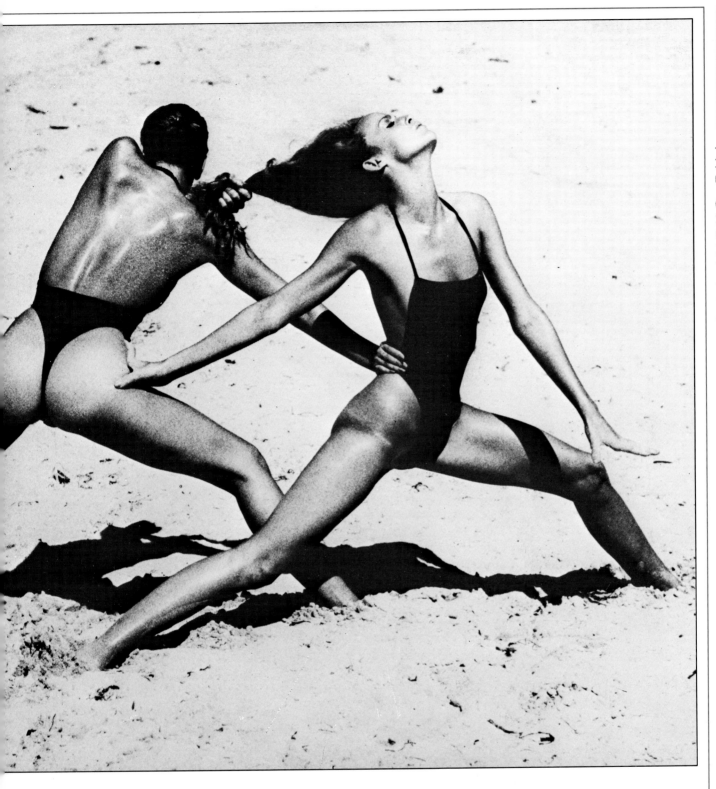

Upon his return a year later, Penn was invited to take his first photographs for *Vogue* magazine. It was the art designer Alex Liberman who sensed the potential in Penn and began a collaboration between the photographer and Condé Nast, publishers of *Vogue*, which was to establish the basis for his career as a photographer. Liberman and *Vogue* were sufficiently enlightened to allow Penn maximum creative freedom, and this patronage has been amply rewarded by the many sensitive and stylish spreads he has created for the magazine over the years.

Penn's work falls into three broad categories: fashion, portraiture and still-life. His approach, however, is such that the categories at times tend to overlap and, through the photographer's piercing scrutiny, superficially diverse subjects become inextricably related. Through Penn's lens, a Moroccan's traditional robes are observed with the same respect for hierarchical values and intrinsic beauty as a Balenciaga or a Dior. The velvety petal of a

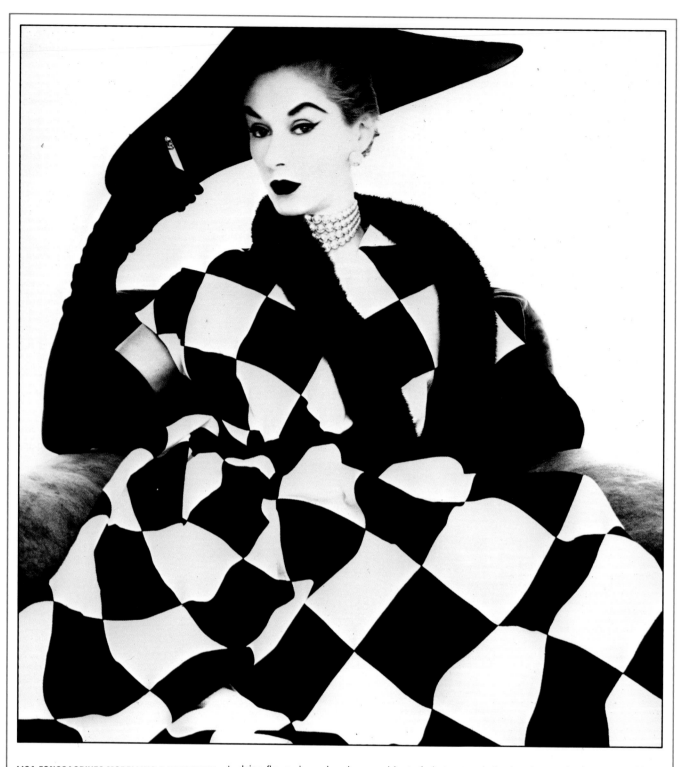

LISA FONSSAGRIVES MODELLING A HARLEQUIN COAT BY JERRY PARNISS (1951) *This stunning fashion photograph was published in the American edition of* Vogue, *on 1 April 1951. Penn has captured the very essence of the sublime artifice and sophistication of high fashion. The qualities of this image transcend the merely fashionable to express in a timeless way the very spirit of fashion.*

dying flower is analyzed as an object of abstract and absolute beauty in the same spirit as a model's lips or fingernails, or the stylized debris of a meal. Penn is as intent on capturing the presence of a New Guinea tribesman as he is on capturing the spirit of a Picasso, a Colette, a fashion model – or a London window cleaner.

Penn shot to success, and his work and style dominated the 1950s. A major landmark in his career was the publication in 1960 of his first and still most impressive book, *Moments Preserved,* a brilliant résumé in the form of eight essays in photographs and words of his achievements. This was followed after an interval of 14 years by the publication of *Worlds in a Small Room;* the next book *Inventive Paris Clothes, 1909–1939,* published in 1977, was eclipsed by the superlatively conceived and produced *Flowers,* published in 1980.

Penn has shown his work in a number of exhibitions, with one-man shows at both the Museum of Modern Art and the Metropolitan Museum of Art, New York. His perfectionism and concern for print quality – the latter no doubt heightened by the opportunities he has enjoyed for exhibiting his work – have led to Penn's increasing interest in the making of

prints and the revival in 1967 of the archaic platinum process. Using old negatives or creating new images. Penn has created prints of outstanding quality through his painstaking exploration of the platinum process.

The making of a fine print, however, is the last stage of Penn's creative process. Forming the very basis of his skills are his feeling for light and his intense concentration. Penn's ideal light is that which falls into a studio from the north: 'It is,' he claims, 'a light of such penetrating clarity that even a simple object lying by chance in such a light takes on an inner glow, almost a voluptuousness . . . Electric lights are a convenience, but they are used, I believe at the expense of that . . . *absolute existence* that a subject has standing before a camera in a north-light studio.'

The intense concentration which Penn builds up when working was described by a *Vogue* editor who worked regularly with him: 'Penn's sittings were psychological struggles for everyone involved. He suffered over these pictures as no fashion deserves being suffered over . . . my own enthusiastic approach succumbing under his tense, anguished, soul-searching attack.' Every session for Penn – whoever or whatever the subject – is an endeavour to express perfect observation of the subject, which is usually isolated against a characteristic and much-copied neutral backdrop.

Penn seems to keep no secrets and has published detailed explanations of the technical means he uses to achieve a desired result. In his notes to *Worlds in a Small Room*, he tells of his devotion to the Rolleiflex, of the film used for the majority of the photographs – Tri-X – and his methods of rating and developing the film. In introductions to exhibition catalogues he gives, in minute detail, explicit accounts of his skills, including the manipulations involved in the making of platinum prints and permanent pigment colour prints. These are skills, however, that would stand for little without the genius with which Penn uses them to transform deceptively simple compositions into images which, in addition to showing an inherent graphic brilliance and powerful symbolic essence, are magical hymns of light and shade, at once lyrical and incisive.

TWO GUEDRAS (1971) *Penn has travelled the world, often with his portable daylight studio tent, recording the features and the character of a remarkable variety of ethnic groups, from Hell's Angels to tribesmen. All his subjects present themselves with a considerable dignity. Isolated against Penn's neutral back-drops they participate in the making of images which capture their characteristics.*

DAVID BAILEY
British born/1938

'Seeing-pictures are to me people, places and things that are in their own space and not rearranged by the eye.'

David Bailey has achieved something relatively rare among photographers. His name has become a household word among his fellow countrymen, although, perhaps, he is better known for his colourful reputation than for his work. His reputation, however, is the very stuff of popular legend, for Bailey, born in 1938 in London, is the working class boy, the East Ender who, despite the many odds stacked against him, broke into a closed and elitist world to capture all the prizes of material success.

Bailey willingly concedes that chance and circumstance played as important a role as talent in his meteoric rise to success as both a chronicler and the personification of the 'youth culture' that characterized the 1960s. Brash, disarmingly blunt, deliberately unsophisticated and iconoclastic, Bailey and his contemporaries would admit to little respect for tradition. It was Bailey who played out the role of the fashion photographer-hero and was the prototype for the photographer-hero in *Blow-Up*, Antonioni's 1967 film which explored the ambiguities between image and reality. Today, the myth is more than tarnished. Bailey said his farewell to the 1960s with the publication of his 'saraband for the sixties', *Goodbye Baby & Amen* published in 1969. He continues to flourish, however, and it is his energy and tireless appetite for photography which have carried him successfully through the years.

With the exception of a distinctive phase in his fashion and portrait work in the 1960s. Bailey's photography is singularly styleless. In his fashion work, his models are his muses. 'I'm styleless,' he says, 'but my girls aren't.' He experiments in many directions, with eyes constantly inquisitive as he works in the studio or on location, and his approach – infinitely

adaptable – seeks only the image appropriate to the context. His profession is fashion and advertising photography and directing video commercials, but his natural photographic curiosity also embraces the documentation of places visited, things observed, 'mixed moments', and, above all, portraiture.

When Bailey entered the world of fashion photography, the two major figures in the field were Irving Penn and Richard Avedon. He acknowledges a respect for Penn, but it was from Avedon that so many features of Bailey's early work were derived. The blur of movement, wide-angled distortions, tight composition with subjects filling or even cropped within the film frame, high-key subjects against dead-white grounds – all were techniques first used by Avedon. As well, the portraits in Bailey's 1965 *Box of Pin-Ups*, owe a debt to Avedon's *Observations* of 1959.

The refreshing element Bailey brought to fashion photography was a naturalness in his models who took the place of the haughty, super-sophisticated creatures who typified the 1950s. His formula was timely, as was his discovery of the model Jean Shrimpton in 1960 when he was first under contract to *Vogue*. Through two decades the *enfant terrible* matured into the dependable professional, capable of working under incredible pressure to meet impossible deadlines.

His rapture with British *Vogue* in the 1970s – a contract which had exhausted its original vitality – the success of his fashion/gossip newspaper *Ritz*, launched in 1977, and his marriage to Marie Helvin, all marked the emergence of a new phase in Bailey's career. His fascination with photography continues unbridled. He is constantly curious about the work of other photographers and obsessively interested in equipment, conceding that he would probably be a better photographer if he stuck to one format rather than dabbling in so many techniques. At a recent count he had over 60 cameras, ranging from lightweight automatics to 10 × 8in plate cameras. As a rule, Bailey uses 35mm equipment on location for ease, and 2¼ × 2¼in or larger formats in the studio. He always crops his photographs in the camera, using instinct, and frequently prints up his work to include the black border. He has experimented with various artificial light set-ups including ring-flash, used since the early 1960s, and strobe lights for American and British *Vogue*.

JOHN LENNON AND PAUL MCCARTNEY (1965) *This photograph was published as one of the 36 plates in* David Bailey's Box of Pin-Ups, *a series of portraits of 'the people who in England today seem glamorous to him'. The tight cropping and strong black/white contrasts are typical of Bailey's picture-making techniques. The impact of this portrait, however, owes everything to the powerful presence of the sitters, caught so succinctly by the photographer.*

HIGH-HEELED SHOE IN KNICKERS *David Bailey has over the last few years taken countless photographs of the model Marie Helvin. This near-abstract study has the flawless quality of a fashion photograph, but, at the same time, its erotic implication cannot be overlooked.*

Bailey works regularly in colour but his forte is black-and-white photography; and within this, his most characteristic images are strong contrast studies. The grainy effect of his early work was achieved by using Tri-X at 800 ASA. He later '. . . went through an FP-4 phase, thinking it had more tones and less grain,' but now has gone back to Tri-X.

Tri-X may be a staunch ally, but there is not a film, lens, or camera that he has not tried, his enthusiasm undimmed. For Bailey is a survivor whose energy and drive have kept him working while the fads and popular faces he has recorded have long since faded from memory.

JOEL MEYEROWITZ
American born/1938

'I am most pleased when a photograph allows one to enter in, in an evenhanded way, where time can be spent, just looking.'

At the beginning of his career in 1962, speed was a determining factor in Joel Meyerowitz's approach to photography. After spending an intriguing afternoon watching the Swiss photographer Robert Frank work in his New York studio, within a week Meyerowitz had left his job as art director of an advertising firm, bought a 35mm hand camera, and was out on the streets of New York snapping at anything that moved. The first images were taken in colour, but these were soon replaced by black-and-white.

Born in 1938, and a child of the Bronx area of New York, street photography was the most natural course for Meyerowitz to pursue. 'Street-wise' from an early age, his father had taught him not only how to defend himself physically but how to read the signs of aggression in a would-be attacker, thereby avoiding or negating a confrontation. As a photographer, this intuitive reflex enabled Meyerowitz to interpret a situation before it became manifest, and his incident photographs, shot at speeds of around 1/1000 of a second, not only manage to capture sensational moments with perfect timing, but also succeed in producing an image that is both composed and controlled.

By 1968 Meyerowitz had begun to establish himself as a prominent figure on the American photographic scene following a one-man exhibition at the Museum of Modern Art, New York, entitled 'My European Trip: Photographs from a Moving Car'. But along with his growing expertise in high-speed photography came a sense of frustration with the limitations of his aesthetic stand.

BOY, PROVINCE-TOWN (1980)
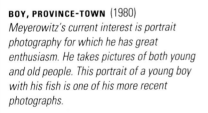
Meyerowitz's current interest is portrait photography for which he has great enthusiasm. He takes pictures of both young and old people. This portrait of a young boy with his fish is one of his more recent photographs.

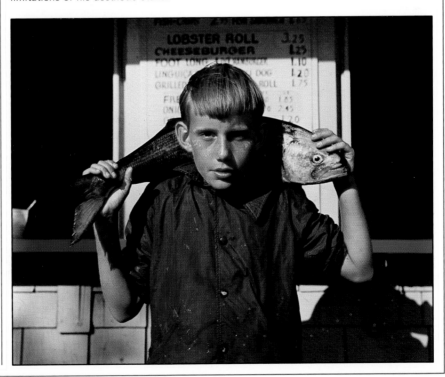

ST LOUIS AND THE ARCH (1977) *Meyerowitz photographed Eero Saarinen's monumental arch from many different angles. This is one of the more abstract images – an exercise in the purity of form and colour.*

Although his two early mentors, Robert Frank and Henri Cartier-Bresson, still maintain an influence on his work today, it was the work of the film-maker Federico Fellini who instigated the fundamental change in attitude that was gradually to revolutionize Meyerowitz's approach to photography. Meyerowitz noticed how in his films, Fellini allowed diverse images to wander loosely across the screen without making any attempt to impress them upon the viewer and thus stimulating the viewer to draw closer to the image and explore it in a random style. Clearly, this was the very opposite of what Meyerowitz had been trying to achieve in demanding the viewer's attention with a highly objective image brought out in bold relief.

By the end of the decade, Meyerowitz was steering himself in a new direction. In 1970 his experiments with colour produced a collection of colour and black-and-white images in a still unpublished work entitled *Going Places*, with a selection of these photographs shown at the 'Expo-70' in Japan. By 1971 colour was playing an increasingly important role in Meyerowitz's work, and he had even begun to give lessons in colour photography at the Cooper Union in New York. By 1973 he was photographing and printing almost exclusively in colour and, as his control of the medium grew, so he began to move away from incident photography and concentrate on overall field photography. This in turn brought about a new awareness of the roles of light, space and form – the latter particularly in reference to architecture.

This revolution came full cycle when in 1976 Meyerowitz bought an 8× 10in Deardorff field view camera. This unwieldy instrument, made in 1938 and weighing a healthy 45lbs, (20.5 Kg) has the very unsettling complication of viewing an image both upside down and backwards which Meyerowitz has overcome by using the horizon as his 'local vertical'. He feels that by using the Deardorff with a 250mm field Ektar lens he can obtain pure results because the camera does not add sophistication to what he sees before him, either by magnifying or reducing the field of vision, thereby allowing a clear record of his own sensations to come through. The cumbersome Deardorff, with its rectilinear grid and fixed tripod, demands a certain formality in the taking of a picture and this, combined with the austerity with which Meyerowitz approaches his subject matter, produces serene images rich in subtle hues and forms.

In 1976 Meyerowitz began work on a project in the Cape Cod area near Boston. Massachusetts, with the results published in book form in 1979 as *Cape Light*. *Cape Light* unequivocally demonstrates Meyerowitz's exploration of a new aesthetic discipline. It is an impressive work that fully reveals his ability to use colour with great sensitivity and feeling.

In 1977 Meyerowitz was commissioned by the St Louis Art Museum, Missouri, to photograph Eero Saarinen's monumental Gateway Arch. The theme of these images is the pervasiveness of the Arch and, even when it appears as a reflection or an impression, the images create an effect that is both haunting and mildly claustrophobic.

In 1978, as a sequel to his work on the St Louis Arch, Meyerowitz returned to his native New York to work on another architectural project: photographing the Empire State Building. In the same year he was also a participant in 'Mirrors and Windows: American Photography since 1960', an exhibition held at the Museum of Modern Art; and in 1979 the *Cape Light* images were exhibited for the first time at the Museum of Fine Art, Boston. During this period Meyerowitz was reactivating his early interests and joined up with Colin Westerbeck to write a book on the history of street photography. He had also started working again on the streets with the 35mm camera, but this time using colour film. This was followed by a trip to China, where Meyerowitz became the first American photographer to venture up the Yangtze River.

Within two decades Meyerowitz has established a reputation in the widely divergent fields of incident and field photography. He has demonstrated his ability to master a wide range of photographic techniques and he is one of today's most versatile and exciting prospects.

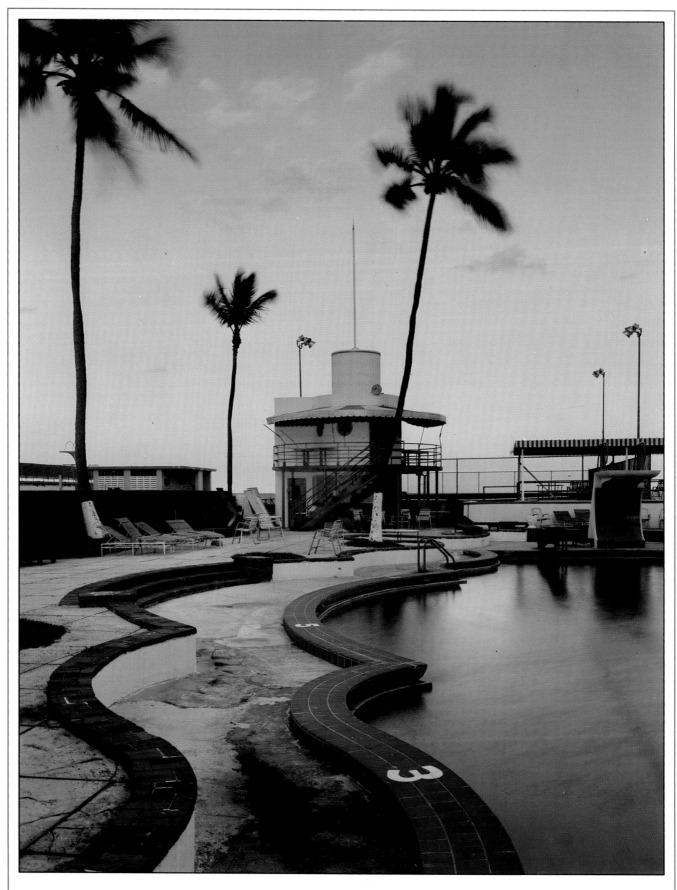

FLORIDA (1978) *Between 1976 and 1978
Meyerowitz executed a series of studies on
swimming pools in Florida. This particular
image shows Meyerowitz's ability to use colour
to its fullest extent.*

A

Aberration Lens fault in which light rays are not focused properly, thereby degrading the image. It includes chromatic and spherical aberration, coma, astigmatism and field curvature.

Achromatic lens A lens constructed of different types of glass, to reduce chromatic aberration. The simplest combination is of two elements, one of flint glass, the other of crown glass.

Acutance The objective measurement of how well an edge is recorded in a photographic image.

Additive process The process of combining lights of different colours. A set of three primary colours combined equally produces white.

Aerial perspective The impression of depth in a scene that is conveyed by haze.

Amphibious camera Camera which is constructed to be waterproof without the addition of a separate housing, by means of O-ring seals.

Anastigmat A compound lens, using different elements to reduce optical aberrations.

Angle of view Angle of the scene included across the picture frame by a particular lens. This varies with the focal length of the lens and the film format.

Angstrom Unit used to measure light wavelengths.

Aperture In most lenses, the aperture is an adjustable circular opening centred on the lens axis. It is the part of the lens that admits light.

Aperture-priority Automatic camera mode in which the photographer selects the aperture manually; the appropriate shutter speed is then set automatically according to the information from the camera's metering system.

Area light Photographic lamp/s enclosed in a box-like structure, the front of which is covered with a diffusing material such as opalescent plastic. Light is diffused by increasing the area of the light source. Also known as soft light, window light or 'fish-fryer'.

Archival techniques Methods of handling, treating and storing photographic emulsions so as to lessen the deteriorating effects of ageing.

Astigmatism A lens aberration in which light rays that pass obliquely through a lens are focused, not as a point but as a line. Astigmatism is normally found only in simple lenses.

ASA Arithmetically progressive rating of the sensitivity of a film to light (American Standards Association). ASA 200 film, for example, is twice as fast as ASA 100 film. This has now been replaced by the ISO rating.

Audio-visual (AV) Method of slide presentation to an audience in which the sound-track of music, voice and effects is synchronized to the projected images.

Auto focus System in which the focus is adjusted automatically, either passively by measuring the contrast of edges, or actively by measuring the reflection of an ultrasonic pulse.

Automatic exposure control Camera system where the photo-electric cell that measures the light reaching the film plane is linked to the shutter or lens aperture, adjusting exposure automatically.

Axial lighting A method of illuminating a subject in which the light travels along the lens axis, thereby casting no visible shadows. The normal means is by an angled, half-silvered mirror, which is a part of front-projection sytems.

B

Back projection Slide projection systems in which the image is projected onto a translucent screen from behind. It is both a method of presenting slides to an audience and a method of creating an apparently realistic background for a studio photograph. In the latter use it is less efficient than front projection.

Back scatter The visual result of using a flash underwater from the camera position when the water contains particles or air bubbles. It appears as a 'snowstorm'.

Background roll A standard type of studio background, in the form of heavy-gauge coloured paper, in 9ft (3m) wide rolls.

Barn doors Adjustable flaps that fit at the front of a photographic studio lamp to prevent light from spilling at the sides. Normally two or four hinged flaps on a frame.

Barrel distortion A lens aberration in which the shape of the image is distorted. The magnification decreases radially outwards, so that a square object appears barrel-shaped, with the straight edges bowed outwards.

Base The support material for an emulsion – normally plastic or paper.

Base density The minimum density of the film base in a transparency or negative. Determines the maximum brightness of highlights in a transparency.

Base lighting Lighting directed upwards from beneath a subject. Also known as ground lighting.

Bas-relief A method of producing images that appear to stand out slightly in relief. It is produced by sandwiching a positive and negative of the same image slightly out of register, and then printing the combination.

Bellows Flexible black sleeve of concertina-like construction, connecting the camera-back or body with the lens. Used in view cameras and in close-up attachments.

Between-the-lens shutter A leaf shutter located inside a compound lens, as close as possible to the aperture diaphragm.

Blind American term for 'hide' – camouflaged camera positions in wildlife photography.

Boom Counter-weighted lighting support in the form of a metal arm that pivots on a vertical stand. Useful for suspending lights high over a subject.

Borescope A rigid endoscope, developed artificially for industrial inspection.

Bounce flash Diffusion of the light from a flash unit, by directing it towards a reflective surface, such as a ceiling or wall. This scatters the light rays, giving a softer illumination.

Bounce light Diffusion of any light source in the same way as described for bounce flash.

Bracketing A method of compensating for uncertainties in exposure, by making a series of exposures of a single subject, each varying by a progressive amount from the estimated correct aperture/speed setting.

Brightfield illumination The basic lighting technique for photomicrography, directing light through a thin section of the subject. In effect, a form of back-lighting.

Brightness range The range of tones in a photographic subject, from darkest to lightest. Usually measured as a ratio or in f-stops.

C

Camera angle Common term to describe the direction of view of a camera, particularly in reference to its angle from the horizontal.

Camera movements Mechanical adjustments normal on view cameras that permit the lens panel and/or film back to be shifted laterally and pivoted. They allow adjustments to the coverage and geometry of the image and the distribution of sharpness.

Capacitor Electrical device that allows a charge to be built up and stored. An integral part of electronic flash units.

Cartridge camera/film Photographic system in which the film is enclosed in a plastic cartridge, simplifying loading and unloading. Designed for amateur use.

Catadioptric lens See *Mirror lens*.

CdS cell Cadmium sulphide cell used commonly in through-the-lens light meters. Its proportionate resistance to the quantity of light received is the basis of exposure measurement.

Centre of curvature The centre of an imaginary sphere of which the curved surface of a lens is a part.

Central processing unit (CPU) In an automatic camera, the part of the electronic circuitry that co-ordinates the programming.

Centre-weighted exposure Standard method of exposure measurement in TTL-metering cameras in which extra value is given to the tones in the centre of the picture.

Characteristic curve Curve plotted on a graph from two axes – exposure and density – used to describe the characteristics and performance of sensitive emulsions.

Chromatic aberration A lens aberration in which light of different wavelengths (and therefore colours) is focused at different distances behind the lens. It can be corrected by combining different types of glass.

Chromogenic film Photographic emulsion in which dyes are formed at the sites of the silver grains. Normal for colour film.

Circle of confusion The disc of light formed by an imaginary lens. When small enough, it appears to the eye as a point, and at this size the image appears sharp.

Click stop The graduation of the aperture ring on a lens that allows the change between individual f-stops to be felt and heard.

Clinometer Device for measuring angles from the vertical. Useful in copying paintings that hang at an angle.

Clip test A short strip from an exposed film that is processed in advance to determine whether any adjustment is needed in processing. Useful when the exposure conditions are uncertain.

Coating A thin deposited surface on a lens, to reduce flare by interference of light waves.

Colour balance Adjustment made at any stage of photography, from film manufacturers to post-production, to ensure that neutral greys in the subject appear neutral in the photograph.

Colour cast An overall bias in a photograph towards one particular colour.

Colour compensating filter Filter used to alter the colour of light. Available in primary and complementary colours at different strengths, and used to correct deficiencies in the lighting and film manufacture.

Colour conversion filter Coloured filter that alters the colour temperature of light.

Colour coupler A chemical compound that combines wtih the oxidizing elements of a developer to form a coloured dye. It is an integral part of most colour film processing.

Colour temperature The temperature to which an inert substance would have to be heated in order for it to glow at a particular colour. The scale of colour temperature significant for photography ranges from the reddish colours of approximately 2000°K through standard 'white' at 5400°K, to the bluish colours above 6000°K.

Coma A lens aberration in which off-axis light rays focus as different distances when they pass through different areas of the lens. The result is blurring at the edges of the picture.

Combination printing Method of combining images during enlargement by sandwiching two negatives.

Complementary colours A pair of colours that, when combined together in equal proportions, produce white light (additive process).

Compound lens Lens constructed to more than one element, making optical corrections possible.

Condenser. Simple lens system that concentrates light into a beam. Often used in enlargers.

Contact sheet A print of all the frames of a roll of film arranged in strips, same-size, from which negatives can be selected for enlargement.

Contrast Difference in brightness between adjacent areas of tone. In photographic emulsions, it is also the rate of increase in density measured against exposure.

Contrast range The range of tones, from dark to light, of which film or paper is capable of recording. Usually measured as a ratio or in f-stops.

Convergence In terms of perspective, the appearance of parallel lines in the subject as they are reproduced in the image when photographed from an angle.

Converging lens Lens which concentrates light rays towards a common point. Also known as a convex lens.

Covering power The diameter of usable image produced at the focal plane by a lens when focused at a given distance. An important consideration when choosing view camera lenses, which must cover more than just the film format if the camera movements are to be used.

Coving A concave shape of background, usually moulded, that smooths out the normally sharp edge between a studio wall and floor. Gives a 'horizonless' background.

Cyan Blue-green, complementary to red. Produces white in combination with magenta and yellow by the additive process.

Cyclorama See *Coving*.

D

Darkcloth Black cloth used by view camera photographers to eliminate the distraction of ambient light when looking at the image on the ground-glass screen.

Darkfield lighting Lighting technique used in photomicrography and in photomacrography in which the subject is lit from all sides by a cone of light directed from beneath the subject. The background appears black.

Darkslide A lightproof sheet used to protect film from exposure until it is mounted in the camera. Used with sheet film and certain rollfilm systems.

Daylight film Colour film balanced for exposure by daylight or some other source with a colour temperature of 5400°K, such as electronic flash.

Dedicated flash The integration of a flash unit with the camera's automatic exposure system.

Definition The subjective effect of graininess and sharpness combined.

Densitometer Device for measuring the density of specific parts of the image in film or on paper. Allows precise measurement of tones. Necessary for making separation negatives.

Density In photographic emulsions, the ability of a developed silver deposit to block transmitted light.

Depth of field The distance through which the subject may extend and still form an acceptably sharp image, in front of and beyond the place of critical focus. Depth of field can be increased by stopping the lens down to a smaller aperture. It is a subjective measurement.

Depth of focus The distance through which the film plane can be moved and still record an acceptably sharp image.

Diaphragm An adjustable opening that controls the amount of light passing through a lens. Often referred to as the aperture diaphragm.

Diffraction The scattering of light waves when they strike the edge of an opaque surface.

Diffuser Material that scatters transmitted light and increases the area of the light source.

Digital Principle of recording, storing and processing information in discrete units.

DIN Logarithmically progressive rating of the sensitivity of a film to light (Deutsche Industrie Norm). Currently being replaced by the ISO rating.

Diopter Measurement of the refractive ability of a lens. It is the reciprocal of the focal length, in metres; a convex lens is measured in positive diopters, a concave lens in negative diopters. Used, for example, for supplementary close-up lenses.

Direct reading Common term for reflected light reading.

Disc camera/film Amateur photographic system in which the film frames are arranged on a flat disc.

Diverging lens Lens which causes light-rays to spread outwards from the optical axis.

D-Max Abbreviation for maximum density.

Documentary photography Type of photography in which an accurate, objective record, undistorted by interpretation, is held to be the ideal.

Dolly A rolling trolley to support either a camera tripod or a lighting stand. The wheels can be locked when it is in place.

Dye cloud Zone of colour in a developed colour emulsion at the site of the developed silver grain, which itself has been bleached out during development.

Dye-image film See *Chromogenic film*.

Dye-sensitization The standard manufacturing process of adding dyes to emulsion in order to control its spectral sensitivity. Used in the manufacture of normal black-and-white films to make them panchromatic.

Dye transfer process Colour printing process that uses colour separation negatives which in turn produce matrices that can absorb and transfer coloured dyes to paper.

E

Effects light A photographic light used to produce a distinct visual effect rather than to provide basic illumination. A spotlight to give a halo effect to hair in a portrait is one example.

Electromagnetic spectrum The range of frequencies of electromagnetic radiation, from radio waves to gamma rays, including visible radiation (light).

Electronic flash Artificial light source produced by passing a charge across two electrodes in a gas. The colour balance is about 5400°K.

Electrophotography The formation of images on emulsion by means of passing an electrical charge. Kirlian photography is one form.

Emulsion Light-sensitive substance composed of halides suspended in gelatin, used for photographic film and paper.

Endoscope Device built around a miniature lens for photography in small, normally inaccessible places, such as internal organs of the body.

Exposure In photography, the amount of light reaching an emulsion, being the product of intensity and time.

Exposure latitude For film, the increase in exposure that can be made from the minimum necessary to record shadow detail, while still presenting highlight detail.

Exposure value (EV) Notation of exposure settings for cameras that links aperture and shutter speed. A single EV number can, for example, represent 1/125 at f5.6 and 1/1500 at f2.8.

Extension A fixed or adjustable tube placed between the lens and camera body, used to increase the magnification of the image.

F

F-number The notation for relative aperture, which is the ratio of the focal length to the diameter of the aperture. The light-gathering power of lenses is usually described by the widest f-stop of which they are capable, and lens aperture rings are normally calibrated in a standard series: f1, f1.4, f2, f2.8, f4,

f5.6, f8, f11, f16, f22, f32 and so on, each of these stops differing from its adjacent stop by a factor of 2.

Fibre optic Optical transmission systems in which light is passed along flexible bundles of light-conducting strands. Within each fibre, the light is reflected with high efficiency to prevent any significant loss over a distance.

Field camera Traditional folding design of view camera, often of mahogany construction with a flat-bed base, that is sufficiently portable for carrying on location.

Field curvature In this lens aberration, the plane of sharpest focus is a curved surface rather than the flat surface needed at the film plane.

Fill The illumination of shadow areas in a scene.

Fill-flash As fill (above) but performed with an electronic flash, usually camera-mounted.

Film holder Specifically, a container for sheet-film for loading in the back of a view camera. The standard design has room for two sheets, one in each side of the flat holder, each protected by a dark slide. Film is loaded by the user in darkness.

Film plane In a camera, the plane at the back in which the film lies and on which the focus is set.

Film speed rating The sensitivity of film to light, measured on a standard scale, now normally ISO, formerly either ASA or DIN.

Filter factor The number by which the exposure must be multiplied in order to compensate for the loss of light due to absorption by a filter.

Fish-eye lens A very wide-angle lens characterized by extreme barrel distortion.

Flag A matt black sheet held in position between a lamp and the camera lens to reduce flare.

Flare Non-image-forming light, caused by scattering and reflection, that degrades the quality of an image. Coating is used to reduce it.

Flash See *Electronic flash*.

Flash guide number Notation used to determine the aperture setting when using electronic flash. It is proportionate to the output of the flash unit.

Flash synchronization Camera system that ensures that the peak light output from a flash unit coincides with the time that the shutter is fully open.

Floppy disc A floppy video disc is used as a substitute for film in video stills cameras. It is re-usable.

Focal length The distance between the centre of a lens (the principal point) and its focal point.

Focal plane The plane at which a lens forms a sharp image.

Focal plane shutter Shutter located close to the focal plane, using two blinds that form an adjustable gap which moves across the film area. The size of the gap determines the exposure.

Focal point The point on either side of a lens where light rays entering parallel to the axis converge.

Focus The point at which light rays are converged by a lens.

Follow focus Lens focusing technique with a moving subject, in which the focusing ring is turned at exactly the rate necessary to maintain constant focus.

Fresnel screen A viewing screen that incorporates a Fresnel lens. This has a stepped convex surface that performs the same function as a condenser lens, distributing image brightness over the entire area of the screen, but is much thinner.

Front projection System of projecting a transparency's image onto a background screen from the camera position, thus ensuring minimum loss of image intensity and quality (the chief problem with back projection). The system relies upon axial lighting via a half-silvered mirror, and on a super-reflecting screen.

Full-tone An image containing a continuous gradation of tones, as in an original photographic print (see *Half-tone*).

Fully automatic diaphragm (FAD) System in an SLR camera which allows full-aperture viewing up to the moment of exposure; linkages between the mirror box and the lens stop down the aperture to its selected setting an instant before the shutter opens.

G

Gamma Measure of the steepness of an emulsion's characteristic curve being the tangent of the acute angle made by extending the straight line position of the curve downwards until it meets the horizontal axis. Average emulsions averagely developed have a gamma of about 0.8, while high contrast films have a gamma greater than 1.0.

Gel Common term for coloured filter sheeting, normally used over photographic lamps.

Gelatin Substance used to hold halide particles in suspension, in order to construct an emulsion. This is deposited on a backing.

Gelatin filter Thin, coloured filters made from dyed gelatin that have no significant effect on the optical quality of the image passed. Normally used over the camera lens.

Grade Classification of photographic printing paper by contrast. Grades 0 to 4 are the most common, although they are not precisely comparable across makes.

Grain An individual light-sensitive crystal, normally of silver bromide.

Graininess The subjective impression when viewing a photograph of granularity under normal viewing conditions. The eye cannot resolve individual grains, only overlapping clusters.

Granularity The measurement of the size and distribution of grains in an emulsion.

Ground-glass screen Sheet of glass finely ground to a translucent finish on one side, used to make image focusing easier when viewing.

Ground light A design of studio light that sits on the floor and is aimed upwards, normally to illuminate a background.

Gyro stabilizer Electrically powered camera support that incorporates a heavy gyroscope to cushion the camera from vibrations, particularly useful when shooting from helicopters, cars and other vehicles.

H

Half-tone An image that appears at normal viewing distance to have continuous gradation of tones, but which is made up of a fine pattern of dots of solid ink or colours.

Hardener Chemical agent – commonly chrome or potassium alum – that combines with the gelatin of a film to make it more resistant to scratching.

Heat filter Transparent screen used in front of a photographic lamp to absorb heat without reducing the light transmission.

Hide Term for camouflaged camera position in wildlife photography.

High key Type of image made up of light tones only.

Hyperfocal distance The closest distance at which a lens records a subject sharply when focused at infinity. It varies with the aperture.

Hypo Alternative name for fixer, sodium thiosulphate.

Hypo eliminator Chemical used to clear fixer from an emulsion to shorten washing time.

I

Incident light reading Exposure measurement of the light source that illuminates the subject. It is therefore independent of the subject's own characteristics.

Infra-red radiation Electromagnetic radiation from 730 nanometers to 1/32in (1mm), longer in wavelength than light. It is emitted by hot bodies.

Instant film Photographic system pioneered by the Polaroid corporation, in which processing is initiated as soon as the exposed film is withdrawn from the camera and is normally completed within a minute or so.

Instant-return mirror The angled viewing mirror in a SLR camera, which flips up to allow the film to be exposed and then immediately returns.

Integral film Type of instant film in which the entire development process, chemicals, and materials take place and remain within a sealed packet.

Integral masking The addition of dyes to colour negative film in its manufacture to compensate for deficiencies in the image forming dyes.

Intensifier Chemical used to increase the density or contrast of an image or an emulsion. Particularly useful with too-thin negatives.

Internegative A negative copy of a transparency. Internegative film is formulated to prevent any build-up of contrast.

Inverse square law As applied to light, the principle that the illumination of a surface by a point source of light is proportional to the square of the distance from the source to the surface.

ISO (International Standard Organization) Film speed notation to replace the ASA and DIN systems, made up of a combination of these two.

J

Joule Unit of electronic flash output, equal to one watt-second. The power of different units can be compared with this measurement.

K

Kelvin (K) The standard unit of thermodynamic temperature, calculated by adding 273 to degrees centigrade/Celsius. In photography it is a measure of colour temperature.

Key light The main light source.

Key reading Exposure reading of the key tone only. A form of spot metering.

Key tone The most important tone in a scene being photographed that must be rendered accurately.

Kilowatt Unit of electrical power, equivalent to 1000 watts.

Kirlian photography Form of electrophotography in which the subject is placed against film and its image appears as an outline of electrical discharge.

L

Latent image The invisible image formed by exposing an emulsion to light. Development renders it visible.

Latitude The variation in exposure that an emulsion can tolerate and still give an acceptable image. Usually measured in f-stops.

LCD (Liquid crystal diode) A solid-state display system used in viewfinder information displays particularly. Consumes less power than LEDs (light emitting diodes).

Lens A transparent device for converging or diverging rays of light by refraction. Convex lenses are thicker at the centre than at the edges; concave lenses are thicker at the edges than at the centre.

Lens axis A line through the centre of curvature of a lens.

Lens flare Non-image-forming light reflected from lens surfaces that degrades the quality of the image.

Lens hood Lens attachment that shades the front element from non-image forming light that can cause flare.

Lens speed Common lens designation in terms of maximum light-gathering power. The figure used is the maximum aperture.

Light tent Enclosing device of translucent material placed so as to surround a subject, the lighting is directed through the material to give an extremely diffused effect, useful with rounded shiny objects.

Line film Very high contrast film, which can be developed so that the image contains only full-density black, with no intermediate tones.

Long-focus lens Lens with a focal length longer than the diagonal of the film format. For 35mm film, anything longer than about 50mm is therefore long-focus, although in practice the term is usually applied to lenses with at least twice the standard focal length.

Low key Type of image made up of dark tones only.

Luminaire Large photographic tungsten lamp which focuses by means of a Fresnel lens.

Luminance The quantity of light emitted by or reflected from a surface.

M

Macro Abbreviation for photomacrographic, applied to close-up photography of at least life-size reproduction. In particular, used to designate lenses and other equipment used for this purpose.

Macrophotography The photography of large-scale objects. Hardly ever used to mean this, but often misused to mean 'photomacrography'.

Magnification Size relationship between image and its subject, expressed as a multiple of the dimension of the subject.

Manual operation The operation of camera, flash or other equipment in non-automatic modes.

Maximum density The greatest density of silver or dye image that is possible in a given developed emulsion. In transparency film, the dark rebate is at maximum density.

Masking Blocking specific areas of an emulsion from light. For example, a weak positive image, when combined with the negative, can be used to mask the highlights so as to produce a less contrasty print.

Matrix Sheet of film used in the dye transfer process that carries a relief image in gelatin. This is temporarily dyed when printing.

Mean noon sunlight An arbitrary but generally accepted colour temperature to which most daylight colour films are balanced – 5400° Kelvin being the average colour temperature of direct sunlight at midday in Washington DC.

Medical lens Type of lens designed specifically for medical use, having close-focusing capability and a built-in ringflash.

Mercury vapour lamp Form of lighting sometimes encountered in available light photography. It has a discontinuous spectrum and reproduces as blue-green on colour film.

Mid-tone An average level of brightness, halfway between the brightest and darkest areas of scene or image (that is, between highlight and shadow areas).

Mired value A measurement of colour temperature that facilitates the comparison of different light sources. It is calculated by dividing 1,000,000 by the colour temperature of the light source in Kelvins.

Mirror lens Compound lens that forms an image by reflection from curved mirrors rather than by refraction through lenses. By folding the light paths, its length is much shorter than that of traditional lenses of the same focal length.

Mode In camera technology, the form in which the basic functions (including exposure measurement, aperture and shutter speed settings) are operated, many automatic cameras have a choice of modes, from a high degree of automation to manual operation.

Modelling lamp A continuous-light lamp fitted next to the flashtube in studio flash units that is used to show what the lighting effect will be when the discharge is triggered. Modelling lamps are usually low-wattage and either tungsten or fluorescent, and do not interfere with the actual exposure.

Modular construction Method of camera construction in which several elements can be assembled by the user in a variety of combinations to suit particular uses. Monorail view cameras, for example, are designed in this way.

Monopod Single leg of a tripod, as a lightweight camera support for hand-held shooting.

Monorail The base support for the standard modern design of view cameras, in the form of an optical bench. Also, abbreviation for such a camera.

Motor-drive Device that either attaches to a camera or is built into it, that motorizes the film transport, enabling a rapid sequence of photographs.

Multiple exposure Method of combining more than one image on a single frame of film by making successive exposures of different subjects.

Multiple flash The repeated triggering of a flash unit to increase exposure (with a static subject).

Multi-pattern metering The metering system in which areas of the image frame are measured separately, and weighted according to a predetermined programme.

Nanometer 10° metre.

Negative Photographic image with reversed tones (and reversed colours if colour film) used to make a positive image, normally a print by projection.

Neutral density Density that is equal across all visible wavelengths, resulting in absence of colour.

Night lens Camera lens designed for optimum use at a wide maximum aperture, usually about f1.2. Often incorporates an aspherical front element.

Non-substantive film Colour film in which the colour-forming dyes are not present in the film as manufactured, but added during the processing. Kodachrome is the best known example.

Northlight The light, usually large in area, from a north-facing window. Also, sometimes used to refer to artificial lighting which delivers the same effect. Noted for its diffuse but directional qualities.

O

Opalescent Milky or cloudy white, translucent quality of certain materials, valuable in the even diffusion of a light source.

Open flash Method of illuminating a subject with a flash unit, by leaving the camera shutter open, and triggering the flash discharge manually.

Optical axis Line passing through the centre of a lens system. A light ray following this line would not be bent.

Optimum aperture The aperture setting at which the highest quality images are formed by a lens. Often two or three f-stops less than maximum.

Orthochromatic film Film that is sensitive to green and blue light, but reacts weakly to red light.

OTF metering Off-the-film metering – a TTL system in which the exposure is measured from the image that is projected inside the camera at the film plane.

Outrig frame Open metal frame that fits in front of a lamp and can be used to carry filters, gels or diffusing material.

P

Panchromatic film Film that is sensitive to all the colours of the visible spectrum.

Panning Smooth rotation of the camera so as to keep a moving subject continuously in frame.

Pantograph In photography, a device constructed of interlocking, pivoted metal arms that allows the extension and retraction of lamps.

Parallax The apparent movement of two objects relative to each other when viewed from different positions.

Peel-apart film Type of instant film comprising two sheets, one carrying the negative image, the other receiving the positive image. After the short development time, the two sheets are peeled apart and the negative discarded.

Pentaprism Five-sided prism, which rectifies the image left-to-right and top-to-bottom.

Peripheral photography Photographic system in which the image of a revolving subject is projected through a moving slit onto the film. By correlating the two rates of movement, the circumferences of the subject can be recorded in a continuous strip.

Perspective correction (PC) lens A lens with covering power greater than the film area, part of which can be shifted to bring different parts of the image into view. Mainly used to correct converging verticals in architectural photography.

Phase detection Method of autofocus using CCD array in camera body to assess light entering the lens.

Photo composite A photograph assembled from two or more photographs. Normally a transparency, the assembly being accomplished by line film masks and duplication.

Photo-electric cell Light sensitive cell used to measure exposure. Some cells produce electricity when exposed to light; others react to light by offering an electrical resistance.

Photoflood Over-rated tungsten lamp used in photography, with a colour temperature of 3400°K.

Photogram Photographic image made without a camera, by placing an object on a sheet of emulsion and briefly exposing it to light. The result is a kind of shadow picture.

Photojournalism Relating a newsworthy story primarily with photographs.

Photomacrography Close-up photography with magnifications in the range of about 1× to 10×.

Photomicrography Photography at great magnifications using the imaging systems of a microscope.

Picture area The area in front of the camera that is recorded as an image.

Pincushion distortion A lens aberration in which the shape of the image is distorted. The magnification increases radially outwards, and a square object appears in the shape of a pincushion, with the corners 'stretched'.

Pixel Smallest unit of digital picture information in a digitalized picture, it is usually an extremely small square, of a certain tone and hue.

Plane of sharp focus The plane at which an image is sharply focused by a lens. In a fixed-body camera it is normally vertical and perpendicular to the lens axis, but it can be tilted by means of camera movements.

Polarization Restriction of the direction of vibration of light. Normal light vibrates at right angles to its direction of travel in every plane; a plane-polarizing filter (the most common in photography) restricts this vibration to one plane only. There are several applications, the most usual being to eliminate reflections from water and non-metal surfaces.

Port In underwater photography, the window in the front of a housing. To avoid image distortion, it should ideally have a curve similar to that of the front element of the lens.

Posterization Photographic image produced in blocks of solid tone, by means of tonal separation.

Post-production The photographic processes that take place after the image has been developed, including re-touching, special effects and treatment.

Printing controls Shading and printing-in techniques used during enlargement to lighten or darken certain parts of a photographic print.

Printing-in Printing technique of selectively increasing exposure over certain areas of the image.

Prism Transparent substances shaped so as to refract light in a controlled manner.

Process lens Flat-field lens designed to give high resolution of the image on a flat plane. This is achieved at the expense of depth of field, which is always shallow.

Programmed shutter Electronically operated shutter with variable speeds that is linked to the camera's TTL meter. When a particular aperture setting is selected, the shutter speed is automatically adjusted to give a standard exposure.

Pull-processing Giving film less development than normal, in order to compensate for overexposure or to reduce contrast.

Push-processing Giving film more development than normal, in order to compensate for underexposure or to increase contrast.

Ram card Card-shaped alternative to floppy video disc used to record stills video images.

Rangefinder Arrangement of mirror, lens and prism that measures distance by means of a binocular system. Used on direct viewfinder cameras for accurate focusing.

Rebate The margin surrounding the image area on film; dark on a developed transparency, clear on a developed negative.

Reciprocity failure (reciprocity effect) At very short and very long exposures, the reciprocity law ceases to hold true, and an extra exposure is needed. With colour film, the three dye layers suffer differently, causing a colour cast. Reciprocity failure differs from emulsion to emulsion.

Reciprocity law EXPOSURE − INTENSITY × TIME. In other words, the amount of exposure that the film receives in a camera is a product of the size of the lens aperture (intensity) and the shutter speed (time).

Reducer Chemical used to remove silver from a developed image, so reducing density. Useful for overexposed or overdeveloped negatives.

Reflected light reading Exposure measurement of the light reflected from the subject (cf *Incident light reading*). Through-the-lens meters use this method, and it is well-suited to subjects of average reflectance.

Reflector Surface used to reflect light.

Refraction The bending of light rays as they pass from one transparent medium to another when the two media have different light-transmitting properties.

Register system System used in darkroom and assembly work in which separate pieces of film can be aligned exactly in position. The usual method is a matching punch and pin bar.

Relative aperture The focal length of a lens divided by the diameter of the entrance pupil, normally recorded as f-stops, eg a 50mm lens with a maximum aperture opening 25mm in diameter has a relative aperture of f4 $\left(\dfrac{100mm}{25mm}\right)$.

Reportage photography Capturing images on film that manage to sum up a typical news story.

Reproduction ratio The relative proportions of the size of the subject and its image.

Resolution The ability of a lens to distinguish between closely spaced objects, also known as resolving power.

Reticulation Crazed effect on a film emulsion caused by subjecting the softened gelatin to extremes of temperature change.

Reversal film Photographic emulsion which, when developed, gives a positive image (commonly called a transparency). So called because of one stage in the development when the film is briefly re-exposed, either chemically or to light, thus reversing the image which would otherwise by negative.

Rifle stock Camera support that enables a camera normally with a long-lens, to be hand-held more securely, in the same manner as a rifle.

Ringflash Electronic flash in the shape of a ring, used in front of and surrounding the camera lens. The effect is of virtually shadowless lighting.

Rollfilm Film rolled on a spool with a dark paper backing. The most common current rollfilm format is 120.

S

Sabattier effect Partial reversal of tone (and colour when applied to a colour emulsion) due to brief exposure to light during development.

Safelight Light source used in a darkroom with a colour and intensity that does not affect the light-sensitive materials for which it is designed.

Sandwich Simple, physical combination of two sheets of film: transparencies for projection, negatives for printing.

Scheimpflug principle Principle by which the orientation of the plane of sharp focus varies with the orientation of both the front and rear standards of a view camera: the plane and lines extended from the two standards meet at a common point.

Scoop Smoothly curving studio background, used principally to eliminate the horizon line.

Scrim Mesh material placed in front of a lamp to reduce its density, and to some extent to diffuse it. One thickness of standard scrim reduces output by the equivalent of about one f-stop.

Selenium cell Photo-electric cell which generates its own electricity in proportion to incident light.

SEM Scanning electron microscope.

Sensitometry The scientific study of light-sensitive materials and the way they behave.

Separation guide Printed guide containing a set of standard colours, when photographed alongside a subject that must be reproduced with great colour accuracy by printer (a painting for example), the separation maker can match the image against another, identical guide.

Separation negative Black-and-white negative exposed through a strong coloured filter to record an image of a selected part of the spectrum, normally one-third. Used in dye transfer printing, and also in non-photographic printing.

Serial flash See *Multiple flash*.

Shading Photographic printing technique where light is held back from selected parts of the image.

Shadow detail The darkest visible detail in a subject or in the positive image, often sets the lower limit for exposure.

Shadow fill See *Fill*.

Sharpness The subjective impression of acutance when viewing a photograph.

Sheet-film Film used in the form of flat sheets rather than rolls or strips. The most common formats are 4 × 5 inch and 8 × 10 inch.

Shift Lateral camera movement (qv) – of either the front standard or rear standard.

Shift lens See *Perspective control lens*.

Short-focus lens Lens with a focal length shorter than the diagonal of the film format. For the 35mm format, short-focus lenses generally range shorter than 35mm.

Shutter Camera mechanism that controls the period of time that image-focusing light is allowed to fall on the film.

Shutter priority Automatic camera mode in which the photographer selects the shutter speed manually; the appropriate aperture is then set automatically according to the information from the camera's metering system.

Single lens reflex (SLR) Camera design that allows the image focused on the film plane to be previewed. A hinged mirror that diverts the light path is the basis of the system.

Skylight Light from the blue sky (as opposed to direct sunlight).

SLR See *Single lens reflex*.

Slave unit Device that responds to the light emission from one flash unit, to activate additional flash units simultaneously.

Slit-scan Method of photography in which the image is projected onto the film through a moving slit (or else the film moves and the slit remains still). Periphery photography is one form of this.

Snoot Generally, cylindrical fitting for a light source, used to throw a circle of light.

Soft-focus filter A glass filter with an irregular or etched surface that reduces image sharpness and increases flare in a controlled fashion. Normally used for a flattening effect in portraiture.

Solarization Reversal of tones in an image produced by greatly overexposing the emulsion. A similar appearance can be created by making use of the Sabattier effect.

Spectral response/sensitivity The pattern of response of an emulsion to the different wavelength of light.

Spherical aberration In this aberration, light rays from a subject on the lens axis passing through off-centre areas of the lens focus at different distances from the light rays that pass directly through the centre of the lens. The result is blurring in the centre of the picture.

Split-field filter Bi-focal filter, the top half of which consists of plain glass, the lower half being a plus-diopter lens that allows a close foreground to be focused at the same time as the background.

Spotlight A lamp containing a focusing system that concentrates a narrow beam of light in a controllable way.

Spotmeter Hand-held exposure meter of great accuracy, measuring reflected light over a small, precise angle of view.

Standard The upright unit of a monorail view camera. The front standard carries the lens panel; the rear carries the film back and viewing screen.

Standard lens See *Normal lens*.

Step photography Type of multiple-exposure photography in which either the camera or subject (or both) are moved in measured steps between exposures.

Step wedge Strip of developed film containing a measured graduated scale of density. Used for exposing alongside separation negatives to check accuracy of exposure.

Stereography Type of photograph in which two simultaneous exposures are made, the receiving frames of film being separated by at least a few inches, and the developed pair presented to the view in such a way as to reproduce the impression of three-dimensional depth.

Stills video Electronic camera which records a still image on floppy video disc or ram card.

Stop bath Chemical that neutralizes the action of the developer on an emulsion, effectively stopping development.

Streak photography Type of photography in which the camera or subject (or both) are moved during a continuously lit exposure (usually long). The image shows the trace of the movement.

Stress polarization Stress patterns in materials that polarize light made visible by viewing them through crossed polarizing filters.

Strobe Abbreviation for 'stroboscopic light'. A rapidly repeating flash unit, used for multiple-exposure photographs of moving subjects.

Substantive film Colour film in which the colour-forming dyes are included at manufacture. Most colour films are of this type.

Substitute reading Exposure measurement of a surface or subject that is similar in tone or appearance to the subject about to be photographed.

Subtractive process The process of combining coloured pigments, dyes or filter, all of which absorb light. Combining all three primary colours in this way produces black (an absence of light).

Swing Rotating camera movement of the front or rear standard around a vertical axis. See *Camera movements*.

T

Technical camera Flat-bed view camera, similar in basic construction to a field camera but of metal and to greater precision.

Tele-converter Supplementary lens that attaches between a telephoto lens and the camera body to increase the focal length.

Telephoto lens Design of long-focus lens in which the length of the lens is less than the focal length.

Test strip Test of various exposures made with an enlarger.

Thermography Method of imaging heat emission from a subject.

Through-the-lens (TTL) meter Exposure meter built into the camera, normally located close to the instant-return mirror of a single lens reflex or to the pentaprism.

Tilt Rotating camera movement of the front or rear standard around a horizontal axis. See *Camera movements*.

Time exposure Exposure of several seconds or more that must be timed by the photographer.

Tone separation The isolation of areas of tone in an image, normally by the combination of varying densities of line positives and negatives.

Toner Chemicals that add an overall colour to a proceed black-and-white image, by means of bleaching and dyeing.

Trans-illumination See *Back-lighting*.

Transposed processing The processing of reversal film as if negative, or negative film as if reversal, for special effect.

Tri-chromatic Method of reusing or reproducing specific colours by the variable combination of only three equally distributed wavelengths, such as blue, green, red or yellow, magenta, cyan.

Tri-pack film Colour film constructed with three layers of emulsion, each sensitive to a different colour. When exposed equally, the three colours give white.

Tungsten-balanced film Film manufactured for use with tungsten lighting without the need for balancing filters. Type A film is balanced for 3400°K; the more common type B film is balanced for 3200°K.

Tungsten-halogen lamp Tungsten lamp of improved efficiency, in which the filament is enclosed in halogen gas, which causes the vaporized parts of the filament to be re-deposited on the filament rather than on the envelope.

Tungsten lighting Artificial lighting caused by heating a filament of tungsten to a temperature where it emits light.

U

Ultraviolet radiation Although it is invisible, most films are sensitive to this electromagnetic radiation.

USM Ultrasonic motor built into some autofocus lenses to activate the focusing mechanism.

V

Variable contrast paper Printing paper with a single emulsion which can be used at different degrees of contrast by means of selected filters.

View camera Large-format camera in which the image is projected onto a ground-glass screen. After viewing, the film is inserted into a holder in the same position as the viewing screen.

W

Wavelength of light The distance between peaks in a wave of light. This distance, among other things, determines the colour.

Wetting agent Chemical that weakens the surface tension of water, and so reduces the risk of drying marks on film.

Wide-angle lens Lens with an angle of view wider than that of the human eye and having a short focal length.

Z

Zoom lens Lens with a continuously variable focal length over a certain range at any given focus and aperture. It is generated by differential movement of the lens elements.

INDEX

Page numbers in *italic* refer to illustrations.

ACKNOWLEDGEMENTS

Key: t=top, b=bottom, l=left, r=right, c=centre.

Alpha: 253; **Ansel Adams**: 49, 141t, portrait by Gerry Sharpe 312; 313–5; **David Bailey**: portrait by John Swannell/Camera Press 324; **Cecil Beaton**: portrait – National Portrait Gallery 302, Sothebys of Belgravia 303–4; **Keith Bernstein**: 34br, 74, 106tr, 129bl, 138b, 156, 194l, 268; **Werner Bischof**: 254; **Brassaï**: Museum of Modern Art/Victoria & Albert Museum 308–9, portrait – The Photographer's Gallery, London 306; **Henri–Cartier Bresson**: Magnum 305–7; **Bill Brandt**: 310–11, portrait by John Paul Kernot 310; **Romano Cagnoni**: 259; **Julia Margaret Cameron**: portrait – National Portrait Gallery 290, 291; **Steve Dalton**: 227; **Peter Henry Emerson**: Robert Hershkowitz 292, 294; Foote Cone & Belding: 191; **William Henry Fox Talbot**: (Fox Talbot Museum) 47br; **Neyla Freeman**: 931; **Robert Golden**: 135c; **Gustave le Gray**: Victoria & Albert Museum 47tr; **Ernst Haas**: Magnum/John Hillelson Agency: 198; **Hipgnosis**: 95; **Gavin Hodge**: 51br, 53, 42; **Anthony Howarth/Alexander Low**: 269r; **Ian Howes**: 152l; **Walter Iooss**: 269l; **Rose Jones**: 28b, 196b, 275c; **Michael Joseph**: 249, 250; **David Kilpatrick**: 207 (brickwork); **Kobal Collection**: 135bl&r; **George Krause**: 149; **Andre Martin**: 8; **Laszlo Moholy-Nagy**: 299; **Joel Meyerowitz**: 325–8; **Arnold Newman**: 245, 246, 257; **Helmut Newton**: 319–21; **Norman Parkinson**: 288; portrait by Robert Pascall 316; courtesy of Condé Nast Publications (Vogue) 316–8; **Irving Penn**: courtesy of Condé Nast Publications: 320–3; **John Pfahl**: 233br; **Man Ray**: 298–300; **Sanders**: 54l; **Scotsman Publications Ltd** 244r; **George Selwyn**: 92b; **Yoshikaza Shirakawa**: Image Bank 154; **Snowdon**: 246/7; **Jerry Uelsmann**: 219; **Weegee**: 295–6; **Tony Weller**: 207cr; **Mike Wells**: Aspect Picture Library 139b; **Brett Weston**: 139; **Sue Wilks**: 184tr&b; **John Zimmerman**: 270/1.

All other photographs by **Michael Freeman**.